STRONG
LIKE A
WOMAN

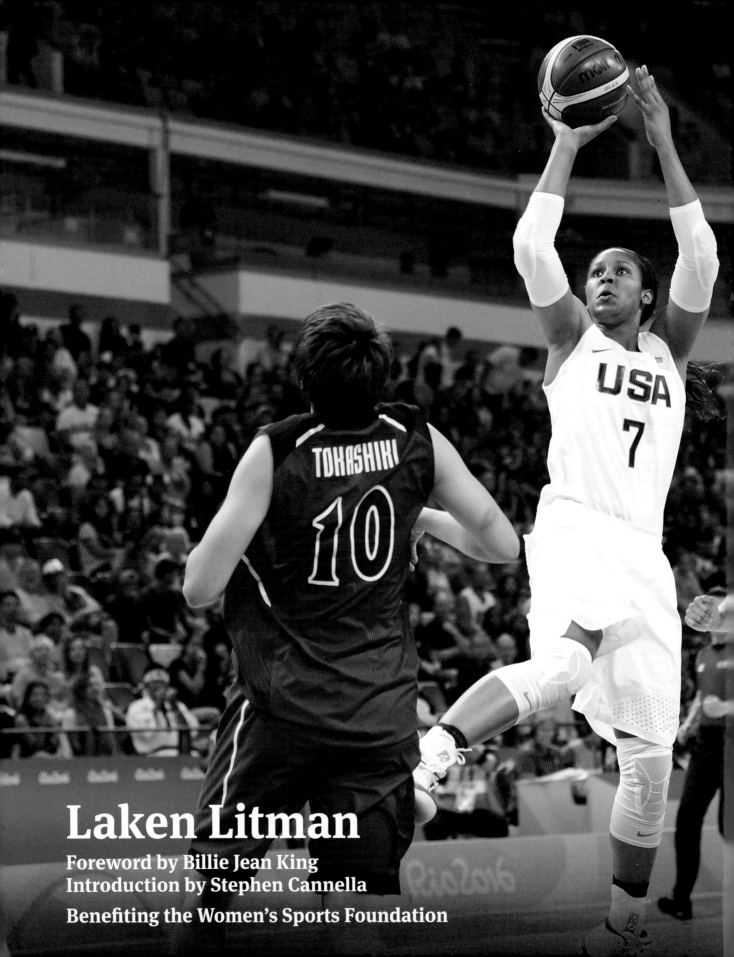

Laken Litman

Foreword by Billie Jean King
Introduction by Stephen Cannella

Benefiting the Women's Sports Foundation

Sports Illustrated

STRONG
LIKE A
WOMAN

100 Game-Changing
Female Athletes

UNIVERSE

A portion of proceeds will benefit the **Women's Sports Foundation**, established in 1974 by Billie Jean King. Their mission is to enable all girls and women to reach their potential in sport and life. It provides financial fuel to aspiring champion athletes, funds groundbreaking research, educates and advocates, and helps communities get girls active. For more information, please visit WomensSportsFoundation.org.

First published in the United States of America in 2022 by
Universe Publishing
A Division of Rizzoli International Publications, Inc.
300 Park Avenue South
New York, NY 10010
www.rizzoliusa.com

Photography Credits (SI = Sports Illustrated)
Scott Barbour/ALLSPORT/Getty Images: p. 251; **Robert Beck/SI:** pp. 9 (middle row, right), 11 (bottom row, right), 25, 32, 34, 117, 124–125, 151, 173, 181, 188, 195, and 225; **John Biever/SI:** pp. 11 (top row, left), 24, 64–65, 68–69, 164, and 165; **Simon Bruty/SI:** pp. 5, 9 (top row, right), 11 (top row, right), 21, 92, 115, 123, 139, 140, 155, 170, 176, 177, 186, 193, 201, 204, 215, 218, 220–221, 226–227, 228, and 241; **Darren Carroll/SI:** p. 233; **Jerry Cooke/SI:** pp. 8 and 106; **James Drake/SI:** pp. 120 and 244; **Tony Duffy/Allsport/Getty Images:** p. 98; **Mike Ehrmann/SI:** p. 167; **Graham Finlayson/SI:** p. 71; **Bill Frakes/SI:** p. 169; **Valery Hache/AFP via Getty Images:** p. 137; **Andy Hayt/SI:** pp. 84 and 185; **John Iacono/SI:** pp. 63 and 147; **Walter Iooss Jr./SI:** pp. 9 (bottom row, middle), 132, 148–149, and 156; **Jed Jacobsohn/SI:** pp. 178–179; **Kohjiro Kinno/SI:** pp. 9 (bottom row, left), 87, 168, and front cover; **Heinz Kluetmeier/SI:** pp. 10 (right), 42, 53, 56, 57, 88, 89, 103, 108, 109, 111, 212, 213, 216–217, 243, 246, 247, and 248–249; **David E. Klutho/SI:** pp. 9 (top row, left), 12, 83, and 235; **Christof Koepsel/Bongarts/Getty Images:** p. 70; **Michael Lebrecht II/SI:** p. 198; **Neil Leifer/SI:** pp. 10 (middle), 17, 36, 75, 102, 174–175, 184, 187, and 191; **Caryn Levy/SI:** pp. 81 and 232; **Thomas Lovelock/SI:** pp. 11 (bottom row, middle) and 105; **Bob Martin/SI:** pp. 11 (bottom row, left), 172, and 236; **John W. McDonough/SI:** pp. 38, 39, 46, 66, 74, 118–119, 126, 127, and 207; **Richard Meek/SI:** p. 112; **Manny Millan/SI:** pp. 9 (middle row, left), 18, 19, 28, 29, 58, 80, 85, 128–129, 135, 146, 202, 203, and 242; **Peter Read Miller/SI:** pp. 35, 62, 110, and 145; **Donald Miralle/SI:** p. 130; **Marcel Mochet/AFP via Getty Images:** p. 136; **Jordan Murph/SI:** pp. 100 and 101; **Michael O'Neill/SI:** p. 43; **Mike Powell/SI:** p. 16; **Erick W. Rasco/SI:** pp. 2–3, 22–23, 27, 48, 50–51, 61, 104, 154, 160, 162–163, 182–183, 238–239, and back cover; **Bob Rosato/SI:** pp. 97 and 116; **William R. Sallaz/SI:** pp. 30 and 31; **Stephen Slade/SI:** p. 11 (top row, middle); **Lane Stewart/SI:** pp. 222 and 223; **Damian Strohmeyer/SI:** pp. 141 and 152–153; **George Tiedemann/SI:** p. 134; **Al Tielemans/SI:** pp. 26, 44, 45, 52, 67, 93, 94–95, 114, 122, 197, 211, and 230–231; **Tony Triolo/SI:** pp. 9 (top row, middle), 59, 91, 107, 133, and 159; **John van Hasselt/Corbis via Getty Images:** p. 208; **Chris Weeks/Getty Images for The Heroes Project:** p. 54; **Kevin Winter/Getty Images for The Recording Academy:** p. 40; **Jim Wright/SI:** p. 14; **John G. Zimmerman/SI:** pp. 9 (bottom row, right), 10 (left), 72, 73, 76, 77, 78, 90, 113, 142, and 190.

Publisher: Charles Miers
Associate Publisher: James Muschett
Managing Editor: Lynn Scrabis
Editor: Candice Fehrman
Design: Lori Malkin Ehrlich
Text: Laken Litman

Authentic Brands Group
President, Entertainment: Marc Rosen
Vice President, Media Brands: Michael Sherman
Brand Director, Sports Illustrated: Mychal Bogee
Director, Content Management–Sports Illustrated: Prem Kalliat
Manager, Syndication–Sports Illustrated: Will Welt

Printed in China

2022 2023 2024 2025 / 10 9 8 7 6 5 4 3 2 1

ISBN: 978-0-7893-4119-8

Library of Congress Control Number: 2021946570

Visit us online:
Facebook.com/RizzoliNewYork
Twitter: @Rizzoli_Books
Instagram.com/RizzoliBooks
Pinterest.com/RizzoliBooks
Youtube.com/user/RizzoliNY
Issuu.com/Rizzoli

PREVIOUS SPREAD: Maya Moore in action during quarterfinals, Summer Olympics, Rio de Janeiro, Brazil, 2016; **OPPOSITE:** USWNT celebrating after winning FIFA World Cup, Vancouver, British Columbia, Canada, 2015

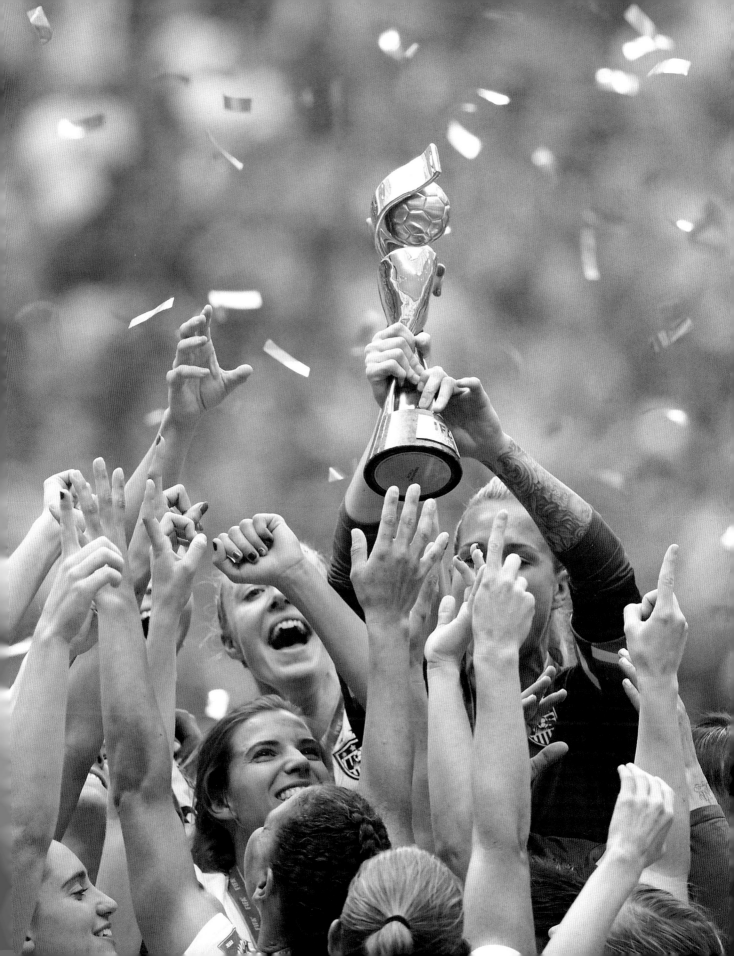

CONTENTS

Foreword

Access and opportunity. A place to play and a chance to compete. Those words have been part of the mantra of my life since I was a young girl. In *Strong Like A Woman*, we relive some of the most extraordinary moments and stories in sports history—yes, I said sports history, not just women's sports history—as captured by the men and women of *Sports Illustrated*. This look into the path to where we are today refreshes our memory of how challenging the road has been. It is also the perfect reminder that the more you know about history, the more you know about yourself.

In this wonderful chronicle of women's sports, we reexperience the history of such original trailblazers as Althea Gibson, Wilma Rudolph, Ann Meyers Drysdale, and Kathy Whitworth. We remember the game changers who revolutionized their sports, such as Pat Summitt, Misty Copeland, Peggy Fleming, Jackie Joyner-Kersee, Chris Evert, Nancy Lopez, Mia Hamm, Tatyana McFadden, Cammi Granato, Martina Navratilova, Nadia Comaneci, Minxia Wu, Joan Benoit Samuelson, Trischa Zorn, and Grete Waitz. And we showcase many of the stars of today, such as Simone Biles, Katie Ledecky, Elena Delle Donne, Megan Rapinoe, and Carli Lloyd. There are 100 stories of 100 women who have changed our world on and off the field of play.

It is easy to forget that women's sports are still in their infancy. Many of the major men's sports have been around for more than a century. And for years, women's sports were considered more of a sideshow than a main event. But these stories and photos have helped change that dynamic.

My generation relied on traditional media to tell our stories, to show our pictures, and to help us build our brands. We didn't have the immediacy of today's social-media platforms. We had relationships with writers and photographers who saw value in our action and our journey.

A central theme from the early days of women's sports that continues today is equal pay. It began in 1970 with the Original Nine of women's tennis, who not only started women's professional tennis as we know it today, but also opened the door on the equal-pay discussion—eventually achieving equal pay at all four major tournaments in 2007. Women's tennis was—and is—the leader in women's sports. Today, the equal-pay conversation is alive and well in soccer and hockey; it's part of the dialogue of all women's sports in the 21st century.

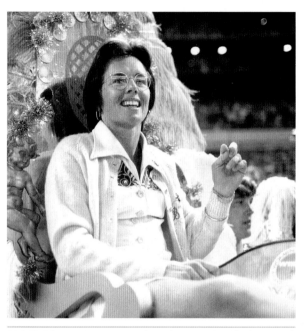

ABOVE: Billie Jean King posing on throne before Battle of the Sexes match against Bobby Riggs, Houston, Texas, USA, 1973

This is part of the reason I founded the Women's Sports Foundation in 1974. With the passage of Title IX on June 23, 1972, women could look forward to receiving some of the educational benefits and sporting opportunities that had previously been available only to men. While the focus of women in sports was much more on individual athletes, Title IX allowed the "team" concept in women's sports to step into the spotlight.

Creating sustainable professional women's sports leagues has been on a long and often challenging road. It didn't happen overnight, and it often didn't happen on the first try. The WNBA was founded in 1997. The NWSL was founded in 2012. There is so much that has happened, but so much more that still needs to be done.

The stories and images in *Strong Like A Woman* showcase the groundbreakers, trailblazers, and visionary women who often risked everything to have a career in sports. They found the access and created the opportunity to open the doors for future generations of young girls and women.

The 100 athletes featured in *Strong Like A Woman* may have been the first, but they will certainly not be the last. We are just beginning.

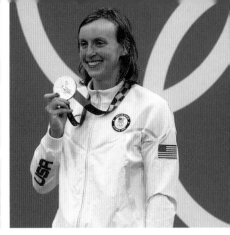

TOP ROW: Cammi Granato in action, Winter Olympics, West Valley City, Utah, USA, 2002 (left); Nancy Lopez in action, U.S. Women's Open, Chaska, Minnesota, USA, 1977 (middle); Katie Ledecky posing with gold medal after 1,500-meter freestyle, Summer Olympics, Tokyo, Japan, 2021; **MIDDLE ROW:** Jackie Joyner-Kersee in action during 100-meter race, Summer Olympics, Seoul, South Korea, 1988 (left); Mia Hamm in action during Women's International Friendly, San Jose, California, USA, 2003 (right); **BOTTOM ROW:** Simone Biles posing during training session, Spring, Texas, USA, 2016 (left); Martina Navratilova in action during Avon World Championship Series, Hilton Head Island, South Carolina, USA, 1982 (middle); Ann Meyers Drysdale in action during UCLA game, Fullerton, California, USA, 1977 (right)

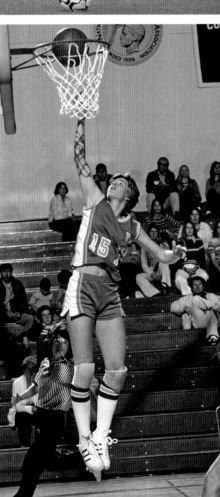

Introduction

Stephen Cannella, Editor in Chief, *Sports Illustrated*

Before Billie Jean King played her first Grand Slam event, before Wilma Rudolph sprinted to Olympic superstardom, and long before Title IX became law or Brandi Chastain celebrated or Simone Biles dominated, *Sports Illustrated* created a women's sports milestone of its own. Less than a year into its existence, the fledgling weekly magazine featured a pair of gymnasts on the cover of its January 24, 1955, issue. Doris Hedberg and Maud Karlen, members of a Swedish gymnastics team that was touring the United States, were the first female athletes to grace a *Sports Illustrated* cover. The next two issues also featured women at the top of their games: Jill Kinmont, a national champion skier, and figure skater Carol Heiss, who would win a silver medal at the 1956 Winter Olympics and a gold in 1960.

Three issues, three covers devoted to strong, skilled, accomplished women—the images are still striking in the context of an era not exactly remembered as a heyday of women's sports. The point here is not a victory lap; *Sports Illustrated*, like most mainstream outlets, could certainly have done more—and still can—to promote gender balance in sports media coverage. But those 1955 covers helped establish *Sports Illustrated* as a place where the accomplishments, stories, and spirit of female athletes could and would be celebrated. In the history of women's sports, it was a small step forward. But it was a step.

As you'll see in the pages that follow, *Sports Illustrated* has continued to tell those stories for nearly seven decades. Stories of trailblazers who opened new doors through sports: King, Janet Guthrie, Althea Gibson. Stories of perseverance, inspiration, and the awesome power of the will to compete: Kirstie Ennis, Gabriele Grunewald, Jessica Long. Stories of activism and the ways sports can be a platform in the fight for equal rights, equal pay, and equal opportunity: Martina Navratilova, Megan Rapinoe, Mo'ne Davis. And, of course, stories of sheer athletic dominance: Serena Williams, Marit Bjoergen, Jackie Joyner-Kersee, Steffi Graf.

The title of this collection may be *Strong Like A Woman*, but at heart these aren't women's sports stories. They're sports stories, period. They resonate because they remind us why we compete, why we watch, and why we care so deeply about the games we play. They're also a reminder of how far female athletes and women's sports have come since those *Sports Illustrated* covers of the Eisenhower era. In 1972, when Title IX was passed to create gender equity in access to educational opportunities and programs, some 294,000 American girls played a high school sport. By 2019, that number had grown to more than 3.4 million. It has been exhilarating over the decades to watch the 100 athletes featured in this book energize and revolutionize

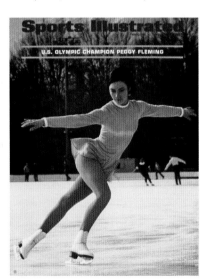 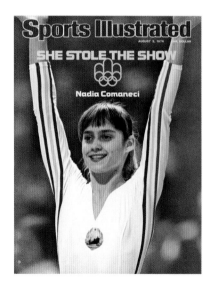 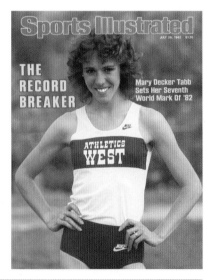

ABOVE: Peggy Fleming, Grenoble, France, 1968 (left); Nadia Comaneci, Montréal, Québec, Canada, 1976 (middle); Mary Decker Slaney, Knoxville, Tennessee, USA, 1982 (right); **OPPOSITE, TOP ROW:** Bonnie Blair, Albertville, France, 1992 (left); Diana Taurasi, Storrs, Connecticut, USA, 2003 (middle); Danica Patrick, Indianapolis, Indiana, USA, 2008 (right); **OPPOSITE, BOTTOM ROW:** Serena Williams, London, United Kingdom, 2015 (left); Chloe Kim, Saas-Fee, Switzerland, 2017 (middle); Megan Rapinoe, San Jose, California, USA, 2019 (right)

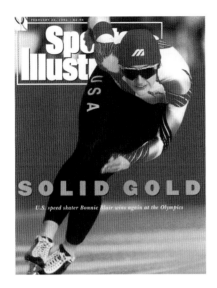

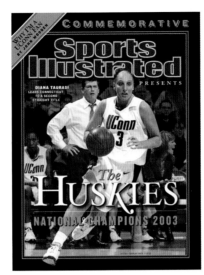

their chosen sports. It's going to be equally fun to watch the next 100 game changers emerge in the coming years. One might be shooting baskets or taking penalty kicks or running sprints in a park near you. She might even be thumbing through these pages, soaking up inspiration and dreaming of new barriers to break.

The history of women's sports is a tapestry of stories large and small, all worth telling even if they don't quite crack a top 100. Take the young skater on the cover of the February 7, 1955, issue of *Sports Illustrated*. Carol Heiss (now Carol Heiss Jenkins) not only won those two Olympic medals, but also took five straight world championships in the 1950s and accelerated the evolution of her sport by becoming the first woman to land a double axel in competition. After her 1960 Olympic gold at age 20, she was honored with a ticker-tape parade in New York City—the last such moment for a female athlete until 2015, when the World Cup-winning U.S. women's national soccer team (USWNT) rode through the Canyon of Heroes. As the USWNT prepared for the celebration, Heiss Jenkins reflected on the moment. "If you believe in something, write it down, because if you believe it, then it becomes a goal," she said. "Young girls have to have dreams and believe in those dreams in order to make them happen."

Goals set, dreams fulfilled—this book is full of both. Strong like a woman, indeed.

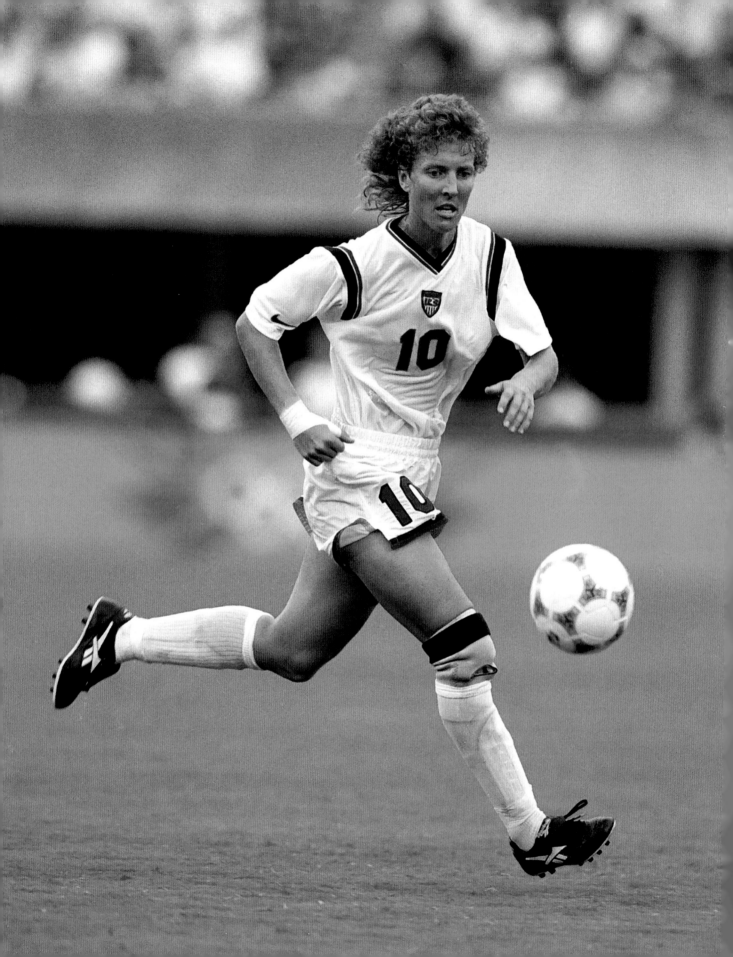

Michelle AKERS

soccer

Before there was Abby or Alex or Brandi or Mia, there was Mich. Or rather, Michelle. She was easily recognizable, from her unruly curly hair among a team of ponytails to how she towered over both teammates and opponents at five-foot-ten. Her teammates called her Mufasa—yes, like in *The Lion King*—because of her long mane. But perhaps what stood out most about Michelle Akers was her intensity and dominance.

Akers scored 105 goals and won two World Cups and an Olympic gold medal for the United States during her 15-year soccer career. For much of that time, Akers was a ruthless goal scorer, playing forward before dropping back into the central midfield.

"I still think she's the best player who ever played," former U.S. head coach Tony DiCicco, who led the 1999 World Cup-winning team, told *Sports Illustrated* writer Grant Wahl in 2011. "Players like [Brazil's] Marta will challenge that, but from a physical standpoint, with her technical ability and her mentality, from every aspect of the game, Michelle was at the top. That's why I think she was able to play so long even with her physical challenges. Finishing, heading, dribbling—Michelle was the model."

By physical challenges, DiCicco was referencing the slew of injuries Akers endured, which included more than 30 knee surgeries. She also suffered for years from Epstein-Barr virus, which causes debilitating fatigue among other symptoms. She'd be absolutely exhausted after a short flight with the national team, feeling more like she'd flown around the globe. While her body tried to slow her down, Akers's ferocity only increased. Toward the end of her career, coaches tried to coax Akers into playing 20 minutes a game, but she always negotiated with them, asking for a full 90 minutes. Depending on the day, she'd have to settle for 70 or sometimes even 45 minutes.

When Akers was on the field, though, it was hard to tell she suffered from anything. She was renowned for her heart-stopping shots, or, as DiCicco described them, "like cannonballs

when you [caught] them." Akers was the "ultimate soccer warrior," according to *Sports Illustrated* writer Michael Bamberger. Mia Hamm once gave a perfect example of that description to *Sports Illustrated* writer Kelly Whiteside when she detailed how an Akers goal would unfold: "Usually she draws a crowd of defenders around her, and when she gets the ball, she turns and gets hit, then she turns again and gets hit again, then she claws her way through the pack, calms herself for the shot—she's so composed and focused at a time of so much panic—and strikes the ball perfectly."

Akers was the oldest U.S. member on the 1999 team that won the World Cup after the famous round of penalty kicks. But she wasn't even on the field when Brandi Chastain scored the winning goal. Near the end of regulation, Akers went up to defend a corner kick with her head just as U.S. goalkeeper Briana Scurry went up to punch the ball out. Scurry ended up getting a piece of Akers's head in the process and the midfielder fell to the ground. She was already feeling fatigued, so this took her out for good.

Bamberger described the aftermath of the injury in his story. Akers was helped to the training room, where she was hooked up to two IVs and an oxygen tank. She described herself at the time as "loony" and couldn't even focus well enough to watch her team on the television. When it was time for the penalty kicks, the U.S. team's medical professionals propped Akers up so she could watch, despite her feeling so out of it. By the time Chastain set up to take her legendary winning shot, Akers was glued to the television. When the shot went in, Akers pulled out the IVs (with the help of the medical professionals, of course) and ran out onto the field to celebrate with her teammates.

Akers retired before the 2000 Olympics in Sydney, but she still keeps busy living on an eight-acre farm outside of Atlanta that rescues horses. There's always something to do there, from taking care of the horses and other animals to sometimes hosting soccer camps for kids. Whatever she does, though, you can bet she's bringing the same kind of passion and fervor that made her one of the greatest soccer players of all time.

The Best High-Protein, Low-Fat Snack Ever, p. 51

SPORTS ILLUSTRATED WOMEN

FITNESS ◆ NUTRITION ◆ STYLE ◆ ADVENTURE SPIRATION

WHAT'S NEW, COOL, NEXT

31 Things That Will Change Your Life in 2003—and Beyond

How to Get Strong, Lean, RIPPED LEGS NOW

12 Athletes Reveal Their STAY-FIT SECRETS

DECEMBER/JANUARY 2003

LISA ANDERSEN
Four-Time World
Champion Surfer

AOL KEYWORD: SIWOMEN siwomen.com

Lisa ANDERSEN

surfing

isa Andersen's story sounds more like a movie than reality. She ran away from home when she was 16 years old, bought a one-way ticket to California, and never looked back. She left a note for her mom under her pillow that read, "Dear Mom, Someday I'm going to be the No. 1 female surfer in the world."

Which is exactly what happened. Andersen pursued her passion and turned it into a Hall of Fame career, becoming a four-time world surfing champion and winning four successive world titles from 1994 to 1997. And her wild story was turned into a documentary called *Trouble: The Lisa Andersen Story* in 2018.

"I felt my story needed to be shared with girls," Andersen said in an interview with the *Daytona Beach News-Journal* in 2019. "Don't let [adversity] hold you back. The goal was to show girls that whatever obstacles that are there, you can overcome those, follow your dreams and make them real."

Growing up in an unhappy home that ultimately resulted in her parents' divorce in 1985, Andersen would often escape to the local surf shops in her hometown of Ormond Beach, Florida, which is near Daytona. But her mother, Lorraine, didn't understand and thought surfing was "all drinking and drugging," according to a story written by *Sports Illustrated*'s Franz Lidz in 1995. "I was hoping she'd be a veterinarian," Lorraine said.

Back then, Andersen often surfed against the boys because the girls weren't as good. Soon she felt the pull of the California waves. One night, when her mom was out of town, as Lidz wrote, Andersen packed up all of the money she had from busing tables at a pancake house and took a taxi to the airport. There were no flights until the morning, so she slept on the floor. "I was totally paranoid," she told *Sports Illustrated*. "I was sure everyone knew I was running away."

Andersen lived with a friend in Huntington Beach, California. She didn't have much money or really any belongings,

so she borrowed a wet suit to surf in every day. But it didn't matter because she was pursuing her dreams.

Four months after arriving in California, Andersen entered her first event, sponsored by the National Scholastic Surfing Association, which she won. She kept on winning. In fact, according to *Sports Illustrated*, Andersen had one eight-month period early on where she won 35 trophies.

Meanwhile, Lorraine didn't know where her daughter was. A jaywalking citation eventually blew the surfer's cover. Andersen was written up by a Huntington Beach cop who asked her for an address. Nervous, Andersen gave Lorraine's. When she received the ticket in the mail, Lorraine put two and two together, remembering her daughter's friend in California. She looked up his number and called. She asked to speak with her daughter, saying, "Tell Lisa it's her mother. Tell her all is forgiven, and if she wants to talk, to call collect." Eventually, mother and daughter reconciled and became close.

In 1993, Andersen competed into the sixth month of her pregnancy with her first-born daughter, Erica. She'd later say that having a baby—and becoming the first mother on tour—motivated her even more to become the world's greatest surfer. Andersen returned to the tour two weeks after giving birth with the support of her mom, who helped take care of the baby. "Having a baby focused me," Andersen told *Sports Illustrated*. "I felt more responsible."

She went on to win her first world title in 1994.

"People compliment Lisa by telling her she surfs like a man," former surfing mentor Ian Cairns told *Sports Illustrated*. "The truth is, most men aren't as good as she is."

Andersen retired after back injuries forced her to stop surfing. She has two kids, and remains connected to the sport as an ambassador for Roxy, a women's surf, gear, and clothing brand.

LEFT: Lisa Andersen posing for the cover of *Sports Illustrated Women*, Santa Monica, California, USA, 2002

Kristin ARMSTRONG

cycling

Kristin Armstrong has never been fond of the word "retirement." After winning a gold medal in the women's individual time trial at the 2008 Beijing Olympics, Armstrong retired from professional cycling to become a mom. But two years later, she returned to the sport with her sights set on the 2012 London Games, where she won another gold medal in the same event. Armstrong retired again after her second Olympics, but, like clockwork, she came back again in 2015 and then made

history at the 2016 Rio de Janeiro Games by becoming the first rider to win three gold medals in the same discipline. Armstrong is one of only two women in any sport to have earned three gold medals in the same Olympic discipline (speed skater Bonnie Blair also holds this distinction).

Armstrong also became the oldest female cyclist to win an Olympic medal, turning 43 one day after her event.

"I don't have words to describe it," Armstrong said after completing her hat trick of medals. "When you've already been

two times at the pinnacle of the sport, why risk coming back for the gold medal? The best answer I can give is that I can."

After winning her third medal, Armstrong immediately burst into tears. Her son, Lucas, who was five years old at the time, asked her why she was crying. "He said, 'Mama, why are you crying? You won,'" Armstrong recounted to TeamUSA.org. "And I said, that's a great question from a five-year-old. Why am I crying? That's what we do, we cry when we're happy!"

Armstrong remembers when cycling first came on her radar. According to a *USA Today* article from 2009, Armstrong was standing outside her sorority house at the University of Idaho in 1994, watching triathletes zoom by her during a competition. A former high school swimmer, Armstrong thought adding biking and running into the mix was "nuts."

Then, of course, she turned herself into one of those nuts. In 1999, she completed an Ironman in Hawaii. Eventually, she got osteo-arthritis and stopped running. She settled on being the most decorated female cyclist in U.S. history, becoming a two-time world champion, and winning six U.S. national championships (in addition to her three Olympic gold medals).

These days Armstrong—who lives in Boise, Idaho, with her husband and son—spends her free time public speaking and serving as the manager of community health for St. Luke's Health System, with a goal of making her city one of the healthiest communities to live in.

It will take another once-in-a-lifetime athlete to achieve what Armstrong has in her stellar career. Perhaps Derek Bouchard-Hall, former president of USA Cycling, summed her up best: "Kristin Armstrong is a legend," he tweeted after she won gold in Rio de Janeiro. "3 golds in 3 Olympics. LEGEND!"

ABOVE: Kristin Armstrong in action during individual time trial, Summer Olympics, London, United Kingdom, 2012; **RIGHT:** Armstrong posing for a portrait with her son, Lucas, after winning gold medal for individual time trial, Summer Olympics, London, United Kingdom, 2012

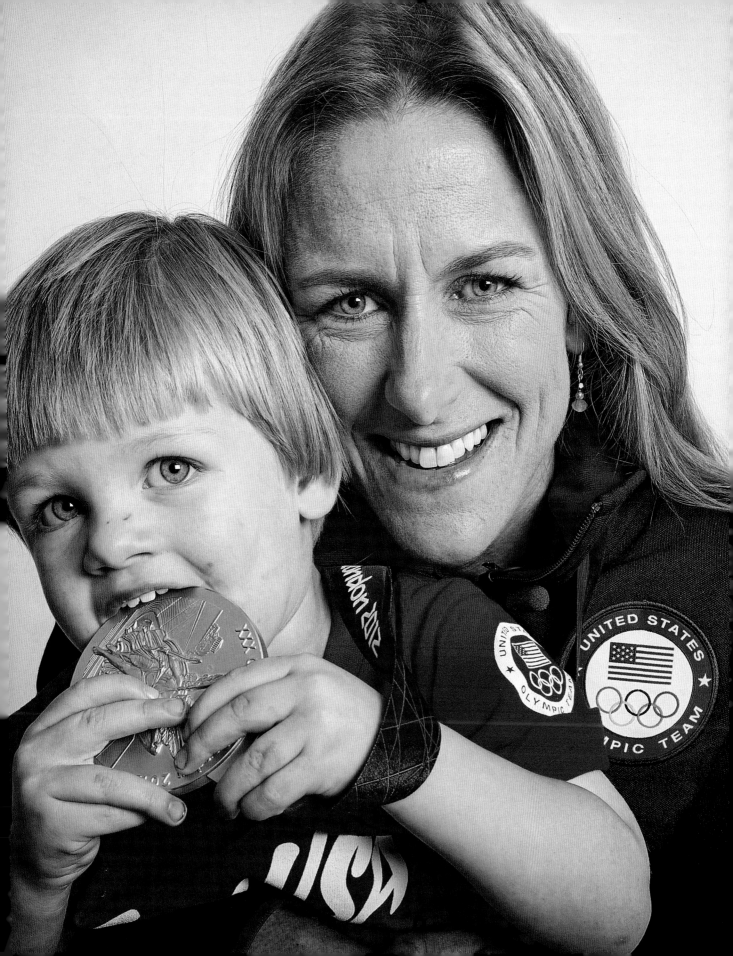

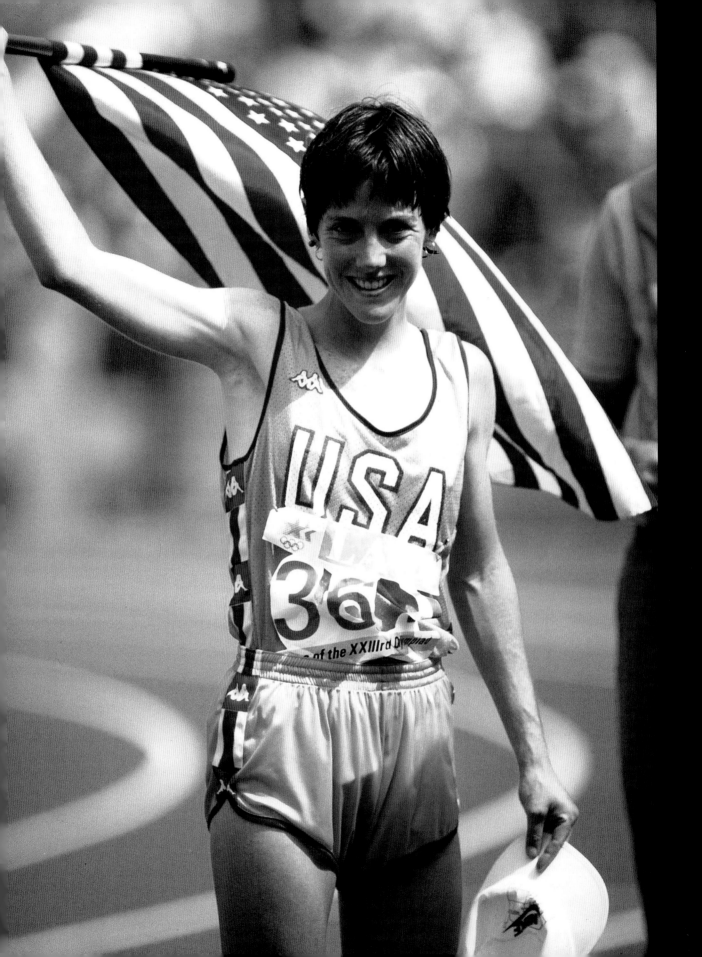

Joan BENOIT SAMUELSON

track and field

Joan Benoit Samuelson ran her best race ever at the 1985 Chicago Marathon. She set an American record of 2 hours, 21 minutes, and 21 seconds to beat reigning world-record holder Ingrid Kristiansen of Norway and 1988 Olympic gold medalist Rosa Mota of Portugal. Benoit Samuelson's U.S. record stood for 20 years, up until fellow countrywoman Deena Kastor broke it in 2005. It is still one of the 100 fastest times in the world and fifth-fastest U.S. time.

This feat occurred one year after Benoit Samuelson made history as the first woman to win gold in the inaugural women's Olympic marathon at the 1984 Los Angeles Games. And months before that, she famously won the Olympic Marathon Trials just 17 days after arthroscopic surgery on her right knee. Kenny Moore wrote for *Sports Illustrated* in 1985 that before Benoit Samuelson's best races, she would run 110 miles per week, running twice a day, with the hardest workouts being loops of 16 and 20 miles, plus she incorporated a weekly track session. It would have been a miracle if she avoided any type of injury. And she endured many.

But it was worth it to become one of the most acclaimed female distance runners in U.S. history—in addition to winning the first Olympic marathon for women, her résumé includes being a two-time Boston Marathon champion and a former world-record holder.

Benoit Samuelson recalled what the final stretch of winning the 1984 Olympics was like for *Sports Illustrated* in 1985: "Before going in that tunnel [of the Los Angeles Coliseum], I somehow heard or sensed the crowd inside come to its feet. I thought, 'This is the dream. This is the first women's Olympic marathon. This could really change my life.'"

Benoit Samuelson first got into running as part of her recovery from a skiing injury. She ran track and cross-country at Bowdoin College. As a senior, she won the 1979 Boston Marathon in 2:35:15, which was an American record at the time. At the 1983 Boston Marathon, she took more than 10 minutes off her time and ran 2:22:43 to win.

Even after making history in the 1980s, Benoit Samuelson kept competing. In 2008, she ran a sub-2:50 marathon at age 50 in the U.S. Olympic Marathon Trials (where she placed 90th); in 2010, at age 53, she set a record for her age when she ran 2:47:50 at the Chicago Marathon; and in 2013, at age 55, she won her age group with a time of 2:50:29.

The 2018 Chicago Marathon was special because she crossed the finish line in 3:12:13–right behind her daughter Abby (who is also a professional runner). Then, in 2019, she hoped to run the Boston Marathon within 40 minutes of her winning time from 40 years ago, which was 2:35:15. At 61 years old, Benoit Samuelson crushed that goal with a time of 3:04.

Benoit Samuelson lives in Maine, where she's originally from, with her husband, Scott. Their two grown kids are both runners, and she's still as active as ever. If she's not running, Benoit Samuelson is kayaking, biking, hiking, cross-country skiing, or gardening.

LEFT: Joan Benoit Samuelson celebrating after winning marathon, Summer Olympics, Los Angeles, California, USA, 1984; **ABOVE:** Samuelson in action during marathon, Summer Olympics, Los Angeles, California, USA, 1984

Simone BILES

gymnastics

We may never see someone like this again. Simone Biles has 32 Olympic and world medals and four gymnastics skills named after her. Once, in 2018, she won five individual medals at the world championships in Doha, Qatar, while suffering through a kidney stone. It's no wonder *Sports Illustrated* ran a story about her with the headline "Legend in Her Prime." Biles is transforming the sport while transfixing all of us.

At the 2019 world championships in Stuttgart, Germany, Biles won five gold medals, giving her a total of 25 world championship medals and passing Russia's Vitaly Scherbo (23) for the most ever. She also debuted two new moves. One was a double-double dismount off the balance beam, which consists of two twists and two backflips and is now known as the "Biles." The other was a triple-double, composed of a double backflip with three twists, in her floor routine, which is now called the "Biles II."

But her latest move—the Yurchenko double pike—is undoubtedly the one that has caused the most jaws to drop and heads to shake. At the U.S. Classic in May 2021, Biles attempted the stunning feat that had previously only been tried by men. To execute such an intimidating and dangerous move, Biles launches herself into a roundoff back handspring on the vault and then does two backflips with straight legs before landing perfectly on her feet.

There were murmurs she might try this skill again at the Tokyo Olympics in 2021, but instead Biles stunned the world and owned headlines when she withdrew from the team finals competition and, later, one individual competition after another to prioritize her mental health. Biles admitted that she had been struggling with intense pressure to perform and being the face of the Olympics. Additionally, she was having a case of the "twisties." While the word itself may sound cute, it's an incredibly dangerous, frightening, and common situation where gymnasts lose control of their bodies as they spin through the air. Biles couldn't figure out why her body and mind weren't in sync, so she and her team felt it was in her best interest—mentally and physically—if the world's top gymnast bowed out of the competition.

Biles was embraced for having the courage to speak up and very publicly acknowledge her own vulnerability. While there's still a stigma about mental health in sports, Biles joins a list of elite athletes—such as Michael Phelps and Naomi Osaka—in being brave, speaking up, and bringing awareness to an important topic. Biles did compete in one Olympics final event—the balance beam—where she took home a bronze medal.

This certainly wasn't the first time Biles stood up for herself. In January 2018, she became a leading voice against sexual abuse when she penned an Instagram post announcing that she had also been sexually abused by former USA Gymnastics team physician Larry Nassar.

"After hearing the brave stories of my friends and other survivors, I know that this horrific experience does not define me," Biles wrote. "I am much more than this. I am unique, smart, talented, motivated, and passionate. I have promised myself that my story will be much greater than this and I promise all of you that I will never give up. I will compete with all my heart and soul every time I step into the gym. I love this sport too much and I have never been a quitter. I won't let one man, and the others that enabled him, to steal my love and joy."

Biles's words helped prompt USA Gymnastics to shut down the mighty Karolyi Ranch, a training facility run by Bela Karolyi and his wife, and move to a new facility. Additionally, Biles criticized insensitive social media posts from Mary Bono, former interim CEO and president of USA Gymnastics, which helped force her resignation only four days after being hired.

It has never been a simple road for Biles. Having grown up in foster care, she has also become an advocate for education and foster kids. Her birth mother suffered from drug addiction. When Biles was three years old, she and her siblings were removed from their mother's custody and later formally adopted by their grandparents. In 2018, Biles launched a scholarship fund at the University of the People to assist with covering costs associated with students earning their degrees.

Yes, Biles will go down as one of the greatest athletes of all time. But her legacy will undoubtedly be more than just what she did as a competitor.

RIGHT: Simone Biles posing for a portrait with her Olympic medals, Summer Olympics, Rio de Janeiro, Brazil, 2016; **OVERLEAF:** Biles in action on balance beam, U.S. National Championships, Boston, Massachusetts, USA, 2018

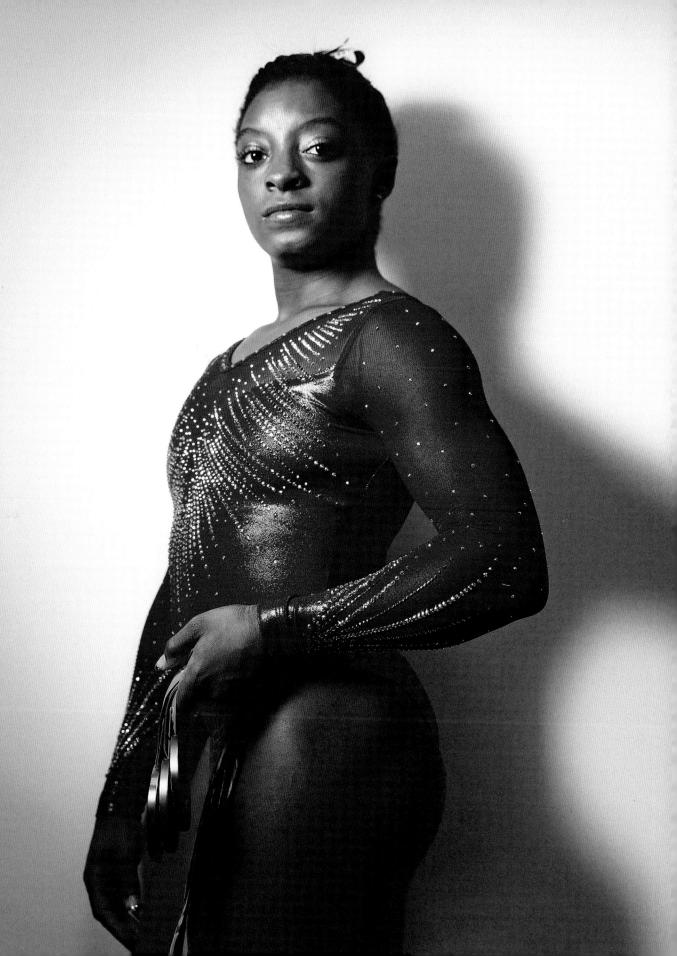

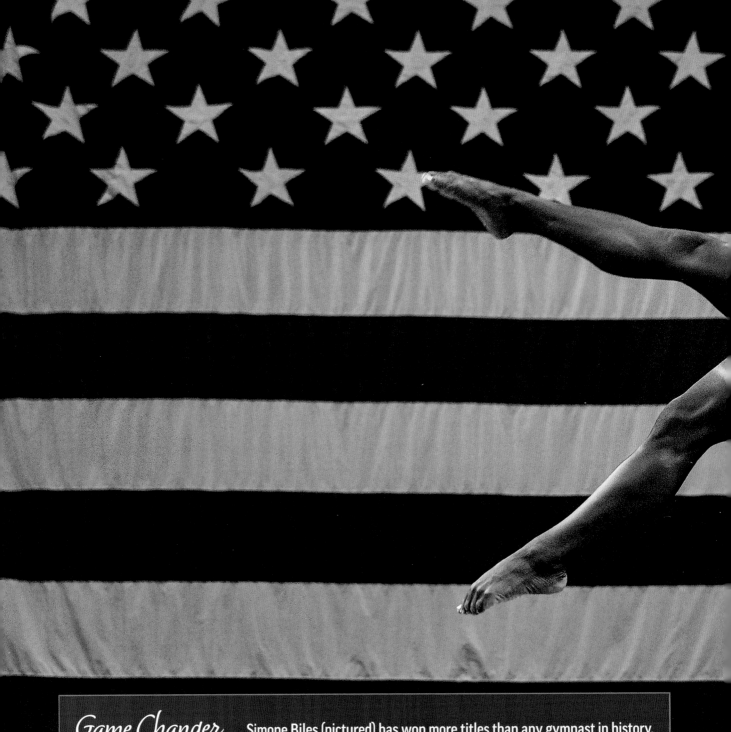

Game Changer... Simone Biles (pictured) has won more titles than any gymnast in history, male or female, including when she won her fifth senior women's all-around title at the 2018 U.S. National Gymnastics Championships. Later that year, she competed at the world championships in Doha, Qatar, and won it all—with a kidney stone! No matter how many more national or international meets Biles competes in, she will undoubtedly go down in history as the greatest gymnast of all time.

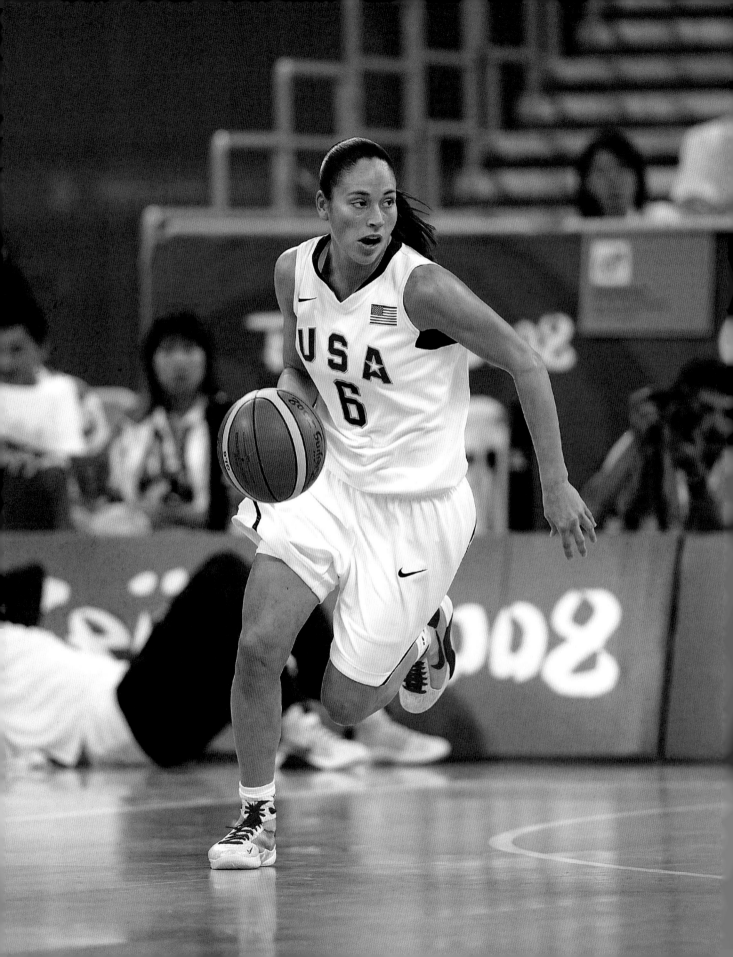

Sue BIRD
basketball

Sue Bird will go down as one of the most decorated basketball stars in the world. At 40 years old, she has won at every level—from high school state titles to two NCAA national championships at the University of Connecticut (UConn) to four WNBA titles and a record five Olympic gold medals.

These days, UConn is a dynasty known for winning NCAA championships. But those accolades hadn't come for Geno Auriemma's program until stellar players like Bird arrived on campus. As a sophomore during the 1999–2000 season, Bird averaged 10.9 points and 4.3 assists as the Huskies went 36–1 and won the program's second overall national title. As a senior, with then-sophomore Diana Taurasi by her side, Bird averaged 14.4 points and 5.9 assists and was the consensus Naismith College Player of the Year. Three weeks after leading UConn to another championship, the Seattle Storm selected Bird as the No. 1 pick in the WNBA draft.

Bird is charismatic, personable, and easy to talk to. "Unlike any other athlete I've seen, Sue Bird is a natural in all different contexts, with fans, with kids, with media, on the court," former Storm executive Karen Bryant told *Sports Illustrated*'s Kelli Anderson in 2002. "People relate to that, the athlete who seems like the girl next door."

While Bird's trophy case may be overflowing, her legacy off the court is arguably more impactful. Among the many important things she has accomplished, Bird played an integral role in leading a historic collective bargaining agreement for WNBA players in early 2020, which included maternity leave and family planning. She also took initiative, alongside her WNBA peers, to use her voice and lead the fight for social justice while playing in the WNBA "wubble." (WNBA players and personnel were confined to playing and living in a "bubble" at IMG Academy in Bradenton, Florida, for the duration of the 2020 season in order to minimize the risk of catching or spreading COVID-19.) Ahead of the start of the season, WNBA players decided together that they'd dedicate it to Breonna Taylor and the "Say Her Name" campaign, which brings awareness to Black female victims of police violence. Taylor was shot and killed by Louisville police officers while sleeping in her apartment during a botched raid in March 2020. Taylor's name was chanted all over the country at mass protests against police brutality and racial injustice.

In a lengthy *ESPN* profile in 2017, Bird came out as gay and revealed that she was dating soccer star Megan Rapinoe. The couple, who got engaged in October 2020, met during the 2016 Rio de Janeiro Olympics, hit it off, and quickly became everybody's favorite power couple. They were also the first gay couple to appear in the *ESPN* Body Issue.

Bird and Rapinoe can always be seen supporting each other, whether it's Bird flying to France to cheer on Rapinoe during the 2019 World Cup, or Rapinoe sitting courtside at every Storm game in the "wubble" during the 2020 WNBA season.

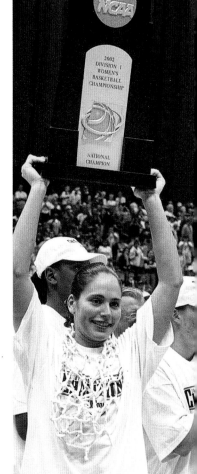

While we don't know how much longer Bird's basketball career will last—she was limited to 11 regular-season games in the shortened 2020 season due to knee issues and has dealt with other injuries in the past—she competed in her fifth Olympics in 2021, where she won a fifth gold medal, and has said she hopes to play through her 18th WNBA season.

What we do know is that regardless of when her retirement comes, Bird's legacy on and off the court will live for many generations to come.

LEFT: Sue Bird in action during quarterfinals, Summer Olympics, Beijing, China, 2008; **RIGHT:** Bird posing with trophy after UConn won the NCAA Championship, San Antonio, Texas, USA, 2002

Marit BJOERGEN

cross-country skiing

Quick, guess who is the most decorated winter Olympian of all time? Probably a figure skater or an Alpine skier or perhaps a luger?

No, it's actually Norwegian cross-country skier Marit Bjoergen, who has won a total of 15 medals, including eight gold, across five different Olympic Games. In her most recent and final Olympics appearance at the PyeongChang Games in 2018, she won five medals, two of them gold. She has also won 26 world championship medals, 18 of them gold.

Bjoergen started crushing the international circuit in 1999 when she was 19 years old. She won her first Olympic medal in the women's 4x5-kilometer team relay at the Salt Lake City Games in 2002 and later that year got her first International Ski Federation World Cup win in the freestyle sprint. She won

the world title the following year. While she started out as a sprinter, she added more events to her list, and with that came more victories and more medals.

While she won World Cup titles in 2005, 2008, 2012, and 2015, Bjoergen didn't win her first Olympic gold medal until the

2010 Vancouver Games. She was on the podium in each event she competed, including winning three consecutive golds in the sprint, 15-kilometer pursuit, and 4x5-kilometer team relay. She also won bronze in the 10-kilometer freestyle and silver in the 30-kilometer classical. After her performance in Vancouver, she was awarded with the Holmenkollen Medal, which is the highest honor for a Nordic skier.

Bjoergen took a break from competition to have a baby in December 2015, but was able to return in time to win four gold medals at the 2017 world championships.

It was only fair that Bjoergen, who had earned the nickname "Queen Marit," would win the gold medal in the final Olympic event of her career. On the last day of competition, the 38-year-old won the 30-kilometer classical to collect her record eighth Olympic gold. With her 15 total medals, she became the third-most decorated Olympian of all time behind U.S. swimmer Michael Phelps (28 medals) and Soviet gymnast Larisa Latynina (18 medals).

Bjoergen retired from competition following PyeongChang, but her impact and records will stand for generations to come. While it was tough to leave a sport after dedicating more than 20 years of her life to it, she told Olympics.com that the future is bright for cross-country skiing in Norway. "More and more young athletes [are] making it to the top," she said. "I also think that the reason why we're so strong is that they have idols who've shown the way and who they can identify with. After [the Olympics], we're perhaps going to see more boys and girls coming through. If they're doing cross-country or something else like Alpine skiing or skating, then it's all good for the future."

ABOVE: Marit Bjoergen celebrating after winning gold medal in 30-kilometer mass start freestyle, Winter Olympics, Krasnodar, Russia, 2014; **RIGHT:** Bjoergen in action during 30-kilometer mass start freestyle, Winter Olympics, PyeongChang, South Korea, 2018

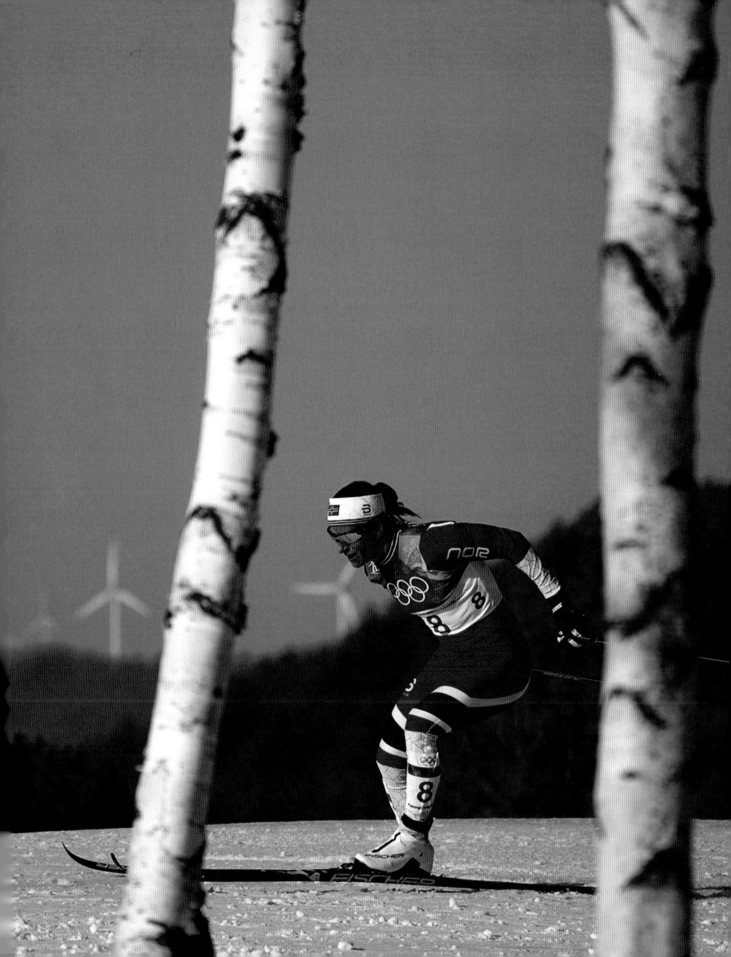

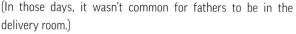

Bonnie BLAIR

speed skating

onnie Blair prefers gold over diamonds. Gold medals over diamond necklaces, that is. Blair, who won five gold medals in four Olympics and is recognized as one of the most decorated speed skaters in history, set a world record of 39.10 seconds in the 500 meters at the 1994 Winter Games in Lillehammer. Afterward, a jeweler in her hometown made her a necklace out of 39 diamonds. Blair's sister Suzy joked that it was actually a good thing she didn't skate a 38, because that would have meant one less diamond on the necklace. Blair, of course, would have preferred to go sub-39. That achievement came a month later, when she became the first woman to break the 39-second barrier with her time of 38.99 seconds in the 500 meters. She went even faster the following year, in February 1995, clocking in at 38.69 seconds.

No woman had ever won consecutive 500-meter speed-skating championships at the Olympics, and Blair won three in a row. She also picked up two 1,000-meter titles. Even with all of her accolades, Blair stayed humble and even-keeled. "She has been so successful for so long because she approaches every race the same way, whether it's an Olympic final or some weekend derby in Wauwatosa. It's all very simple: You can't count on winning, so you have to make it happen," wrote Alexander Wolff for *Sports Illustrated* in 1994.

As the youngest of six children, all of whom were skaters, Blair naturally fell into speed skating. In fact, skating was so ingrained in their family that on the day Blair was born her father, Charlie, dropped her mother, Eleanor, off at the hospital and took the other children to a skating rink nearby.

(In those days, it wasn't common for fathers to be in the delivery room.)

Blair was a smart kid and never made trouble for her parents, who had already seen everything from her older siblings. "I was too scared to do anything wrong," Blair told *Sports Illustrated*. "Her eagerness not to disappoint and willingness to do what she was told made her uncommonly coachable," wrote Wolff. To belabor the point, Blair said, "No matter what the competition, no matter what the training routine, I'd try to find a goal within it and try to better it."

Having a big family meant having an even bigger cheering section. At her first Olympics, the 1988 Calgary Games, about 30 members of what became known as the "Blair Bunch" traveled to cheer her on. Even more traveled to the 1992 Albertville Games. During one race, television cameras caught 45 "Bunch" members, all clad in purple team jackets, singing "My Bonnie Lies Over the Ocean." More than 60 members went to Lillehammer in 1994.

That was nothing compared to one of her final meets before retiring in 1995, when roughly 300 family members and friends came to watch Blair. *Sports Illustrated* writer Steve Rushin described them as a rowdy bunch with clanging cowbells that filled 12 percent of a 2,600-seat arena during the women's world sprint speed-skating championships.

Blair ultimately retired at her peak. On March 18, 1995, which also happened to be her 31st birthday, she set a personal best and an American record with a time of 1:18.05 in the 1,000 meters. It was quite the send-off for her final race.

Blair is married to her former Olympic teammate Dave Cruikshank and they have two children who have grown up on the ice. Their son, Grant, plays college hockey, while their daughter, Blair, has taken up her parents' sport. Blair Cruikshank, who is coached by her four-time Olympian father, competed at the 2018 U.S. Olympic Speed-skating Trials in the 500 meters, and has her sights set on making the team for the 2022 Olympic Games in Beijing. Perhaps we haven't seen the last of the Blair Bunch after all.

LEFT: Bonnie Blair celebrating after winning speed-skating race, Winter Olympics, Hamar, Norway, 1994; **RIGHT:** Blair in action during 500-meter race, Winter Olympics, Albertville, France, 1992

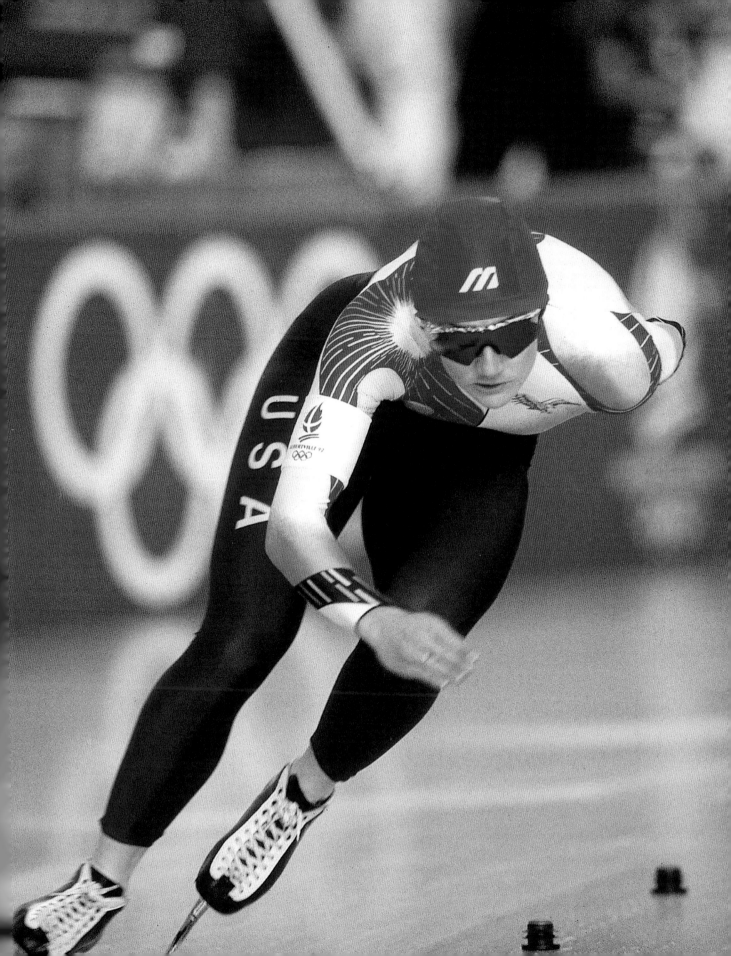

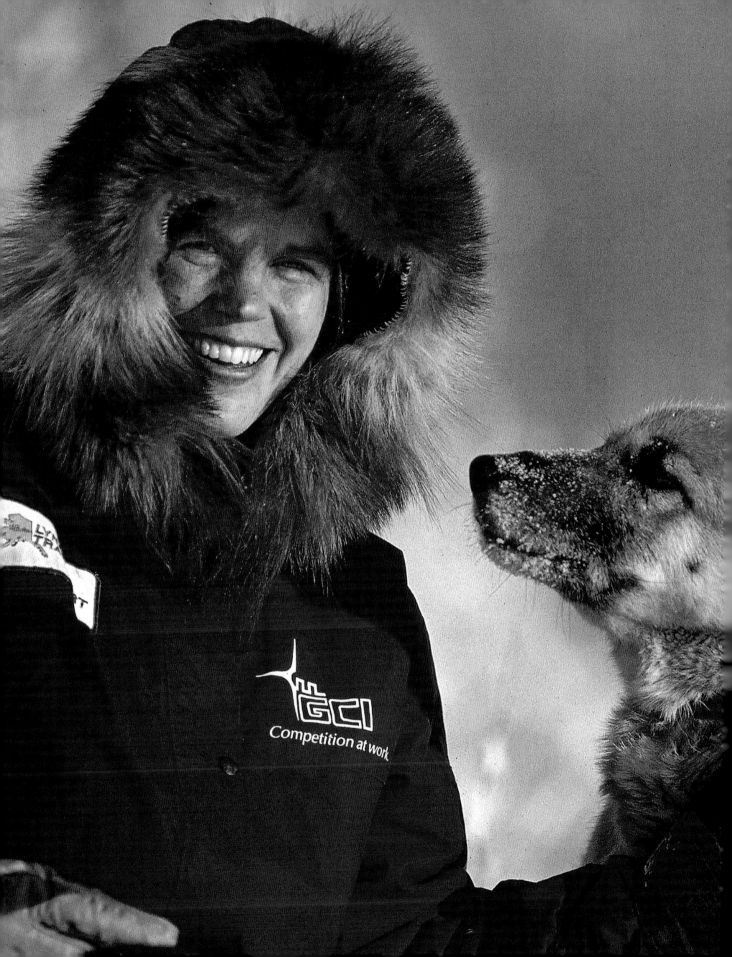

Susan BUTCHER

sled-dog racing

Susan Butcher's parents once thought their daughter might become a veterinarian. "Susan is more comfortable with animals than she is with most people," her father, Charlie, told *Sports Illustrated* in 1991. "Animals are emotionally honest. She loves that quality in them."

Butcher didn't become a vet, but she did become a four-time Iditarod champion, claiming all of her victories between 1986 and 1990. Only one musher, Rick Swenson, has won more, with five titles. (A musher is someone who drives a dogsled over snow.) The annual sled-dog race begins in Anchorage, Alaska, the first weekend in March, and ends approximately two weeks and 1,100 miles later in Nome.

Butcher lived in Eureka, a small mining and mushing enclave smack dab in the middle of Alaska. The village, which is 100 miles south of the Arctic Circle, had 13 residents when *Sports Illustrated* interviewed Butcher in 1991. But that's exactly the type of quiet place Butcher wanted to live most of her life. When she was eight years old, she wrote an essay for school titled "I Hate the City," and she tried to convince her parents to tear down their home in Cambridge, Massachusetts, and build a log cabin instead. She was always happiest frolicking in a field or playing with her dog. She eventually got her wish, living a quiet life among her dogs. According to a *Sports Illustrated* story by Sonja Steptoe, Butcher lived without indoor plumbing and the town didn't even have paved roads. She didn't care—all she needed was the creek that ran through her backyard, the rugged mountain ranges, and the fields of aspen and birch trees surrounding her. "This is what I want in life," Butcher told the magazine. "To live out here in the bush."

Butcher decided to move to Alaska after reading a magazine story about the first Iditarod in 1973. She lived in near isolation, focusing on her 150 dogs. She was once asked how she could remember all of their names. "It's easy when you know them," she said. "Like having 150 kids." She'd wake up at 6:00 a.m. to feed them, take them out on training runs, and even massage their muscles afterward. "When I'm mushing or caring for the dogs or picking up after them, I am in total contentment," she said. "I have found something that was made for me."

She entered her first Iditarod in 1978 and her last in 1994, retiring after finishing in 10th place. She was a fierce competitor, but even she couldn't always anticipate unpredictably bitter race conditions. During the 1982 race, Butcher's sled crashed into a tree, which injured her and four of her 15 dogs. Later in that same race, a violent snowstorm wiped out the trail and Butcher veered 10 miles off course. She was stranded for 52 hours in a freezing storm, chopping firewood in 80-mile-per-hour winds amid 30-foot snowdrifts to stay alive. She still finished second. Then, in 1985, she fended off an angry pregnant moose for 20 minutes with nothing but a poking ax until another competitor came along and shot the animal, which had already killed two of her dogs and injured others. Butcher ended up dropping out of that race.

After her last race in 1994, Butcher settled down with her husband and two daughters. She passed away in 2006 at the age of 51 after a battle with leukemia.

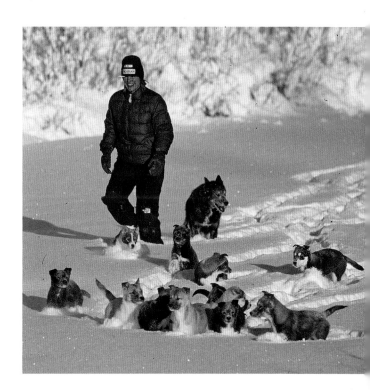

LEFT: Susan Butcher posing for a portrait with one of her dogs, Anchorage, Alaska, USA, 1990; **RIGHT:** Butcher at home with her dogs, Anchorage, Alaska, USA, 1990

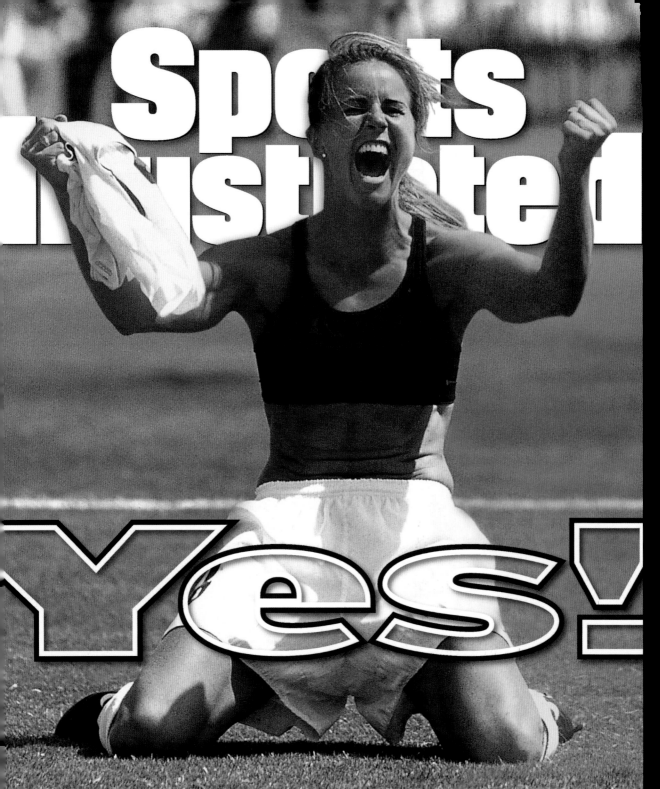

Sports Illustrated

Yes!

Why Brandi Chastain and the U.S. Women's
Soccer Team Were Unbeatable

JULY 19, 1999
www.cnnsi.com

*Brandi*CHASTAIN

Some headline writers called it "the bra heard 'round the world." Others called it the most iconic and important bra in sports history. What they were referencing, of course, was the simple, black Nike sports bra Brandi Chastain wore the day she scored a game-winning penalty kick in the World Cup final against China. In that pivotal moment for women's team sports in the United States and around the world, Chastain yanked off her jersey, twirled it in the air, fell to her knees, and pumped her arms in pure jubilation for a billion viewers worldwide to see on television.

"So many people have told me they'll never forget where they were when Brandi scored that goal," former U.S. women's national soccer team (USWNT) coach Tony DiCicco told *Sports Illustrated* in 2000. "That's history. I mean I remember where I was when John F. Kennedy was shot, and that's about it."

The result was not just one of the most iconic sports photographs ever taken or an image permanently seared "into the nation's collective consciousness," as Kelli Anderson wrote for *Sports Illustrated*. It was also a moment of liberation for women's sports.

"With one swift kick, Chastain coronated the U.S. women as Queens of the World, which seemed like the next logical step for a team that had gone from near obscurity to a national conversation piece in just three weeks," Grant Wahl wrote for *Sports Illustrated* after the game. "With an estimated 40 million U.S. viewers, the Cup final was the most watched soccer match in the history of network television, and the turnout of 90,185 at the Rose Bowl was the largest ever at a women's sporting event."

According to a 2000 *Sports Illustrated* story by Tim Crothers, over the next year, Chastain—who was 30 years old during the tournament—was everywhere, from the covers of *Sports Illustrated*, *People*, and *Time* to the Wheaties box. She threw out the ceremonial first pitch at Yankee Stadium. She sat behind President Bill Clinton's desk during the USWNT's visit to the White House. Tiger Woods even gave her a golf lesson.

After the famous moment, members of women's teams from the University of Santa Clara to Colorado's Highlands Ranch High started celebrating victories by shedding their jerseys. Male TV reporters ripped off their shirts while interviewing Chastain. "All the fuss raises a question: Would Chastain have reached the same level of celebrity if she'd merely kicked the Cup-clinching shot without the shirtless postscript?" Crothers wrote.

But Chastain pointed out that men often punctuate goals by removing their jerseys. "You see women more scantily clad on the beach every day," she said. "It's not like I'm a stripper."

Most of the stories told about Chastain focus on her game-winning penalty kick, and rightfully so, but the tales about how she let go of her ego and moved from striker to defender to regain her spot on the U.S. roster are not often highlighted. She played every minute of the 1996 Olympic gold-medal run despite suffering a torn right knee ligament in the semifinals.

"Brandi has fought through physical and mental battles that would have made others bail out," her husband, Jerry Smith, told *Sports Illustrated*. "But she breathes soccer. Two weeks ago, she flew 15 hours back from Australia, and an hour after she landed, she was on the field in a dribbling drill."

Chastain didn't retire with her teammates Mia Hamm, Julie Foudy, and Joy Fawcett in 2004. She wasn't ready to put her cleats away just yet.

"We always said you're going to have to drag Brandi off the field," Foudy told *Sports Illustrated*. "She'll be 60 years old, and somehow she'll still be out there."

We will always remember Chastain for her mark on the game of soccer and how she helped the USWNT transcend sports. And if anyone needs their memory jogged, just take a look at the famous photo *Sports Illustrated* photographer Robert Beck snapped that day. When he met Chastain a few years after the 1999 World Cup, she jumped into his arms, screaming and crying. "I thought, 'This is kind of weird,'" Beck said, "but then she said, 'You don't understand what that picture meant to thousands of little girls across the country. It conveyed that they could play sports and be on the cover of *Sports Illustrated*.'"

LEFT: Brandi Chastain on cover of *Sports Illustrated* after scoring game-winning penalty kick in the FIFA World Cup Final, Pasadena, California, USA, 1999

Kelly CLARK
snowboarding

t was during the Winter X Games in 2011 that Kelly Clark decided that she'd try something different and see what happened. Clark had already secured the title, so she had some flexibility on what she'd do for her last lap.

What she did was become the first woman to ever attempt and then land a 1080—which is when a snowboarder twists three full rotations in the air—in competition. While that move once seemed inconceivable, that is what snowboarders do. They push the limits and raise the bar.

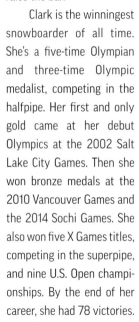

Clark is the winningest snowboarder of all time. She's a five-time Olympian and three-time Olympic medalist, competing in the halfpipe. Her first and only gold came at her debut Olympics at the 2002 Salt Lake City Games. Then she won bronze medals at the 2010 Vancouver Games and the 2014 Sochi Games. She also won five X Games titles, competing in the superpipe, and nine U.S. Open championships. By the end of her career, she had 78 victories.

Clark, who retired in 2019, will go down as one of the greatest trailblazers in her sport. "This sport has always been about more than just winning and losing," Clark told the Associated Press when she stepped away from the sport she'd dedicated her life to since she was 15 years old.

Clark burst onto the scene in 2001 "as a fresh-faced teenager from Vermont whose parents had indulged her dream—maybe a fantasy—to shred down halfpipes with the hopes of making it big someday," the Associated Press wrote. "She had no real expectations, and the thought of making the Olympics the next year seemed far-flung."

Except that Clark started winning Olympic qualifiers. In February 2002, as the youngest member of the U.S. team at 18 years old, she became the first American to ever win an Olympic snowboarding gold medal. "[It was] the ultimate peak at the ultimate time," Clark said.

However, despite her success, Clark struggled mentally and was distracted by the newfound pressure to be great. Sometimes she found herself not having fun anymore. But she persevered, won more medals, and helped bring more attention to snowboarding. The fruits of her success can be seen in young, dominant athletes like Chloe Kim, who became the youngest American snowboarder to win a gold medal in the halfpipe at the 2018 Olympic Games in PyeongChang. Kim has said that Clark is her idol and she was speechless when she met her for the first time.

Clark has kept busy in retirement, designing an environmentally friendly snowboard for women, writing a book called *Inspired: Pursuit of Progress*, and keeping active with her nonprofit foundation. The Kelly Clark Foundation was established in 2010 to provide young snowboarders with the resources and opportunities they need to reach their full potential. With the help of various partners and donors, the foundation has been able to award more than $100,000 in scholarships to ease the financial burden of young athletes across the country.

"Anyone in a leadership role wants to know they can step away and the culture can be real exciting and healthy without them," Clark told the Associated Press. "A few years ago, perhaps there would've been a hole. But there are no holes now. It's thriving, it's progressing. It's everything I dreamed it would be."

LEFT: Kelly Clark in action during snowboarding halfpipe final, Winter Olympics, Vancouver, British Columbia, Canada, 2010; **RIGHT:** Clark celebrating after winning snowboarding halfpipe final, Winter Olympics, Park City, Utah, USA, 2002

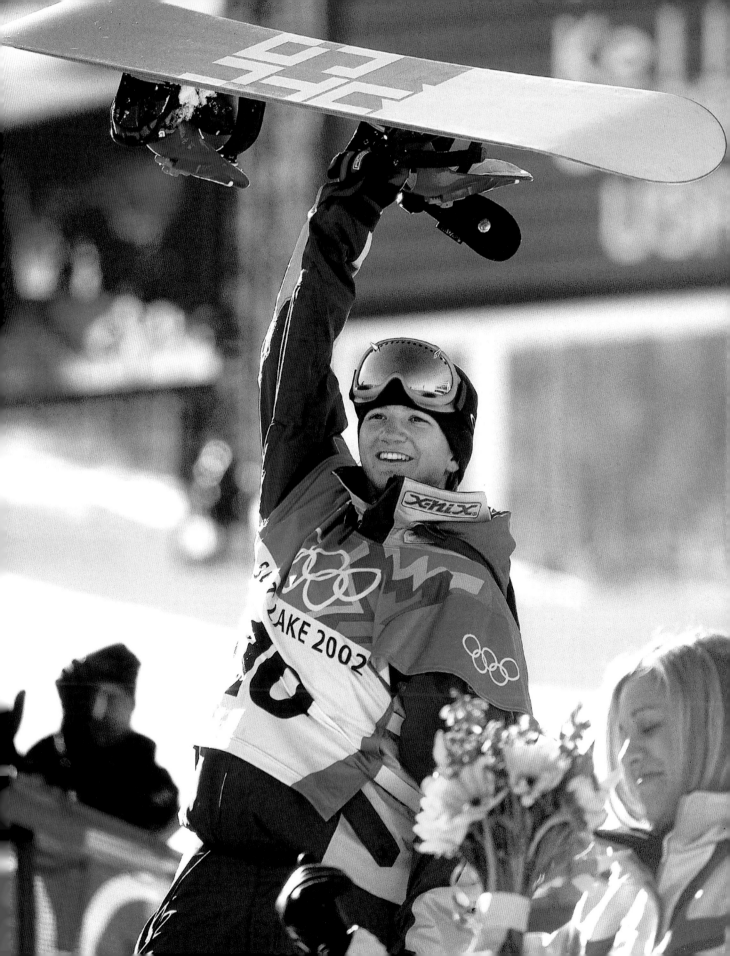

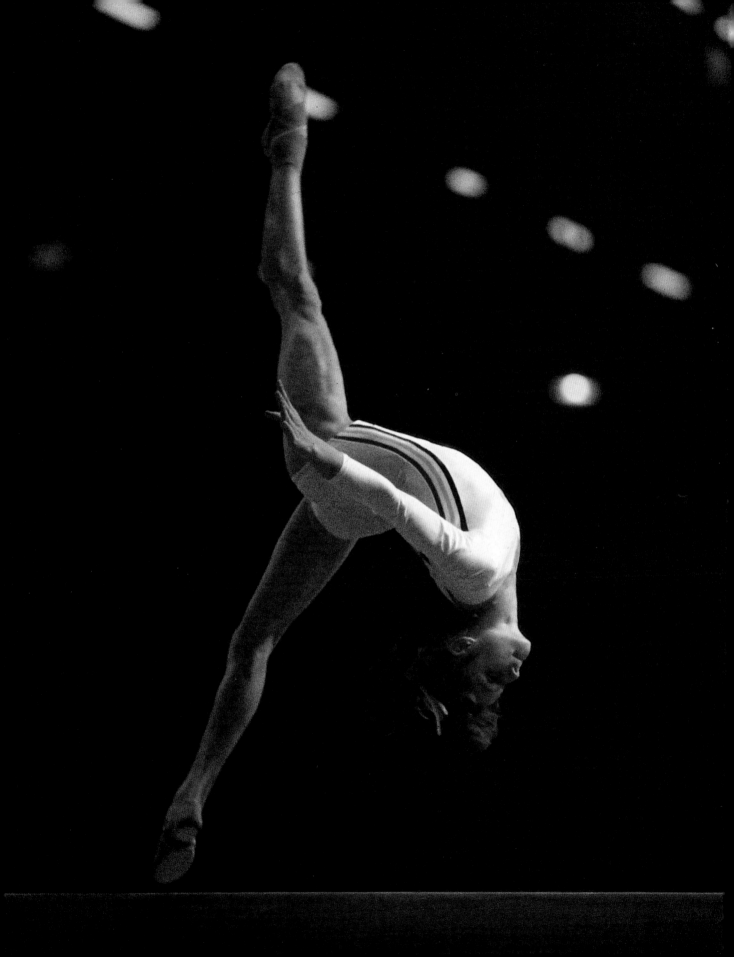

Nadia COMANECI

gymnastics

t was at the 1976 Olympics that the world fell in love with Nadia Comaneci. At the Montréal Games, the Romanian gymnast scored the first-ever perfect 10 in Olympic history for her uneven bars routine. She went on to earn six more 10s in Montréal and win three gold medals in the all-around, beam, and uneven bars competitions. She also won a silver medal and a bronze, and was quickly recognized as the world's new gymnastics queen.

By the time she retired in 1981, Comaneci had earned nine Olympic medals, including those three golds in Montréal and two more golds at the 1980 Moscow Games.

While she didn't become a global phenomenon until the Montréal Olympics, she had been preparing for that moment her whole life. As Bob Ottum noted in an article for *Sports Illustrated* in 1979, Comaneci became Romania's junior champion in 1971, three years after taking up gymnastics. She was a national champion by age 11, and, at 13½, she became the youngest gymnast to ever win the European Championship. She was 14 at her first Olympics in 1976.

Everyone fawned over the young star. She was five feet tall and weighed 85 pounds, she had a doll collection, and her favorite place to visit in the United States was Disneyland. While she was described as a perfectionist and had beautiful routines, one thing about Comaneci confused people. She never showed emotion. From the outside, she appeared more machine than human. "It is not her nature to smile," a Romanian judge told *Sports Illustrated* writer Anita Verschoth in 1976.

"Comaneci's large brown eyes, hidden under long bangs, are solemn, perhaps too solemn for a 14-year-old," Verschoth wrote. "She answered questions crisply, without elaboration. Has she ever been afraid? 'Never.' Has she cried? 'Never.' What was the happiest moment in her life? 'When I won the European Championship.' What is the secret of her success? 'I am so good because I work very hard for it.' What is her favorite event? 'The uneven bars. I can put in more difficulties. It is more challenging.' How did she rate her performance in the American Cup? 'It was a preparatory step toward the Olympics.' Does she enjoy being famous? 'It's all right, but I don't want to get too excited about it.'"

Comaneci was one of the first protégés of Bela Karolyi, the infamous Romanian-American gymnastics coach who later defected to the United States with his wife, Marta, and built a gymnastics empire. The Karolyis used to scout kindergartens all over Romania for the most talented girls to join their exclusive team in Transylvania, which is how he discovered Comaneci in 1968. (The Karolyis and their storied careers were eventually dismantled by their involvement in the USA Gymnastics sex abuse scandal.)

In the gym, Comaneci nailed moves that only men could do at the time. For example, her pike back somersault from the vault "was done more crisply than by Japan's Mitsuo Tsukahara, the guy who invented it," Ottum wrote. "She also introduced startling new gyrations that now carry her name, like the Salto Comaneci dismount off the top of the uneven bars, a high arc featuring a half-twist into a back somersault."

Other routines looked so difficult that gymnastics critic Josef Goehler once wrote in *International Gymnast* magazine, "From a biomechanic viewpoint, this is hardly conceivable." Conceivable or not, they were dazzling to watch. Comaneci's moves were so sensational that little girls all over the world began joining gymnastics teams.

In 1989, Comaneci defected from Communist Romania in a story made for movies. In their effort to escape Nicolae Ceausescu's regime, Comaneci and six others were driven in a rented car to a deserted road near the Romanian-Hungarian border. Around midnight, they started walking into Hungary and from there to Austria. They went to the U.S. embassy, where Comaneci was able to procure a flight to New York. She was worried she'd never see her family again. Little did she know that her country would soon start a revolution. Two weeks after Comaneci escaped, the Ceausescu regime fell and Romania ushered in a new era of democracy and freedom.

A few years later, Comaneci met American gymnast Bart Conner, whom she later married and started a family with. They now split their time between homes in Oklahoma (where Conner runs a gymnastics center) and Los Angeles. Comaneci travels the world for charity events and speaking engagements. She's also in the International Gymnastics Hall of Fame and the Oklahoma Sports Hall of Fame.

LEFT: Nadia Comaneci in action on balance beam, Summer Olympics, Montréal, Québec, Canada, 1976

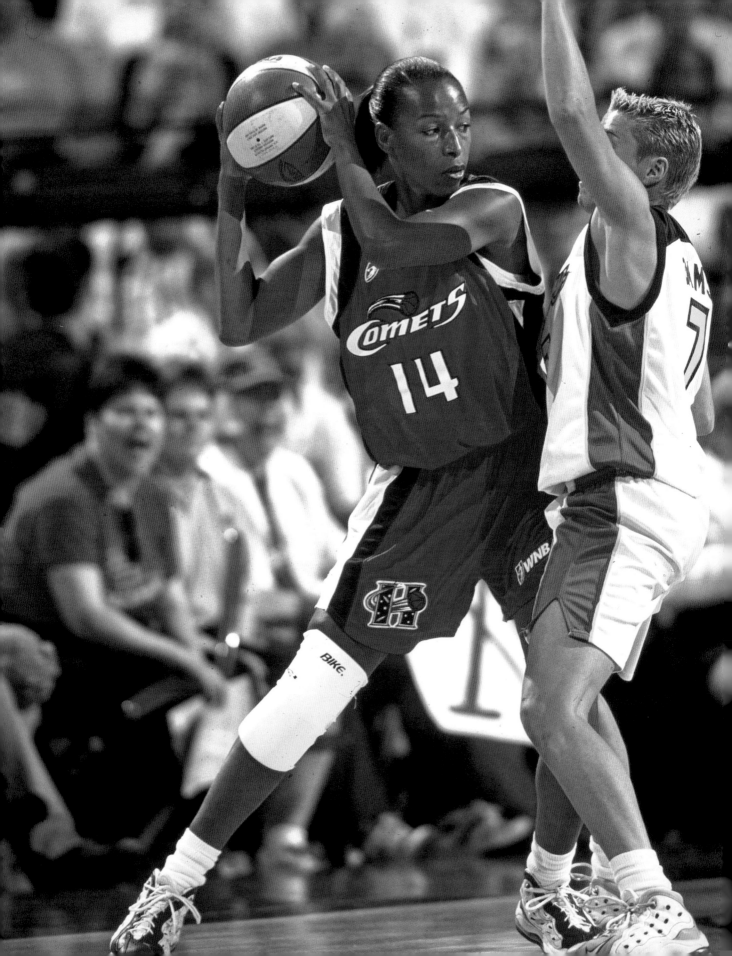

Cynthia COOPER

basketball

ynthia Cooper was one of the first great WNBA stars. With the league's inception in 1996 and its first season in 1997, it was point guard Cooper who took the league by storm at age 34. In that inaugural season, she led the league in scoring with 28.0 points per game, was named WNBA MVP, led the Houston Comets to a championship, and was crowned Finals MVP.

Cooper played for the Comets from 1997 to 2000, won four championships, and was named WNBA Finals MVP all four seasons—she still holds the record for most Finals MVP awards. Her various accolades include being a two-time league MVP, three-time scoring champion, three-time All-Star, two-time Olympian, and two-time NCAA champion at the University of Southern California (USC). After retiring at the top of her game in 2000, she briefly returned to play for Houston in 2003.

While her résumé speaks for itself, Cooper did so much more off the court. During her first couple of years in the WNBA, she was simultaneously taking her mother to cancer treatments and helping raise her nieces and nephews. According to *Sports Illustrated* writer Kelli Anderson, before the 1999 season Cooper lost her house to a fire, her mother to breast cancer, and her best friend and teammate, Kim Perrot, to lung cancer. But at 36 years old, when many of her contemporaries were retiring, Cooper still led the league in scoring (22.1 points per game) and took the Comets to a title, even with all of those losses weighing so heavily on her.

"She is the most focused basketball player I have ever seen," Houston coach Van Chancellor told Anderson. "She practices, she plays and she lets nothing bother her. She plays at a top level night in and night out. How she does it physically is a mystery to me."

One of the more unusual facts about Cooper's career is that she didn't even start playing basketball until she was 16 years old. And it happened by total accident. "I just happened to be in the gym at my junior high school one day and saw this older girl come down the court, put the ball behind her back from her left to her right hand and then make a layup," Cooper

told *Sports Illustrated*'s Johnette Howard. "Up until then I had run track. But just like that I said, 'Oooh. Wow. I want to play like that someday.'"

And so she did. Cooper earned a scholarship at USC, where she played with Cheryl Miller and Pamela and Paula McGee on the 1983 and 1984 NCAA title teams. Cooper also played on two U.S. Olympic teams, winning a gold medal at the 1988 Seoul Games and a bronze medal at the 1992 Barcelona Games.

After graduating from college, she played professionally in Europe for Parma and Alcamo. In her final season for Alcamo in 1995–1996, she averaged 35.5 points per game. When she headed to the WNBA, she was known for the fact that she could score, but her game was so much more than that.

"She's the best all-around player I've ever faced," former New York Liberty guard Vickie Johnson told Howard following the 1997 regular season. "She can go left if you stop her from going right, and she goes right if you stop her from going left. She can shoot the three, she can drive and score or pass off. After seeing her for four games now, nothing she does surprises me. She always seems to have something up her sleeve."

Cooper's career took her to coaching as well. She had a brief, albeit unsuccessful stint with the Phoenix Mercury from 2001 to 2002 before coming out of retirement to play again. Later, she started over at Prairie View A&M from 2005 to 2010, where she took the team to three Southwestern Athletic Conference championships while earning a bachelor's degree and studying for her master's degree. She also coached at UNC Wilmington and her alma mater, USC. She was named to the Women's Basketball Hall of Fame in 2009 and inducted into the Naismith Memorial Basketball Hall of Fame in 2010.

These days, Cooper serves as the head coach at Texas Southern University, a position she has held since 2019. She is also a mother to twins.

LEFT: Cynthia Cooper in action during WNBA Finals, Phoenix, Arizona, USA, 1998; **RIGHT:** Cooper celebrating after the Houston Comets won the WNBA Finals, Houston, Texas, USA, 1999

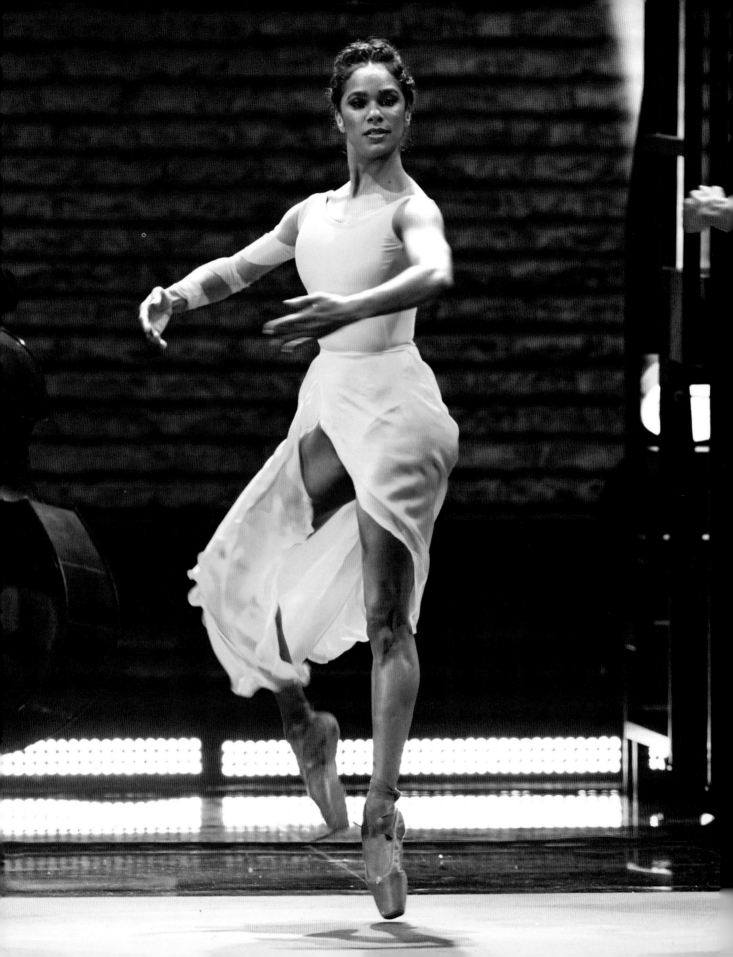

Misty COPELAND
ballet

Misty Copeland has always been very different than her peers. She is a Black woman in a profession that is largely white. Throughout her career, she has been told that her muscular frame didn't fit the typical prima ballerina mold or that, because of her skin color, she'd never make it at a major company. It's this type of adversity that has shaped Copeland into one of the greatest dancers and athletes in the world. And her story of triumph and breaking barriers to achieve her dreams is one that movies are made of.

While purists believe ballet should be categorized as an art rather than a sport, it would be unfair to Copeland and her fellow ballerinas to state that arts and sports must be mutually exclusive. While that is often up for debate, what shouldn't be is that Copeland embodies everything an athlete is: She's strong, muscular, competitive, and inspirational. She used to be sponsored by sports manufacturing company Under Armour. Take away the tutus and ballerinas like Copeland are undoubtedly elite athletes.

Copeland, who didn't start dancing until she was 13 years old, had to grow up much quicker than most kids her age. As she detailed in her best-selling memoir *Life in Motion: An Unlikely Ballerina*, Copeland grew up in San Pedro, California, where she and her five siblings were raised by a single mother who had various boyfriends and husbands. The family was always packing up and moving around, Copeland wrote, "often barely surviving." She discovered ballet at the San Pedro Boys & Girls Club, where she and her siblings spent their after-school hours. A teacher encouraged her to take up ballet, which she did, using it as an escape from her family situation.

Copeland studied at the San Francisco Ballet School and the American Ballet Theatre (ABT) Summer Intensive on full scholarship. She joined ABT's studio company in 2000, became a corps member in 2001, and became the company's second Black female soloist in 2007. Over the course of her career, Copeland has earned countless lead roles, such as Clara in ABT's production of *The Nutcracker* in 2014. Earlier that year, she made history as the first Black woman to perform the lead role of Odette/Odile in ABT's rendition of *Swan Lake* on the company's tour of Australia. She reprised the role at the Metropolitan Opera House the following spring. She also starred as Juliet in *Romeo and Juliet*.

"When I first saw her, I almost laughed, she was just so coordinated with such amazing facility," ABT's artistic director, Kevin McKenzie, told the *New York Times* in 2014. "I have seen her grow up through injury and difficulties. I think, to some degree, the racial issue has got to be a driving force, because there really haven't been that many dancers of color who have reached this level in a classical art form. She has kept her connection to her community and accepts being a symbol and has kept her eye on what it means to excel." In 2015, she became the first Black woman to ever be promoted to principal dancer in ABT's 75-year history.

Copeland told the *New York Times* that her life experiences have been integral to her development. "I think that I came into this profession with something that most of the dancers didn't have," she said. "As hard as it all was, it helped me from a young age to become a character, to feel certain emotions when dancing."

Those outside of the dance world didn't meet Copeland until she starred in the "I Will What I Want" commercial for Under Armour in 2014. It quickly went viral, drawing four million views on YouTube within a week of its release.

In addition to her dancing career, Copeland works with various charities and dedicates much of her time to mentoring young girls and boys. In 2014, President Barack Obama appointed her to the President's Council on Fitness, Sports, and Nutrition. She has written two autobiographical books and is constantly working to help diversify the arts.

LEFT: Misty Copeland performing at the Grammy Awards, Los Angeles, California, USA, 2020

Natalie COUGHLIN

swimming

She was often touted as the female version of Michael Phelps because of her versatility and the number of events she swam. But that comparison might not be totally fair to Natalie Coughlin, who won 12 Olympic medals in three Olympic Games, which makes her tied with Dara Torres and Jenny Thompson for the most decorated female swimmer of all time.

As Chris Ballard wrote for *Sports Illustrated* in 2002, Coughlin started swimming when she was 10 months old. By the time she was six years old, she was competing in meets, and at 13, she won races at the state and national levels. At

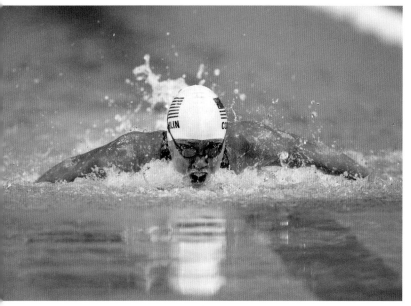

15, she became the first person in history to qualify for all 14 women's individual events at nationals, and at the U.S. Open in 1998, she won four of the five events she entered. She told *Sports Illustrated* writer Kelli Anderson that she was setting herself up to kill it at the 2000 Olympic Trials. "I was kind of the golden child who had so much potential," Coughlin said.

But in March 1999, Coughlin tore her labrum in her left shoulder after a long butterfly set just weeks before nationals. The best option was surgery, but with the Olympic Trials coming up, Coughlin chose physical therapy. She didn't fully recover in time. She earned fourth place in the 200-meter individual medley and missed the cut for the Olympic Games.

"I didn't care. I wasn't happy, I wasn't upset. I was indifferent," Coughlin told Anderson. "I just thought, Well, that's over with. I just wanted to go to college and have a different environment, a different everything."

But when she went to college her career blossomed and she regained a love for her sport by swimming for University of California at Berkeley coach Teri McKeever. In three years at Cal, Coughlin won 11 individual NCAA national championships and was named NCAA Swimmer of the Year all three seasons. As a sophomore in 2002, she became the first woman to swim the 100-meter backstroke in under one minute. She was undefeated in 61 dual-meet races during her college career and set eight different school records.

Coughlin competed in three Olympics, with her overall best performance coming at the 2008 Beijing Games. That's where she became the first female U.S. athlete to win six medals in one Olympics, including gold in the 100-meter backstroke, where she was the first woman to defend her title in that event (she'd won gold in 2004 as well).

Her final Olympics came in 2012, where she earned a bronze medal in the 4x100-meter freestyle relay. Coughlin was also a three-time Sullivan Award finalist (honoring the nation's top amateur athlete), and she broke 35 American records. She will undoubtedly always be remembered, like Phelps, as a rare swimmer who could be a threat in pretty much any race she entered.

"She has changed swimming," University of Georgia swimming and diving coach Jack Bauerle told Anderson in 2003. "She doesn't break records just by hundredths, she breaks them by body lengths. Thanks to her, what we thought was fast is no longer."

These days, Coughlin is married with two young kids. They live in Napa Valley. Coughlin actually grew up near wine country and loved going to tastings with her family, and now she owns her own winery.

ABOVE: Natalie Coughlin in action during 100-meter butterfly, FINA World Championships, Barcelona, Spain, 2003; **RIGHT:** Coughlin posing for a portrait ahead of Summer Olympics, New York, New York, 2004

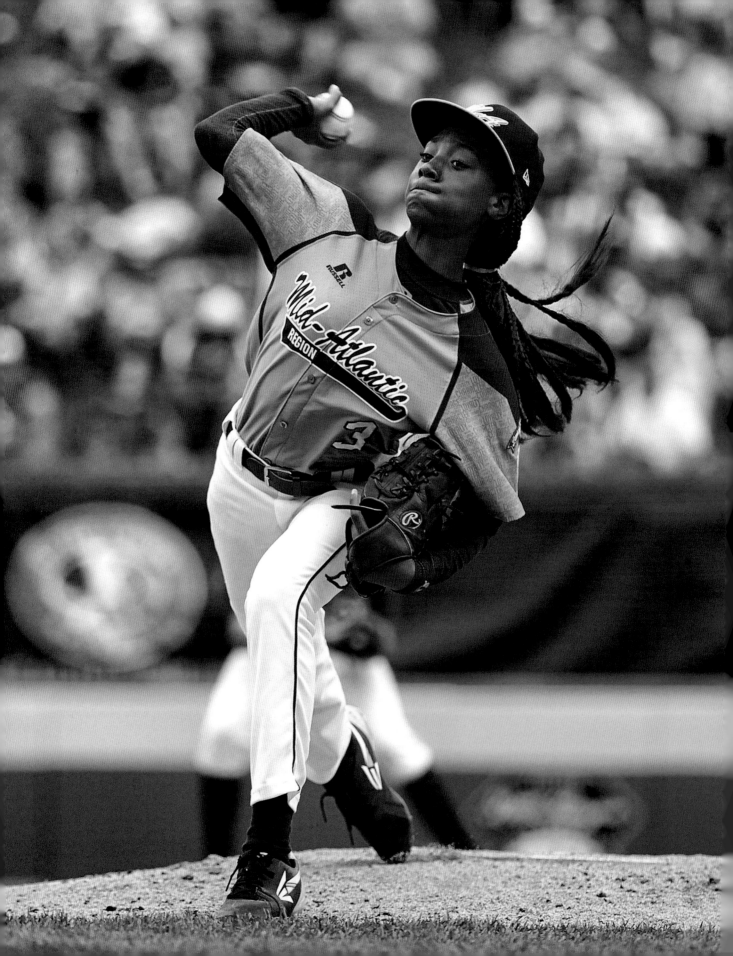

Mo'ne DAVIS

softball

Thanks to Mo'ne Davis, the phrase "You throw like a girl" is no longer demeaning, but rather complimentary. And it has been since at least 2014, when Davis, then just a 13-year-old girl with long braids, captured America's heart with her 70-mile-per-hour fastball. It was during the Little League World Series (LLWS), where she threw a complete-game, two-hit shutout against an all-boys team and helped lead her team, Philadelphia's Taney Dragons, to the U.S. semifinals. Davis was the fourth female player to ever play a game in the LLWS, but the first to pitch a shutout and win a game.

She captivated the nation. Kids and adults alike adored her. "One time a couple showed up at the school with a painting of me, which I appreciated, but it was definitely a little creepy," Davis told *Sports Illustrated* reporter Albert Chen in 2014. But when she heard from kids, Chen wrote, "she [lit] up."

Davis is the epitome of that old Gatorade campaign featuring Mia Hamm and Michael Jordan, set to the song "Anything You Can Do, I Can Do Better." She grew up in South Philadelphia, dominating the boys in every sport she played. She was a center midfielder on a boys' soccer team and played basketball too. She was actually "discovered" at seven years old while playing football with some friends. Davis was the one throwing tight spirals while the boys were running downfield to catch them. As Chen wrote in his cover story, she caught the attention of youth sports coach Steve Bandura, who happened to be grooming the baseball field at the same time. Davis eventually became the ace of his team.

As Davis's fame grew during the summer of the LLWS, she admitted that she never thought she'd be famous for playing baseball. She had hoped to star as a point guard for the University of Connecticut (UConn) when she went to college. "I just thought I was going to play baseball in the summer, have fun with my friends, then go back to school this fall," Davis told Chen. "But now, because everything got so big and because we're doing well, I do feel like a role model."

Davis graced the cover of *Sports Illustrated* on August 19, 2014, with the headline "Remember Her Name." And we do. "Last week, this week, maybe next week, she's owned the sports conversation," former *Sports Illustrated* managing editor Chris Stone said. "How often do you get to say this about a 13-year-old girl? It's the easiest type of story to identify as a cover story."

Chen described Davis's impact perfectly: "A feminist meme, a totem for inner-city baseball, your 10-year-old niece's new role model, your 10-year-old nephew's new role model." But Davis was also just a 13-year-old who was about to start the eighth grade.

Davis's celebrity status not only landed her on national magazine covers, but also on *The Tonight Show Starring Jimmy Fallon* and *The Ellen DeGeneres Show*. She got to go backstage at the ESPY Awards. She received tweets from Michelle Obama, Kevin Durant, and Billie Jean King.

While she didn't end up playing basketball for Geno Auriemma at UConn, she did play softball at Hampton, a historically black university. In 2019, Davis told *Sports Illustrated* that, after attending a mostly white private school since second grade, she wanted to attend a school where she was in the majority, not the minority. She's a communications major and hopes to have her own sports show one day.

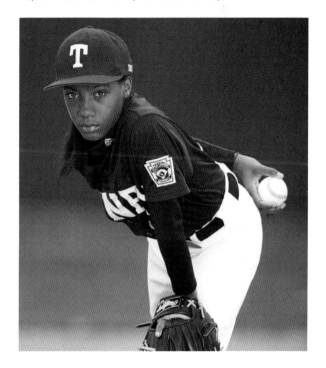

LEFT: Mo'ne Davis in action during Little League World Series, Williamsport, Pennsylvania, USA, 2014; **RIGHT:** Davis posing for a portrait for cover of *Sports Illustrated for Kids*, Philadelphia, Pennsylvania, USA, 2014

Mary DECKER SLANEY

It's truly unfortunate and perhaps unfair that Mary Decker Slaney's career is mostly remembered by her worst moment.

Decker Slaney is one of the most accomplished middle-distance runners in U.S. history. She's the only athlete ever to hold every American record from 800 to 10,000 meters. In 1983, when she won gold medals in the 1,500 and 3,000 meters at the first world championships in Helsinki, the wins were famously dubbed the "Decker Double." As of 2021, Decker Slaney still, incredibly, holds American women's records in the mile (4:16.71), 2,000 meters (5:32.70), and 3,000 meters (8:25.83).

Over her long career, Decker Slaney set 36 American records and 17 official or unofficial world records at various distances. She was a six-time winner at the Millrose Games in New York, winning her first title when she was 15 and her last when she was 38. She won her first national title in the 800 meters in 1974 when she was 15, and made four U.S. Olympic teams, although she never won a medal.

Decker Slaney was always feisty. She started running when she was 11 years old as a way to escape an unhappy home where her parents didn't get along. Decker Slaney graced four different *Sports Illustrated* covers and was named Sportswoman of the Year in 1983 after the Decker Double. In that cover story, Kenny Moore wrote about an incident where 15-year-old Decker Slaney, with braces and pigtails, threw a relay baton at a Soviet runner who cut her off in an indoor meet in Moscow. This was not lost on the media who covered track and field, as Decker Slaney's rise coincided with the Cold War.

Years later, at the 1983 world championships in Helsinki, Decker Slaney beat Soviet champion Zamira Zaitseva. The two had been pacing stride for stride, which thoroughly annoyed Decker Slaney, who told *Sports Illustrated*, "I thought about taking a swing at her, but then I worried about being disqualified, too. I was conscious of the U.S. vs. U.S.S.R. thing there a little. But it's lucky I didn't have a relay baton this time. I might have thrown it again." In the final stretch, Decker Slaney went all out. She told *Sports Illustrated* that she lost her temper and won because she was so angry. Zaitseva threw herself at the line to try to edge out a victory, but spectacularly fell to the ground instead.

LEFT: Mary Decker Slaney in action during the Bruce Jenner Classic, 1984

Decker Slaney was too young to make the Olympic team in 1972, was injured in 1976, and missed out in 1980 due to the U.S. boycott, so her first opportunity to compete in an Olympics didn't come until 1984. She was set to run the women's 3,000-meter final on the last Friday of the 1984 Los Angeles Games. While she was the gold-medal favorite, there was also Zola Budd, an 18-year-old South African who famously ran barefoot. The media hyped up the Decker-Budd matchup, which they rightfully nailed as the main event.

Decker Slaney led through four laps. Then, midway, Budd tried to take the lead and cut in front of her. Their feet collided, Decker Slaney lost her balance, and they fell onto the infield grass. Both athletes were in tears of humiliation.

Time photographer David Burnett, who took some very famous photos of that moment in the Los Angeles Coliseum, also wrote about the entanglement for *Runner's World*. "The pain in Mary Decker's face—so raw, and apparent—was something that almost should have remained the ultimate private moment," Burnett wrote. "It was the anguish of a moment seen by 75,000 in the stadium, and millions around the world via television. Never have I witnessed such a raw public-private moment. When a young runner saw her Olympic dreams go up in smoke, you can easily imagine something astonishingly personal about it. Yet it was played out before the world. It became Mary's worst day."

Decker Slaney and Budd met again a year later at London's Crystal Palace. This time, Decker Slaney won gold while Budd finished in fourth place.

Despite her records and accolades, Decker Slaney often trained too hard. This naturally led to a slew of injuries and subsequent surgeries, including one in 1994 when she had to remove 25 percent of her left Achilles tendon. Perhaps no sentence about her was ever truer than this one Merrell Noden wrote for *Sports Illustrated* in 1997: "Throughout her career Slaney has been forced to accept that her fiercest opponent is often her own ambition. Under its merciless lash her body has frequently broken down."

Decker Slaney is married to Richard Slaney, a British discus thrower. While she does not run anymore due to arthritis, she enjoys tending to her vegetable gardens and walking her dogs near her home in Eugene, Oregon.

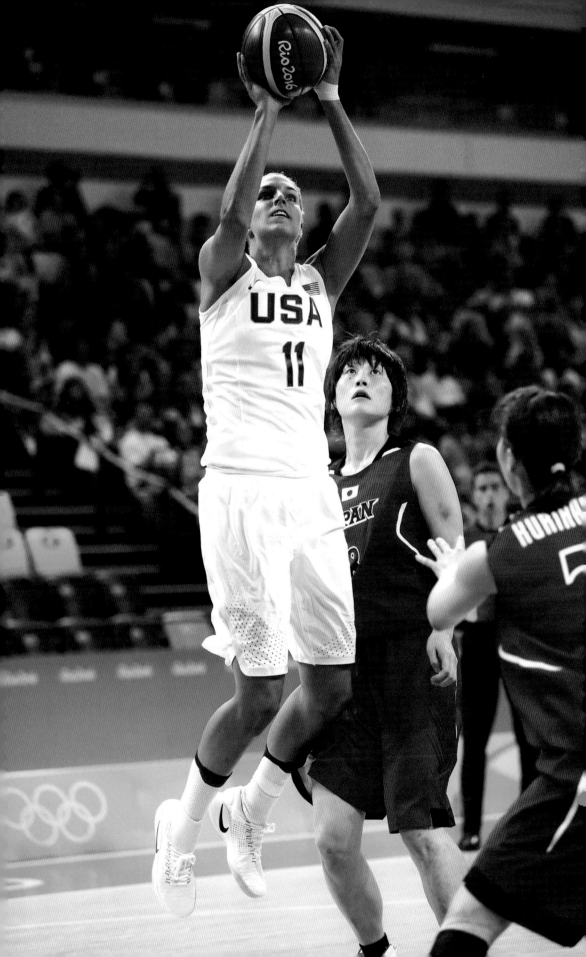

Elena DELLE DONNE

basketball

As the nation's No. 1 overall high school recruit, and once described by the *New York Times* as the next LeBron James, Elena Delle Donne had her pick of schools to go to. She'd narrowed her choices down to the top two teams in the country at the time: University of Connecticut (UConn) and Tennessee. Delle Donne ultimately committed to playing for Geno Auriemma and the Huskies, and had she stayed, she would have been part of a dynasty, won national championships, and played with four-time All-American Maya Moore.

But Delle Donne only lasted in Storrs, Connecticut, for a few weeks before heading home to Wilmington, Delaware. She was burned out by basketball and homesick for her family. She especially missed her older sister, Lizzie, who was born deaf, blind, and with cerebral palsy. Lizzie, who communicates through sign language, knows her sister by her hugs and kisses. The siblings are extremely close.

As Jon Wertheim wrote for *Sports Illustrated* in 2012, Delle Donne could not pinpoint why she "suddenly had such little passion for basketball and such little desire to play for what was likely a championship team" at UConn. "But it made more sense when she came home and hugged Lizzie."

"Remember, if I don't have physical contact with her, I don't have any contact with her," Delle Donne told Wertheim. "It's not like I can Skype with her or email or text her."

Delle Donne enrolled at the University of Delaware as a freshman in 2008 and joined the volleyball team as a walk-on. But in the spring, while watching the women's basketball team in the NCAA tournament, she decided she wanted to play again. Delle Donne started practicing her jump shot in the school gym early in the morning and late at night so as not to draw attention to herself, and quickly thereafter joined the team.

As Wertheim wrote in 2012, Delle Donne playing for Delaware, a program that had never won an NCAA postseason game or held a top 25 ranking until she arrived, was like "Adele singing in the church choir [or] Serena Williams in the ladies' scrambler at the country club."

"Let's be honest, from a basketball standpoint there was nothing I could do to top a UConn or Stanford or Tennessee,"

Delaware coach Tina Martin told *Sports Illustrated*. "But for Elena, this was home."

By the time Delle Donne graduated, she became the first University of Delaware player to be named an All-American and was the school's all-time leading scorer for both men's and women's basketball. Delle Donne was the second pick overall in the 2013 WNBA draft and played four years for the Chicago Sky before being traded to the Washington Mystics after the 2017 season. She was named rookie of the year in 2013.

Delle Donne is an Olympic gold medalist, two-time league MVP, and six-time All-Star (and three-time starter). She led the Mystics to a WNBA title in 2019 with three herniated discs in her back. She famously opted out of the 2020 season during the COVID-19 pandemic after penning an open letter about her health in the *Players' Tribune*. Delle Donne wrote that she takes 64 pills a day because she has had Lyme disease for more than a decade and taking the medication keeps her condition under control. Lyme disease makes Delle Donne immunocompromised and therefore at a much higher risk of contracting any illness, much less COVID. Knowing this about herself, the reigning league MVP decided the smartest decision for her health would be to not live in the WNBA bubble in Florida, where COVID cases were spiking. But the league's panel of doctors denied her request for a health exemption for the 2020 season. This put Delle Donne in an impossible position. "I'm now left with two choices: I can either risk my life . . . or forfeit my paycheck," she wrote.

After using her platform to speak out about her battle with Lyme disease, the Mystics announced they would pay her, even if the league denied her medical exemption. Delle Donne did not play in the 2021 season because she was rehabbing after two back surgeries. She was left off the Team USA roster for the 2020 Tokyo Olympics, which were postponed to 2021 due to COVID-19, for the same reason.

LEFT: Elena Delle Donne in action, Summer Olympics, Rio de Janeiro, Brazil, 2016; **OVERLEAF:** Delle Donne and teammates posing with their gold medals, Summer Olympics, Rio de Janeiro, Brazil, 2016

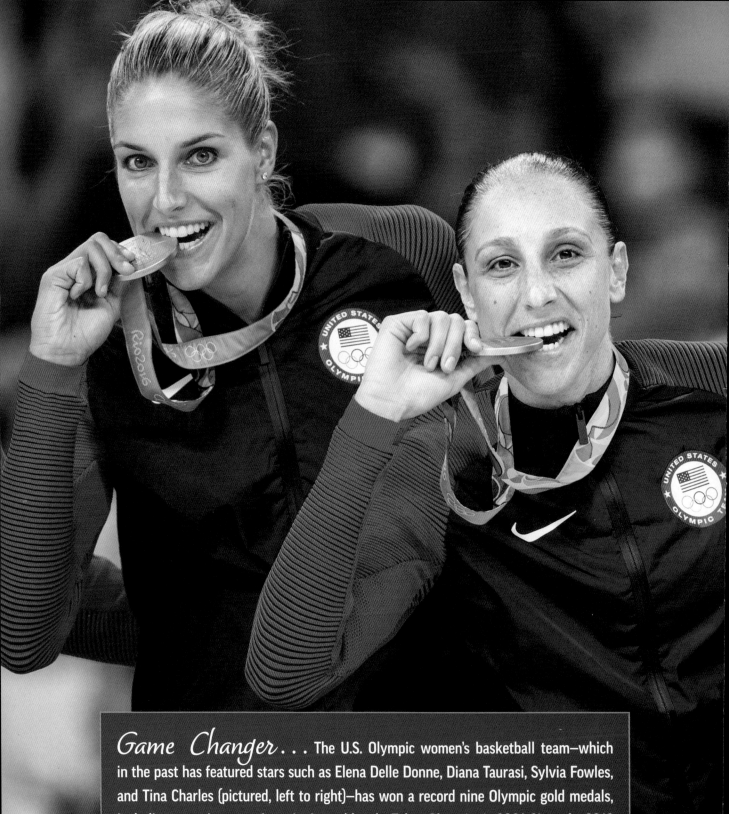

Game Changer . . . The U.S. Olympic women's basketball team—which in the past has featured stars such as Elena Delle Donne, Diana Taurasi, Sylvia Fowles, and Tina Charles (pictured, left to right)—has won a record nine Olympic gold medals, including seven in a row after winning gold at the Tokyo Olympics in 2021. Since the 2016 Rio de Janeiro Games, the dynasty that is Team USA owns a dominant 55-game winning streak in Olympic competition and an overall record of 72–2 since beginning play at the 1976 Montréal Games.

Gail DEVERS

track and field

Gail Devers didn't know if she'd ever be able to walk again, and then she won three Olympic gold medals. Devers was a young and talented sprinter at the University of California, Los Angeles (UCLA) in the late 1980s. During her senior year in May 1988, she set a U.S. 100-meter hurdles record of 12.61 seconds and made the team for the Olympic Games in Seoul. But in her big international moment, she ran poorly, didn't make the finals, and, afterward, grew gravely ill.

As Kenny Moore wrote for *Sports Illustrated* in 1993, for almost two years, "Devers suffered vision loss, wild weight fluctuations, fits of shaking and nearly perpetual menstrual bleeding." Eventually she was diagnosed with Graves' disease, which is a hyperthyroid disorder. While the illness could be controlled by medication, this particular pill was on the Olympic banned-substance list so Devers refused to take it. Instead, she opted for radiation, not knowing at the time how traumatic the side effects would be.

The radiation that was supposed to destroy the bad part of her thyroid gland ended up destroying the whole gland.

"Her feet began to swell and ooze, her skin to crack and bleed," Moore wrote. "The pain became such that her parents had to carry her to the bathroom. Her suppurating feet were on the verge of requiring amputation before doctors realized that her radiation treatments may have been to blame."

Her therapy was changed. A month later, she could walk, albeit slowly around the UCLA track while wearing only socks. "It was the start of the greatest comeback in track history," Moore wrote.

By the time the 1991 world championships in Tokyo rolled around, Devers was not only healthy enough to compete, but also finished second in the 100-meter hurdles. Then, in 1992, she won gold in the 100-meter dash at the Barcelona Games by 0.06 seconds and soon after graced the cover of *Sports Illustrated* with the headline "Hail Gail." She competed in the 100-meter hurdles five days later, but finished in fifth place after tripping over a hurdle.

Devers wasn't done. She went on to win two more gold medals at the 1996 Atlanta Games in the 100 meters—making her the second woman ever to successfully defend the Olympic title—and in the 4x100-meter relay. Ironically, sprints weren't even her specialty—hurdles were. She never won gold in that event, but she was a three-time winner in the 100-meter hurdles at the world championships.

Devers, easily recognizable by her signature colorful fingernails, competed in two more Olympics (2000 and 2004), but did not medal. After the Athens Games, she took a couple of years off, had a baby, then returned to the track when she was 40 with an unexpected victory in the 60-meter hurdles at the 100th Millrose Games. She won in 7.86 seconds, which was then the fastest time in the world and nearly a full second faster than the world record for over-40 athletes. "People thought I went away," Devers told Tim Layden in 2007. "I always knew I could come back."

Devers was elected to the National Track and Field Hall of Fame in 2011 and the U.S. Olympic Hall of Fame in 2012. And to think, her career could have ended before it truly began.

LEFT: Gail Devers in action during 100-meter race, Summer Olympics, Athens, Greece, 2004; **RIGHT:** Devers posing with gold medal after winning 100-meter race, Summer Olympics, Barcelona, Spain, 1992

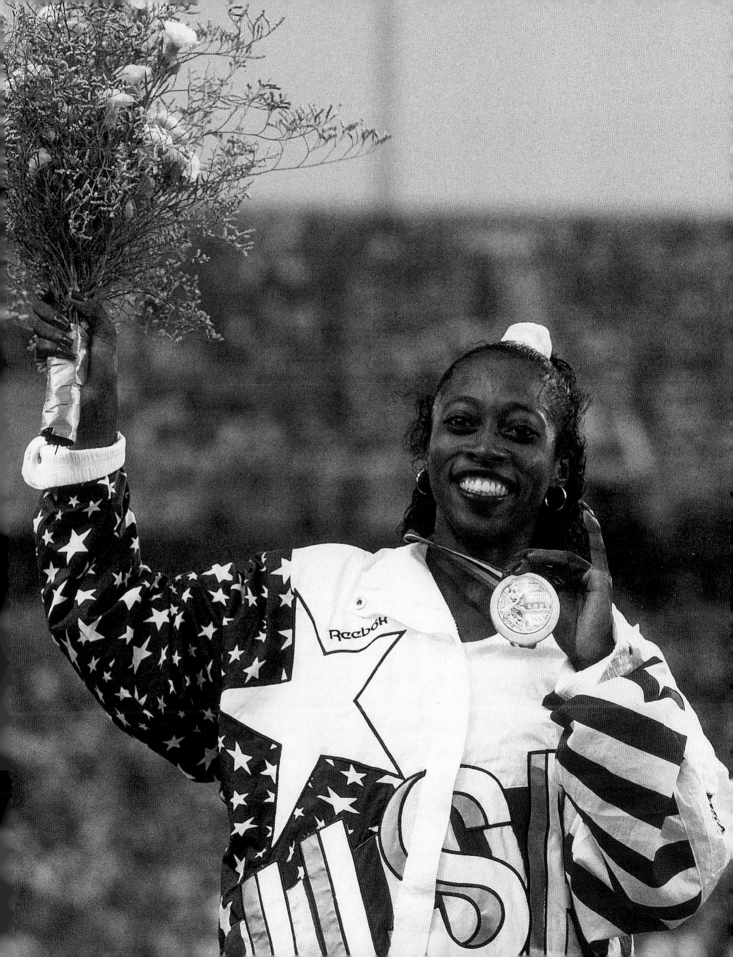

Kirstie ENNIS
mountain climbing

Kirstie Ennis has a goal of standing on top of all Seven Summits, the highest mountains on each of the seven continents. It's an aggressive feat most people with two legs would never dream of attempting, and it's something Ennis is determined to achieve with just one.

Ennis's remarkable story began when she lost her leg after a helicopter crash in Afghanistan in June 2012. Ennis, then a U.S. Marine Corps sergeant serving her second tour, suffered traumatic injuries to her brain, spine, and face. After more than 40 surgeries, doctors amputated her leg first below the knee, and then above the knee after a life-threatening infection.

As Ennis detailed in a first-person account for the *ESPN* Body Issue in 2017, "I was in shambles and I had huge self-esteem issues. My first thoughts were, Am I going to be able to walk again? Wear a dress again? How will people look at me? Who's going to find me attractive? I went through a phase of being very uncomfortable with my body."

As a competitive person all her life, Ennis joined the Marines when she was 17 as an aircraft mechanic. She was inspired to enlist since her parents both served. "I idolized what they were doing," Ennis wrote on her website. "I have always wanted to serve and to help others who can't protect themselves." After the helicopter accident, she regained her confidence through a different competitive outlet: sports. Specifically mountain climbing. And yes, with just one leg.

"I found myself in the mountains because that's where it's hard," Ennis told *ESPN*. "In the mountains, you have to be self-reliant. There's no coach to say, 'This is how you're going to get out of this.' You need to figure it out yourself. I want to master mountaineering, and I want to bring other adaptive mountaineers to the highest peaks in the world."

One of her first conquests was Mount Kilimanjaro, the highest summit in Africa. She climbed it in an effort to raise money for Waterboys, a group that brings clean drinking water to communities in need. She ended up raising $150,000.

"People were watching and paying attention to this crazy one-legged lady that was going to go out and climb all these big mountains—that solidified this idea that when I go over to these other countries, I want to do something for the local people there," Ennis told *Glamour* in 2019. "I don't just want to go over there, use their department of tourism to climb a mountain, and then say I'm out. I want there to be purpose and passion behind my climbs."

She started the Kirstie Ennis Foundation to keep serving people long after her military service was over. She plans to keep climbing mountains and to reach her goal of conquering the Seven Summits. Beyond that, she plans to accomplish other major athletic feats, like swimming the English Channel, in an effort to raise money for more nonprofit organizations.

In her spare time, Ennis has completed three master's degrees in human behavior, business administration, and public administration. She is also working to complete her doctorate in education. Ennis has also participated in motivational speaking events, is an entrepreneur, and has her real estate license.

LEFT: Kirstie Ennis attending Cycle for Heroes, Santa Monica, California, USA, 2016

Janet EVANS
swimming

Perhaps the perfect way to describe Janet Evans is how writer J. E. Vader led his *Sports Illustrated* story about her in April 1989: "It's hard to tell if Janet Evans is better at swimming or smiling, because she is world class at both."

Evans was already one of the world's best swimmers by the time she was 15, when she broke the world records in the 400-, 800- and 1,500-meter freestyle events. When she was 17, Evans won three individual gold medals at the 1988 Seoul Olympics in the 400-meter free (breaking her own world record), 800-meter free, and 400-meter individual medley. She became only the fifth woman in history to win three or more individual swimming gold medals at one Olympics. While her talent is what got her on the national stage, her personality is what charmed the nation.

Evans was just your average teenager: a fast food–eating, U2-listening high school senior, who was dating the student body president and was named junior class princess at the prom. As Bruce Anderson wrote for *Sports Illustrated* in 1988, "Evans exudes wholesomeness. She is, as her father says, 'peaches and cream,' and she has a lot of Everygirl in her."

While she became a dominant swimmer at such a young age, it wasn't because her parents were overbearing drill sergeants. Jill Lieber wrote for *Sports Illustrated* in 1988 that when Evans was younger, her father, Paul, never asked how she did after meets. "Instead, he demanded an account of how much fun she had had." That became ingrained in Evans, who enjoyed acting her age and didn't take things too seriously on the world's greatest stage. According to Anderson, after she became the only American woman to win individual gold in Seoul, she said "I'm smiling because I'm having fun. That's what this is all about, to have fun."

Evans was a spunky and hyper kid. She started taking swimming lessons shortly after her first birthday, mainly, her mother told Lieber, because she wouldn't sit still during her brothers' lessons. So her mom asked the teacher if she could swim too. The rest is history.

Evans didn't have a typical swimmer's body. By the time she competed in the Seoul Games, she was five-foot-five-and-a-half and 102 pounds. "When she stepped up on the blocks for the 800 freestyle, the 6'1", 180-pound Astrid Strauss was on her right and the 5'10", 150-pound Anke Moehring was on her left. Evans looked like an age-group swimmer who had somehow stumbled into the wrong race," Anderson wrote. But Evans won gold in that race.

Because of her smaller stature, Evans compensated for her size by taking more strokes. Newspapers at the time described her as "a windup bathtub toy" and "a windmill in a hurricane." Her style didn't matter much to her, or at least not as much as getting to the other end of the pool faster than everybody else.

At the 1992 Barcelona Games, her second Olympics, Evans won two more medals: a gold in the 800 free and a silver in the 400 free.

By the end of her swimming career, Evans held seven world records, five Olympic medals (four of them gold), and 45 American national titles. Per the official Olympic website, between 1986 and 1995, Evans won 25 of 27 major international races in the 400 free and 22 of 23 in the 800 free. Her world record for the 800 free (a time of 8:16.22 that she set in August 1989) lasted through four Olympics until it was finally broken at the 2008 Beijing Games by British 19-year-old Rebecca Adlington (her time was 8:14.10).

These days, Evans is married with two kids. In 2021, she was named the chief athlete officer of the Los Angeles 2028 Olympic Committee. She helped secure the Olympic Games as the vice chair of Los Angeles's bid committee, and she hopes to use her experience as an Olympian to make a positive impact on her community.

LEFT: Janet Evans in action during 400-meter individual medley, Summer Olympics, Seoul, South Korea, 1988; **RIGHT:** Evans posing with her gold medal after winning 400-meter freestyle, Summer Olympics, Seoul, South Korea, 1988

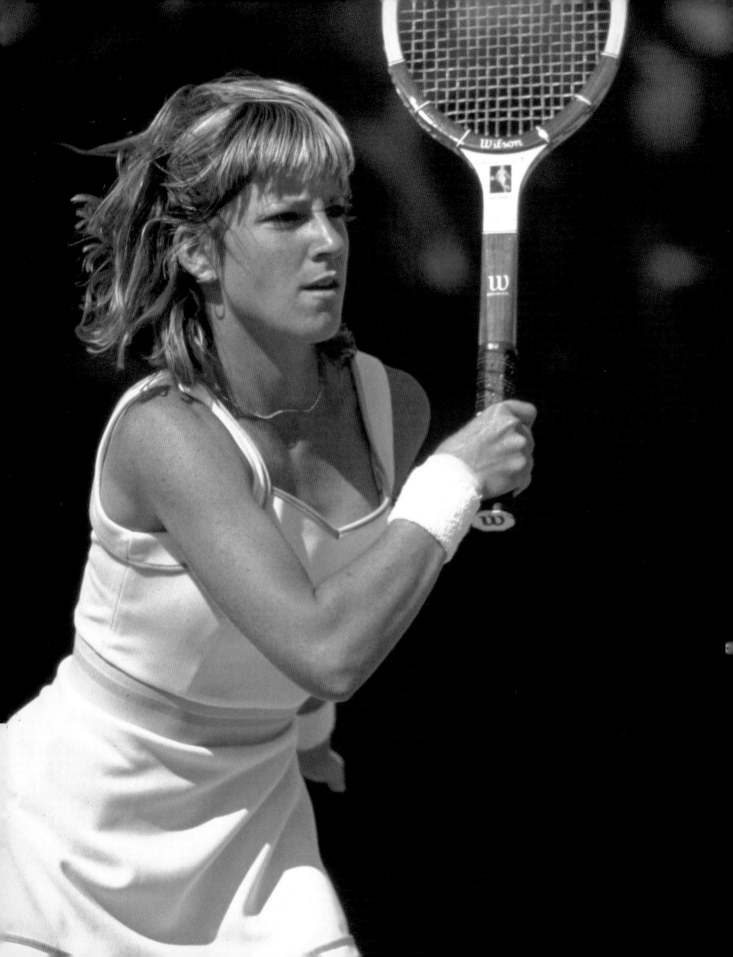

Chris EVERT

tennis

hris Evert was 16 years old when she made her major national debut. The high school girl from Florida beat three pros at the 1971 U.S. Open—coming from behind each time—before succumbing to the eventual champion, a star by the name of Billie Jean King. While she didn't make the final that time, she stole America's heart as an amateur and became the youngest semifinalist in U.S. Open history.

That was just the beginning of Evert's storied career, in which she won 18 Grand Slam singles titles—six U.S. Opens, three Wimbledons, seven French Opens, and two Australian Opens. She won at least one major tournament for 13 consecutive years and was at least a semifinalist in 52 of the 56 majors she played. Evert was also never ranked lower than No. 4 in the world and ended the year ranked No. 1 seven times (1974–1978, 1980, and 1981).

In 1974, Evert went on a 55-match winning streak, winning the French Open and Wimbledon along the way. That year she had a record of 106–7 and won 16 of 24 tournaments.

Throughout her career, Evert was perceived in many different ways. In 1976, writer Curry Kirkpatrick wrote a lengthy feature about her in *Sports Illustrated* with the headline "Say Hello to the Girl Next Door." When she was an amateur coming from behind to beat established pros, crowds were enamored with her. But as she got older and more successful, she had a reputation of being cold and was given the moniker "Ice Princess" by the press.

"Chris fascinated me because she stayed unknown," Lesley Hunt, another prominent tour player, told Kirkpatrick. "She never cried, never cracked. Whether she was or not, she made everybody think she was so cold. That in itself was intimidating. It was like playing against a blank wall. In our matches I used to watch for the slightest sign of emotion as a hint of nervousness. Even a raised eyebrow would be a terrific breakthrough."

Perhaps it was her impassiveness that irritated people, or the fact that she won so much. Not everybody likes a consistent winner—just ask Geno Auriemma and the UConn Huskies or Nick Saban and the Alabama Crimson Tide. When Evert was asked what made her so attracted to tennis, she didn't hesitate with her answer. "The winning," Evert told *Sports Illustrated*. "I always liked the winning."

Evert appeared on *Sports Illustrated*'s cover three times, including when she was named Sportswoman of the Year in 1976. She rubbed shoulders with celebrities and had a public dating life. She was involved with former No. 1 American tennis player Jimmy Connors before she turned 20. She dated Jack Ford (President Gerald Ford's son) and actor Burt Reynolds, and was also married to British tennis player John Lloyd and former Olympic skier Andy Mill.

But, as she told Kirkpatrick in 1976, "I'm not glamorous. I'm not beautiful. I don't want to be on a plateau higher than anyone else. I don't want the younger girls to be in awe of me. I talk to them about their matches, congratulate them on key victories. I ask them to practice and hit with me. Not many of the older players came over and asked me to practice when I first came up. I think that's important."

In the late 1970s, fans ate up the rivalry between Evert and Martina Navratilova. The tennis pros were friends, but the media loved pitting the two women against each other, painting Evert as the hero and Navratilova as the villain. When all was said and done, Navratilova, who also won 18 major titles, held a 43–37 advantage over Evert, including 10–4 in Grand Slam finals.

Evert retired in 1989 and, in 1995, was elected unanimously into the International Tennis Hall of Fame. She is the mother of three boys and serves as an ESPN analyst.

LEFT: Chris Evert in action during U.S. Open, Flushing, New York, USA, 1980; **RIGHT:** Evert holding trophy after winning Wimbledon, London, United Kingdom, 1974

Allyson FELIX

track and field

Her high school teammates called her "Chicken Legs." It wasn't meant to be demeaning, just a fun nickname for Allyson Felix because of her slim physique and explosiveness. Growing up in Los Angeles, Felix won three individual track and field state titles. As a junior, she won the 200 meters in 22.83 seconds, which at the time was the fastest ever for a high school girl. It made perfect sense that she would later be named High School Athlete of the Year by *Track & Field News* magazine. While she had the University of Southern California (USC) in her sights—and eventually earned her education degree from there—Felix signed a professional contract with Adidas instead, giving up her college eligibility.

Fast-forward to the present day and Felix is the most decorated American track and field star, male or female, with the most career Olympic medals. She passed Carl Lewis's record of 10 medals by capturing her 11th at the Tokyo Olympics in 2021, and only stands behind Finnish runner Paavo Nurmi with the most in the history of the sport (12). Felix is a five-time Olympian with seven gold medals, three silver, and one bronze. She has competed in 18 world championships and won 13 golds.

Felix burst onto the global track and field stage as a teenager in 2005, becoming the youngest to win a world championship gold medal in the 200 meters. Since then, Felix's career has spanned two decades. She was 35 years old in Tokyo when she won a bronze medal in the 400 meters with her second-fastest time ever (49.46 seconds), which was faster than her silver-medal performance in the 2016 Rio de Janeiro Games and the fastest ever for a woman over age 35. Felix also ran the second leg for the U.S. women's 4x400-meter relay team that won gold.

The life span of many track and field superstars doesn't usually last this long—for example, Usain Bolt competed in three Olympics and retired at age 31. But Felix ignored naysayers and kept training, even after she became a mother. After winning two gold medals and a silver at the 2016 Olympics, Felix and her husband decided to start a family. This was also around the time Felix was negotiating a contract renewal with Nike. As she wrote in a powerful op-ed for the *New York Times*, Felix "felt pressure to return to form as soon as possible after the birth of [her] daughter," even after an emergency C-section at 32 weeks because of severe preeclampsia. Meanwhile, negotiations weren't going well and Nike wanted to pay Felix 70 percent less than she was making before she gave birth.

Felix stood up for herself, left Nike, and signed with Athleta. She joined U.S. teammates and fellow mothers Alysia Montaño and Kara Goucher to break her nondisclosure agreement and openly talk about Nike's lack of a maternity policy. In doing so, she leaned deeper into her activism and helped make impactful changes for women while setting an important example for her daughter, Camryn.

"This isn't just about pregnancy," Felix wrote. "We may stand behind the brands we endorse, but we also need to hold them accountable when they are marketing us to appeal to the next generation of athletes and consumers."

Nike later announced a new maternity policy for all sponsored athletes, but it was too late. Felix created a new shoe company called Saysh, and she wore the brand each time she crossed the finish line in Tokyo.

According to *Sports Illustrated*'s Greg Bishop, after winning bronze in the 400 meters in Tokyo, Felix pondered where that particular finish ranked among so many of her other memorable races. "It meant more because [Felix] clawed back to second place at the U.S. trials," he wrote. "It meant more because she said things like, 'There were a lot of moments where I was doubtful I would be able to feel like myself again.'"

Somewhere in between becoming a superstar, speaking up for women, and creating her own company, Felix pursued a degree in education from USC. Her mother was a teacher, and it's something she has always felt passionate about. That's why whenever Felix retires, she'd like to work with kids in some capacity. Ahead of the Tokyo Olympics, she partnered with sponsor Athleta and the Women's Sports Foundation to help Olympians and Paralympians pay for childcare while they competed, which enabled mom-athletes to travel to competitions without barriers.

While Felix will go down as the greatest American track and field athlete of our time, her work fighting for women's rights and maternity protections and leaving the sport better than she found it for the next generation will be more important to her legacy.

RIGHT: Allyson Felix celebrating after winning bronze medal in 400-meter final, Summer Olympics, Tokyo, Japan, 2021

Lisa FERNANDEZ

softball

Kelley King once described Lisa Fernandez for *Sports Illustrated* like this: "She's Randy Johnson and Pedro Martinez rolled into one, the most dominant pitcher in softball's most formidable rotation."

And Kelly Inouye, Fernandez's former teammate at the University of California, Los Angeles (UCLA), once described the pitcher like this: "She's got it all. It's scary. She throws so hard. Catching her all these years—my body is a wreck."

Fernandez, a three-time Olympic gold medalist, learned how to play softball from her parents. As Shelley Smith wrote

for *Sports Illustrated* in 1993, Fernandez's father, Antonio, played semiprofessional baseball in Cuba before fleeing to the United States in 1962. Her mother, Emilia, a native of Puerto Rico, played in several softball leagues after she met Antonio in Los Angeles.

"My first game as a pitcher was when I was eight years old," Fernandez told Smith. "I walked 20 batters and lost 28-0. But I just resolved that I would do better the next time out."

And that's exactly what she did, becoming one of the most widely regarded softball players in the world. Fernandez totally

dominated from 1990 to 1993 at UCLA, where she became a four-time All-American and led the Bruins to two national championships. She posted a 0.22 career ERA, a 93-7 record, 784 strikeouts, 74 shutouts, and 11 no-hitters, including a pair in the 1993 Women's College World Series. Fernandez won just about every award an elite college athlete could win, including becoming a three-time winner of softball's Honda Sports Award, given to the sport's best player. She was also a powerful hitter, batting .382 with 15 home runs and 128 RBI.

Fernandez was brilliant in all three of her Olympic appearances, pitching in three consecutive gold-medal games. In 1996, she threw the final three outs and earned the save in the United States' 3-1 gold-medal victory over China; she pitched the semifinal win over Australia and the final gold-medal game against Japan in the 2000 Sydney Games; and in 2004 she was Team USA's top pitcher and hitter.

Fernandez also won three gold medals at the Pan American Games and four world championships. After the 2004 Olympics, she took three years off to start a family with her husband, Michael (they have two boys named Antonio and Cruz). By the time the 2008 Beijing Games rolled around, though, Fernandez was not in good enough form to make the 15-player roster.

"I have no regrets," Fernandez told *Sports Illustrated* in 2008. "I know I gave it everything I had. There wasn't a corner cut or a practice missed. I just ran out of time."

Her teammates, however, were disappointed by the coaches' decision to not include her. "It's like Michael Jordan getting cut from the basketball team," catcher Stacey Nuveman told *Sports Illustrated*.

These days, Fernandez, who was inducted into the ASA/USA National Softball Hall of Fame in 2013, spends her time as an assistant softball coach for her alma mater, UCLA. It's her second stint coaching the Bruins, serving on staff from 1997 to 1999 and again from 2007 to the present. In that time, the Bruins have remained a college softball juggernaut, winning five national championships and four Pacific-10/12 Conference titles since 1999.

LEFT: Lisa Fernandez in action during preliminaries, Summer Olympics, Sydney, Australia, 2000; **RIGHT:** Fernandez in action, Summer Olympics, Columbus, Georgia, USA, 1996; **OVERLEAF:** Fernandez and teammates celebrating after winning gold medal, Summer Olympics, Sydney, Australia, 2000

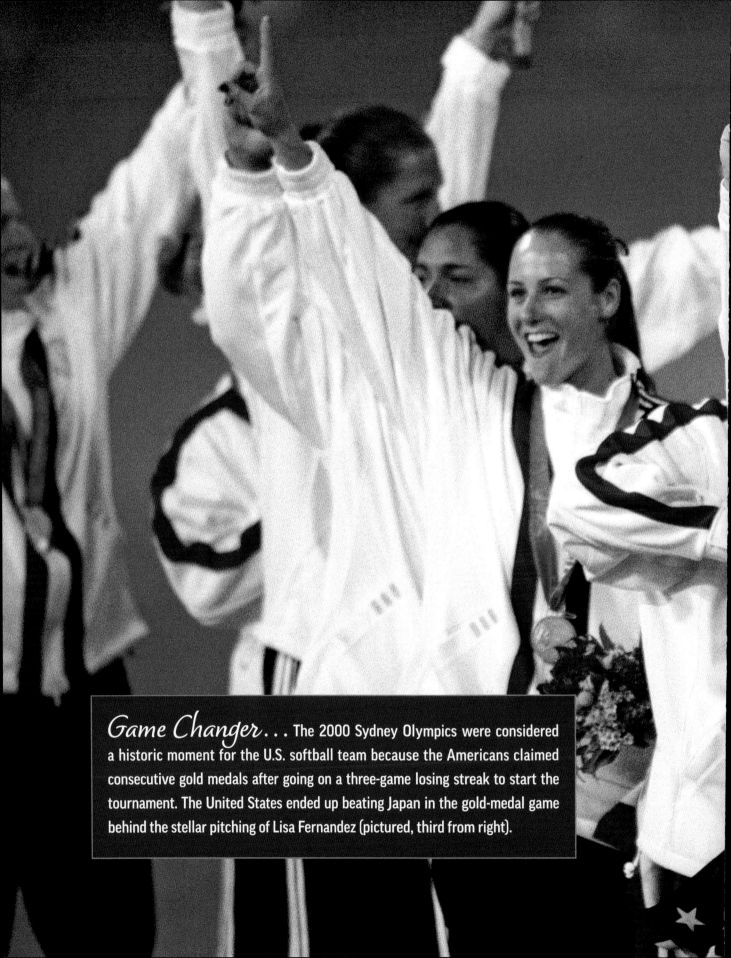

Game Changer . . . The 2000 Sydney Olympics were considered a historic moment for the U.S. softball team because the Americans claimed consecutive gold medals after going on a three-game losing streak to start the tournament. The United States ended up beating Japan in the gold-medal game behind the stellar pitching of Lisa Fernandez (pictured, third from right).

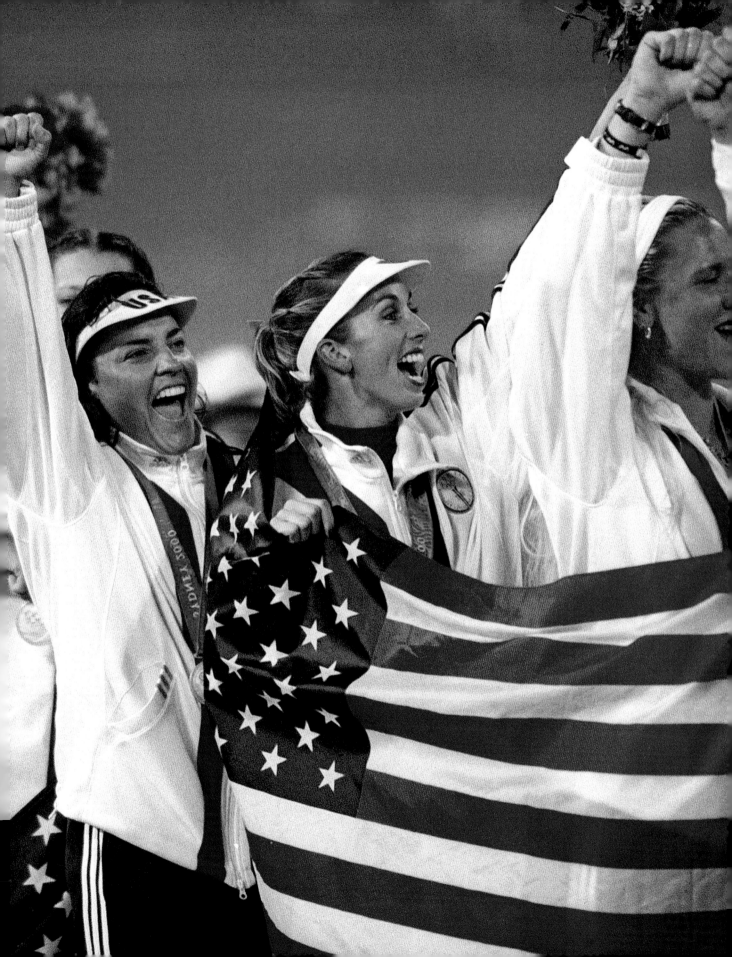

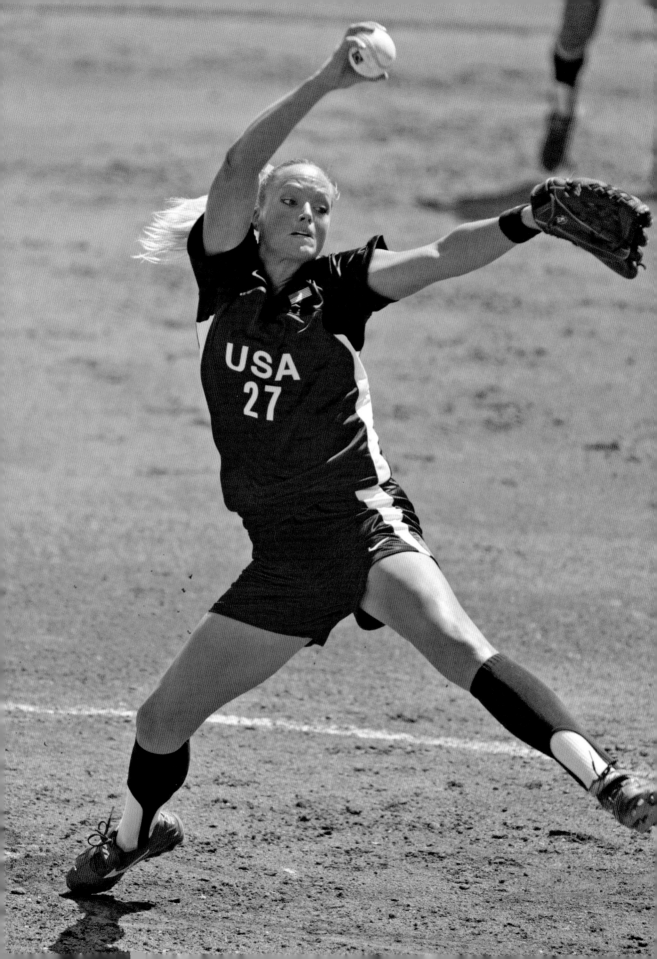

*Jennie*FINCH
softball

As David Epstein once wrote for *Sports Illustrated*, "Sometimes all it takes is one transcendent player to insinuate a sport into the national consciousness. For softball, that player was 29-year-old Jennie Finch."

It's what Mia Hamm was to soccer, what Shaun White was to snowboarding and the X Games. Softball was a popular sport before Finch, but the game was forever changed after she helped lead Team USA to a gold medal at the 2004 Olympic Games in Athens.

Finch first started pitching when she was eight. By 10 years old, she was playing for a traveling All-Star team. At 12, she led the California Cruisers to the 12-and-under American Softball Association national title, and a few years later she did the same thing with her 14-and-under team. Eventually, Finch was recruited to play in college and landed at Arizona, where she "windmilled her way," as Epstein wrote, to an NCAA record 60 wins. Her fastball could reach 70 miles per hour (which is the equivalent of a 98-mile-per-hour major league fastball).

At the 2004 and 2008 Olympics, Finch went 4-0 in 19 scoreless innings, striking out 27. "At times Finch was so dominant that it seemed as if she were playing in a video game," Epstein wrote for *Sports Illustrated* in 2010.

Finch rose to superstar status after the 2004 Athens Games and seamlessly crossed over from the sports world to the entertainment world and back again. She appeared on *The Apprentice* and *Late Show with David Letterman* and was featured in the *Sports Illustrated* Swimsuit Issue. She was once named by *People* as one of its "50 Most Beautiful People" and she received plenty of other endorsements, some of which she declined. "I'm not a celebrity," Finch said. "I'm just a girl trying to win a gold medal."

Which she did. In Athens, Finch's first Olympics, the United States completely dominated its opponents and won gold. *Sports Illustrated* slapped the team on the cover of the magazine with the headline "The Real Dream Team." (There's no word on if the other "Dream Team," the 1992 U.S. men's basketball team with Michael Jordan, Patrick Ewing, and Magic Johnson, agreed or disagreed with such a proclamation.)

The United States won silver at the 2008 Olympics after losing the final to Japan. It was the last time softball would be classified as an Olympic sport for some time. The International Olympic Committee (IOC) had decided in 2005 to drop both softball and baseball from the Olympics. Finch used her platform to urge the IOC to reconsider. Both sports lost appeals for reinstatement in 2006 and 2009, but they returned for the 2020 Tokyo Games (which were postponed to 2021 due to COVID-19).

In addition to her national team experience, Finch played five seasons in the National Pro Fastpitch league, where she posted a 32–5 record. In the 2006 and 2007 seasons, she gave up just two earned runs in 73⅓ innings. The league has been around in some capacity since 1997. It tried to gain momentum after the 2004 Olympics with stars like Finch and Jessica Mendoza playing, but it still lacks the kind of sponsorships and promotion of other professional women's sports.

Finch married former MLB pitcher Casey Daigle in 2005 and they have three kids (their oldest son is named, appropriately, Ace). Finch retired in 2010, ending her career as a two-time Olympian, a two-time Pan American gold medalist, a three-time World Cup champion, and a three-time world champion. Since then, she has continued to help grow the game by hosting summer softball camps around the country in hopes that future generations of young women and girls can reap the sport's benefits just like she did.

LEFT: Jennie Finch in action during preliminaries, Summer Olympics, Athens, Greece, 2004; **RIGHT:** Finch and teammates posing for cover of *Sports Illustrated* after winning gold medal, Summer Olympics, Athens, Greece, 2004; **OVERLEAF:** Finch and teammates celebrating after winning silver medal, Summer Olympics, Beijing, China, 2008

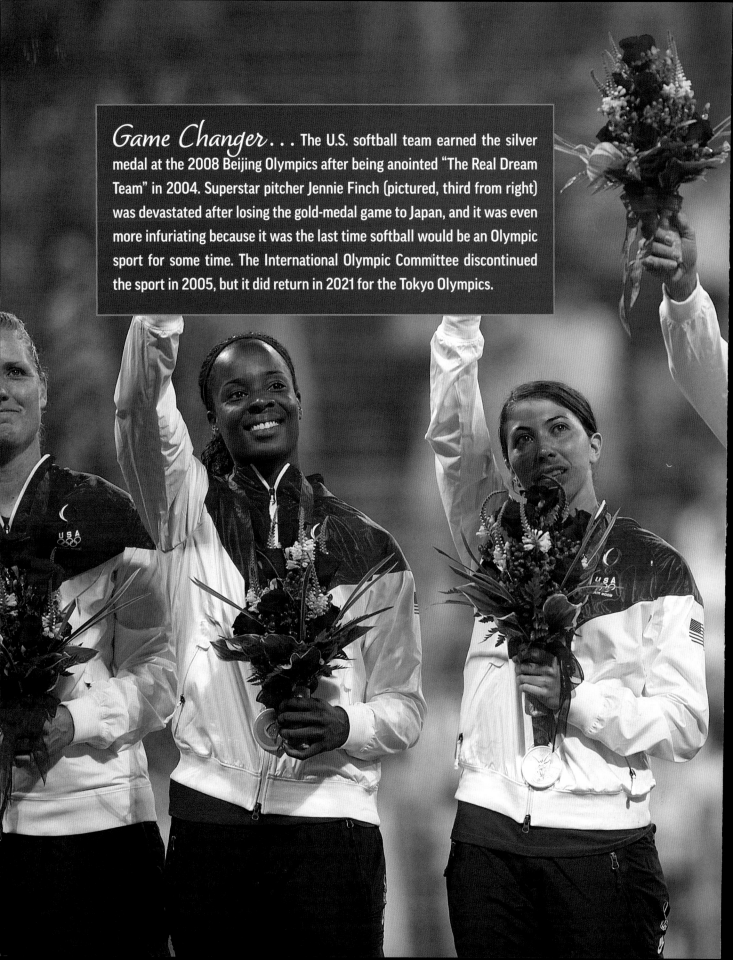

Game Changer . . . The U.S. softball team earned the silver medal at the 2008 Beijing Olympics after being anointed "The Real Dream Team" in 2004. Superstar pitcher Jennie Finch (pictured, third from right) was devastated after losing the gold-medal game to Japan, and it was even more infuriating because it was the last time softball would be an Olympic sport for some time. The International Olympic Committee discontinued the sport in 2005, but it did return in 2021 for the Tokyo Olympics.

Birgit FISCHER
kayaking

This might sound confusing at first, but Birgit Fischer is the world's youngest *and* oldest kayaking champion. While her name might not be as familiar as Michael Phelps or Simone Biles, she is considered one of the greatest, most legendary Olympians in history.

Fischer won 12 Olympic medals, including eight gold, in 13 events over six Olympics spanning 24 years. She also won 37 world championship medals from 1979 to 2005, coming in and out of retirement at least four times after having two kids.

Fischer, who is from the East German town of Brandenburg, first got into kayaking when she was six. She followed her older brother Frank, an avid kayaker, who would go on to win nine world championship medals, including three gold, in his own career. With her father, Karl, coaching her, Fischer rose up in the sport and started dominating in time to make her Olympic debut in the 1980 Moscow Games. At age 18, she won the K1 500-meter race, becoming the youngest kayaker to ever win an Olympic gold medal. The young German star went on to win three consecutive world championships in the 500 meters. She wasn't able to defend her title at the 1984 Olympic Games in Los Angeles because of a boycott by Eastern Bloc countries, but she returned stronger, hauling in two gold medals and a silver at the 1988 Seoul Olympics.

Fischer retired for the first time after the 1988 Seoul Games after having her second child. She had a satisfying career, compiling three Olympic gold medals and one silver. But she was too competitive to stay away from the sport, so Fischer returned for the next three Olympics and added more medals to her collection, including four more golds.

LEFT: Birgit Fischer in action during Internationale Kanu (Canoe) Regatta, Duisburg, Germany, 2000; **ABOVE:** Fischer in action during a training exercise, Leipzig, Germany, 1988

Fischer retired for the second time after the 2000 Sydney Games, but she came out of retirement once more in time to make the German team for the 2004 Athens Games. "I wanted to see if I could be really fast at 42," Fischer said at the time. "I wanted to challenge myself again."

In a surprise to no one, Fischer won another gold medal, edging out Team Hungary by 0.2 seconds in the K4 500-meter event. It was Fischer's 12th Olympic medal and eighth gold. That same year, Fischer was named German Sportswoman of the Year, and, in 2008, she was inducted into Germany's Sports Hall of Fame.

Fischer retired for good in 2005, at age 43, after winning her last two world championship bronze medals. Had she decided to keep her career going until at least the 2008 Olympics, she could have been on the same team as her niece, Fanny Fischer, who won gold in Beijing.

While Fischer hasn't come out of retirement since then, she remains an active member of the kayaking community. She started a company called KanuFisch, in an effort to keep growing the sport.

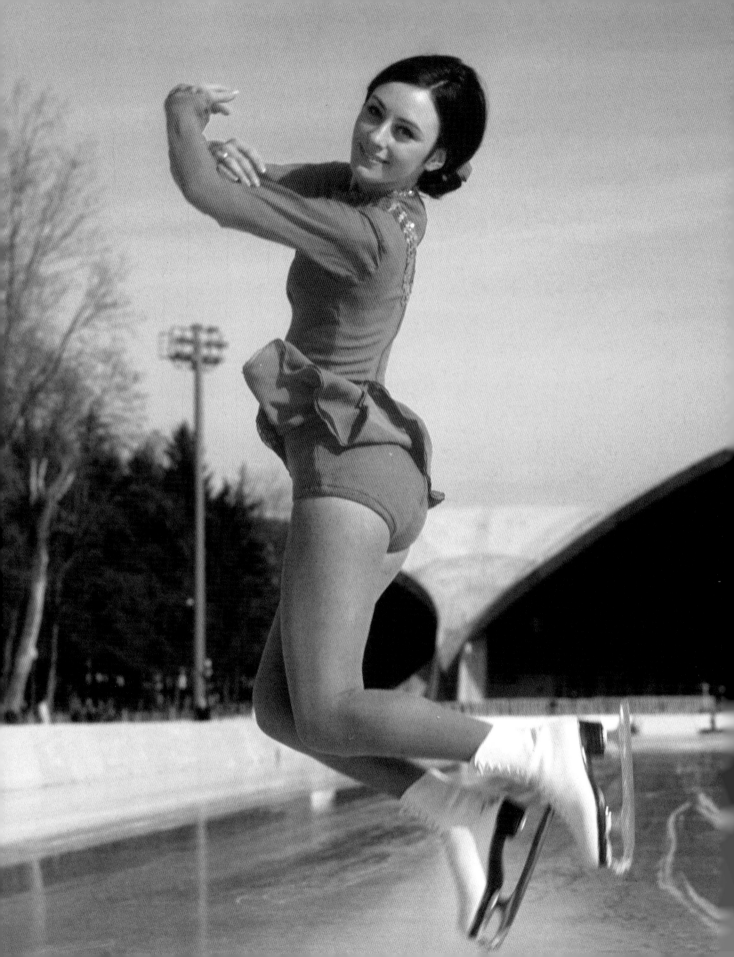

Peggy FLEMING
figure skating

As E. M. Swift so perfectly wrote for a *Sports Illustrated* story in 1995, "When 19-year-old Peggy Fleming glided into the adoring embrace of the American public by winning the gold medal at the 1968 Olympics in Grenoble, she launched figure skating's modern era. Pretty and balletic, elegant and stylish, Fleming took a staid sport that was shackled by its inscrutable compulsory figures and arcane scoring system and, with television as her ally, made it marvelously glorious."

Fleming first started skating when she was nine years old. By the time she was 15 in 1964, she became the youngest U.S. women's champion ever and went on to win five straight national titles. In 1966, when she was 17, she won her first of three consecutive world championships. By the 1968 Grenoble Games, Fleming's one and only Olympics, she was well known by the international media. Because she was pretty and petite, she was often unfairly described as "fragile" or "America's shy Bambi," despite being as strong and tough as she was graceful and dazzling.

"Actually, despite her 109 pounds and translucent-china look, there is every reason to believe Peggy could break the Oakland Raiders' Ben Davidson in half with one quick body block," Bob Ottum wrote for *Sports Illustrated* in 1968.

Fleming went on to win the United States' only Olympic gold of the entire competition. She built up a big lead after the compulsory figures (the circular patterns skaters trace on the ice to demonstrate skill) and won the first-place votes from all nine judges. It was also the first time that the Olympics were televised live, which helped propel her national popularity.

Despite carrying herself like a star on the ice, Fleming was actually incredibly unpretentious, hardworking, and level-headed. Her mom even made all of her costumes, including the chartreuse outfit she wore while stealing everyone's hearts during her gold medal–winning routine in Grenoble.

After the Olympics, Fleming's fame continued to soar. She was invited to the White House twice, appeared on magazine covers, toured the world in skating shows, and remained in the public eye as a commentator on ABC and ESPN for 28 years. "Who knows how many girls worldwide got into figure skating

after having first been exposed to the sport by Fleming?" Swift wrote in his 1995 story about her.

In 1999, at *Sports Illustrated*'s 20th Century Sports Awards, Fleming was honored as one of seven "Athletes Who Changed the Games." She had helped bring U.S. figure skating back into the spotlight after the tragedy in 1961, when the entire U.S. national team was killed in a plane crash on its way to the world championships in Prague. And to this day, the sport remains as popular as ever. With mega skating stars like Dorothy Hamill, Nancy Kerrigan, Michelle Kwan, and Sarah Hughes gracing the ice over the years, figure skating has become must-see TV during the Winter Olympics.

Fleming was diagnosed with early breast cancer in 1998, well after her skating career was over. After her recovery, she became a spokeswoman for women's health, promoting breast cancer awareness, early detection, and regular checkups.

LEFT: Peggy Fleming posing for a portrait, Winter Olympics, Grenoble, France, 1968; **RIGHT:** Fleming receiving gold medal after winning singles event, Winter Olympics, Grenoble, France, 1968

Missy FRANKLIN
swimming

As a five-time Olympic gold medalist and multiple world-record holder, Missy Franklin is one of the greatest international swimmers of all time. But what you won't see on her résumé is her bubbly personality, warm smile, and relentless positivity, which are things that 100 percent contributed to her success.

As Kelli Anderson wrote for *Sports Illustrated* in 2011, Franklin's six-foot-one frame, big hands, and size 13 feet coupled with a lifetime of training at altitude while growing up in Colorado certainly helped her develop into the dazzling swimmer we saw at the 2012 Olympic Games in London. But there was so much more to her endless achievements than those built-in advantages. Perhaps Franklin's club coach, Todd Schmitz, said it best when he described her mental approach. "You watch her before a race, she comes out and waves and smiles," Schmitz told Anderson. "Then she gets behind the block and it's boom—the goggles go on, and she's looking down that lane, and it's game on. When she finishes, she's out of game mode just like that. It's a special skill to have, I don't care what sport you're talking about."

At the 2012 London Games, Franklin became the first female U.S. swimmer to take on seven events in one Olympics. Then a 17-year-old high school senior, Franklin won four gold medals in the 100-meter backstroke, 200-meter backstroke, 4x200-meter freestyle relay, and the 4x100-meter medley relay. She also won bronze in the 4x100-meter freestyle relay. She broke the world record in the 200-meter backstroke with a time of 2:04.06, marking the first time that an American had won the event in 40 years. Her overall performance went down as the greatest by an American female swimmer at an Olympics since Natalie Coughlin won a record six medals (but only one gold) in Beijing. Franklin's performance was the most impressive debut for any other American swimmer not named Michael Phelps, who once called her a "stud."

Franklin, who was raised in Centennial, Colorado, first started swimming competitively when she was five and competed in her first international event by age 14. In 2011, she became the next big thing in swimming by winning five medals—including three gold—at the 2011 FINA World Championships in Shanghai, which she called "the time of my life." *Sports Illustrated* soon after featured her in "Faces in the Crowd." Then, later that year, Franklin broke her first world record at the FINA World Cup in Berlin.

One of the biggest story lines surrounding Franklin at the London Olympics was if she would turn professional instead of going to school. Franklin, though, dreamed of going to college and ultimately chose to forgo sponsorships and prize money to attend the University of California, Berkeley. At school, she won four individual NCAA titles and helped the Bears win the 2015 NCAA national championship.

Meanwhile, Franklin continued her international dominance by winning six gold medals at the 2013 FINA World Championships in Barcelona. And in 2015, she made history again by becoming the first woman to win 11 career world championship titles.

Franklin struggled during the 2016 Olympics in Rio de Janeiro, however. She failed to qualify for the finals in her individual events, but won gold in the 4x200-meter freestyle relay. It was later revealed that she was battling bursitis in both shoulders, which required surgery the following year. She retired from swimming in December 2018 at age 23 due to severe chronic tendinitis in her rotator cuff and bicep tendon. She later revealed to *People* magazine that she can barely swim anymore because of her various shoulder injuries.

While she misses the pool, Franklin is happily married to fellow swimmer Hayes Johnson. They had their first child in 2021. She will always be remembered as one of Team USA's most dominant and happiest swimmers of all time.

LEFT: Missy Franklin celebrating after winning 100-meter backstroke final, Summer Olympics, London, United Kingdom, 2012; **RIGHT:** Franklin posing with her medals, Summer Olympics, London, United Kingdom, 2012

Althea GIBSON

tennis

When Althea Gibson became the first Black tennis player to win Wimbledon, Queen Elizabeth II was there to present her with the tournament's trophy. It was a surreal moment for Gibson, the daughter of a South Carolina sharecropper. "Shaking hands with the Queen of England was a long way from being forced to sit in the colored section of the bus," Gibson later wrote in her autobiography.

This was the summer of 1957, in the midst of the civil rights movement in the United States. Integration was starting. Two months after Gibson's barrier-breaking Wimbledon win, nine Black students famously tried to enter Little Rock Central High School in Arkansas, but were met by Arkansas National Guardsmen who were blocking the door on orders from the governor. Later that month, President Dwight Eisenhower sent in federal troops to escort the Little Rock Nine into school.

Meanwhile, Gibson returned to America as a hero. New York City threw her a ticker-tape parade down Broadway, making her just the second Black athlete to be honored in that way (Jesse Owens was the first). The 29-year-old who grew up playing paddle tennis with a wooden paddle and a rubber ball on 143rd Street in Harlem had come a long way.

At Wimbledon, Gibson had played "with an athleticism never before seen in women's tennis," Michael Bamberger wrote for *Sports Illustrated* in 1999. "She was Venus and Serena a generation before Papa Williams had his first tennis vision for his yet unborn daughters."

Gibson was the Jackie Robinson of women's tennis, making history with almost every achievement. She was the first Black woman to grace the covers of *Sports Illustrated* and *Time*, as well as the first Black tennis player to be ranked No. 1 in the world and to compete in the U.S. National Grass Court Championships at Forest Hills. There is now a statue of Gibson on the U.S. Open grounds. "Althea reoriented the world and changed our perceptions of what is possible," Eric Goulder, the sculptor who created the statue, told the *New York Times*. "We are still struggling. But she broke the ground."

Gibson won her first major title at the French Open in 1956. She won consecutive Wimbledon titles in 1957 and 1958. She appeared in 19 finals and won 11 titles. In women's singles, she captured the French Open once, Wimbledon twice, and the U.S. Open twice; in doubles, she won the French Open once, the Australian Open once, and Wimbledon three times.

Six-time Wimbledon winner Billie Jean King once told *Sports Illustrated* that when she was 13 and first saw Gibson play her heart was pounding. "I thought, Geez, I hope I can play like that someday," she said.

Gibson was the only woman of color to win a major championship until Evonne Goolagong, who was from an Australian Aboriginal family, won the French Open and Wimbledon in 1971. And it took more than 40 years—until Serena Williams won the U.S. Open in 1999 and Venus Williams won Wimbledon in 2000—for another Black woman to win a major singles title.

Because there wasn't much money to be made in professional women's tennis back then, Gibson retired and turned her attention to golf. In 1964, at age 37, she continued to break barriers by becoming the first Black woman to join the LPGA tour. She lived a full life, from acting in a John Wayne movie to becoming the commissioner of athletics in New Jersey from 1975 to 1977. Gibson was married twice but had no children. She

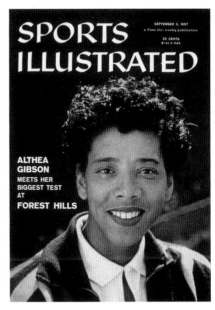

died in 2003 at age 76 from respiratory failure. As Chris Ballard noted in her obituary for *Sports Illustrated*, "In her 1968 memoir, *So Much to Live For*, Gibson wrote, 'I hope that I have accomplished just one thing: that I have been a credit to tennis and my country.'"

She certainly was.

LEFT: Althea Gibson in action during U.S. National Championships, Forest Hills, New York, USA, 1956; **RIGHT:** Gibson posing for a portrait for cover of *Sports Illustrated*, Forest Hills, New York, USA, 1956

Evonne GOOLAGONG

The first time Evonne Goolagong won Wimbledon, she was 19 years old. She beat Nancy Richey-Gunter 6–3, 6–2, then Billie Jean King 6–4, 6–6, and then her idol, tournament champion and fellow Australian Margaret Court, 6–4, 6–1. As Walter Bingham wrote for *Sports Illustrated* in 1971, "Six straight sets from the reigning queens. So goodbye, Nancy, goodbye, Billie Jean, goodbye, Margaret. And hello, Evonne."

Goolagong went on to become one of the greatest tennis players of all time, winning 13 major championships, including one French Open, two Wimbledon, and four Australian singles titles, plus seven Grand Slam titles. As Jon Wertheim wrote for *Sports Illustrated* in 2005, she would have won more if not for her mental lapses. "They used to say, 'Evonne's gone walk-about,'" she said.

Goolagong was hardly an unknown talent before shocking the world by winning Wimbledon in 1971. She had actually been seeded third after the 1970 tournament, where she lost in the second round. Goolagong had also barely lost to Court earlier that year in the finals of the Australian Open, and then won the French Open, her first major singles championship. She was on the cover of *Sports Illustrated* earlier that year too.

Goolagong was young, fresh, and had a fascinating back-story. She was from the Australian outback town of Barellan in New South Wales, was part Aborigine, and was one of eight children of a sheepshearer. She first discovered tennis by reading a fictional story about "a princess who goes to this magical place called Wimbledon," she told Wertheim.

"Using a slat of wood from an apple crate as a make-shift racket, she hit rubber balls against walls, chimneys and every other flat vertical surface in Barellan," Wertheim wrote. "She was discovered by Vic Edwards, a top Australian coach who'd been scouring the bush for talented junior players, and at 13 she moved to Sydney to train with him. By 19 she was the champion at that magical place called Wimbledon, beating Margaret Court in the 1971 ladies' final for the second of what would be seven Grand Slam singles titles."

Goolagong had a uniquely beautiful game. Fans and media alike marveled at how effortless her movements were, so much so that opponents could easily get caught up in her spell.

"She was like a panther compared to me," Billie Jean King told *Sports Illustrated* after losing to Goolagong in the semi-finals of the 1974 Virginia Slims Championship. "She had more mobility and she played beautifully. I started watching her, and then I'd remember all of a sudden that I had to hit the ball."

In 2005, Martina Navratilova told *Sports Illustrated*, "She was such a pretty player. She didn't serve-and-volley; she would sort of saunter-and-volley."

Goolagong made history in 1974 when, as a 23-year-old, she beat King to win the Virginia Slims Championship. She was rewarded with $32,000 in prize money, which was the largest cash prize in the history of women's tennis at the time.

She married British tennis player Roger Cawley in 1975 and had a daughter, Kelly, two years later. Perhaps the greatest moment of Goolagong's career came at Wimbledon in 1980, when she beat rival Chris Evert in the final to become the first mother to win Wimbledon since 1914. What's more, Cawley and Kelly were in the stands.

Goolagong never did win a U.S. Open singles title, but she was a finalist four consecutive times, losing close matches to Court, King, and Evert.

She retired in 1983, and moved with her family from Florida to Noosa, Queensland, in 1991. Since then, according to a story written by Wertheim, she has worked on getting back in touch with her roots and becoming an advocate for Aboriginal causes. Goolagong runs the Tennis Australia Goolagong Getting Started Program, which targets athletically inclined Aboriginal boys and girls and attempts to steer them toward tennis, does program outreach, sets up fundraisers, and launches tennis camps for Indigenous kids, among other things, in the Aboriginal communities.

"I just have such a passion for this," she told Wertheim. "It's not political. It's about educating, about sharing my experiences with my people. And the best part is, I'm learning so much from them too."

LEFT: Evonne Goolagong in action during Virginia Slims Championship, Los Angeles, California, USA, 1976

Steffi GRAF

"There's a new natural law in the universe, as undeniable as gravity," S. L. Price wrote for *Sports Illustrated* in 1996. "Steffi Graf cannot be stopped." Even toward the end of her career, she was so dominant that sometimes her greatest opponent ended up being herself. As Price went on to write, life had thrown her plenty of curveballs—sending her father to jail for tax evasion, putting her through various injuries and surgeries, and bringing her a most formidable challenger in Monica Seles, who she struggled to beat. And yet she still became one of the greatest tennis players of all time.

Graf, who is originally from the German town of Brühl, turned pro when she was 13 years old. By the time she retired at 30, she had won the sport's only historic Golden Slam—winning all four Grand Slam singles titles plus the Olympic gold medal in the same calendar year.

The latter happened in the magical year of 1988, when Graf was 18. And she kept dominating from there. At one point, she was the world's No. 1 player for 377 consecutive weeks—which is more than seven years. It remains the longest streak for any player, male or female. She won 22 Grand Slam singles titles, which ranks third behind Margaret Court and Serena Williams. She and Court are the only players, male or female, to win three Grand Slams in a calendar year—five times! Even when you thought she was the greatest, she kept getting better, which turned out to be a theme throughout her career.

Isabel Cueto saw Graf in a tournament when she was nine years old. "She was running between the points to receive the serve. Her forehand wasn't even her best shot then. She had such a beautiful backhand. No slice or topspin, no nothing. I was nine. My parents and I couldn't believe it. They knew I would need some more lessons," she told *Sports Illustrated* in 1989.

Speaking of her stroke, *Sports Illustrated* writer Curry Kirkpatrick once described Graf's forehand as "wicked." Bruce Newman called it "paralyzing." Whatever it was, it dominated that era of tennis and separated Graf from the pack. And her opponents agreed. "There's nobody else in the world who can do what she does," Zina Garrison told *Sports Illustrated* in 1989. "She's just total power. Her forehand puts fear in everybody."

LEFT: Steffi Graf in action during U.S. Open, Flushing, New York, USA, 1996; **RIGHT:** Graf posing with trophy after winning Wimbledon, London, United Kingdom, 1993

Carling Basset-Seguso also shared a similar sentiment with the magazine: "I would hit a good shot on the run, and she would hit a winner off it. I think the only type of player who has a chance against her is an unbelievable serve-and-volleyer, double what Martina [Navratilova] is now. Some of the things she does don't seem human."

After she fell to Graf in the 1989 Virginia Slims Tournament, Susan Sloane said, "It's no fun playing Steffi. She has no weaknesses, none. Right now I'm playing the best I've ever played, and she beats me oh-and-one. It's scary."

Chris Evert once joked that players wished "she'd fall in love, get married and get pregnant." She eventually did, marrying American tennis star Andre Agassi in 2001. They later had two children together. But that was several years after Graf retired.

Both of Graf's parents were tennis players. Her father, Peter, was her first coach and managed her schedule and finances for most of her career (until he was arrested for tax evasion). At age six, Graf won her first junior tournament, becoming one of Germany's great young talents. She was ranked No. 6 in the world by the time she was 15, and won her first Grand Slam title, by beating Martina Navratilova in the French Open, at 17. In 1991, three years after achieving the Golden Slam, Graf became the youngest woman to reach 500 career wins. When she retired in 1999, she was still one of the top three players in the world.

Graf, who lives in Las Vegas with her family, was inducted into the International Tennis Hall of Fame before she was 40. She once told *Sports Illustrated* that she resented reading that she only lived to play tennis. Graf has always had many interests—she used to check rock concert schedules upon her arrival at various tournaments. These days, she keeps busy with art, design, photography, and her nonprofit foundation, Children for Tomorrow, which supports the mental health of children and their families affected by violence, war, and persecution.

Cammi GRANATO

hockey

Just like her brothers, Cammi Granato dreamed of playing in the NHL. There were plenty of reasons why she had no choice but to be a Blackhawks fan as a kid: she was from Chicago, her parents went on dates to Hawks games, and all four of her brothers played hockey.

"At the Granato house, hockey was inescapable," Kelli Anderson wrote for *Sports Illustrated* in 1993. "Christmas was a Blackhawk paraphernalia swap; family vacation was a hockey camp in Toronto or Colorado Springs; school papers were essays on hockey, short stories on hockey, book reports on hockey; treasure was an autographed kneepad from Blackhawk star Keith Magnuson; recreation was hockey in the Granatos' makeshift backyard rink or full-contact soccer or, later, hockey in the basement of the family's Downers Grove, Illinois, home."

Granato's oldest brother, Tony, starred at Wisconsin, on the 1988 U.S. Olympic team, and for the New York Rangers and Los Angeles Kings, where he played with Wayne Gretzky. The other three Granato boys also played at Wisconsin.

Naturally, Granato fell in love with the sport. She played organized hockey for the Downers Grove Huskies from kindergarten through her junior year in high school. She was usually the only girl, but she didn't care. If the boys checked her, she checked them right back.

"If you were a spectator, you would never have guessed there was a girl out there," Granato's cousin Bob told Anderson. "Of course, you might have wondered who the guy with the long hair was."

Granato was very athletic and played every sport, from basketball to soccer to tennis. She won consecutive medals in team handball in 1989 and 1990 at the Olympic Festivals (an amateur event between Olympic years held by the U.S. Olympic Committee from 1978 to 1995). And it's funny to think that her mother, Natalie, initially signed her up for ice-skating classes when she was little. Thankfully it was near the hockey rink where her brothers played.

"I bought her the whole skating outfit—a little skirt and little pom-poms for her skates," her mother told *Sports Illustrated* back then. "As soon as I turned my back during that first lesson, she walked right off the ice and through the door to watch a hockey game."

It's a good thing Granato followed her instincts and ditched the other kind of skating, because she went on to become one of the greatest female hockey players of all time. She earned a scholarship to play at Providence College (she couldn't play at Wisconsin like her brothers because there was no women's team yet) and then played on the U.S. women's national hockey team for 15 years. As captain, Granato led the United States to the first-ever Olympic medal for women's hockey (a gold) at the 1998 Nagano Games. The team earned a silver medal at the 2002 Salt Lake City Games, and a gold at the 2005 International Ice Hockey Federation World Championships. She became the program's all-time scoring leader with 343 points in 205 games. In 2008, she was the first woman inducted into the U.S. Hockey Hall of Fame.

Granato was cut unexpectedly from the U.S. national team in 2006 ahead of the Olympic Games in Turin. Rumors were floated that the decision was made because Granato had been a vocal advocate for gender pay equity and better treatment from USA Hockey. She had hoped the sport would take advantage of its spotlight after the team won gold at the 1998 Olympics, similar to how the U.S. women's national soccer team capitalized on its popularity following the 1999 Women's World Cup victory.

With many of her teammates too scared to speak up, Granato took the bullet and lost her spot. In 2017, women's hockey players threatened to boycott the world championship tournament over pay equity. American players negotiated better salaries and travel and medical benefits, but the sport has a long way to go to achieve more gender balance and opportunities for young girls and women.

Granato is married to former NHL player Ray Ferraro and they have two boys. While she never made it to the NHL like she dreamed of as a kid, Granato was named the league's first female pro scout in 2019. She was hired by the NHL's new Seattle franchise, which began playing in 2021.

RIGHT: Cammi Granato posing for a portrait, Montréal, Québec, Canada, 1997

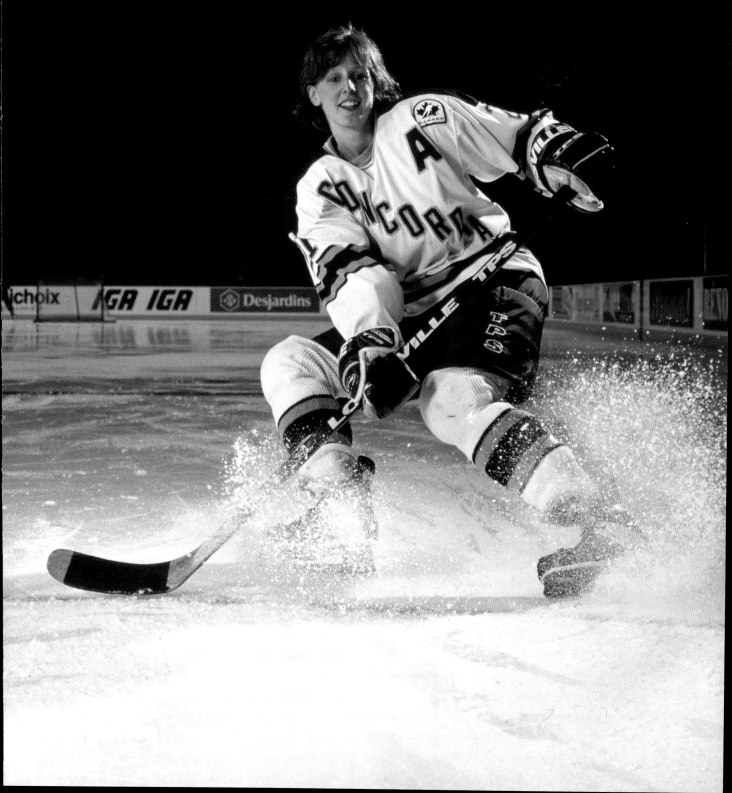

Florence GRIFFITH JOYNER
track and field

There will never be another Florence Griffith Joyner. As Christine Brennan once perfectly summed up in the *Washington Post*, "With her long, painted fingernails, hand-made bodysuits, flowing hair and deep, mellow voice, Griffith Joyner doesn't even need gold medals to make it big."

Griffith Joyner was the fastest woman in the world. And that's exactly how the headline read when she appeared on the cover of *Sports Illustrated*. Flo-Jo was a three-time Olympic gold medalist. She set and broke world records, most notably during the 1988 Seoul Games when she twice broke the Olympic record in the 100 meters and then easily won the final with a wind-aided 10.54 seconds. Four days later, she broke a nine-year-old record in the 200 meters and beat her own time in the final with a time of 21.34 seconds. Her records from those races have still not been broken. Griffith Joyner also ran in both relays in Seoul, winning a third gold medal in the 4x100-meter relay and a silver medal in the 4x400-meter relay.

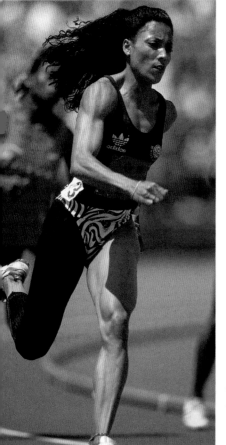

It wasn't just Flo-Jo's killer speed that made her legendary. She had been eccentric ever since she was a kid. She had a pet boa constrictor named Brandy. She read poetry and kept a diary. And she had those long, spectacular nails. For the 100-meter final in Seoul, she painted one fingernail with polka dots, another sparkly red with gold Olympic rings, and another sparkly blue with the word "gold" painted in tiny letters on top.

Her look wasn't complete without a fashionable uniform. Griffith Joyner first created the one-legged unitard by accident. She told *Sports Illustrated* back then that she was trying out a new idea. She cut one leg off some of her running tights, happened to look in the mirror, and said, "That might work." In those days the outfits were judged as maybe a little too revealing or sexy. Some likened her tracksuits to lingerie. But, as it turns out, Flo-Jo was a trendsetter. These days, female athletes wear catsuits and makeup and are always coming up with innovative ways to spice up their respective sports. And regardless of what people thought of her look, Griffith Joyner could run faster than NFL players no matter what she was wearing. "She melded athleticism and glamour like no other woman," Tim Layden wrote for *Sports Illustrated* in 1998.

Griffith Joyner was married to Al Joyner, the 1984 Olympic triple-jump champion and the older brother of heptathlon world-record holder Jackie Joyner-Kersee, whose husband was Bob Kersee. And it was Kersee who discovered Flo-Jo.

Griffith Joyner, who was one of 11 children, grew up in public housing in Los Angeles. After graduating from high school, where she set school records in sprints and long jump, she went to Cal State Northridge. She couldn't afford to return for her sophomore year, so she worked as a bank teller until Kersee, who was a coach at the college, helped her apply for financial aid. When Kersee left for an assistant coach job at the University of California, Los Angeles, in 1980, Griffith Joyner followed him. In 1982, she was the NCAA champion in the 200 meters. Kersee ended up coaching Griffith Joyner for many years.

After Griffith Joyner retired, she served as a cochair of what is now known as the President's Council on Sports, Fitness, and Nutrition and once designed uniforms for the Indiana Pacers. They were called "the Flo-Jos." Griffith Joyner died in her sleep of an apparent epileptic seizure at age 38 in 1998. While she passed away too early, she remains one of the greatest and most recognizable track and field athletes of all time.

LEFT: Florence Griffith Joyner in action during 200-meter race, U.S. Olympic Trials, Indianapolis, Indiana, USA, 1988; **RIGHT:** Joyner celebrating after winning 100-meter race, Summer Olympics, Seoul, South Korea, 1988

Gabriele GRUNEWALD

track and field

Gabriele Grunewald learned she had adenoid cystic carcinoma (ACC), a rare cancer of the salivary gland, one day before a college track meet in 2009. She was 22, a fifth-year senior at Minnesota, and a star middle-distance runner planning to turn pro. She ran her race anyway, clocking a personal best in the 1,500 meters (4:22.87). Grunewald kept training and running through surgery and radiation treatments. She fought off the cancer, but it kept coming back in various forms. And then, in 2010, she found out she had thyroid cancer.

Throughout her cancer journey, Grunewald kept competing and became a mentor and activist who refused to give up. She once competed in the Olympic Trials with a tumor—one that was about four pounds when it was removed—growing inside of her. "Brave Like Gabe" first started as a motto and a hashtag to support Grunewald through treatment during her third battle with ACC, and it evolved into the name of a foundation she created to raise money and awareness for rare cancer research and empower survivors through physical activity.

ACC is so rare that it's diagnosed in just 3.5 out of every one million cancer patients. In his powerful feature story about Grunewald for *Sports Illustrated*, Tim Layden wrote that there was no standard of care for a disease like this one: "There are treatments and there is research, but there is nothing resembling a silver bullet. It is a whack-a-mole cancer that can be repeatedly swatted back into its hole, only to return in the same hole—or somewhere else—sometimes quickly or other times many years later."

Grunewald passed away from complications with ACC in 2019 at the age of 32. But her legacy lives on.

Grunewald, known as Gabe in the running community, was a professional middle-distance runner. She won a high school track and field state title in the 800 meters, and then walked on the cross-country and track and field teams at Minnesota in 2004. She was part of several Big Ten championship teams and was an NCAA All-American. She had a runner-up finish in the 1,500 meters in 2010, after her first diagnosis.

As a pro running for Brooks (a running shoe and apparel brand), she made every U.S. championship 1,500-meter final from 2010 to 2016. She finished in fourth place in the 1,500 meters during the 2012 Olympic Trials, failing to qualify by one spot. In 2013, she ran a time of 4:01.46 in the same event, making her the 11th-fastest female 1,500-meter runner in American history. And, in 2014, she won the U.S. indoor national championship in the 3,000 meters.

Grunewald told Layden that she was never "one of those people who had a transcendental relationship with running." Her feelings changed during her cancer battle as she came to believe that running and physical activity were like medicine. "I love running more now than I ever did. It makes me feel like myself."

Being herself meant being ready to fight at all times and never giving up. Grunewald finished in last place in the 1,500 meters at the 2017 national championships after she'd gone to the emergency room with a fever.

Being herself also meant being a "relentless optimist," as she described on her website. She considered her surgery scars a representation of survival and embraced them as her strength. When her husband, Justin, told her she was dying after lab results determined as much, "she took a deep breath and yelled NOT TODAY," according to Layden's story.

"Gabe spent the last years of her life fighting, living, running . . . inspiring others . . . fully aware that she was not winning her own fight, but fighting ever harder just the same," Layden wrote. Though she passed away far too soon, Grunewald will continue to be an inspiration.

LEFT: Gabriele Grunewald in action during a training run, Minneapolis, Minnesota, USA, 2017; RIGHT: Grunewald posing for a portrait to show her surgical scars, Minneapolis, Minnesota, USA, 2017

Janet GUTHRIE
race-car driving

Janet Guthrie actually wanted to be an astronaut. Both of her parents were airline pilots and her father taught her how to fly Pipers when she was 16, so the idea came naturally. Guthrie pursued her dream by getting her bachelor's degree in physics from the University of Michigan and later worked as a physicist. But in 1963, she was denied a chance to become one of the first scientist-astronauts, so she decided to become a race-car driver instead.

In doing so, Guthrie became a pioneer, breaking the gender barrier and becoming the first woman to race in the Indianapolis 500 and Daytona 500, all while battling vast amounts of sexism in a male-dominated industry.

Before Guthrie qualified for her first Indy 500 in 1977, she was mocked, ogled, and ridiculed by fans. During a race

in 1976, two drunk men taunted her. "Hope you crash in our corner," writer Sam Moses recapped for *Sports Illustrated*.

"Guthrie remained composed and gracious," Moses wrote. "On the track, she was constantly under pressure, too, aware that with one mistake there would be cries of, 'See! We told you a girl doesn't belong out there!'"

The comments continued throughout her career. According to *Sports Illustrated* writer Charles Hirshberg, "One columnist wrote that if women could race, drunk drivers ought to be allowed to also. Driver Richard Petty said that Guthrie was 'no lady' because 'if she was, she'd be at home.'" Guthrie had thick skin and ignored the bigotry the best she could.

Guthrie was a do-it-yourself kind of driver; without the same money and sponsorships as her male counterparts, she had to be. She built her own engines and did her own bodywork. After competing in three Indy 500s, though, she called it quits, mainly for the reason that she struggled to get into the sport in the first place: no money and no sponsorships.

In her autobiography, *A Life at Full Throttle*, Guthrie described how potential sponsors used to put her agent on speakerphone, allow him to make a pitch, and then burst out laughing and hang up. "I kept trying until 1983. Then I said to myself, 'If you keep this up, you're going to jump out of a high window,'" Guthrie told the *Indianapolis Star*.

The prejudice and chauvinism were hurtful, but Guthrie's bravery and determination ultimately paved the way for women in motorsports like Danica Patrick and Pippa Mann. It's still difficult for women to get sponsorships in racing, and the sport still has a long way to go. Most of the companies are filled with male marketing executives and decision makers who often opt to support a male driver over a female. Even so, Guthrie left the sport better than she found it.

"The most gratifying thing was to see attitudes change," Guthrie told the *Indianapolis Star*. "They saw that I knew what I was doing and I could give them some good competition."

Guthrie moved to Aspen, Colorado, in 1985 and married Warren Levine, an American Airlines pilot, in 1989. She published her book, which received rave reviews, in 2005.

ABOVE: Janet Guthrie posing for a portrait with her car, Indianapolis 500 Qualifying Race, Indianapolis, Indiana, USA, 1976; **RIGHT:** Guthrie posing for a portrait, Indianapolis 500 Qualifying Race, Indianapolis, Indiana, USA, 1976

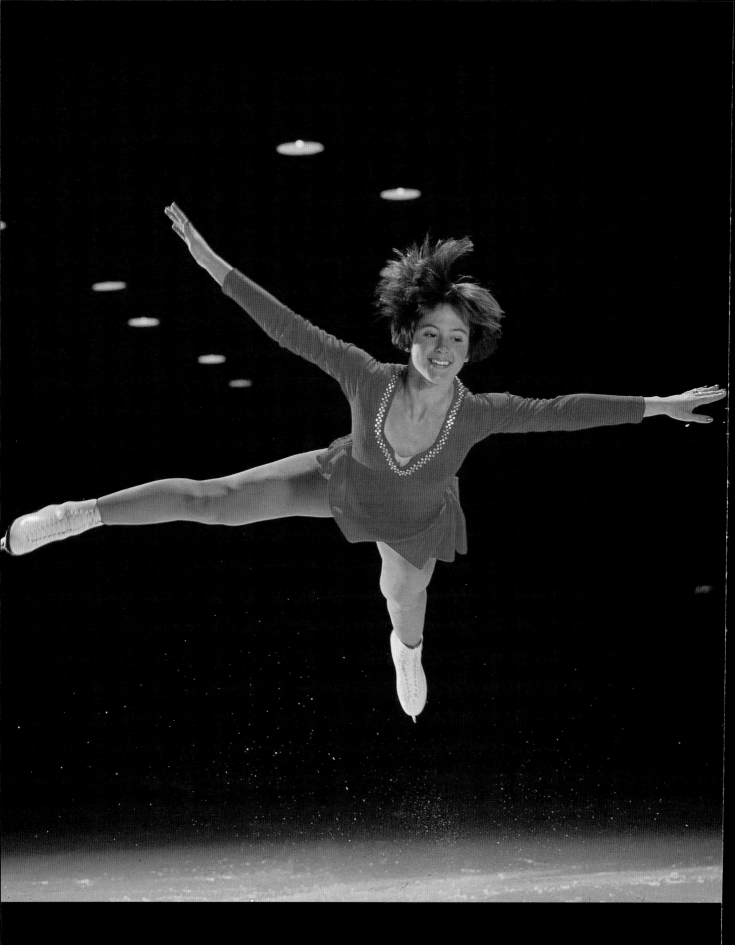

Dorothy HAMILL
figure skating

Dorothy Hamill went from learning how to ice skate on a frozen pond in her grandparents' backyard to winning gold at the 1976 Olympic Games in Innsbruck. With her pink dress, bob hairstyle, and signature move—the "Hamill camel," a camel spin into a sit spin—she quickly became America's sweetheart.

Hamill started winning skating competitions when she was 11, quickly rising through the competition gauntlet and winning two silver medals at the 1974 world championships. Two years later, when Hamill was 19, she won her lone Olympic gold medal in the ladies' singles event. She immediately captivated millions of Americans.

"In four nearly flawless minutes at the Olympic Ice Hall in Innsbruck . . . she walleyed, toe-looped, Salchowed, Axeled and Lutzed her way into our hearts, finishing her performance with her signature Hamill camel," Steve Wulf later wrote for *Sports Illustrated*. "The nearsighted girl in the pink dress further endeared herself to millions by squinting to see her scores (eight 5.8s and a 5.9 in technical merit, all 5.9s in artistic interpretation). The gold medal was hers, and as she stood shyly, demurely on the platform, she seemed to have stepped out of a storybook. And what a storybook name, Dorothy."

After the Olympics, Hamill stayed in Europe a little longer to train for the 1976 world championships, where she won another gold.

By the time she returned to the United States, Hamill's stardom had skyrocketed even more. "She was in a whirlwind romance with the world," Wulf wrote. There were Dorothy Hamill dolls, and women were starting to get their hair done just like her. "Women everywhere began to order up her short and sassy hairdo, the Hamill Wedge," Wulf wrote. "Her hair, in fact, became as famous as she was. A few months after her gold medal, she was touring a museum in Delaware with her mother when a guide came up to her and said, 'I like your Dorothy Hamill haircut.' 'Thanks,' she said, not telling the guide who she was."

After the Olympics, she signed a three-year contract, reportedly for $1 million, to skate with the Ice Capades. She moved from her home in Connecticut to Hollywood and became even more of a celebrity. When she married Dean Paul Martin (son of Dean Martin), Frank Sinatra attended their wedding. (They later divorced.)

Hamill produced and starred in Ice Capades productions like *Cinderella* and *The Nutcracker*. She won an Emmy Award for her role in *Romeo and Juliet on Ice*. In 1991, the Ice Capades were nearly bankrupt, so Hamill bought the company's assets and tried to revive it. It worked for a while, until the company filed for bankruptcy again in 1994.

Hamill was inducted into the U.S. Figure Skating Hall of Fame in 1991 and was chosen to carry the Olympic torch into the stadium for the Opening Ceremony of the 2002 Winter Games in Salt Lake City.

Since her skating career ended, Hamill has involved herself with various charities, including what is now known as the President's Council on Sports, Fitness, and Nutrition; the International Special Olympics; and the American Cancer Society. Hamill was diagnosed with breast cancer in 2007 and launched a national campaign called BeWiseEr+, which encourages breast cancer survivors who are on antiestrogen therapy to learn more about treatment options.

LEFT: Dorothy Hamill posing for a portrait, Winter Olympics, Innsbruck, Austria, 1976; **RIGHT:** Hamill posing after winning gold medal for singles event, Winter Olympics, Innsbruck, Austria, 1976

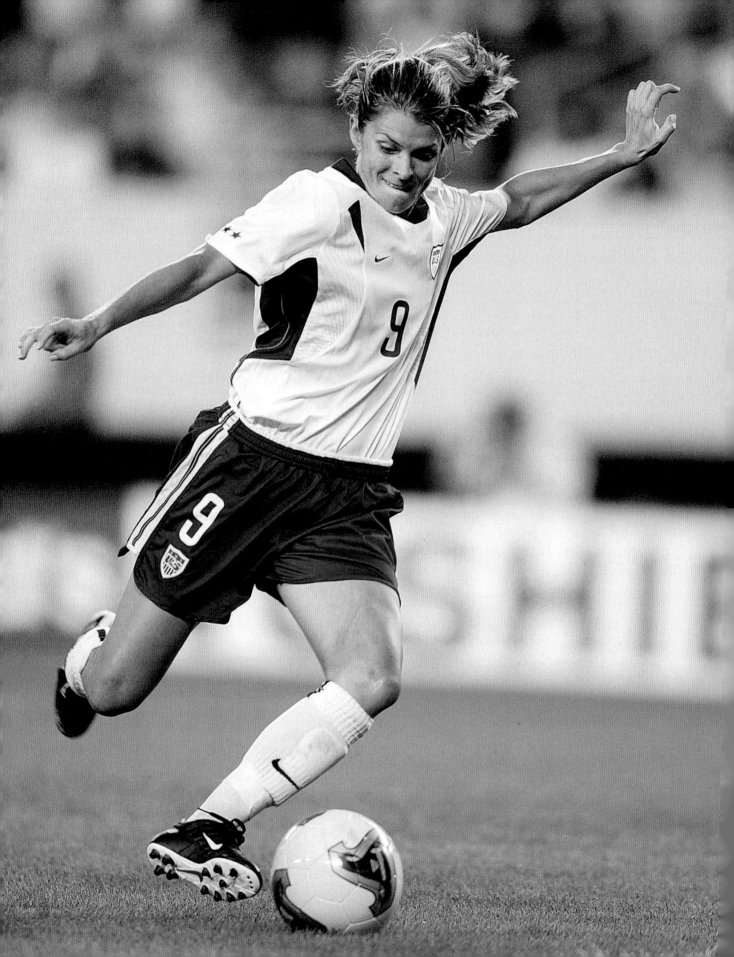

Mia HAMM

When we think of Mia Hamm, we think of her dazzling 18-year career, which included making the U.S. women's national soccer team (USWNT) at age 15, scoring 158 international goals, and winning two World Cups and two Olympic gold medals. She was the face of Title IX. She was the world's first female team-sport superstar. She was in a Gatorade commercial with fellow North Carolina Tar Heel Michael Jordan.

While it would be easy to quickly sum up Hamm's global impact on the sport with a lengthy list of stats and remarkable achievements, that's not where her legacy truly resides. It lives on in the next generation of female athletes—and the next and the next and the next after that. It lives on in the millions of young girls who had—and maybe still have—her face plastered on their bedroom walls, wore her No. 9 jersey to soccer games, and shrieked, "Mia! Mia! Mia!" as they begged for autographs. Hamm was the face of a movement—heck, she practically *was* the movement—that showed girls that if they can see it, they can be it, and that anything a boy could do, a girl could do better.

Early on in Hamm's international soccer career, however, the USWNT didn't garner a ton of attention, certainly not like it does today, with ticker-tape parades and equal-pay lawsuits. Hamm and her teammates often played games in front of only a few hundred fans. They had to drive their own vans, carry their own equipment, and do their own laundry, among other menial tasks that their male counterparts never dreamed of doing. After winning the inaugural 1991 World Cup in China, Hamm and her U.S. teammates returned home with the championship trophy to a welcoming party of three, as *Sports Illustrated* writer Gary Smith wrote in his 2003 cover story about Hamm.

Hamm was a reluctant superstar, but popularity came with the territory. She joined the USWNT as a teenager and was the center of attention, which she hated. Hamm just wanted to be part of the team and recoiled when packs of reporters ignored her teammates and flocked to her after practices or games to ask her questions like, "What's it like to be the best woman player in the world?" In his story, Smith recalled a reporter asking Hamm that very question decades ago and the response she gave in return. "Ask me that question when I can dominate on both offense and defense like [teammate] Kristine Lilly does. Ask me when I can head a ball like Tisha Venturini, defend as well as Joy Fawcett, play an all-around game like Julie Foudy," Hamm said. For Hamm, it was all about putting the team first.

And while she had a gift for scoring magical goals, she was also human. She struggled with self-doubt, and in the 1999 World Cup final shootout against China in the Rose Bowl, she didn't want to take a penalty kick. She did end up taking it, of course, and she booted it into the back of the net.

Hamm retired when she was 32 and now has a family with husband and former MLB All-Star Nomar Garciaparra. She also is co-owner of the Los Angeles Football Club of the MLS and is on the board of directors of Serie A club AS Roma. In 2020, it was announced that Hamm would be part of the fierce all-female ownership group for Angel City, the first NWSL team in Los Angeles.

Hamm still isn't interested in being in the spotlight and keeps her life private. But any forward progress in women's sports, from soccer to basketball to hockey, will undoubtedly always link back to Hamm.

LEFT: Mia Hamm in action during FIFA World Cup, Philadelphia, Pennsylvania, USA, 2003; **RIGHT:** Hamm celebrating after winning gold medal, Summer Olympics, Athens, Greece, 2004; **OVERLEAF:** Hamm posing with teammates after winning gold medal, Summer Olympics, Athens, Greece, 2004

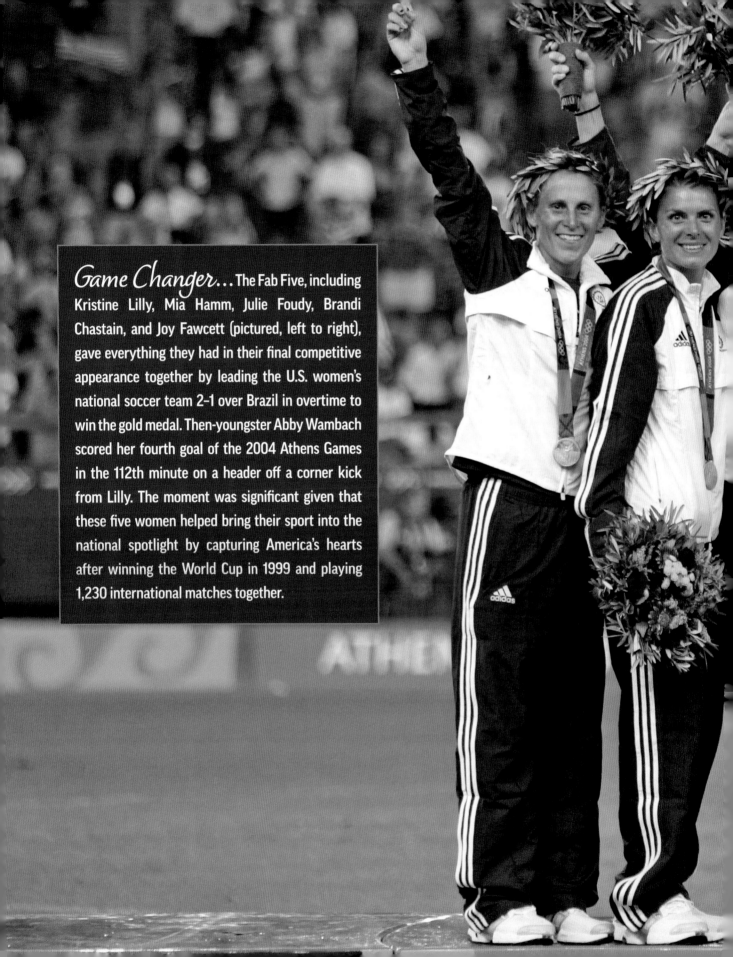

Game Changer… The Fab Five, including Kristine Lilly, Mia Hamm, Julie Foudy, Brandi Chastain, and Joy Fawcett (pictured, left to right), gave everything they had in their final competitive appearance together by leading the U.S. women's national soccer team 2–1 over Brazil in overtime to win the gold medal. Then-youngster Abby Wambach scored her fourth goal of the 2004 Athens Games in the 112th minute on a header off a corner kick from Lilly. The moment was significant given that these five women helped bring their sport into the national spotlight by capturing America's hearts after winning the World Cup in 1999 and playing 1,230 international matches together.

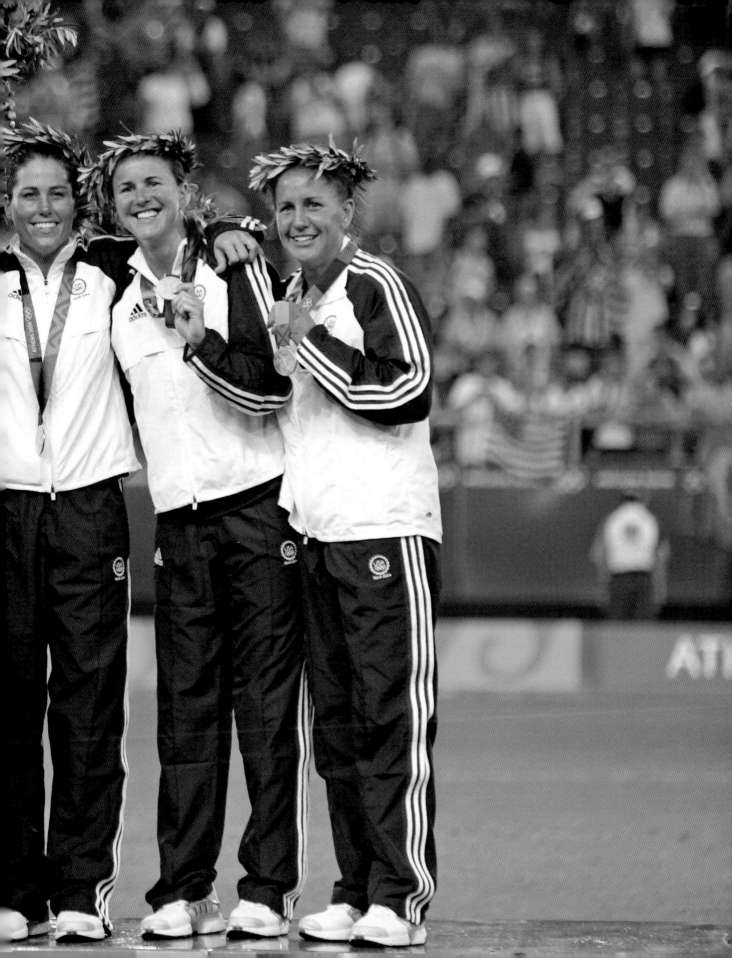

Becky HAMMON
basketball

Before hiring Becky Hammon to become the first full-time female assistant coach in the NBA, Gregg Popovich was impressed by her decision to play for the Russian national team at the 2008 Olympics in Beijing.

"It was pretty brave, because you knew there'd be people of the ilk of 'That's unpatriotic or shortsighted,'" the San Antonio Spurs coach told *Sports Illustrated* in 2015. "It's not about any of that. It's about being a competitor and living a life that lasts not very long, and taking advantage of all life's opportunities without hurting anybody else. She seizes the day."

In 2007, when USA Basketball released its initial list of 21 players, 12 of which would be chosen for the U.S. Olympic team, Hammon's name wasn't on it. So in order to fulfill her childhood dream of playing in the Olympics, she found another way. Hammon signed a contract with the club team CSKA Moscow that was worth $2 million for four years. The contract included the opportunity to play for the Russian Olympic team if she became a naturalized citizen. There was also a six-figure incentive for winning a gold medal.

Since WNBA salaries are a mere fraction of those in the NBA, many players spend their offseason playing overseas, so signing a contract with a Russian club wasn't unique. It's often the most financially prudent thing for players to do. Hammon said she would have turned down all of the money in the world to play for the United States, but that option wasn't on the table. In those games, Hammon and the Russian team won a bronze medal after losing to the heavily favored U.S. team in the semifinal. Hammon led the Russian team with 22 points in the third-place game.

Before all of that, Hammon was just an undersized and overlooked point guard from Rapid City, South Dakota. Hammon didn't have much luck on the recruitment trail and most Division I coaches were turned off by her five-foot-six size. "Average white girl," former Arkansas assistant coach Tom Collen told *Sports Illustrated*. He later became her coach at Colorado State where, as a freshman, Hammon led the Rams to 26 wins and the program's first NCAA tournament appearance. In four years she scored 2,740 points, more than any Western Athletic Conference player ever, male or female, surpassing Utah legend Keith Van Horn in the process. And, as a senior, she took the Rams to the Sweet 16.

She went undrafted by the WNBA in 1999, but eventually signed with the New York Liberty as a free agent and played there for eight years. In April 2007, she was traded to the San Antonio Silver Stars and helped them make it to the playoffs. That season was Hammon's best in the league and she finished second in MVP voting.

After playing 16 years in the WNBA, becoming a six-time All-Star, and being named one of the top 15 WNBA players of all time, Hammon retired in 2014. But it was in 2013, when she suffered a serious left-knee injury, that the wheels started moving on what would become a monumental coaching career. A few weeks after surgery, Hammon asked if she could talk to R. C. Buford, general manager of the San Antonio Spurs, and Popovich to see if she could come to a few practices while she was going through rehab. Needless to say, her apprenticeship went well.

Hammon was hired in 2014 and became the first woman to become a full-time NBA assistant coach. In 2015, she continued to defy gender norms by becoming the first woman to coach an NBA game when she led the Spurs Las Vegas Summer League team to the 2015 title. Hammon made history again in 2020 when she was the first woman to act as a head coach during an NBA regular-season game. She filled in for Popovich after he was ejected in a game against the Los Angeles Lakers.

"Obviously, it's a big deal," Hammon said via *ESPN* at the time. "I've been a part of this organization . . . for 13 years. So I have a lot of time invested, and they have a lot of time invested in me, in building me and getting me better."

Kamala Harris, then vice president-elect, tweeted her congratulations: "Congrats, @BeckyHammon. You may be the first, but I know you certainly won't be the last."

As a pioneer in men's professional sports, Hammon has earned respect from players, coaches, and fans, and paved the way for the next generation of young women. "Becky played, and any player who knows the history of women's basketball knows what she meant to the sport," Spurs guard DeMar DeRozan told *ESPN*. "You don't think twice about it. She's one of us. When she speaks, we are all ears."

RIGHT: Becky Hammon in action during semifinals, Summer Olympics, Beijing, China, 2008

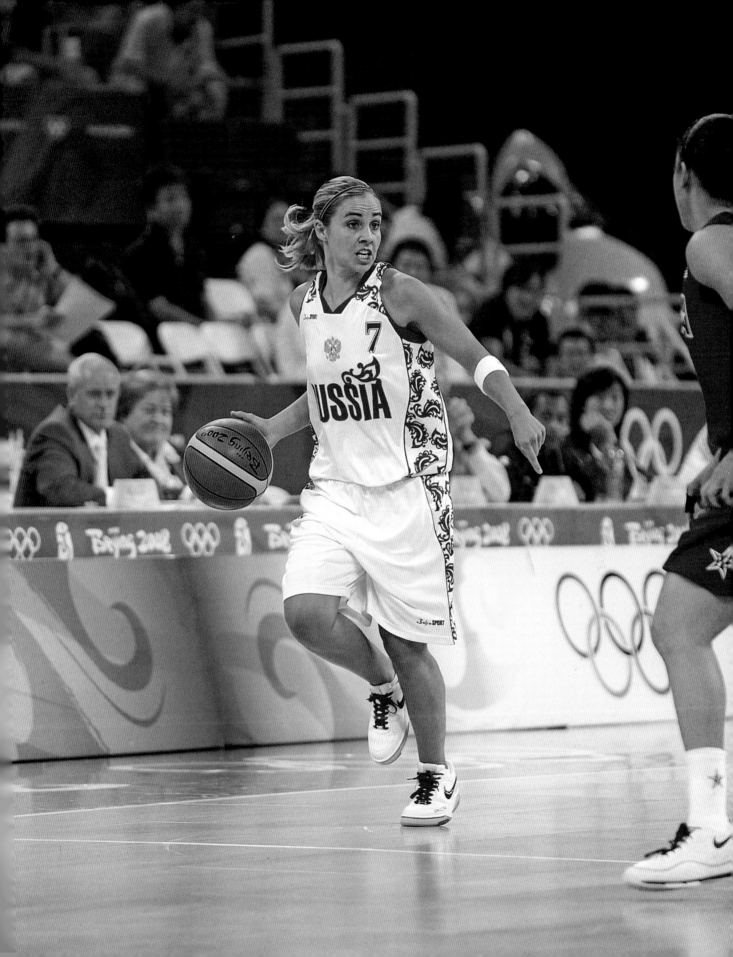

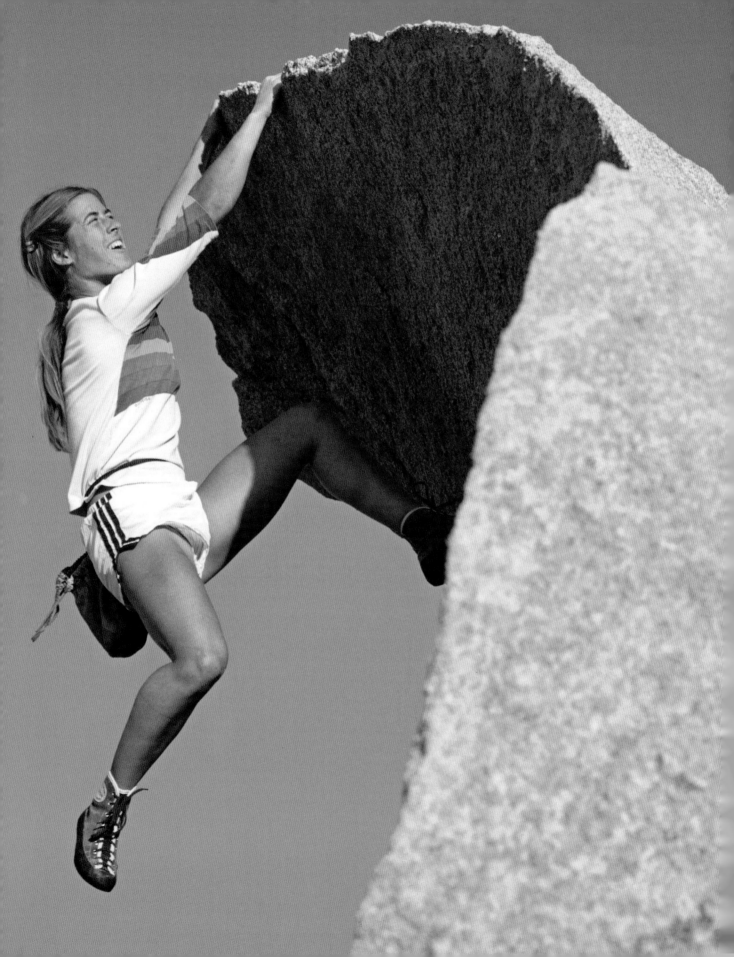

Lynn HILL
rock climbing

erhaps you've heard of El Capitan. Also known as El Cap, it's a vertical granite rock formation in Yosemite National Park that's about 3,000 feet from base to summit. It's two-and-a-half times as tall as the Empire State Building and has become one of the world's ultimate challenges for climbers.

The Nose is the most popular climbing route on El Cap. It was once considered impossible to climb because it goes straight up the middle of the wall. Only two people in the entire world have succeeded in making an all-free one-day ascent of The Nose. One is Tommy Caldwell, who has been featured in major documentaries like *The Dawn Wall* and *Free Solo* and whose journey climbing El Capitan was chronicled by the *New York Times*.

The second person is Lynn Hill, who was actually the first to attempt it more than a decade before Caldwell. Hill is a world-renowned rock climber famous for making the first free ascent of The Nose. And, as the biography on her website perfectly states, "Hill changed the definition of what is possible in rock climbing."

She has become one of the world's greatest climbers, winning more than 30 international competitions, including the World Cup in 1990, and becoming a five-time winner of the Rock Master competition (considered the Wimbledon of climbing). In 1999, Hill led a small team of women to do a first ascent up a steep, 2,000-foot wall of granite in Madagascar.

Hill grew up as an athlete, participating in gymnastics and running a lot as a kid. She first started climbing with her older brother and sister when she was 14 and was immediately hooked. She has always challenged herself to climb some of the most difficult grades in the world. In 1979, she was the first woman to climb a route rated 5.12d (on the climbing grade scale, a 5.0–5.7 is easy; 5.8–5.10 is intermediate; 5.11–5.12 is hard; and 5.13–5.15 is elite). In 1991, she climbed a route rated 5.14, three years before any other woman's attempt.

According to her website, Hill first attempted—and failed—to free climb The Nose in 1989. She tried again in 1993 and became the first person, male or female, to free climb the route. It took her four days with a partner. The next year, she became the first person to free climb the same route in less than 24 hours.

In a 2012 interview with the now-defunct *Climber Magazine*, Hill reflected on that accomplishment and why she felt it was so important to be a trailblazer in her sport. "I thought that climbing was relatively immature in what we were capable of doing, and I had the vision to see that a lot more was capable and there's no reason that a woman couldn't do something out there. That to me was an important statement to make because, in the history of Yosemite, there weren't really that many role models.

"I think that it's really important for women [and] girls to have role models to know that it's possible because it's the mind and belief that drives us. If you don't have any role models then you have even less reason to believe you're going to stand out. I saw that it was possible with the given set of skills and motivation that I had, so I just tried really, really hard."

Hill has traveled the world for climbing. She currently lives in Colorado, and when she's not attempting the most challenging climbs in the world, she enjoys running, skiing, and spending time with her son.

LEFT: Lynn Hill clinging to a rock face during a climb, Yosemite Valley, California, USA, 1983

Sabrina **IONESCU**

basketball

Sabrina Ionescu's parents had never even heard of basketball before it became their daughter's livelihood. The Ionescus emigrated from Romania to Northern California after escaping the 1989 Romanian Revolution. They had three kids—Sabrina and her twin brother, Eddy, plus their older brother, Andrei. The twins started shooting hoops when they were three years old and challenged other duos to games of H-O-R-S-E for 7-Eleven Slurpee rewards.

Fast-forward to Ionescu committing to play basketball at Oregon and becoming one of the greatest college players of all time. The Ducks star was an incredibly versatile player. She was a two-time Wooden Award winner, a three-time All-American, and the only Division I player—male or female—to record 2,000 points, 1,000 assists, and 1,000 rebounds in a career. She also had a record 26 triple-doubles.

Ionescu was the consensus No. 1 pick leading up to both the 2019 and 2020 WNBA drafts. In 2019, she decided to return

to school for her senior year in hopes of leading the Ducks to a national championship after losing to Baylor in the finals the previous year. There's no reason to believe that wouldn't have happened, but March Madness was canceled her senior season due to the COVID-19 pandemic. Ionescu was selected No. 1 overall by the New York Liberty in the 2020 draft, but unfortunately her rookie WNBA season was cut short by an ankle injury.

As a senior at Oregon, Ionescu averaged 17.5 points and 9.2 assists per game and led her school to a historic regular-season win over the University of Connecticut, plus a third consecutive Pacific-12 Conference championship.

Ionescu, who was featured in *Sports Illustrated*'s "Faces in the Crowd" in 2016 after leading her youth basketball team

in California to a 54-1 record, had a special and unique relationship with the late Kobe Bryant. The two first met when Bryant took his daughter Gigi and a few of her teammates to an Oregon-USC game during the 2019 season. Ionescu told the *Los Angeles Times* then that her coaches told her there would be a surprise for her at the game. She thought Nike had probably sent over some new shoes. Instead, it was Bryant and Gigi sitting courtside at one of her games.

A friendship blossomed from there and Bryant became Ionescu's mentor. Later that summer, she went to Los Angeles to work out with Gigi and help Bryant coach her team, the Mamba Ballers. Bryant often gave Ionescu advice on basketball and how to keep improving, and he always sent her motivational texts after games.

"We kept in touch, always texting, calls, game visits," she told the *Los Angeles Times*. "I'd drop a triple-double and have a text from him, 'Another triple-double I see you' with a flex emoji. Another game, another text. 'Yo, Beast Mode,' or 'Easy Money.'"

They became so close that Ionescu spoke at the memorial held for Bryant and Gigi after they tragically died in a helicopter crash in early 2020. Following the service, Ionescu and the Ducks played Stanford, and it was in that game that she notched the 2,000 career points, 1,000 assists, and 1,000 rebounds milestone.

"That one was for him. To do it on 2/24/20 is huge," she told the *Los Angeles Times*, referencing the fact that Gigi wore No. 2 and Bryant wore No. 24. "We had talked about it in the preseason. I can't really put that into words. He's looking down and really proud of me and just really happy for this moment with my team."

Ionescu's college career caught the attention of many other NBA stars, not just Bryant. After a big game, top players like Steph Curry and Kevin Durant would tweet at her. Her legacy, while still in its infancy, will always be synonymous with growing the women's game and commanding the attention and respect it deserves—something Bryant strived to do as well.

LEFT: Sabrina Ionescu in action during Oregon game, Stanford, California, 2019; **RIGHT:** Ionescu in action during Oregon game, Berkeley, California, 2019

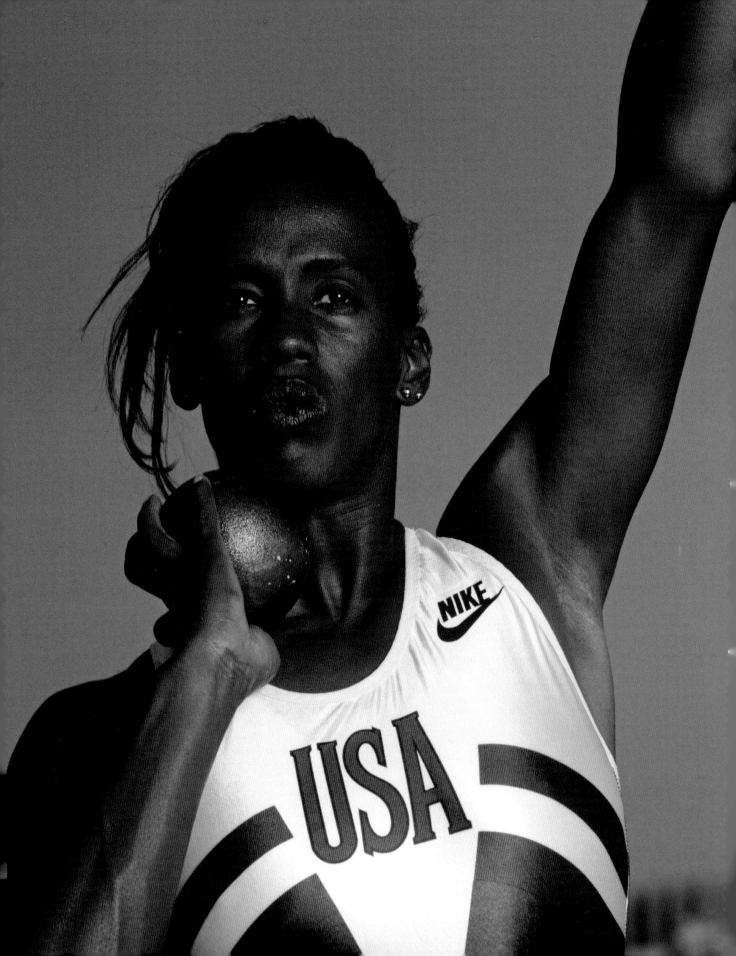

Jackie JOYNER-KERSEE

track and field

Jackie Joyner-Kersee's grandmother was onto something with this one. She had the responsibility of naming her granddaughter, and she chose Jacqueline after President John F. Kennedy's wife because she thought that "someday this girl will be the first lady of something," Kenny Moore wrote for *Sports Illustrated* in 1987.

Joyner-Kersee's grandmother was right. Her granddaughter became a four-time Olympian, winning six medals, including three golds in the heptathlon and long jump. She was the first woman to win consecutive gold medals in the heptathlon and the first Black woman to win an Olympic medal in the long jump. Joyner-Kersee won four golds at the world championships too.

Before the 1988 Olympic Games in Seoul, her husband and coach Bob Kersee told *Sports Illustrated*, "I'm expecting two golds and two world records. If we don't get 'em, it won't be the coaching."

Joyner-Kersee fulfilled the prophecy, setting records and winning golds in both the heptathlon and long jump. Her heptathlon score of 7,291 points is a record that still stands today.

Joyner-Kersee grew up in the tough city of East St. Louis, Illinois. The oldest of four children, she and her brother, Al, the 1984 Olympic triple-jump champion, were inseparable. Their parents, Alfred and Mary Joyner, were married when they were 16 and 14, respectively. Their hometown was dangerous, and the siblings had dreams of making it out. According to Moore's 1987 story, their mother had the same dreams for her kids, always telling them to "be nice to people and understand that a single mistake can be devastating."

"She transferred her aspirations to us," Joyner-Kersee said.

Joyner-Kersee was a natural-born athlete. She took up track and field as a kid and played basketball too. "If they went head-to-head in anything, Jackie won," Moore wrote of the Joyner siblings. "It didn't matter that she was two years younger."

During her junior year in high school, Joyner-Kersee long-jumped a state high school record of 20' 7½". The next year, she jumped 20' 9¾" at the Olympic Trials. She graduated in the top 10 percent of her class and went to the University of California, Los Angeles.

In college, she was a basketball player and a long jumper. She was a four-year starting forward who led the Bruins in rebounding (9.3 per game). It wasn't until her future husband—Bob Kersee, who was then an assistant track and field coach—encouraged her to compete in the heptathlon that she took up track and field.

At the 1984 Los Angeles Games, Joyner-Kersee's first Olympics, she missed winning gold in the heptathlon by five points. Motivated by coming so close but winning the silver medal, she went on to win gold four years later. Joyner-Kersee won the heptathlon again at the 1992 Barcelona Games, plus a bronze medal in the long jump. At age 34, she competed in her final Olympics at the 1996 Atlanta Games, where she earned bronze in the long jump.

After retiring, the Olympic legend founded the Jackie Joyner-Kersee Foundation. Its mission is to ensure that all kids in East St. Louis have access to high-quality after-school programs and safe recreational places in their communities to help them achieve their dreams.

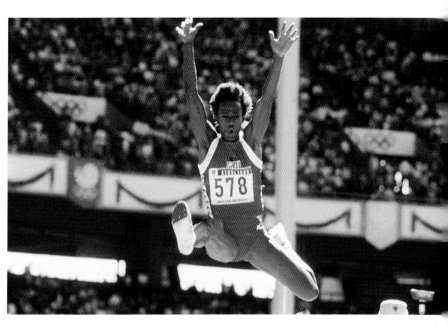

LEFT: Jackie Joyner-Kersee posing for shot-put portrait ahead of Summer Olympics, Northridge, California, USA, 1992; **RIGHT:** Joyner-Kersee in action during long jump final, Summer Olympics, Seoul, South Korea, 1988

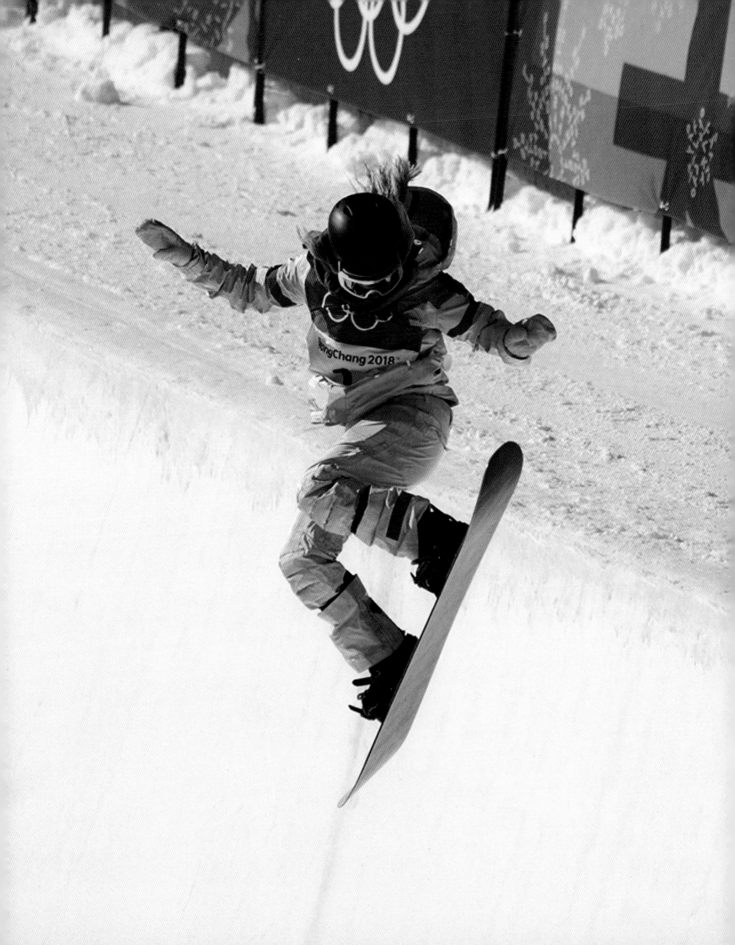

Sports Illustrated nailed it with this headline from a story in 2015: "Queen of the Snow: Chloe Kim looks to rule snowboarding for years to come."

Little did anyone know that, three years later, she would become America's new sweetheart, effortlessly endearing herself to millions at the 2018 PyeongChang Olympics. Kim's father, Jong Jin, is from South Korea, so it was extra special that her stardom took off there. She also found out after her second run that her grandmother, who had never seen her snowboard before, had attended to watch.

A dominant snowboarder, Kim won an Olympic gold medal at age 17 and was the youngest athlete to ever achieve such a feat in that event. As Michael Rosenberg wrote for *Sports Illustrated* in 2018, "she is the halfpipe's Simone Biles." But the reason America loves Kim isn't based on her talent alone. She is bubbly, charismatic, funny, and smart. She tweeted about wanting ice cream, wishing she'd finished a breakfast burrito, and being hangry in between runs.

Before charming the world over in Korea, Kim became the only athlete in X Games history to earn three gold medals before the age of 16. She would have qualified for the U.S. team at the 2014 Sochi Olympics, but she was too young.

Kim has drawn many comparisons to Shaun White, including from the "Flying Tomato" himself. They've both redefined what's possible in their sport, with Kim becoming the only woman to land back-to-back 1080s. According to a *Sports Illustrated* interview with Kim in 2018, "she first did it at the 2016 U.S. Snowboarding Grand Prix, joining White as the only riders to score a perfect 100 on a run at that event." At the 2016 X Games, Kim was 15 years old and won two gold medals.

"She definitely reminds me of myself," White told *Sports Illustrated* then. "But it's not about one big trick, it's about the way she connects the whole run. She does what I strived for: big air at the top, gnarly tricks in the middle, finish it great. I love watching her ride."

And as if that wasn't a big enough compliment, Kim was able to compete in an Olympics with her role model (and snowboarding trailblazer) Kelly Clark. Kim met her idol at her first X Games in 2014 when she was 13.

"Kelly Clark has been my biggest inspiration since Day One and she's been so amazing to me," Kim told *Sports Illustrated* in 2018. "She's always there for me. She's been through it all and there's literally nothing she doesn't know. She's a very comforting person to be around."

While it still seems inconceivable that Kim flew into America's hearts at such a young age, that just means we'll get to watch her compete for years to come.

As Rosenberg wrote in 2018, "For now, let's all appreciate America's delightful, precocious and preposterously talented snowboarding star. Whoever cast Chloe Kim as Chloe Kim nailed it."

LEFT: Chloe Kim in action during halfpipe final, Winter Olympics, PyeongChang, South Korea, 2018; **RIGHT:** Kim posing for a portrait with her snowboard, Saas-Fee, Switzerland, 2017

Billie Jean KING

tennis

Where do you even begin with Billie Jean King? She's a pioneer, a symbol, an equal opportunist, an activist, a role model, and more. As Sally Jenkins wrote for *Sports Illustrated* in 1994, "Tennis is Billie Jean King's passion, but activism is her true game."

She won 39 Grand Slam titles in singles, doubles, and mixed doubles and is one of the greatest tennis players of all time. But her on-the-court accomplishments aren't what make King such an icon. "She isn't happy unless she is championing a cause, whether it's professionalism on the court or feminism in the world at large," Jenkins wrote.

King's impact is felt in every women's locker room, past, present, and future. She paved the way for all female athletes, from the girls' youth softball team at the YMCA to the U.S. women's national soccer team to the Williams sisters. She fought for women's equality everywhere and, in doing so, "made a whole sport boom because of the singular force of her presence," Frank Deford wrote for *Sports Illustrated* in 1975.

King didn't start playing tennis until the fifth grade. Her first favorite sport was basketball and her second favorite was softball. But, as the story goes, King fell in love with tennis after one lesson and later told her mom she was going to be No. 1 in the world. She eventually held that ranking for five years.

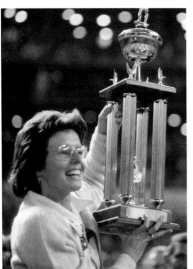

As Jenkins wrote, King became a significant force in changing the culture of the sport from old-time elitism to modern professionalism. As an amateur playing in Long Beach, California, she fought for "equal consideration" with country club players. As a professional in the height of her legendary career, she demanded equal prize money in the men's and women's games. In 1971, King became the first female athlete to earn more than $100,000 in prize money. And after that, she helped create the women's professional tour and became the first president of the Women's Tennis Association.

Then, in 1973, came one of the most famous moments in her fight for equality. In front of a worldwide audience of more than 90 million people, King, then 29, played "self-proclaimed chauvinist" Bobby Riggs in the Battle of the Sexes. Riggs, 55, said that the women's game was inferior to the men's, and King set out to prove him wrong. She did, beating him 6–4, 6–3, 6–3 in a match that was extensively written about. The story was eventually made into a movie as well.

"So every time a little girl beats her brother in a game of pop-a-shot or a sorority girl plays flag football, you might credit King," Jenkins wrote. "There is little in the realm of sports for women that she did not help nurture. Among other things, she was a vocal advocate of establishing college athletic scholarships for women through Title IX legislation; she helped create the Women's Sports Foundation, a fundraising organization for amateur athletes; and she helped found *WomenSports* magazine, which shared her conviction that you did not need a male genetic imprint to read about athletics."

King was later inducted into the International Tennis Hall of Fame in 1987 and became the first woman to have a major sports venue named in her honor. The USTA National Tennis Center in Flushing, New York, where the U.S. Open is played, was renamed the USTA Billie Jean King National Tennis Center in 2006.

Her many other accomplishments and honors include being awarded the Presidential Medal of Freedom by President Barack Obama in 2009 for her advocacy work on behalf of women and the LGBTQ community, and forming the Billie Jean King Leadership Initiative, a nonprofit organization that promotes inclusive and diverse leadership in the workforce. In 1990, *Life* magazine named her one of the "100 Most Important Americans of the 20th Century"—this was not in a category of just sports figures, but all Americans, and she was the only woman on the list.

King, who lives with her partner and former tennis player Ilana Kloss in New York City, will always be known as one of the greatest sports figures of all time. And, as Kloss once described her, King will forever be known as the "people's champion."

LEFT: Billie Jean King celebrating after winning Battle of the Sexes, Houston, Texas, USA, 1973; **RIGHT:** King in action during Wimbledon, London, United Kingdom, 1974

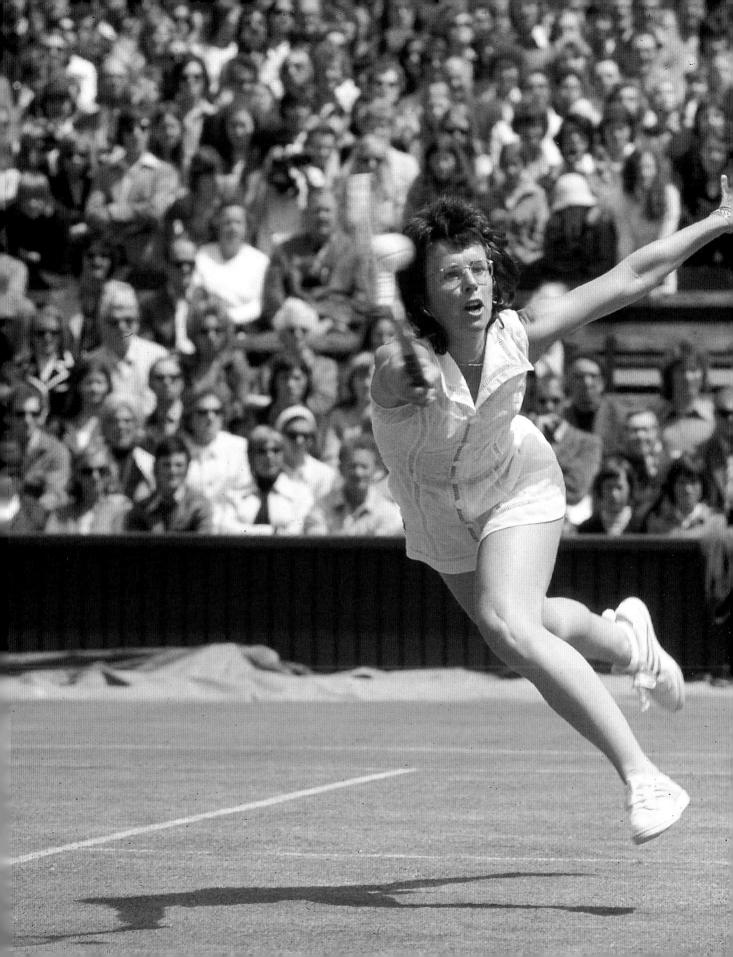

Julie KRONE
horse racing

Julie Krone's father said that as soon as his daughter learned how to ride horses, she wanted to be a jockey. "She made a racehorse out of everything," Don Krone told *Sports Illustrated* in 1987. "If she couldn't find a horse, she'd jump on our backs and make horses out of us."

In 1991, Julie Krone made her Triple Crown racing debut. Then, in 1993, she became the first female jockey to win a Triple Crown race when she drove Colonial Affair to victory at the Belmont Stakes.

"Winning the Belmont Stakes was an amazing thing," Krone told ESPN back then. "I think about where this dream of mine could have come from when there were so many obstacles in my way. When I dreamed of being a jockey, I wasn't even aware of any gender-related stipulations on the sport."

Growing up near Eau Claire, Michigan, her mother, Judi, taught her daughter to love and respect horses. During spring break of her junior year in high school, Krone visited Churchill Downs, where she got her first job—hot walking racehorses for trainer Clarence Picou. After graduation, Krone started racing. Her debut was riding a horse named Tiny Star at Tampa Bay Downs. A month later, she won her first race with Lord Farkle on the same track.

Krone worked her way up to become one of the top five jockeys in the country from 1987 to 1989. But that didn't come without having to deal with sexism, be it from owners, jockeys, or fans.

Krone didn't love to discuss what it was like to be a minority in a male-dominated profession because, as she told *Sports Illustrated* in 1987, the issue was moot. "Riding is part of my bone and blood," she said.

"But you don't have to be around Monmouth long to hear the stories: the male jocks who cheered when the stewards disqualified Krone after a race; fans throwing down bet tickets in disgust, saying, 'I should [have] known not to bet on a [expletive] girl'; the owner who took his horses elsewhere rather than keep them with trainers who wanted to employ Krone," Gina Maranto wrote for *Sports Illustrated*.

One time, during a race at Monmouth in 1986, jockey Miguel Rujano whipped Krone in the face, so she punched him. He retaliated by pushing her into the pool. Then Krone threw a lawn chair at him. They were both fined and suspended for five days.

A few months after her big Triple Crown victory, Krone fractured her ankle in a three-horse accident in Saratoga. Rehabilitation took nine months. Then, after eventually returning to racing, she took another spill and fractured her wrist and hand. Krone again returned to the track, but not for much longer. She

retired in 1999 and became a commentator for the TVG racing network and the Hollywood Park simulcast network. Krone briefly returned to the sport in 2002, but retired again for good in 2004.

Krone tallied more than 3,700 career wins and more than $81 million in career earnings. In addition to becoming the only woman to win a Triple Crown race, Krone became just the third jockey to ride five winners in one day at Saratoga. She also set records in 2003 as the first woman to win a Breeders' Cup event, as well as the first woman to win a million-dollar event at the Pacific Classic.

She will undoubtedly go down as a pioneer in horse racing and one of the greatest jockeys of all time.

LEFT: Julie Krone posing for a portrait, Jamaica, New York, USA, 1989;
RIGHT: Krone in action during race, Jamaica, New York, USA, 1989

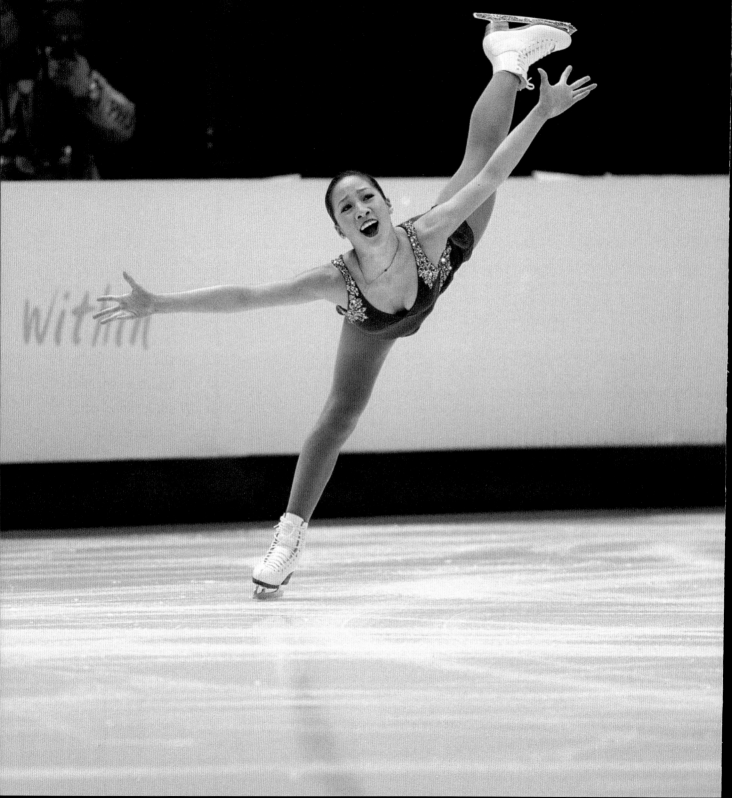

Michelle KWAN
figure skating

Turns out, Michelle Kwan was collateral damage following the Nancy Kerrigan-Tonya Harding tempest. At the 1994 U.S. figure skating nationals, Kwan finished second to Harding after Kerrigan was forced to withdraw. Fearful of a lawsuit, U.S. Figure Skating still put Harding on the Olympic team. Had Harding been disqualified, though, Kwan would have achieved a goal she'd set for herself when she was seven years old.

Kwan started skating near her family's home in Torrance, California, when she was five years old. Her older sister, Karen, also took up the sport, and because the girls showed talent, their parents drove them two hours every weekend to take lessons at the famous training center at Lake Arrowhead. When Kwan watched figure skater Brian Boitano win the gold medal at the 1988 Olympics, she told herself that she would compete in the 1994 Lillehammer Games. It seemed like a reasonable goal–to make her Olympics debut when she would be 13 years old.

In 1993, when Kwan was 12, she became the youngest senior competitor at nationals in 20 years. She finished sixth. At the 1994 nationals, after Harding was included on the Olympic roster, Kwan was named as an alternate.

Kwan persisted. Heading into the 1997 nationals, she told *Sports Illustrated* that she was "on a roll." She'd won nine consecutive competitions in 11 months and 14 of 15 since 1995. She was drawing comparisons to her skating idols Dorothy Hamill and Peggy Fleming. But Kwan fell on a jump early in her long program and stumbled again later. Meanwhile, Tara Lipinski was skating flawlessly.

Kwan figured she would bounce back at the world championships later that year, but Lipinski beat her again.

"Michelle lost her confidence after nationals," her sister told *Sports Illustrated* then. "That was her first bad skate in two or three years, and it didn't help that other people began comparing her to Tara. Michelle had never been compared to anyone before. She'd always been the one who was coming up."

Instead of trying to improve, Kwan wanted to maintain a status quo so she could stay on top of the skating world and win gold at the 1998 Nagano Games. "She loved the sport until she was about 15," her father, Danny, told *Sports Illustrated*. "But then it became the podium and winning that she loved. She lost the purity of a kid."

According to the magazine, Kwan asked herself, "Why am I here if I don't love it? Why am I torturing myself? It's supposed to be fun, and I thought I'd die if I didn't win."

Kwan eventually got back on another roll and was the favorite heading into the 1998 Olympics. But she skated poorly in the free skate and won silver while Lipinski won gold. Then the same thing happened four years later at the 2002 Salt Lake City Games. Kwan didn't have a clean performance and earned a bronze behind American teammate Sarah Hughes, who won the gold.

Kwan finished her career as a nine-time U.S. champion, five-time world champion, and two-time Olympian, and then parlayed her success into endorsement deals. While she was considered one of figure skating's greats, her second act as a political operative might be even more impressive.

Kwan graduated from Tufts with a master's degree in international relations in 2011 and went on to serve in various diplomatic roles. In 2010, she was appointed by President Barack Obama to the President's Council on Sports, Fitness, and Nutrition. In 2011, she was an adviser to the U.S.-China Women's Leadership Exchange and Dialogue. In 2012, she was a U.S. State Department senior adviser for public diplomacy and public affairs. She also worked on Hillary Clinton's presidential campaign in 2016 and President Joe Biden's campaign in 2020.

As Andrew Lawrence wrote for *Sports Illustrated* in 2010, figure skating prepared Kwan well for a second career in diplomacy. It allowed her to travel around the world and meet people from different cultures. It also taught her how to handle failure gracefully.

"When I used to fall on a triple Lutz, I thought, Life is over," Kwan told *Sports Illustrated*. "I don't worry about that now."

LEFT: Michelle Kwan in action during short program, Winter Olympics, Salt Lake City, Utah, USA, 2002; RIGHT: Kwan posing for a portrait after becoming American Public Diplomacy Envoy, Denver, Colorado, USA, 2007

Larisa LATYNINA

gymnastics

Until Michael Phelps broke the record for all-time Olympic medals at the 2012 London Games, Larisa Latynina held that distinct honor for 48 years. Phelps finished his career with 28, but up until then, Latynina was the only athlete in any sport to have won 18 Olympic medals. She still has the most medals of any female athlete (three more than Norwegian cross-country skier Marit Bjoergen), and is also one of only four

athletes to have won nine gold medals (Finland's Paavo Nurmi and the United States' Mark Spitz and Carl Lewis are the others).

Latynina, a Soviet gymnast, was essentially the queen of the Olympics from 1956 to 1964, competing in Melbourne, Rome, and Tokyo and winning six medals each time. She is one of only three women to have won the same event at a Summer Olympics three times. She also won nine world championship gold medals, five of which came while competing in 1958 at almost three months pregnant.

"Nobody knew—even my coach and my best friends," Latynina told Olympics.com during an interview in 2019. "I was just waiting for the end so I was free to tell everyone."

Latynina was a ballerina before she took up gymnastics at age 11. She made her Olympics debut when she was 21 at the 1956 Melbourne Games, winning gold in the all-around competition, vault, and floor (which was her favorite event). She also led what was then the Soviet Union to gold in the team events. Latynina also picked up a silver and a bronze. At the 1960 Rome Games, she defended her all-around title, won another gold with her floor routine, and again led the Soviets to win the team competition. In 1964, at the Tokyo Games—her final Olympics—Latynina won gold again on the floor and in the team competition.

In addition to her Olympic success, Latynina won nine world championships and seven European titles. When you take stock of all of her accomplishments—from Olympic, world, and European championships—Latynina won 25 gold, 15 silver, and six bronze medals. That's 46 total medals over the course of her career.

She said she owes her career to her mother. "I feel so grateful to my mum that I grew up always wanting to win and be a winner," Latynina told Olympics.com. "My mum was alone because my father was killed in [World War II] at [the Battle of] Stalingrad, but she still brought me up like that."

Television coverage of the Olympics during Latynina's career wasn't what it is today, so she hardly received the attention she deserved. It wasn't until nearly 50 years after her last Olympics—when Phelps broke her medal record in 2012—that everyone wanted to hear from her. She was actually in the crowd in London when Phelps made history by winning gold in the 4x200-meter freestyle relay. "I don't remember ever being so popular as I was when I went to the London 2012 Olympics," she said.

ABOVE: Larisa Latynina in action during floor exercise, Summer Olympics, Melbourne, Australia, 1956; **RIGHT:** Latynina posing during USA-USSR Dual Gymnastics Match, University Park, Pennsylvania, USA, 1961

Katie LEDECKY
swimming

Katie Ledecky was a teenager when she became one of the greatest athletes alive. She's a living legend, an otherworldly swimmer, and incredibly humble. Winning medals upon medals is "something I never would have imagined when I first started swimming," she said after earning her 10th Olympic medal in 2021. Thankfully for all sports fans, Ledecky still has a lot of swimming left to do, and she has no plans to retire any time soon.

Ledecky's first true global introduction was at her Olympics debut in 2012. She was 15 years old, the youngest member of the U.S. team in London, and she stunned the world by winning a gold medal in the 800-meter freestyle. She followed that performance by claiming several world records and titles before winning more gold at the 2016 Rio de Janeiro Olympics.

Ledecky has a résumé that could fill this book—and one of the most delightful things about her is that she takes it all in stride. Highlights include winning 24 international gold medals, including 14 world championship titles (the most ever by a woman) and 10 Olympic medals (seven gold and three silver). She's also a Stanford graduate, though she missed the graduation ceremony in 2021 because she was competing in the Olympic Trials in Nebraska.

"What she's doing in the sport is ridiculous," Michael Phelps, winner of an all-time record 28 Olympic medals, told *Sports Illustrated* after the 2016 Olympics. "She gets in the water and pretty much gives every world record a scare."

Ledecky, who grew up outside of Washington, DC, in Bethesda, Maryland, started swimming when she was six. As chronicled by *Sports Illustrated* writer S. L. Price in 2016, Ledecky was relentless, driven, and laser focused even as a young kid. She made a "Want Times" list on a piece of paper that she kept on her nightstand. This is where she would write down her goal times and actual finish times for swimming events so she always knew how much faster she needed to be for the next meet.

After she swam the second-fastest time in history to win the 800 meters in London, she spent the next four years trying to do even better and eventually clocked nine of the top 10 times in the event's history. At one point, her times in the 400 meters and 1,500 meters were so fast that they were good enough to qualify for the men's Olympic team.

"She swims like a guy," 11-time Olympic medalist Ryan Lochte told *Sports Illustrated* before the Rio de Janeiro Olympics. In early 2016, he spent a few days practicing with Ledecky at the Olympic Training Center in Colorado. "Her stroke, her mentality: She's so strong in the water. I've never seen a female swimmer like that. She gets faster every time she gets in, and her times are becoming good for a guy. She's beating me now, and I'm, like, What is going on?"

In Rio de Janeiro, 19-year-old Ledecky became just the second woman ever to sweep the 200-, 400-, and 800-meter freestyle events at an Olympics (the first was American Debbie Meyer in 1968), breaking world records in the latter two races.

The 2020 Tokyo Olympics (which were postponed to 2021 due to COVID-19) were the toughest for Ledecky. In addition to winning the first-ever women's 1,500 meters, she put in 6,200 meters of competition and won two gold and two silver medals. She has now won six individual Olympic gold medals, a record in women's swimming. Ledecky also became the first woman to win three consecutive freestyle Olympic gold medals, crushing her competition in the 800-meter free in 2012, 2016, and 2021.

"She's a mystery," U.S. Olympic women's team coach David Marsh told *Sports Illustrated*. "I've experienced the passion and depth with which Katie trains and races. I've gone back and tried to figure out what causes it, because she doesn't fit the model. She has a wonderful family, has everything, really, that she wants; she's a beautiful person with seemingly no dark sides. But she has this energy stirring in her, not just at meets, but at practice. What is she pursuing? Her personal best, but she's doing it with fury. Where's the fury coming from? We don't know, but the stove is running hot."

LEFT: Katie Ledecky posing for a portrait, Bethesda, Maryland, USA, 2016; **RIGHT:** Ledecky in action during 1,500-meter freestyle, Summer Olympics, Tokyo, Japan, 2021

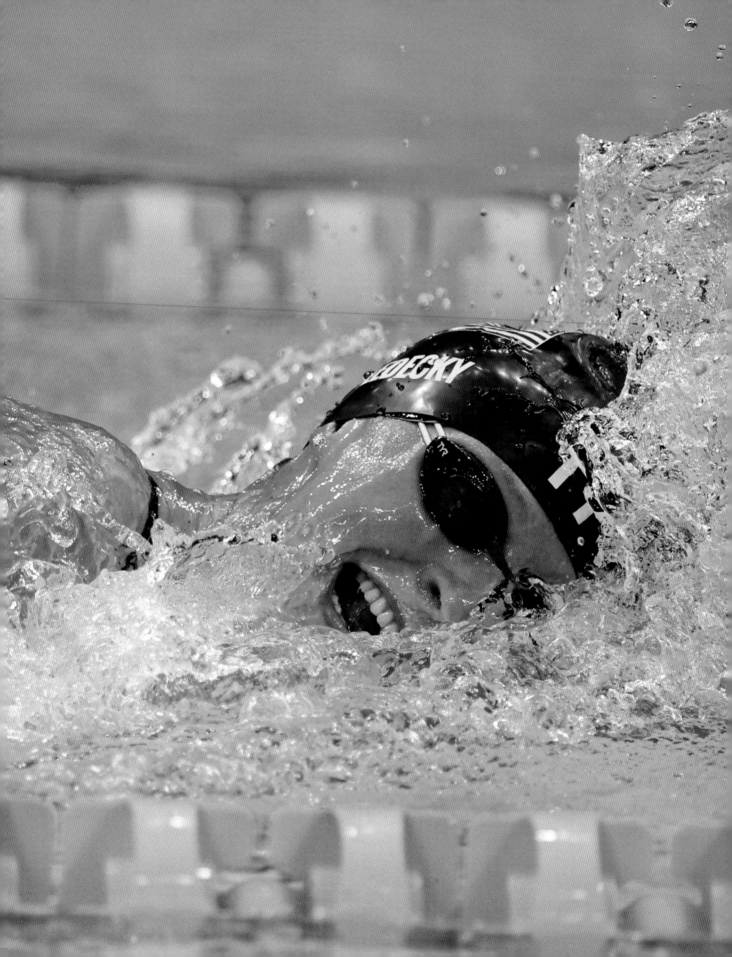

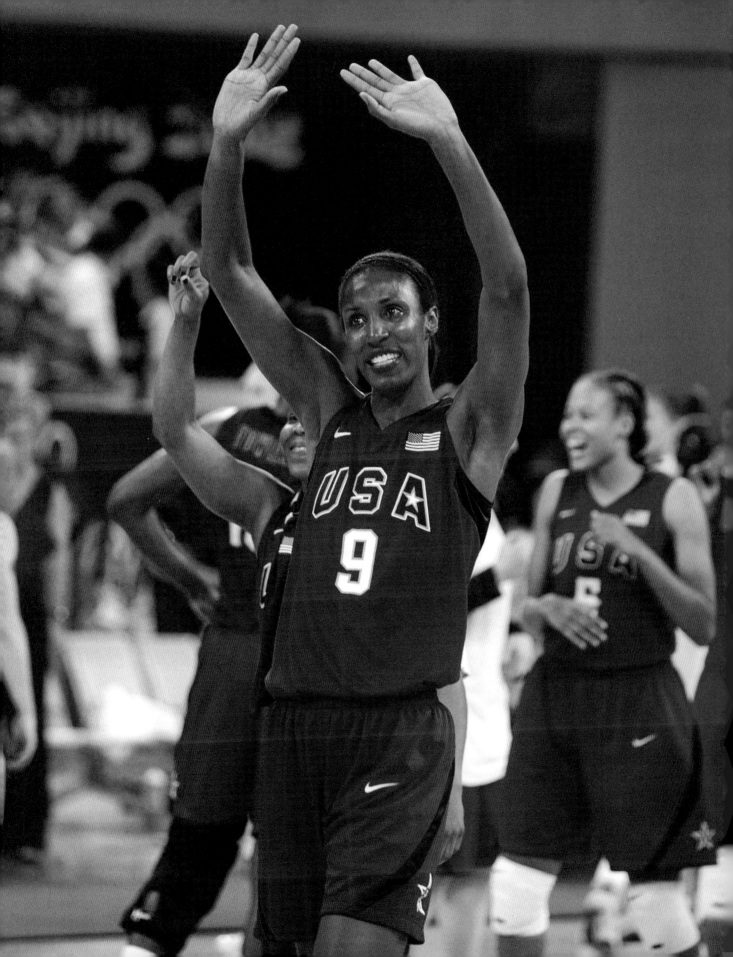

Lisa LESLIE
basketball

L isa Leslie was so dominant during her senior year of high school that she once scored 101 points in a game—before halftime. The opposing team was humiliated. They didn't come out of the locker room for the second half. It wasn't Leslie's intention to embarrass anyone; she was just chasing Cheryl Miller's record for scoring 105 points in a high school basketball game. Because the opponent decided to forfeit, though, Leslie finished four points shy.

While she never did reach that milestone, Leslie still had a pretty good career. The six-foot-five center became a superstar and role model in the early days of Title IX (she was born six days before it was passed into law). She was a three-time All-American at the University of Southern California (USC), two-time WNBA champion and three-time league MVP with the Los Angeles Sparks, an eight-time All-Star, two-time Defensive Player of the Year, four-time Olympic gold medalist, and a Naismith Hall of Famer. She may never have scored 105 points in a high school game, but she did become the first woman to dunk in a game in 2002. So things worked out.

Leslie didn't start playing basketball until she was in seventh grade. By the time she was in high school, she was considered the best player in the country while also maintaining a 3.5 grade point average and being elected class president. The summer before her senior year, Leslie played on the U.S. Olympic junior national team and then became a highly recruited prospect.

She ended up at USC, just like Miller. Leslie was often compared to her predecessor. Initially it had mostly negative connotations, with people wondering if she would be as good or as dominant or as prolific as Miller. The two players had different personalities and styles, but Leslie took it all in stride. The story line eventually died, though, and Leslie transcended the game, proving any doubters wrong.

Growing up, Leslie didn't have many female basketball role models to look up to—the WNBA wasn't founded until 1996—so she tried to model her game after NBA players like Tim Duncan instead.

"I think we do need that one star that even people who aren't familiar with the game can recognize," Leslie told *Sports Illustrated*'s Phil Taylor in 1991. "It not only gets the attention of the public, it gets the attention of the kids who will grow up to be the next superstars. The next Cheryl Miller, whoever she is, can have an impact on women's basketball for years after her career is over."

Leslie herself eventually became that megastar role model for the younger generations. She became a recognizable face and commanded people's attention not only from her career on the court, but also from appearances on Nickelodeon and a brief modeling career. She took advantage of her opportunities and brought the WNBA and aspiring female athletes along with her.

"Going to college on a full scholarship, playing in the Olympics might never have happened for me without [Title IX]," Leslie told Taylor in 2012. "I was lucky to have it in place during my era. I don't consider myself an activist, but it's important I try to help other young women the way that the people who pushed for Title IX helped me."

Since retiring, Leslie has been featured in a variety of television shows and worked as a sports commentator and analyst. In 2011, she became co-owner of the Los Angeles Sparks. Leslie is also a head coach in the BIG3—a three-on-three basketball league that has 12 teams with rosters of former NBA players and international players—joining Nancy Lieberman as the only two women to coach a professional men's team.

LEFT: Lisa Leslie celebrating after gold-medal game, Summer Olympics, Beijing, China, 2008; **RIGHT:** Leslie in action during Los Angeles Sparks game, Seattle, Washington, USA, 2005; **OVERLEAF:** Leslie celebrating with teammates after winning gold medal, Summer Olympics, Athens, Greece, 2004

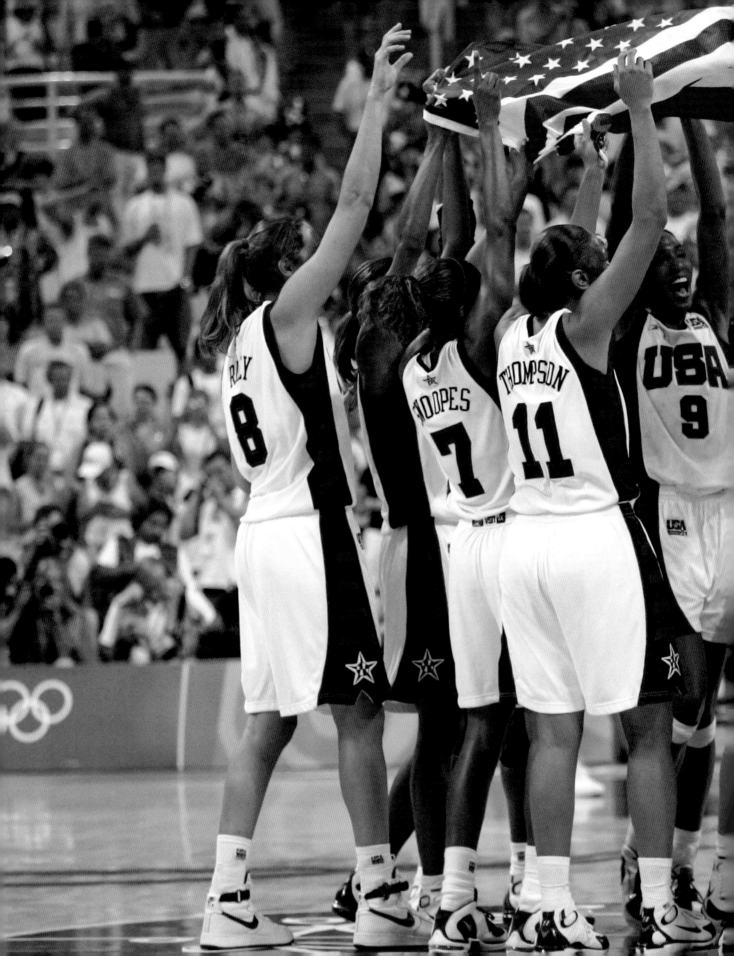

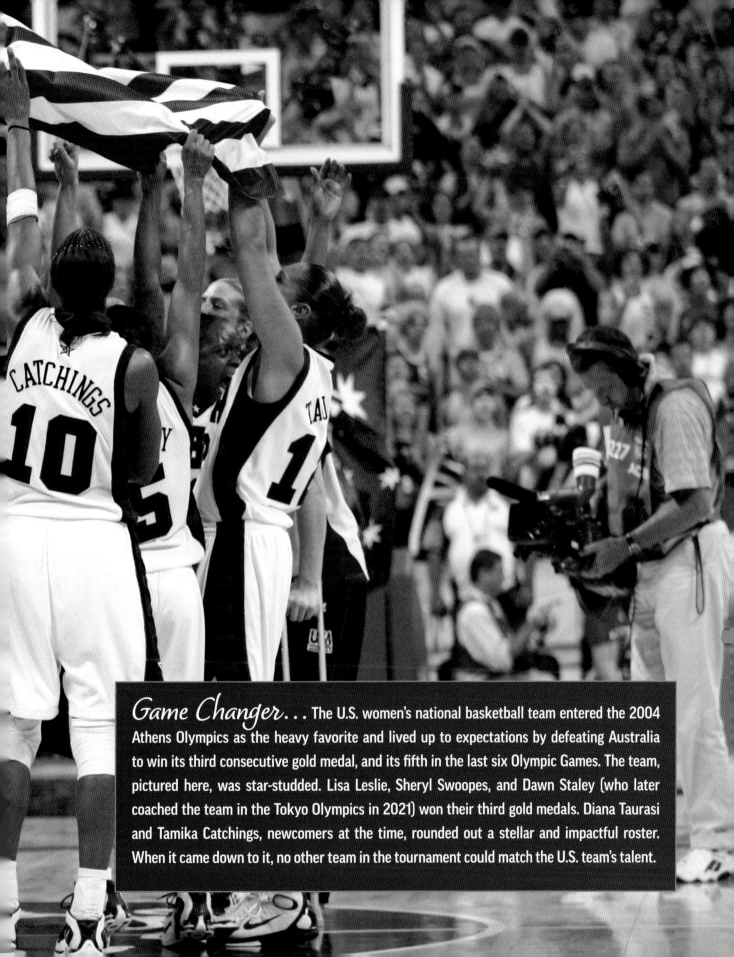

Game Changer... The U.S. women's national basketball team entered the 2004 Athens Olympics as the heavy favorite and lived up to expectations by defeating Australia to win its third consecutive gold medal, and its fifth in the last six Olympic Games. The team, pictured here, was star-studded. Lisa Leslie, Sheryl Swoopes, and Dawn Staley (who later coached the team in the Tokyo Olympics in 2021) won their third gold medals. Diana Taurasi and Tamika Catchings, newcomers at the time, rounded out a stellar and impactful roster. When it came down to it, no other team in the tournament could match the U.S. team's talent.

Nancy LIEBERMAN

basketball

Nancy Lieberman's mom tried very hard to get her daughter not to play sports. "She was so pretty, gosh," Renee Lieberman told *Sports Illustrated* in 1979. "People would call to me, 'Hey, get her out of the tree.' I'd get her dolls, she'd want balls. My kid and sports, you wouldn't believe. I yelled. I screamed, 'I'll murder you. Stop it already. Sports aren't for girls. Why don't you be a secretary? A nurse? Put on a dress?' Nothing worked. She thought it was a challenge having everybody against her. She'd fight the world if she had to."

Curry Kirkpatrick wrote for *Sports Illustrated* then that Renee even punctured Nancy's basketball with a screwdriver. Her daughter's response was to go out and get more balls. "Someday, I'm going to make history," she told her mom.

It's a good thing Nancy Lieberman was so strong-willed at an early age, because she did make history when she broke the gender barrier and became the first woman to play in a men's professional league in 1986, signing with the Springfield Fame in the United States Basketball League (USBL).

"I want to stick around long enough to stay embedded in people's minds," Lieberman told *Sports Illustrated* then. "You can't force-feed them to remember your accomplishments."

Lieberman grew up playing basketball with the boys on the courts of Harlem, New York. That's where she learned how to play physical and aggressive, rare qualities to see in female players at that time. She dreamed of playing the Knicks backcourt like her idol Walt Frazier. She was often praised for "playing like a man," and in college at Old Dominion (ODU), she earned the nickname "Lady Magic" as a nod to Magic Johnson.

"Except for a lack of dynamic jumping ability, there is not much to distinguish Lieberman from the point guard on most of the better varsity male teams," Kirkpatrick wrote. "In technical terms, she 'sees the floor' better than most men, throwing the blind passes she favors—one-handers, bouncers, whirl-aways and other tricky deliveries—with little fear of interception."

As a five-foot-ten point guard, Lieberman was also taller than many other guards she played against, making it easier for her to drive to the hoop, dish out assists, and grab rebounds.

She led ODU to consecutive Association for Intercollegiate Athletics for Women (AIAW) national championships in 1979 and 1980 and was named the nation's top female athlete both of those seasons.

She played professionally for eight years in the Women's Professional Basketball League (WBL) and the WNBA—she was the No. 1 overall draft pick by the Dallas Diamonds of the WBL in 1980 and played for the Phoenix Mercury in the WNBA's inaugural season in 1997. She was the league's oldest player, coming in at age 39.

She later coached in the WNBA, the D-League, and the NBA as an assistant for the Sacramento Kings. She also won a silver medal with the U.S. national team at the 1976 Olympic Games in Montréal, and a gold medal at the 1979 world championships.

In 1980, Lieberman played in the New York Pro Summer League with a bunch of men. She would have spent the summer playing in the 1980 Olympics, but the United States boycotted the event in Moscow. Lieberman needed to sharpen her skills and stay in shape, so she joined the summer league and held her own.

"She's not a woman out there, she's a player," former NBA player Nate Archibald told *Sports Illustrated* at the time.

One of the reasons Lieberman fell in love with sports in the first place, especially basketball, is because it provided a distraction from her chaotic home life. Her parents didn't get along—they eventually divorced—and her father was mostly absent.

"Maybe it was for attention, my father's attention," Lieberman told *Sports Illustrated*. "I don't know. I was terribly bitter for a long time, but after a while I never worried about things like that. The family always said I was so cold anyway. After that, what did they expect? The divorce stopped bothering me. I just went and played ball."

These days, Lieberman, who was elected to the Naismith Memorial Basketball Hall of Fame in 1996, is still involved with the sport. She's a broadcaster for the Oklahoma City Thunder, and in 2018 she joined the BIG3—a three-on-three basketball league that has 12 teams with rosters of former NBA players and international players—and became the first female head coach of a men's professional team.

LEFT: Nancy Lieberman in action during Old Dominion game, Norfolk, Virginia, USA, 1979

Carli LLOYD

soccer

t's hard to imagine that in 2003 Carli Lloyd nearly quit soccer for good. She even planned to get a "real" job and have a "normal" life. She had just been cut from the U.S. under-21 team and was discouraged and out of shape. There was a piece of her, though, that didn't want to give up.

Fast-forward to today: as part of the U.S. women's national soccer team (USWNT), Lloyd is a two-time World Cup champion and four-time Olympian with two gold medals. In fact, she scored both game-winning goals in the 2008 and 2012 gold-medal matches and also made history at the Tokyo Olympics in 2021. Lloyd, then 39 years old, scored twice to become the USWNT's top goal scorer in Olympic history (with 10 total goals). It was the perfect way to mark her 312th international appearance, which made her the second-most capped player in USWNT history behind Kristine Lilly.

Lloyd is also a two-time Ballon d'Or winner (honoring the FIFA World Player of the Year), a World Cup Golden Ball recipient, and the first player in Women's World Cup history to score a hat trick in a final, which she did in a 5–2 victory over Japan as she led the United States to a record third World Cup title.

That hat trick is considered one of Lloyd's most remarkable moments, and certainly one of the greatest feats in women's soccer history. It was July 5, 2015, and the United States was trying to win its first World Cup since 1999. In front of a 53,000-seat sold-out crowd and a U.S. television audience of 26.7 million, Lloyd scored a hat trick in the first 16 minutes of the game to put the USWNT up 3–0. One of her goals came off a shot she launched from midfield.

After the 2016 Olympics, when the United States was surprisingly knocked out by Sweden in the quarterfinals, Lloyd was asked to take on more of a reserve role. It didn't help that, in 2017, she sprained her ankle while playing for the Houston Dash and missed time with the USWNT. She mostly came off the bench in the 2019 World Cup and started in just one game. This really rocked Lloyd, who is the ultimate competitor.

"There's no denying it," Lloyd said on Julie Foudy's *Laughter Permitted* podcast in October 2019. "I deserved to be on that field that whole World Cup, but I wasn't. And I think I've grown as a person, as a player. It sucked. It absolutely sucked."

Later that year, Lloyd made headlines when a video of her kicking a 55-yard field goal on a visit to a Philadelphia Eagles

practice went viral. Afterward, Lloyd said she received some interest from NFL teams about being a professional kicker.

"I think anything is possible," Lloyd told Sports Illustrated TV's *Planet Futbol* at the time. "It's been really interesting because for me, I'm just an athlete, I'm a competitor. But for so many other people, I think they're starting to think, 'Will there ever be a female in the NFL at some point?' And I think we're kind of at that crossroads as far as equality."

Lloyd came back with a vengeance when she made the roster for the Tokyo Olympics in 2021. While she didn't start

in every game, she was an integral part of the lineup, and the USWNT took home a bronze medal. Afterward, she announced her retirement, ending a historic career with 128 international goals. Perhaps now she'll become the first woman to make an NFL roster. Or perhaps she'll take time to soak up all she has accomplished and rest after her stellar career.

LEFT: Carli Lloyd in action during gold-medal match, Summer Olympics, London, United Kingdom, 2012; **ABOVE:** Lloyd posing for a portrait, Jersey City, New Jersey, USA, 2011; **OVERLEAF:** Lloyd celebrating with teammates after winning gold medal, Summer Olympics, London, United Kingdom, 2012

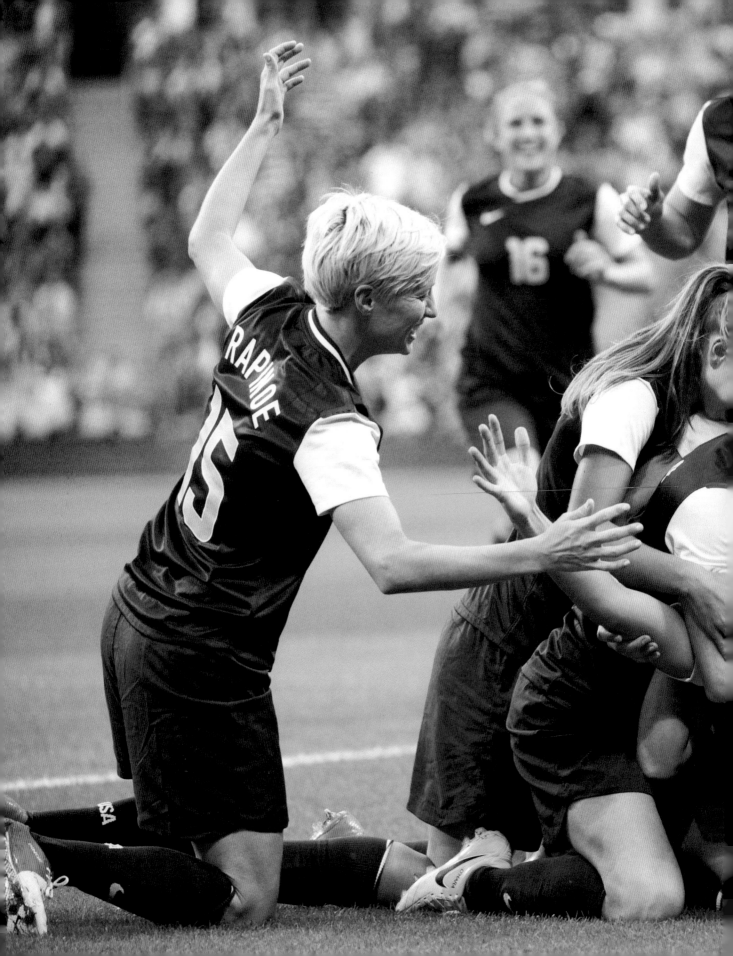

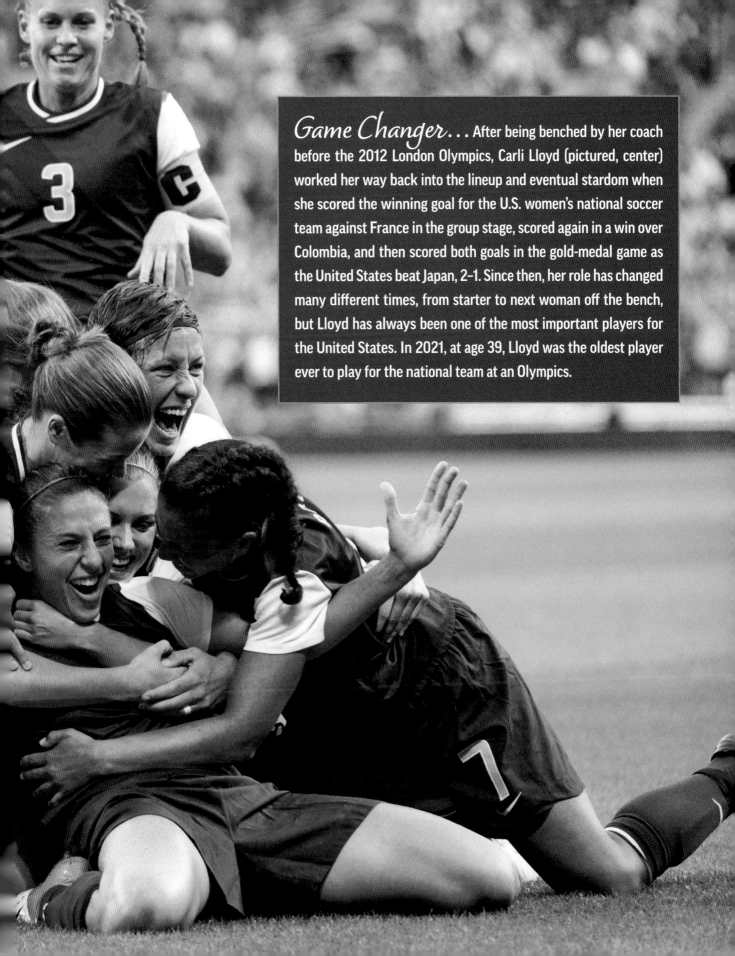

Game Changer... After being benched by her coach before the 2012 London Olympics, Carli Lloyd (pictured, center) worked her way back into the lineup and eventual stardom when she scored the winning goal for the U.S. women's national soccer team against France in the group stage, scored again in a win over Colombia, and then scored both goals in the gold-medal game as the United States beat Japan, 2–1. Since then, her role has changed many different times, from starter to next woman off the bench, but Lloyd has always been one of the most important players for the United States. In 2021, at age 39, Lloyd was the oldest player ever to play for the national team at an Olympics.

Rebecca LOBO
basketball

When Rebecca Lobo was in fifth grade, her teacher sent a note home to her mother, RuthAnn, saying that her daughter "needed to stop playing with the boys at recess and to start dressing like a girl," Steve Rushin, Lobo's husband, wrote for *Sports Illustrated* in 2017. "RuthAnn didn't change her daughter's clothes. She changed her daughter's teacher."

Lobo was born in 1973, the first full year of Title IX. And thankfully she came from a supportive family that stoked her love of sports and passion to play basketball. Her parents were loving and her two siblings were also athletes. The three of them played every sport together in the street, in the backyard, and in the house, as Rick Telander wrote for *Sports Illustrated* in 1995.

According to Telander, one time in fourth grade Lobo found out her grandmother was going to a Boston Celtics game, so she wrote a note for her to give to the team's president, Red

Auerbach. It said, "I'm a really big fan. I want you to know I'm going to be the first girl to play for the Celtics."

Lobo never played for the Celtics, but she did lead the University of Connecticut (UConn) to its first national championship in 1995 as a senior captain. The Huskies went 35-0 that season, which set Geno Auriemma's program up to become the powerhouse it is today. That same year, Lobo was named AP Female Athlete of the Year and NCAA Women's Basketball Player of the Year, and she won an ESPY for Outstanding Female Athlete. She was also a guest on *Late Show with David Letterman*.

The next year, in 1996, Lobo won a gold medal with the U.S. women's national basketball team at the Olympic Games in Atlanta. She followed that up by playing for the New York Liberty in the first season of the WNBA in 1997. She played with the Liberty until 2002, then with the Houston Comets and Connecticut Sun. She retired in 2003.

The Lobo era set UConn on a path toward dynasty status. Her team's overall success—going undefeated and winning that first title—allowed Auriemma to better recruit the top players in the country while Lobo and her teammates brought more attention to the women's game.

"Most women's games at the 8,241-seat Gampel Pavilion are screaming, banner-waving sellouts," Telander wrote in 1995. "While other Big East women's teams often play home games in front of Mom, Dad and a janitor or two, UConn sold 6,541 season tickets this season, generating nearly $700,000 in revenue."

At the time, Lobo was every little girl's idol, with her midrange game and the trademark French braid she often donned on the court. "That's in part so the hair won't get in her eyes while she's playing, and in part to prove, as she says, that 'femininity and sport can go together,'" Telander wrote.

Lobo was inducted into the Women's Basketball Hall of Fame in 2010 and the Naismith Memorial Basketball Hall of Fame in 2017. She remains an ambassador for the women's game as an ESPN analyst and reporter covering the WNBA and women's college basketball.

LEFT: Rebecca Lobo receiving award during WNBA Finals, Houston, Texas, USA, 1997; **RIGHT:** Lobo in action during WNBA Finals, Houston, Texas, USA, 1997; **OVERLEAF:** Lobo and teammates posing after winning gold medal, Summer Olympics, Atlanta, Georgia, USA, 1996

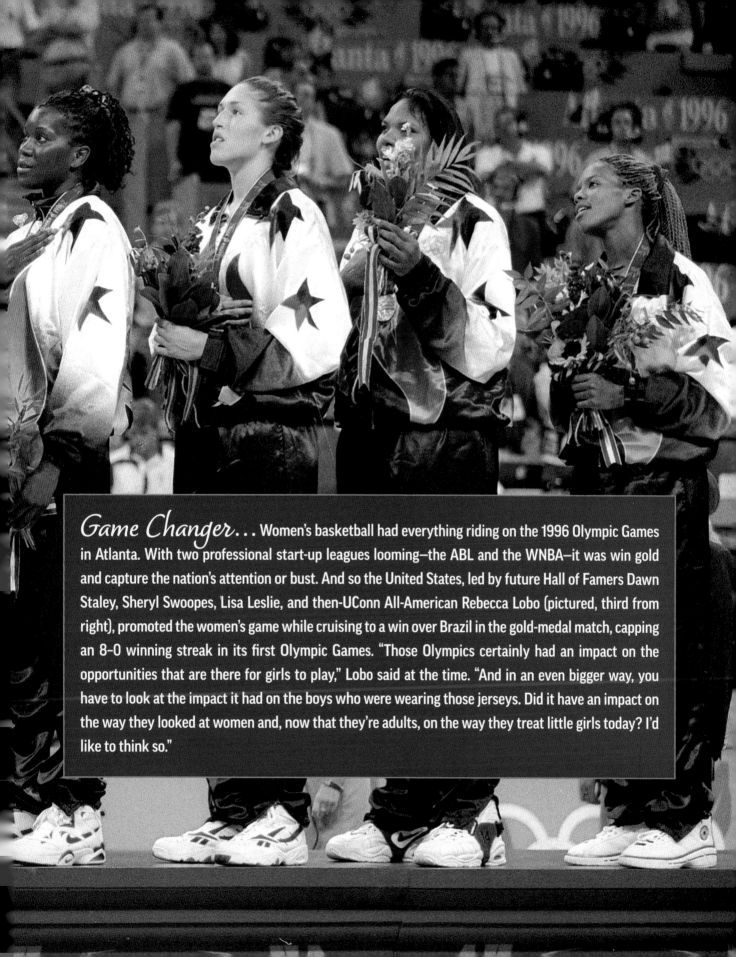

Game Changer... Women's basketball had everything riding on the 1996 Olympic Games in Atlanta. With two professional start-up leagues looming—the ABL and the WNBA—it was win gold and capture the nation's attention or bust. And so the United States, led by future Hall of Famers Dawn Staley, Sheryl Swoopes, Lisa Leslie, and then-UConn All-American Rebecca Lobo (pictured, third from right), promoted the women's game while cruising to a win over Brazil in the gold-medal match, capping an 8–0 winning streak in its first Olympic Games. "Those Olympics certainly had an impact on the opportunities that are there for girls to play," Lobo said at the time. "And in an even bigger way, you have to look at the impact it had on the boys who were wearing those jerseys. Did it have an impact on the way they looked at women and, now that they're adults, on the way they treat little girls today? I'd like to think so."

Jessica LONG

swimming

From Siberia to training with Michael Phelps to becoming one of the most decorated Paralympians in U.S. history, Jessica Long's life seems straight out of a movie.

Long grew up in Maryland but was born in Siberia with a rare condition called fibular hemimelia, which meant she didn't have fibulas, ankles, or heels and was missing bones in her legs. Her birth mother was 16 years old and feared she wouldn't be able to take care of her daughter, so she put her in an orphanage.

When she was 13 months old, Long was adopted by Americans Beth and Steve Long. When she was 18 months old, her legs were amputated below the knees in hopes of improving her mobility with prosthetics. In total, she needed 25 surgeries.

The Longs encouraged their daughter to play sports, and she did, refusing to give up. As a kid, Long liked to rock climb, ice skate, do gymnastics, and play on the trampoline. But most of all, she liked to swim, especially when she spent hours pretending to be a mermaid in her grandmother's pool.

The pool became Long's sanctuary, where she let out all of her emotions and felt like she could accomplish anything. "I literally only got into swimming because I was a very angry child," Long told the *SwimSwam* podcast in 2021. "Swimming was the place to get out my anger and frustration, but it was also a place I felt really free and capable. My childhood was really hard. It was really painful. There are spots of my childhood I don't remember just because I was going in and out of surgery so much."

Long turned those feelings into successes in the water. By the time she was 12, she made the U.S. Paralympic team for the 2004 Athens Games and won three gold medals as the youngest member of Team USA. At that point, she had only been swimming competitively for two years.

Fast-forward, and Long is now a five-time Paralympian and 29-time Paralympic medalist (including 16 gold)—which means she has one more medal than Michael Phelps. And this was all before she turned 30! Long is the second-most decorated

Paralympian in U.S. history behind Trischa Zorn, who has a grand total of 55 medals. Long has trained with Phelps and his coach Bob Bowman, and was featured in a Super Bowl LV commercial for Toyota that put a spotlight on her inspirational story. The ad ran ahead of the 2020 Tokyo Olympics—which were postponed to 2021 due to COVID-19—where Long captured six more medals, including three gold.

While Long said in Tokyo that she plans to compete in at least a few more Paralympic Games, she has contemplated retirement. After the 2016 Rio de Janeiro Games, Long was mentally exhausted and burned out. Despite dealing with two shoulder injuries, Long felt that she had underachieved by winning one gold, three silver, and two bronze medals.

"It's really easy to say that a gold medal doesn't define you, but when you are used to a certain level of performance and then you don't have it, it's really easy to feel that lack of worth," she told Paralympic.org at the time.

Instead of calling it a career, Long scaled back her training regimen, went to therapy, and started coaching a local girls' swim team. She got back in touch with herself and started embracing her own adversity again while also using her platform to bring awareness to all of the things you can do with a disability instead of the things that you can't.

"It took me years to realize that if I act ashamed and I try to hide then people kind of react the same way," Long told Olympics.com. "But if I wear my shorts or a cute summer dress and I show off my legs and I'm willing to talk about it, people are engaged and they want to know about my story. The only disability in life is a negative attitude."

Long took a break from training in 2019 to get married, and then prepared to compete in Tokyo. Her return to the pool was important not just for her own mental health, but also for the growth of the Paralympic movement.

"That was so fun," Long told NBC after winning gold in the 100-meter butterfly. "I got to race the younger Russian girl (16-year-old Victoria Ischiulova), who came up to me and told me I'm her hero. This is really what it's all about, bringing up the younger generation. That was a great race for her and for me, and that is exactly how I wanted to end it here in Tokyo."

LEFT: Jessica Long preparing for a race, Colorado Springs, Colorado, USA, 2020

Nancy Lopez's father, Domingo, would not let her do the dishes growing up. While this is basically every kid's dream, Domingo permitted his daughter to skip out on some chores because "these hands are meant for golf," he told *Sports Illustrated* writer Frank Deford in 1978, the year she graced the magazine's cover. "Our Nancy's gonna be a public figure."

His prediction was correct. Nancy Lopez was to golf what Billie Jean King was to tennis, popularizing the game as a successful and recognizable personality. By the time she retired, Lopez had 48 wins, including three major championships, and $5.3 million in career earnings. According to historian Rhonda Glenn, three years before Lopez's rookie season, LPGA players threatened to boycott the U.S. Women's Open over pay disparity. Per Glenn, the Women's Open purse was $55,000 in 1975, while the men were getting $236,200. Women were paid more after Lopez burst onto the scene—LPGA purses went from $2.6 million to $8.2 million during her career—and it started making people care about women's golf. After Lopez retired, however, the LPGA struggled to find a new face to rally behind.

Perhaps Lopez's most memorable season was her rookie year in 1978, when she won nine tournaments, including five in a row. She was the first woman to be named both LPGA rookie of the year and player of the year. She also earned the Vare Trophy, which is given to the golfer with the lowest average number of strokes per round. And she was only 21.

Lopez quickly became a golfing idol. She was approachable and had a telegenic smile. She had a great rapport with fans, too, and "loved signing autographs, taking pictures and shaking hands," Rick Lipsey wrote for *Sports Illustrated* in 2008.

Lopez also had a made-for-TV backstory. She grew up as a Mexican American in Roswell, New Mexico, without much money. Her father had a third-grade education and worked at an auto body shop, but was dedicated to teaching her how to play golf. She first took up the sport when she was eight years old, and eventually became one of the greatest junior players in the country. By the time she was 18, she said she hoped she could make enough money playing golf to support her father. She went

on to do just that—one time during her rookie year she won a red Mazda RX-7 and gave it to her dad. "He was the cutest thing driving around town," Lopez told *Sports Illustrated* in 2008.

She captivated fans with her passion, charisma, and domination along the way. "Besides having a Jimmy Carter smile and the clean look of innocence, Lopez also drives the ball high, far and straight; carves her iron shots with the decisive sound a butcher makes on his chopping block; and has a delicate touch on the greens, as if all her putts are rolling on velvet," Barry McDermott wrote for *Sports Illustrated* in 1978. "After playing a round with her last week, veteran Judy Rankin, the tour's leading money-winner the last two seasons, shook her head in admiration and fatigue and said, 'They've got the wrong person playing Wonder Woman on TV.'"

Lopez technically retired in 2003, but she entered tournaments here and there, including the LPGA Championship in 2004 and 2007. She has three kids, her own country club, and her own line of women's golf clothing, and hosts various charity golf tournaments.

LEFT: Nancy Lopez in action during JCPenney Classic, Largo, Florida, USA, 1978; **RIGHT:** Lopez in action during U.S. Women's Open, Chaska, Minnesota, USA, 1977

Tegla LOROUPE
track and field

egla Loroupe was six years old when she started running six miles each way to and from school. This was at an elevation above 9,000 feet in Kapsait village in the West Pokot District of Kenya. "You cry at first," Loroupe told *Sports Illustrated* in 1998. "There are lots of hills. After a time, you get used to it."

By age nine, Loroupe was winning her first races and beating the boys and girls in the 1,500, 5,000, and 10,000 meters. The girls her age were confused. Girls and women in Kenya were told they were worthless and weren't meant to have careers, much less become professional world record–holding runners. They were property, meant to be married off, bought, and sold in exchange for cattle.

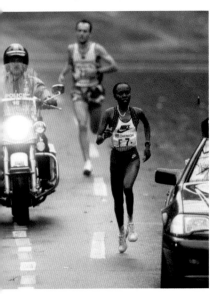

Thanks to her mother, that was not the life Loroupe ever envisioned for herself. Her mother, Mary Lotuma, was the first of her husband's three wives, and she always resented the unfairness of Kenyan society. She instilled in her daughters that they should aspire to be more than wives and mothers.

Loroupe dedicated her life to becoming a role model for Kenyan women. And on her journey to achieving that goal, she became an inspiration for all women. In 1994, Loroupe became the first African woman to win a major marathon, finishing first at the New York City Marathon. She won the next year, too, and also collected titles in Rotterdam, Berlin, London, Rome, and Lausanne over the years. She's a two-time women's world marathon record holder, three-time Olympian, and five-time world champion.

While she pursued her running career without permission from her father—and initially without the support of the Kenya Athletics Federation—she prevailed and became one of the greatest marathon legends of all time. Perhaps her best feat,

though, wasn't running at all, but rather devoting herself to teaching women and girls about self-respect and independence, achieving peace, and ending conflict around the world.

In 2003, she founded the Tegla Loroupe Peace Foundation and created an annual series of peace races, where presidents, prime ministers, ambassadors, and government officials run with warriors and nomadic groups in Kenya, Uganda, and Sudan with the hope of bringing peace to areas infected by tribal war. Loroupe also created the Tegla Loroupe Peace Academy, a school and orphanage for children in northwest Kenya who have been displaced by conflict or HIV/AIDS, and the Tegla Loroupe Training Center, where refugees can train for the Olympics. In 2016, Loroupe worked with the International Olympic Committee (IOC) to organize the refugee team for the Rio de Janeiro Olympics.

She has been recognized globally for her efforts and won countless awards for her life's work, including by the United Nations, who named her an ambassador of sports in 2006, and by the IOC, which honored her with its Women and Sport Award in 2011.

Loroupe has also been generous with her money, sending children from her region to boarding school and paying for their tuition, books, and clothing. One time she paid for a man from her village to get an operation and treatment for his brain cancer. "Always there is somebody you can support," she told *Sports Illustrated*.

Loroupe has led by example her whole life and hopes others will follow in her footsteps. Paulo Amotun Lokoro, who competed for the 2016 Refugee Olympic Team as a 1,500-meter runner, is a perfect example of Loruope's impact. "If I do something better in my life, I want to help the refugees who have suffered like me," Lokoro told *Sports Illustrated* in 2016. "So many refugees have talent but don't have a chance. I want to have a place like [the Tegla Loroupe Training Center] so they can rise up, run and go somewhere, visit other continents like me now. It is all opening up for me. My life, it's like a new one."

And it's all because of Tegla Loroupe.

LEFT: Tegla Loroupe in action during New York City Marathon, New York, New York, USA, 1994; **RIGHT:** Loroupe crossing the finish line, New York City Marathon, New York, New York, USA, 1994

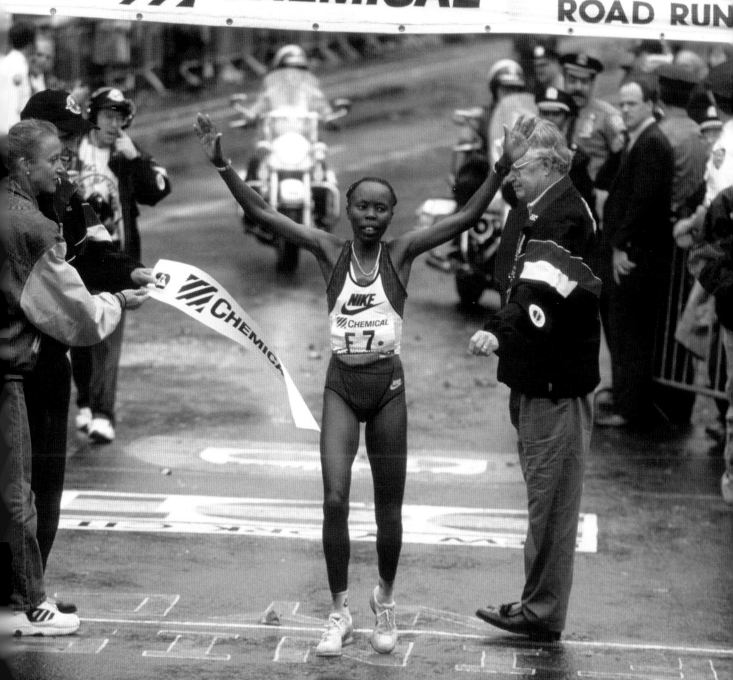

Ellen **MacARTHUR**

Ellen MacArthur became a national hero in England in 2001, when, at the age of 24, she finished second in the Vendée Globe, the world's toughest single-handed sailing race. As Franz Lidz later wrote for *Sports Illustrated*, if not for equipment failure, she might have won.

Four years later, she did one better, breaking the world record for the fastest solo circumnavigation of the globe. It took her 71 days, 14 hours, 18 minutes, and 33 seconds, shaving more than 32 hours off the previous record held by Francis Joyon of France. (He would later come back to reclaim his record in 2008.) Two months later, she became the youngest person to receive a damehood.

"What makes MacArthur extraordinary is not that she's a woman in what has always been a man's sport, but that she has such extraordinary resourcefulness and endurance. During her 27,354-mile voyage last winter, she was battered by mountainous waves and 60-knot winds, dodged icebergs, and nearly collided with a whale off the west coast of Africa," Lidz wrote.

Lidz went on to detail that during one 12-hour stretch off the coast of Chile, MacArthur had to change the sails 14 times. Each adjustment took 30 minutes. Additionally, she had to fix the rigging by "shimmying up the 100-foot mast in a near gale with the boat going full tilt." By the time she reemerged at the finish line, MacArthur had massive bruises on her legs and her body was in tremendous pain.

MacArthur, who grew up in Derbyshire in England, fell in love with sailing when her aunt took her out on the water at Burnham-on-Crouch, one of Great Britain's top spots for yachting.

"I still remember the feeling of freedom when we got out of sight of land," MacArthur told *Sports Illustrated*. "I thought, 'We can go anywhere!'"

She took a sailing course in grade school and eventually saved up enough money to buy a small boat—a fiberglass dinghy—which she kept on a pond near her home. When MacArthur was 17, she bought a Corribee, a 21-foot sailing yacht that she sailed around Britain by herself after she turned 18. It took her 5½ months.

Later on, she became a sailing instructor while also competing on the racing circuit.

But for all of her "relentless ambition," as Lidz perfectly described it, MacArthur wasn't interested in becoming a celebrity or accepting endorsement deals. After she retired, she lent her name to the Ellen MacArthur Cancer Trust, which is a charity that arranges sailing trips for kids with cancer. MacArthur set up the trust after she was invited to go sailing with a group of young cancer patients. She said then that it was the best day she'd ever had and was inspired to do something similar. The trust hopes the sailing trips will help the kids rebuild their confidence after cancer treatment and reengage with society.

"Being a sailor is hard, but I chose the career," MacArthur told *Sports Illustrated*. "Those kids go through things that are much harder than anything I can ever imagine, with smiles on their faces and a great love of life. That's real courage."

After retiring from sailing in 2009, MacArthur also launched the Ellen MacArthur Foundation with the mission of developing and promoting the idea of a circular economy, which aims to extend the life cycle of products for as long as possible.

LEFT: Ellen MacArthur posing off the coast of Lorient, France, 2004; **ABOVE:** MacArthur in action during a solo sailing race between Saint-Malo, France, and Pointe-à-Pitre, Guadeloupe, 2002

arta is the greatest women's soccer player of all time. Now, you might be thinking that's impossible, because no one outside of Mia Hamm or Abby Wambach or Alex Morgan or Megan Rapinoe could possibly be in that conversation. Marta hasn't even won an Olympic gold medal or a World Cup title, so how could she be considered the GOAT?

Just ask Brazilian soccer great Pelé, who calls her "Pelé with skirts." Although his wording may sound insensitive to today's ears, his comment was meant as a compliment to commend her unparalleled skill and brilliant scoring abilities. Marta, whose full name is Marta Vieira da Silva, is Brazil's record goal scorer with 109 international goals. She's the all-time leading scorer in World Cup history with 17. She's also the only player to score in five World Cups. And those records encompass *all* of soccer, not just the women's game.

Think of all the soccer players in the world who haven't achieved those feats, including Lionel Messi, Cristiano Ronaldo, and even Pelé. And we can't forget that she was named FIFA World Player of the Year six times, including five consecutive years from 2006 to 2010. During that time, Marta led Brazil to both a World Cup (2007) and Olympics final (2008). She won the Golden Boot by scoring seven goals during that World Cup.

Despite her success—and that of Brazil's women's team, which has featured other soccer legends Formiga and Cristiane—the Brazilian Federation gives less stature to the women's team than the men's. The women's game still lacks the support and infrastructure needed to become a professional soccer powerhouse.

It has been that way for decades, despite players like Marta trying to fight for equality. When Marta was a kid just getting into the game, there weren't even any girls' teams for her to join in her native Dois Riachos because most girls didn't play soccer—the government didn't allow them to from 1941 to 1979. Marta played with the boys until she was 14, and she traveled nearly 2,000 miles to Rio de Janeiro to play for a club team. When she was 18, she left Brazil to play for Umeå IK in Sweden and led the club to the 2004 Union of European Football Associations (UEFA) title. She led Umeå to the finals in 2007 and 2008 too (she played for the national team in Brazil simultaneously). Marta later played for various teams in the Women's Professional Soccer (WPS) and National Women's Soccer League (NWSL). She currently plays with Alex Morgan on the Orlando Pride.

Even with all of her soccer achievements, what Marta has been most vocal about through her career is gender equality on and off the field. From 2010 to 2018, she served as a Goodwill Ambassador for the United Nations Development Programme, where she promoted women's empowerment.

"We are trying to represent women and show how women can play any type of role," Marta said on FOX after scoring her record-breaking 17th World Cup goal in the 2019 tournament. "All the teams here, we are all representing [women]. Let me be clear, this is not only in sport."

Then, after Brazil lost to France in the knockout round of the 2019 Women's World Cup, Marta took the opportunity to use her platform and speak to the next generation watching. She looked directly into the cameras with tears in her eyes and said, "It's wanting more. It's training more. It's taking care of yourself more. It's being ready to play 90 plus 30 minutes. This is what I ask of the girls."

She explained there's not going to be a Formiga or a Marta or a Cristiane forever, and younger players need to step up and fill their shoes. "The women's game depends on you to survive," Marta said. "So think about that. Value it more. Cry in the beginning so you can smile in the end."

In 2020, the Brazilian Federation hired two new women's soccer coordinators and announced it will pay women and men proportionally the same amount of prize money for playing on the national team. The Brazilian women's team has only played in five games since, so it's too early to tell if they have achieved some semblance of equality.

While the fight for equality is still very much a work in progress, it's hopefully a step in the right direction, and it wouldn't have been possible without Marta.

RIGHT: Marta in action during FIFA World Cup Final, Shanghai, China, 2007

Tatyana McFADDEN
track and field

Tatyana McFadden, a six-time Paralympian and 20-time Paralympic medalist, was born with spina bifida, which left her paralyzed from the waist down. She was abandoned by her birth mother and left at a Russian orphanage, where she spent the first six years of her life. In order to keep up with the other kids, McFadden learned how to walk on her hands. Little did she know the upper-body strength she was building would someday make her one of the greatest athletes of all time.

In 1993, Deborah McFadden, who was the commissioner of disabilities for the U.S. Department of Health and Human Services, saw Tatyana while she happened to be visiting that orphanage. She felt a connection and adopted then-six-year-old Tatyana and brought her home to the United States.

Growing up in Maryland, McFadden played all kinds of sports to build strength—wheelchair basketball, sled hockey, swimming, gymnastics, and track and field. She fell in love with the speed of track and field and started wheelchair racing when she was eight. When she was 15, McFadden qualified for the 2004 Paralympic Games in Athens as the youngest member of the U.S. Paralympic track and field team. She won a silver and a bronze medal.

McFadden returned for the 2008 Beijing Games where, at 19 years old, she won four more medals. In London she collected another four, including three gold, and in Rio de Janeiro she captured six medals, four of them gold. She also won a silver medal for cross-country skiing in the 2014 Winter Paralympics in Sochi.

When the 2020 Tokyo Games were postponed because of the COVID-19 pandemic, McFadden took some time to make a film. The movie, *Rising Phoenix*, is a Netflix original drama that tells the story of the Paralympic Movement through the lives of nine Paralympians, including McFadden. The film chronicles the obstacles and accomplishments these athletes have experienced. And it has been supported by Prince Harry, the founder of the Invictus Games, which is an adaptive sporting event for veterans who were wounded, injured, or ill.

"We're trying to have a new perception of inspiration," McFadden told *Women's Running Magazine* in 2020. "We want to be called inspirational for the work we put in, the medals we get, or how strong we are—not just because we get out of bed every day. We have to break the stereotype."

In addition to her Paralympic success, McFadden has also won 23 marathons, including four consecutive Grand Slams—coming in first place in Boston, Chicago, New York City, and London in the same year (2013). At the 2013 Boston Marathon, McFadden crossed the finish line before the bombs went off, and later dedicated her first-place finish at the London Marathon to the victims who were tragically killed.

Other accolades she has earned include being featured on the *Forbes* "30 Under 30" list in 2017, being named Best Female Athlete of the 2016 Paralympic Games by the U.S. Olympic and Paralympic Committee, and receiving an ESPY Award for the Best Female Athlete with a Disability that same year.

McFadden's goal was to win seven medals in Tokyo. She ended up with three, including when she led Team USA to gold in the debut of the 4x100-meter Paralympic universal relay, helping set a new world record of 45 minutes, 52 seconds. She plans to compete again, at least until the 2028 Paralympics in Los Angeles so she can race at home in the United States.

LEFT: Tatyana McFadden posing for a portrait, Clarksville, Maryland, USA, 2004; **ABOVE:** McFadden posing with trophy after winning wheelchair portion of Boston Marathon, Boston, Massachusetts, USA, 2014

Ann MEYERS DRYSDALE

Everything changed for Ann Meyers Drysdale when she was a senior in high school. It was 1974 and Title IX had just passed, requiring equal opportunity regardless of gender in any educational program or activity.

One day her brother, David, who was playing basketball at the University of California, Los Angeles, surprised his sister by coming home with the Bruins' women's basketball head coach, who promptly offered her a chance to make history. Right then Meyers Drysdale was offered a four-year athletic scholarship, something that had never been done in women's sports. It took a minute to sink in.

"For me, it was like, 'You're kidding. I can go and get an education at UCLA?'" Meyers Drysdale told NBA.com in 2020. "I didn't understand the impact of what getting a scholarship would mean and what going to UCLA would mean."

At UCLA, Meyers Drysdale was a four-time All-American and led the Bruins to a national championship. She also played for Team USA, winning a silver medal at the 1976 Olympic Games in Montréal, a gold medal at the FIBA World Championship in 1979, and another silver at the Pan American Games, where she was the first woman to carry the U.S. flag.

Meyers Drysdale was planning to compete in the 1980 Olympics, too, but at the time athletes were required to retain amateur status in order to be eligible and could not play professionally. She was selected first overall in the inaugural Women's Professional Basketball League (WBL) draft in 1978, but decided to stay in school because she wanted to play in another Olympics. She figured she would join the WBL a few years later.

Then something crazy happened. In 1980, the year of the Olympics, Indiana Pacers owner Sam Nassi called and offered Meyers Drysdale the opportunity to try out. He wanted the best female basketball player in the country to play for his team. Meyers Drysdale told NBA.com that she was "blindsided" and had never expected anything like that to happen. Sure, she pretended to be Jerry West and Bill Russell in pickup games with her siblings, but she never imagined an opportunity of this magnitude. Saying yes, however, meant giving up the chance to participate in a second Olympics. After consulting with her family, she decided trying out for an NBA team was worth it.

LEFT: Ann Meyers Drysdale posing during photo shoot on UCLA campus, Los Angeles, California, USA, 1975

Not surprisingly, her effort to fight for gender equality was met with controversy. Meyers Drysdale did her best to ignore her detractors. Being the only female player didn't bother her because she had been playing against the boys all her life. "I remember parents saying to their boys, 'You're going to let that girl beat you?'" Meyers Drysdale told NBA.com. "It was very difficult. At that age, you really care about what people say and they can say hurtful things."

Meyers Drysdale signed the NBA contract and battled during tryouts. She was in the best shape of her life and thought there was a legitimate chance of making the roster.

"I'll tell you one thing," Pacers coach Slick Leonard told the *Indianapolis Star* in 2015. "She was better. We had a bunch of guys come in trying out and she was better than a whole bunch of them."

Meyers Drysdale would be lying if she said being the only woman was easy. She drew a crowd of media, which made her uncomfortable, and some male players worried they hurt her anytime they collided. In the end, she didn't make the team, but she did open doors for female athletes everywhere, proving that women belong on a basketball court, or a soccer field, or anywhere—even if a majority thinks otherwise.

"Annie was one of the best basketball players ever. I didn't say male or female. I said ever," Boston Celtics legend Bill Russell once said.

Meyers Drysdale went on to play in the WBL, and later traded her playing career for one in sports broadcasting, where she broke down more gender barriers by becoming one of the first female color analysts in the NBA. She started with Pacers games and currently does Phoenix Suns and Mercury games. She also served as an analyst for NBC Sports.

Meyers Drysdale was inducted into the Basketball Hall of Fame in 1993 and the Women's Basketball Hall of Fame in 1999. She also wrote a book, *You Let Some Girl Beat You?*, which chronicles her inspirational life story. Meyers Drysdale was married to Don Drysdale, a Hall of Fame pitcher, until he passed away in 1993.

In addition to her color commentary, Meyers Drysdale is also the vice president of the Phoenix Suns and the general manager of the Phoenix Mercury. The team has won three WNBA titles since she took over in 2006.

Cheryl MILLER

basketball

Nobody remembers that Reggie Miller scored 39 points for the Poly High varsity boys' basketball team in 1982. That's because, on the same night, his sister Cheryl scored 105 points in a 179–15 win over the poor souls at Norte Vista High for the girls' varsity team. Two of her 105 points came on a one-handed breakaway dunk. "As far as anyone knows, Miller is the only woman ever to jam in organized competition," wrote Roger Jackson for *Sports Illustrated* in 1982. (This was well before Lisa Leslie dunked in a WNBA game in 2002.)

While that game was one of her greatest highlights, Miller's famous career was only beginning. She graduated high school as a four-time state champion and four-time All-American and became the most heralded recruit in history at the time. She had set records for the most points in a high school career (3,405), season (1,156), and game (105), and reportedly had more than 250 college offers. Miller chose the University of Southern California (USC) over top programs like Louisiana Tech and Tennessee.

At USC, Miller was a four-time All-American and a three-time Naismith College Player of the Year, and she led the Trojans to back-to-back NCAA championships alongside future Hall of Famers Cynthia Cooper and Pamela McGee (mother of current NBA player JaVale McGee). Miller won nearly every other national award along the way, including being named MVP after both title runs. As a sophomore, Miller won a gold medal playing for Team USA at the 1984 Olympics while averaging more than 16 points per game, a smidge below what she accomplished over four years at USC, where she averaged 23.6 points and 12.0 rebounds per game.

Miller came from an incredibly athletic family. Her father, Saul, was an all-state high school forward. Her siblings were all athletic as well, and not many families can say they had two kids become Hall of Famers. Reggie and Cheryl are the most famous siblings to do so in history.

But to just list Miller's basketball statistics would not do her career justice. She was so much more than what she accomplished on the court. She offered charisma and style and showmanship and a little drama. "She was—and is and ever will be—excitement, intensity, flamboyance, a mode of excellence, a mood even," Curry Kirkpatrick wrote for *Sports Illustrated* in 1985. She was a women's basketball icon.

"She has pointed in enemy faces and at scoreboards, blown kisses to crowds and opponents, executed arched-back cheerleader leaps after baskets, drop-kicked the ball and climbed on the rim after NCAA titles," Kirkpatrick wrote.

She brought attention to the women's game through her personality, which was great timing considering that Miller's arrival to the "big time" coincided with Title IX and the positive attention surrounding the feminist movement. Nancy Lieberman and Ann Meyers Drysdale might have been just as talented in their eras, but they unfortunately didn't get the same opportunities or attention that Miller did. She set the tone for future generations. Or, as Phil Taylor wrote for *Sports Illustrated* in 1991, "women's basketball rode her shirttail to greater recognition and popularity."

"Of course Cheryl has revolutionized the game," Lieberman told *Sports Illustrated* in 1985. "She's taught young girls to play hard all the time and to be physical. She learned to do that the same way I did—we had to play like the guys. The flamboyance is her bread and butter. She sees those cameras and she seizes the moment. Sure, it's all Hollywood, but that's OK . . . I think Cheryl is the best thing that could have happened to the game."

After graduating from USC, Miller was drafted into the United States Basketball League, a men's league, since the WNBA did not yet exist. A knee injury prevented her from playing and ultimately forced her to retire. In 1986, Miller became an assistant coach for USC while also taking up a career in television as an analyst and reporter for the NBA. In 1995, Miller was inducted into the Basketball Hall of Fame, and in 1996, she became the first woman to call a nationally televised NBA game. Miller has had several head coaching jobs, too, including at USC, the Phoenix Mercury (where she was also briefly the general manager), and most recently Cal State Los Angeles.

As the women's game continues to grow, Miller's impact is forever etched in its history. "There have been other women players with flair . . . but none has had Miller's impact," Taylor wrote. "Many of today's college players credit her with making them see their own possibilities in the sport. Little girl players fantasized about Cheryl Miller the way little boy players fantasize about being Michael Jordan."

RIGHT: Cheryl Miller in action during USC game, Los Angeles, California, USA, 1983

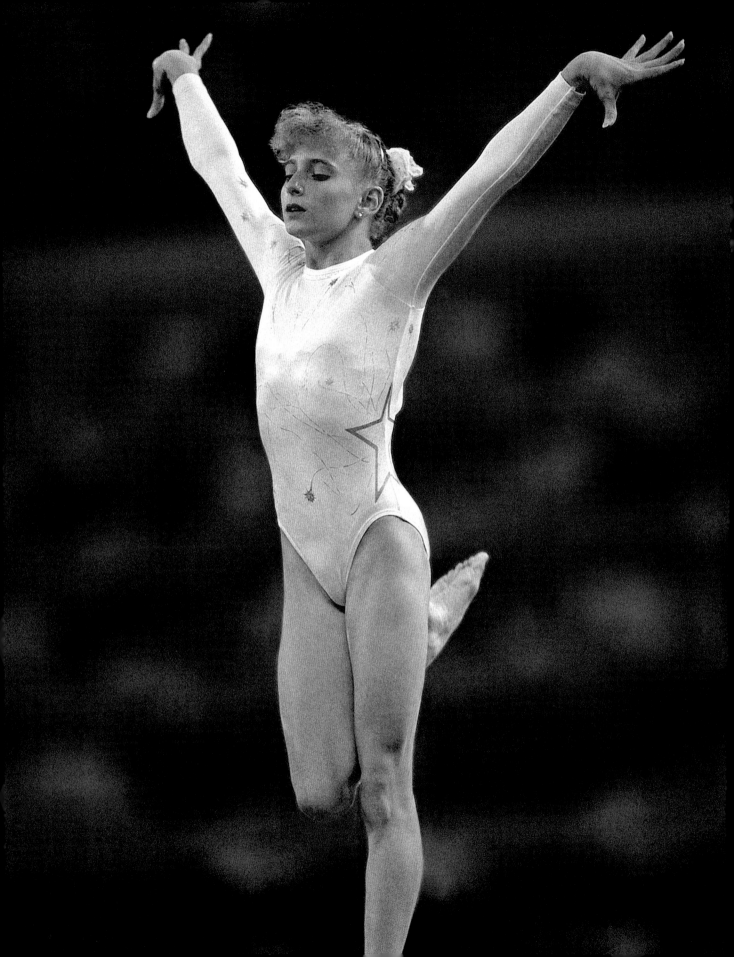

Shannon MILLER
gymnastics

Shannon Miller got her first car before she was legally old enough to drive. It was in 1992. Miller was 15 and had just returned home to Oklahoma after winning five medals (two silver and three bronze) at the Barcelona Olympic Games. Everyone in her hometown of Edmond had been so excited by her success that locals raised $35,000 so her parents and two siblings could travel to watch her compete, according to a 2003 *Sports Illustrated* story by Brian Cazeneuve. Upon her triumphant return, city and state officials threw her a parade and the Edmond Saturn dealership gave her a car.

Miller received another car—this time a Chevy Camaro—and another city parade when she came home from the 1996 Atlanta Games, where she'd won two gold medals for team competition and her individual performance on the balance beam. Years later, the city erected an 18-foot-tall statue of Miller in a park named after her.

"People in Oklahoma stopped at nothing to support me," Miller told *Sports Illustrated*.

There's nothing wrong with a city wanting to go all out for a hometown hero. After all, Miller is one of the most decorated American gymnasts in history, winning 59 international medals, 46 national medals, nine world championship medals, and seven Olympic medals over the course of her career. In 1996, she was the anchor of the U.S. team nicknamed the "Magnificent Seven," which captured America's hearts and defeated Russia for the first time in Olympic history to win gold in the team competition. Miller was Team USA's highest scorer throughout those Olympics and became the first American woman to win the balance beam finals.

Miller first started to gain international recognition when she was 14, winning two silver medals at her world championship debut in 1991. She carried that momentum over to her first Olympic Games the following year and continued to dominate international competition over the next few years. She became the first American gymnast to win back-to-back world all-around titles at the 1993 and 1994 world championships, which helped propel her into her next Olympics.

After the 1996 Atlanta Games, Miller and her Magnificent Seven teammates toured the country in their own rock-star bus, traveling to 34 cities and doing more than 90 performances in front of sold-out crowds.

When her gymnastics career was over, Miller became a motivational speaker, mostly talking to Rotary Clubs and non-profits about her Olympic experience. She later went to law school at Boston College and, in 2010, started a company called Shannon Miller Lifestyle, which focuses on women's health and wellness.

In 2011, Miller was diagnosed with a rare form of ovarian cancer—doctors removed a tumor the size of a baseball. "I think at that point is when I reverted back to that competitive mindset that I knew so well through sport," Miller told *Sports Illustrated* in 2020 as she celebrated being nine years cancer free. "I felt like I could wake up each day and have control over something, no matter how small. Maybe it was: Could I walk around the dining room table? I may have been an Olympic medalist, but at that moment if I could get up and walk around the dining room table, that was a win."

Miller is a staunch advocate for early detection and promotes awareness through Our Way Forward, a program that provides a space for ovarian cancer patients and providers to come together as a community and share stories about their own cancer journeys in hopes of helping others understand that they're not alone in their fight.

LEFT: Shannon Miller in action during all-around, Summer Olympics, Barcelona, Spain, 1992; **RIGHT:** Miller posing with silver medal, Summer Olympics, Barcelona, Spain, 1992; **OVERLEAF:** Miller and her teammates posing for a portrait, Summer Olympics, Atlanta, Georgia, USA, 1996

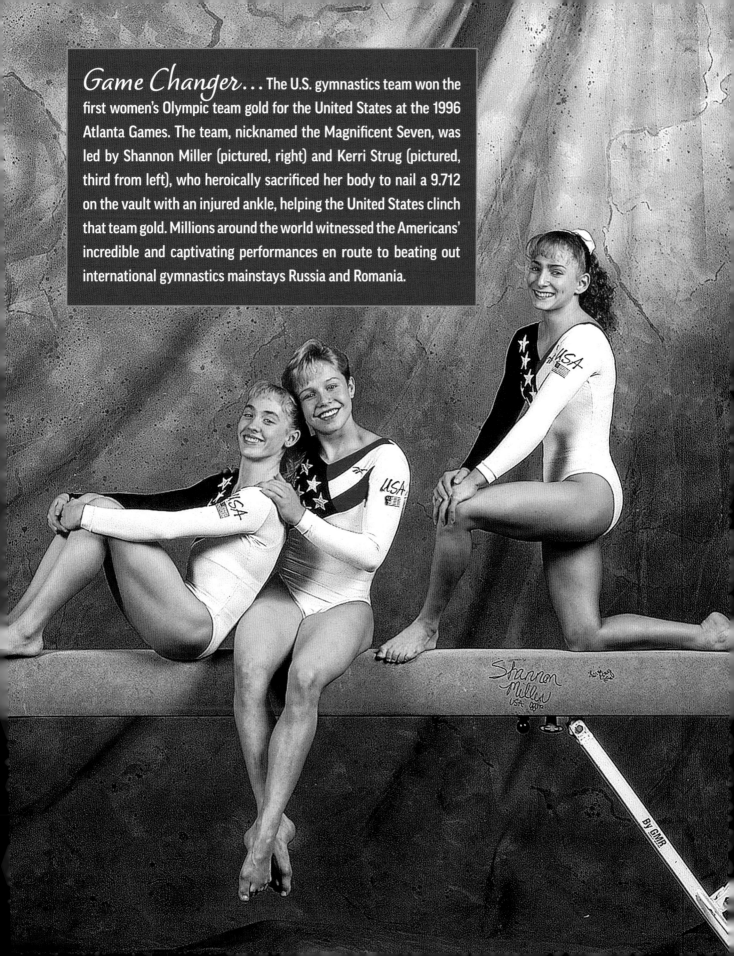

Game Changer… The U.S. gymnastics team won the first women's Olympic team gold for the United States at the 1996 Atlanta Games. The team, nicknamed the Magnificent Seven, was led by Shannon Miller (pictured, right) and Kerri Strug (pictured, third from left), who heroically sacrificed her body to nail a 9.712 on the vault with an injured ankle, helping the United States clinch that team gold. Millions around the world witnessed the Americans' incredible and captivating performances en route to beating out international gymnastics mainstays Russia and Romania.

Maya MOORE

basketball

Maya Moore is regarded as one of the greatest basketball stars of all time. But instead of continuing her career in the WNBA, Moore has chosen to sit out—two straight seasons now—and remove herself from Olympics contention in an effort to advocate for civil justice reform.

When you think of Moore, perhaps you first remember her at the University of Connecticut, where she is still the program's all-time leading scorer. Moore scored 3,036 points playing for Geno Auriemma from 2007 to 2011. The second player on that list is Breanna Stewart, who scored 2,676 points in four years. Tina Charles, Diana Taurasi, and Rebecca Lobo rank well behind. Moore led the Huskies to two NCAA titles. She became the first freshman—male or female—to be named Big East Player of the Year and finished second in AP Player of the Year voting behind Tennessee senior Candace Parker.

Moore chose to play college ball at UConn over women's basketball powerhouse Tennessee because, as she told *Sports Illustrated* in 2008, she knew that by playing for Auriemma her weaknesses would be exposed every day and she wanted to improve on them. She flourished in his system.

"Like Diana [Taurasi], Maya has this incredible self-belief: As long as I'm on the court, we can win. As long as there is time left on the clock, we can win. If there's a play that has to be made, I'm going to make it," Auriemma told *Sports Illustrated* in 2008 when Moore was a sophomore. "She might make eight threes in a row or get seven offensive rebounds in a row, and the other players will just look at her [in awe]. Yet there is just enough dorkiness in her that you can't put her on that pedestal. She'll do an impromptu cheer and everyone will look at her like she's a [goofball]. She's a normal 19-year-old kid, which is a good thing. Otherwise you'd start to think she's a 29-year-old who snuck into college."

If Moore's UConn résumé doesn't come to mind first, maybe you think about her professional basketball career. Moore was the first overall pick in the 2011 WNBA draft by the Minnesota Lynx and was named rookie of the year. She led the Lynx from 2011 to 2018, won four WNBA championships, was named Finals MVP in 2013, and became a six-time All-Star. Moore was also a two-time Olympian and helped Team USA win gold medals in the 2012 London Games and 2016 Rio de Janeiro Games.

Even with those untouchable accolades, Moore may be remembered for the new purpose she has found off the court. In February 2019, Moore shocked the sports world by announcing via an article in the *Players' Tribune* that she would be taking time away from basketball to focus on family and "ministry dreams that have been stirring in my heart for many years."

For the next year and a half, Moore went on a sabbatical in the name of social justice. She was 30 years old and perfectly healthy and fit—enjoying the peak of her career. But Moore decided to put basketball on hold and commit herself to working for the release of a man serving a 50-year prison sentence. Jonathan Irons, who is from Moore's home state of Missouri, had been wrongly convicted of burglary and assault with a deadly weapon in 1998 when he was 16 years old. Moore met Irons at a correctional facility she visited in 2007 and believed he was innocent.

Thanks to the remarkable effort from Moore and Irons's supporters to win his freedom, a judge ruled in March 2020 to overturn his conviction after 23 years. There were problems with the way the case was investigated and tried, including suppressed fingerprint evidence that would have helped Irons's defense. Irons was released from prison in July 2020. Along the way, Moore and Irons developed a relationship and got married later that year.

Moore will remain a strong voice for change while pushing for civil justice reform with her husband. She has no plan yet to return to basketball.

"I'm in a really good place right now with my life, and I don't want to change anything," Moore told the *New York Times* in early 2020. "Basketball has not been foremost in my mind. I've been able to rest, and connect with people around me, actually be in their presence after all these years on the road. And I've been able to be there for Jonathan."

While her decision might be viewed by some as a blow to the WNBA—losing one of its most marketable, charismatic, and well-known players—it encourages future generations of athletes to use their platform to fight for causes they believe in.

RIGHT: Maya Moore posing for a portrait at UConn, Storrs, Connecticut, USA, 2008; **OVERLEAF:** Moore and her teammates celebrating during UConn game, Storrs, Connecticut, USA, 2009

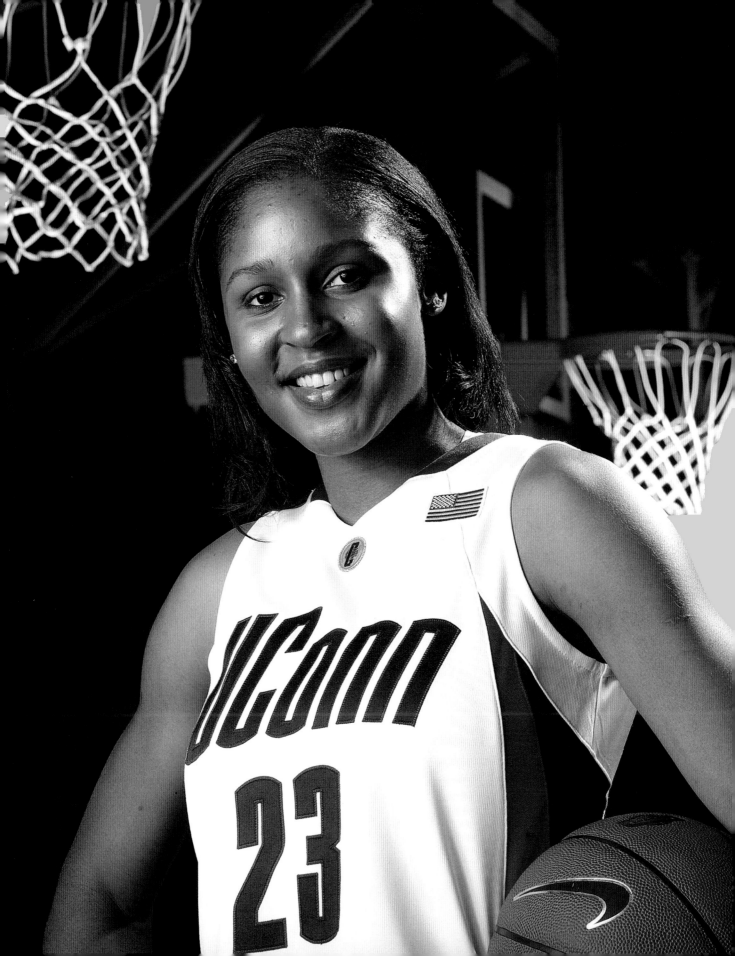

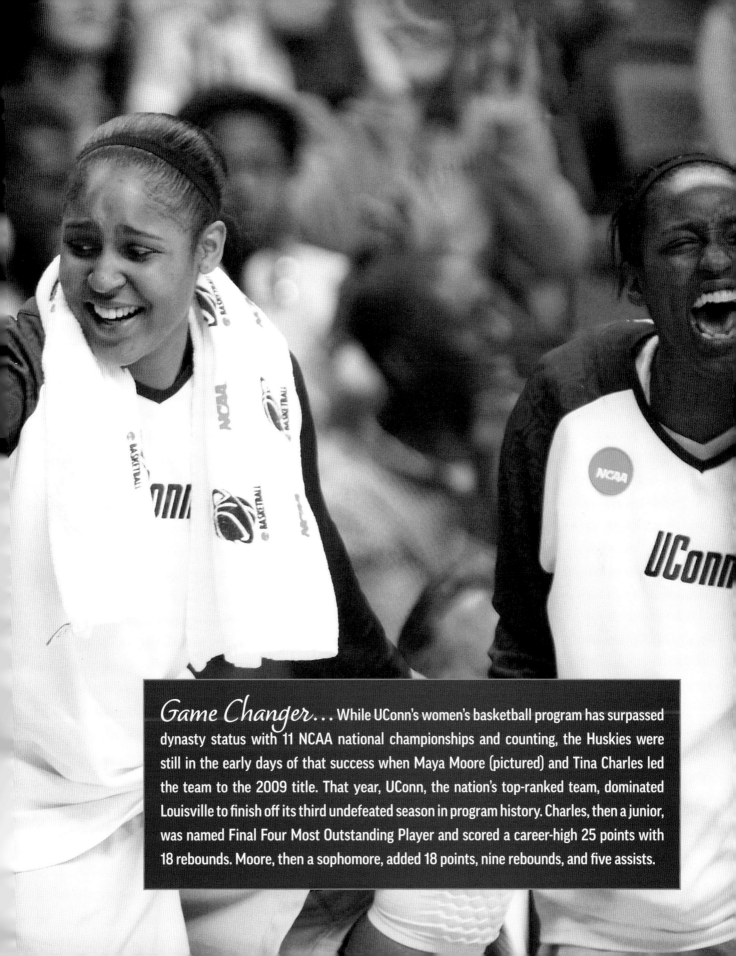

Game Changer... While UConn's women's basketball program has surpassed dynasty status with 11 NCAA national championships and counting, the Huskies were still in the early days of that success when Maya Moore (pictured) and Tina Charles led the team to the 2009 title. That year, UConn, the nation's top-ranked team, dominated Louisville to finish off its third undefeated season in program history. Charles, then a junior, was named Final Four Most Outstanding Player and scored a career-high 25 points with 18 rebounds. Moore, then a sophomore, added 18 points, nine rebounds, and five assists.

Alex MORGAN

soccer

t seems like there's nothing Alex Morgan hasn't done or can't do. While most people know her as the captain of the U.S. women's national soccer team (USWNT), she is so much more than that.

For starters, Morgan is a superstar goal-scoring machine who is a two-time World Cup champion and Olympic gold medalist. But her legacy will encompass even more. She has taken a stand for gender equality and is fighting for equal pay. She has created a media company geared toward women with other female Olympic athletes. She has appeared on countless magazine covers and posed in body paint for the 2012 *Sports*

Illustrated Swimsuit Issue because, as she told the magazine then, "I wanted to help young women feel comfortable in whatever body type they have." She has brought her baby girl with her to every single game and tournament around the world, showing how women can be professional athletes and mothers too.

In 2019, Morgan was a *Time* top 100 most influential person of the year. She's friends with Taylor Swift. She has more than a dozen sponsors, including Nike, Coca-Cola, and AT&T, and there's even an Alex Morgan Barbie doll. She's the *New York Times* best-selling author of *The Kicks*, a children's book series about a young female soccer player. As Grant Wahl wrote for *Sports Illustrated* in 2013, before she became the household name she is today, "One of Morgan's most remarkable achievements . . . may be that she's done all of this without generating open resentment from her peers."

Everything she does has purpose, from her ventures in business and marketing to being one of the greatest soccer players of all time.

Morgan was the youngest member of the national team at the 2011 World Cup, where she scored goals in the semifinals

and the final loss to Japan. Somewhat of an unknown 21-year-old then, Morgan's Twitter following boomed from 15,000 to 135,000. A decade later, after becoming a USWNT leader, an international role model for young girls and women everywhere, and winning the Silver Boot at the 2019 World Cup, Morgan has nearly four million followers, which is considerably more than any other U.S. soccer star, including the likes of Abby Wambach, Christian Pulisic, or Landon Donovan.

Back in the early days of her national team career, Morgan's teammates nicknamed her "Baby Horse" because of her lanky gait. But now, according to teammate Megan Rapinoe, she's a "full-on stallion." Heading into the 2020 Tokyo Olympics (which were postponed to 2021 due to COVID-19), the forward had 109 goals and 43 assists. She made the roster one year after giving birth to her daughter. She has experience playing in Europe—she played in Lyon in 2017 and Tottenham in 2020. And she's a member of the NWSL's Orlando Pride, where she plays alongside several USWNT teammates, as well as Brazil legend Marta.

As soon as Morgan joined the national team, she was considered to be the heir to Mia Hamm's legacy. She was mentored by Wambach, who was ahead of the curve when she told *Sports Illustrated* in 2013 that Morgan would be the face of women's soccer.

"She's not just a pretty face," Wambach said. "So much attention on women in sports is based on looks, but Alex backs that up with even stronger athleticism. I'd absolutely compare her to David Beckham in terms of her appeal. And this national team has kind of missed that element . . . Alex, being a forward, really is the perfect storm. She'll benefit women's soccer and women's sports in a larger scope."

Morgan is married to MLS player Servando Carrasco, who she has been with since their freshman year at the University of California, Berkeley, where they both played from 2007 to 2010. They have one daughter named Charlie.

Morgan still has so much of her career left. On the field, she has at least one (if not more) Olympics and World Cup to play in, and off the field she's really just getting started.

LEFT: Alex Morgan posing with trophy after FIFA World Cup win, New York, New York, USA, 2019; **RIGHT:** Morgan in action during FIFA World Cup Final, Décines-Charpieu, France, 2019

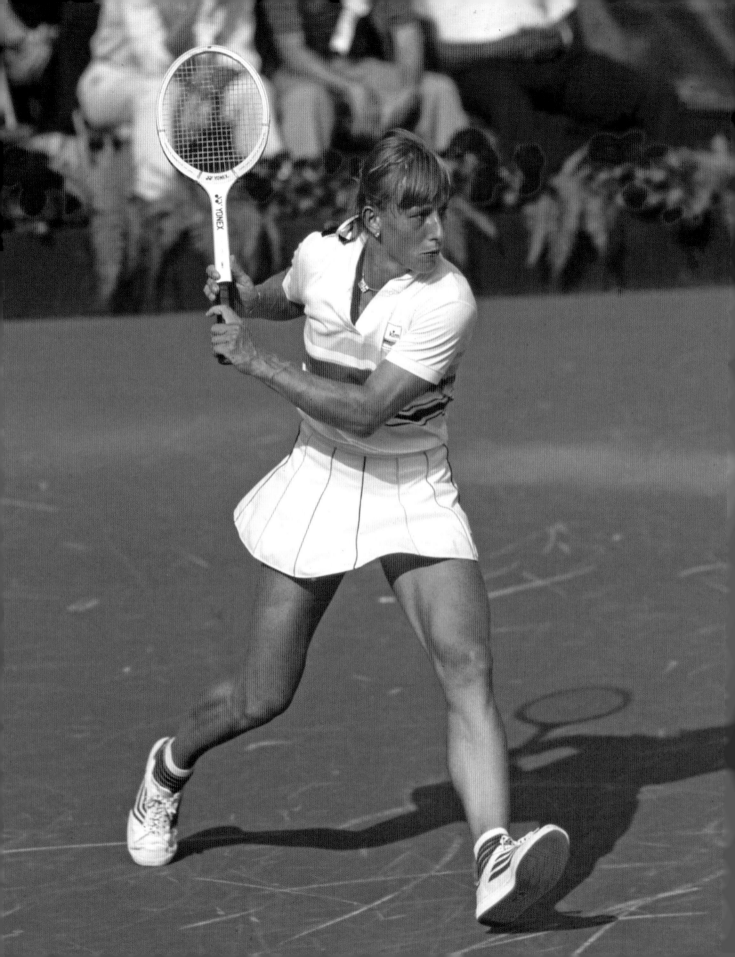

Martina **NAVRATILOVA**

tennis

Martina Navratilova is a record-breaking force in tennis whose impact has reverberated across generations. Since the Open Era began in 1968, no male or female player has won more singles tournaments (167), doubles events (177), or matches (2,189). Navratilova won 18 major singles titles, including four U.S. Opens, three Australian, two French, and a record nine Wimbledons. Add that to her 41 doubles and mixed-doubles titles and she has won 59 Grand Slam crowns. Only Margaret Court has more with 62.

Navratilova spent a total of 332 weeks as the No. 1 player in the world and was also ranked in the top spot in doubles for 237 weeks.

Frank Deford wrote about her career for *Sports Illustrated* after she won her ninth Wimbledon title in 1990, which broke a 52-year-old record held by Helen Wills Moody: "How gratifying it must have been for her, to have achieved so much, triumphed so magnificently, yet always to have been the other, the odd one, alone: lefthander in a right-handed universe, gay in a straight world; defector, immigrant; the (last?) gallant volleyer among all those duplicate baseline bytes."

While her stats go on and on, Navratilova's influence off the court has had a greater impact on tennis, sports, and society at large.

Navratilova was born in Czechoslovakia and started playing tennis when she was four. In 1972, at age 15, she won the Czechoslovakia national tennis championship and started competing on tour a year later. The next year, at age 16, she turned pro. She defected to the United States in 1976 and became a U.S. citizen five years later. Navratilova won her first major title in doubles with Chris Evert at the 1975 French Open, and her first singles title in 1978 when she defeated Evert in the Wimbledon final. Navratilova would go on to beat Evert in five of the nine Wimbledon finals she won. The duo became one of tennis's greatest rivalries, facing off a record 80 times, with Navratilova holding a 43–37 overall edge, but Evert having a 36–25 record in tournament finals.

In the midst of her stellar career, Navratilova broke barriers by coming out as bisexual. While she was a role model for the LGBTQ community, her honesty cost her millions in endorsement money thanks to a homophobic corporate America. But it allowed her freedom to promote her own beliefs, from animal rights to environmental awareness, and, as Alexander Wolff wrote for *Sports Illustrated*, "to follow in the footsteps of her sports heroes, so many of whom championed causes beyond the arena and suffered big for doing so: Muhammad Ali, Billie Jean King, Jackie Robinson, John Carlos. In going from Communist Czechoslovakia, her native country, to the forefront of the U.S. gay-rights movement, she simply redirected her indignation. She once said, 'I've always had this outrage against being told how to live, what to say, how to act, what to do, when to do it.'"

Navratilova also struggled with her weight. While she was born in Czechoslovakia, she was more American than anything, so much so that she got into a bad relationship with fast food. The extra pounds affected her game, and eventually she worked hard to drop 22 pounds with a dedication to diet and exercise, showing women that it was OK to have muscles.

"Through all her transformations—of body, hair, clothes, classes, nationalities, coaches, lovers—the one thing, ever the same, ever distinct, is her voice, which is pitched to shatter a champagne flute," Deford wrote for *Sports Illustrated*. "It brought forth sounds of decency and forthrightness, leavened with wit and compassion. Tennis was very blessed to have such a voice for so long, for these times."

Navratilova retired from the tour in 1994, but returned in 1995 to win her third Wimbledon mixed-doubles title. She retired again in 2006 after playing mixed doubles with Bob Bryan at the U.S. Open a month before her 50th birthday, becoming the oldest major championship winner. Later, she became a Tennis Channel commentator and is a staunch advocate for equal rights and a respected voice in the LGBTQ community. Recently, Navratilova penned an open letter in the *Sydney Morning Herald* asking that Margaret Court Arena, home to the Australian Open, be renamed because of the legendary tennis player's controversial views on sexuality and race.

LEFT: Martina Navratilova in action during U.S. Open, Flushing, New York, USA, 1981

The first time Diana Nyad attempted to swim 110 miles from Cuba to Florida, she was blown way off course and stung by poisonous jellyfish. It was 1978, and she was 28.

Nyad called the swim "my own private Olympics" and trained for a year leading up to the attempt. She was going to start in July, when winds were normally light and the waves in Florida were smaller. But, as Dan Levin wrote for *Sports Illustrated* in 1978, there were issues with the Cuban government so Nyad couldn't begin her swim until mid-August. The winds were so strong and Nyad was swimming so far off course that one of the trainers following her suggested that maybe she swim from Cuba to Mexico instead.

"The wind, which was supposed to die at dusk, blew into the night, and Nyad screamed as poisonous jellyfish washed against her arms," Levin wrote. "Her trainers bathed the stings with ammonia, but she was losing strength–from pain, from vomiting up her hourly feedings, from battling the waves. She shivered when she momentarily stopped swimming. She began to swim breaststroke and backstroke, slowing to only a mile an hour. 'My God,' she called out, 'if it's this bad after only 12 hours . . .' At 2 a.m. her trainers fed her chicken soup, but she threw it up. The waves rose to four feet and Nyad said, 'This is the worst night of my life.'"

Nyad suffered from sleep deprivation and hallucinations. According to Levin, she thought there were barracudas and lizards at the bottom of the self-propelled shark cage she was swimming in (trainers assured her there weren't). Eventually Nyad called it quits. She'd gone 76.1 miles, but in a very circuitous fashion–first northwest, then north, then northeast, and then southeast. But because she swam that far, even if it wasn't exactly in the right direction, her trainers agreed she was capable of swimming from Cuba to Florida one day.

Nyad, a former Olympic hopeful, was known as a great long-distance swimmer. In 1979, she swam the then-longest swim in history, going 102.5 miles from the Bahama island of Bimini to Florida. She also broke world records, including what had been a 50-year mark for circling the island of Manhattan, which she did in seven hours and 57 minutes.

Though she had failed on her 1978 attempt to swim from Cuba to Florida, Nyad had no plans of giving up what she called her "big dream." Nyad tried the swim again and again–twice in 2011 and once in 2012–but her plan was foiled each time by some mixture of bad weather, asthma, strong currents, and more jellyfish stings.

But on September 2, 2013, she was finally successful. At the ripe age of 64, Nyad emerged onto the sands of Key West as the first person to ever swim from Cuba to Florida without the protection of a shark cage. It was her fifth attempt–three decades after her first one–and it took 53 hours. She had a 35-person crew that helped keep sharks and jellyfish away, and the weather wasn't perfect–she endured four-foot swells–but it was nothing she couldn't handle.

"The biggest factor in Nyad's favor was her capacity to power through misery," Kelli Anderson wrote for *Sports Illustrated* in 2013. This time, Nyad wore a custom silicone mask that protected her from jellyfish. Nyad said she wouldn't have even tried to swim without the mask, which she wore for 13 hours in choppy waters where jellyfish might be present.

While it might seem crazy that Nyad was able to accomplish such an insane feat, she explained that age and experience helped her persist. "I was definitely faster as a kid, but everything else–emotional maturity, perspective on life, ability to handle pain, ability to handle disappointment–are far superior," she told *Sports Illustrated*. "I've learned you don't lift up at the 36th hour and go, 'Oh my god, I feel great! There will never be a problem.' You don't know what's going to happen in the 37th hour. You put your head down until some tells you, 'There's the shore.' That's the only time you know you're going to make it."

After finally conquering her lifelong quest, Nyad was done with swimming. Since then, she has written four books, is an NPR contributor, and has given TED Talks about her motivational journey. She is also an advocate for the #MeToo movement, sharing her story of the sexual abuse she experienced all through childhood from a swim coach. When she was 68 years old, Nyad wrote an op-ed in the *New York Times*, bravely opening up about that painful part of her life with the hope that she could inspire other sexual assault survivors to have the confidence to tell their stories.

RIGHT: Diana Nyad posing before starting a swim around the island of Manhattan, New York, New York, USA, 1975

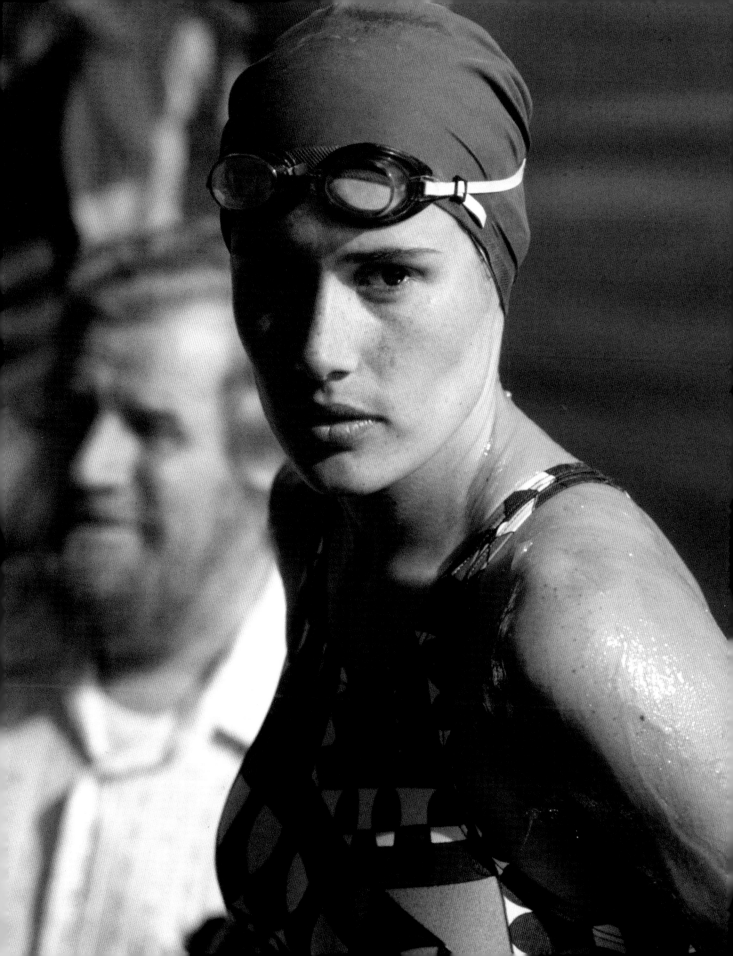

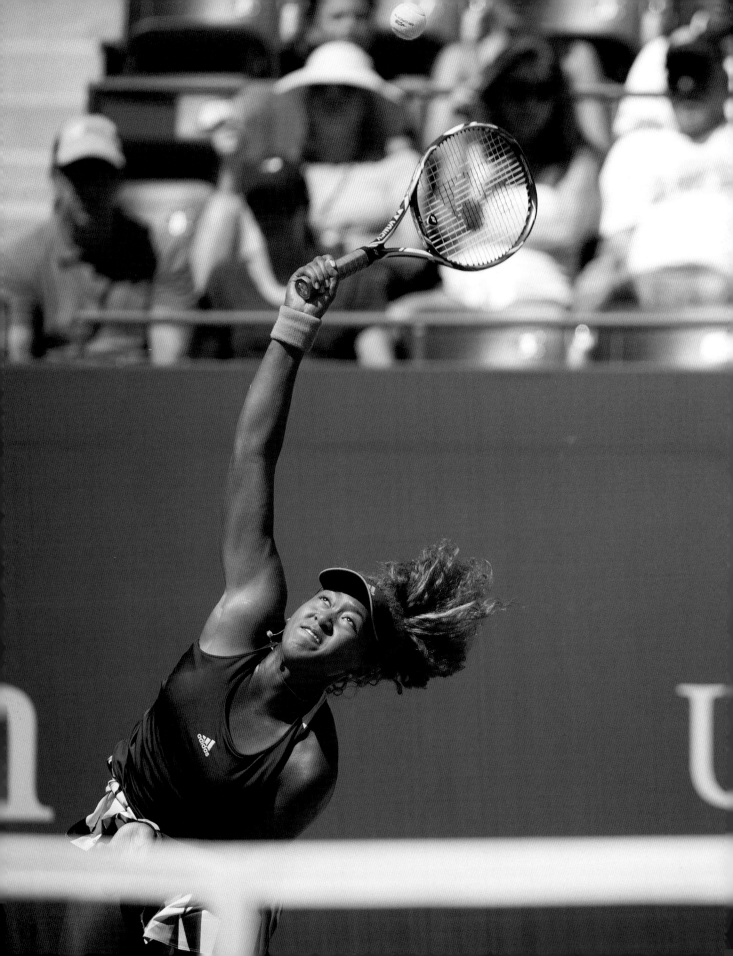

Naomi OSAKA

tennis

Naomi Osaka, a global tennis superstar, would probably rather not be as famous as she is. Osaka is young and at the top of her sport. She has won four Grand Slam singles titles—the 2018 and 2020 U.S. Opens, plus the 2019 and 2021 Australian Opens—and has never lost a major final. According to the *Wall Street Journal*, tennis legends Serena Williams, Steffi Graf, Martina Navratilova, and Chris Evert each finished as runners-up at least once before winning four titles.

Osaka, who was born in 1997, has so much of her career left, which inevitably means her celebrity status will only continue to skyrocket. This is an uncomfortable place for her, given that she's incredibly introverted and shy. She has said before that her fear of speaking up has come at a cost. "There's a lot of times where I see myself in situations where I could have put my input in, but instead I've held my tongue and things kept moving in a way that I didn't really enjoy," Osaka told CNN.

"At a time when it seems that almost everyone in the world wants to be famous, whether they have a talent or not, there's something very sweet and refreshing about Naomi, who certainly has a talent, but no need to be famous," Navratilova wrote for *Sports Illustrated* when Osaka was one of five Sportsperson of the Year winners in 2020. "She just wants to play ball."

In 2020, Osaka overcame her greatest weakness and found her voice with incredible displays of activism. For example, during her run to winning the 2020 U.S. Open, she wore seven different face masks for each match featuring the name of a Black victim of alleged police or racist violence. She started with Breonna Taylor in her first-round match against Misaki Doi and then wore one with Tamir Rice's name in the final against Victoria Azarenka.

"I'm aware that tennis is watched all over the world, and maybe there is someone that doesn't know Breonna Taylor's story. Maybe they'll like Google it or something," said Osaka, who is a Japanese citizen of Haitian heritage but grew up in Florida. "For me, [it's about] spreading awareness. I feel like the more people know the story, then the more interested they'll become in it."

Osaka turned pro in 2013, qualified for the WTA tour championship in 2014, and played in her first Grand Slam in 2016, where she made it to the third round of the Australian Open. She made it to the third round of the French and U.S. Opens that same year. In September 2016, Osaka played in her first WTA final at the Toray Pan Pacific Open, where she placed second. She also won Newcomer of the Year at the 2016 WTA Awards.

In 2018, Osaka won her first Grand Slam at the U.S. Open when she dismantled her idol, Serena Williams, who was vying for a record-tying 24th major singles title. Williams had been a dream finals opponent for Osaka, and her trajectory was the template Osaka's family followed to help get her to this point in her career. According to a 2018 *Sports Illustrated* story, Osaka's father, Leonard Francois, once saw a 1990s interview with Williams's father and decided to follow his lead.

After winning the 2018 U.S. Open, Osaka turned around and won her first Australian Open 138 days later, becoming the first Asian player—male or female—to achieve a No. 1 ranking. She was only 21 years old.

Osaka had an incredibly brave and admirable 2021. Ahead of the French Open, she announced that she would not participate in the post-match press conferences required of players, citing her mental health. The French Open fined her $15,000 and threatened more penalties if she did not oblige. She decided to withdraw from the tournament and also opted out of Wimbledon. Osaka explained in a social media post that she was struggling with depression and talking in front of a room full of reporters gave her anxiety.

And Osaka is not alone. She's helping lead the way as a new generation of athletes understands the importance of speaking out about uncomfortable issues, like racial injustice and mental health. When Simone Biles pulled out of the gymnastics team final at the Tokyo Olympics in 2021 to focus on her mental health, Osaka reached out in support.

Also at the Tokyo Games, Osaka was chosen to carry the Olympic torch and light the cauldron. "Undoubtedly the greatest athletic achievement and honor I will ever have in my life," she wrote on Twitter. "I have no words to describe the feelings I have right now but I do know I am currently filled with gratefulness and thankfulness."

LEFT: Naomi Osaka in action during the U.S. Open, Flushing, New York, USA, 2016; **OVERLEAF:** Osaka with Serena Williams after final match, U.S. Open, Flushing, New York, USA, 2018

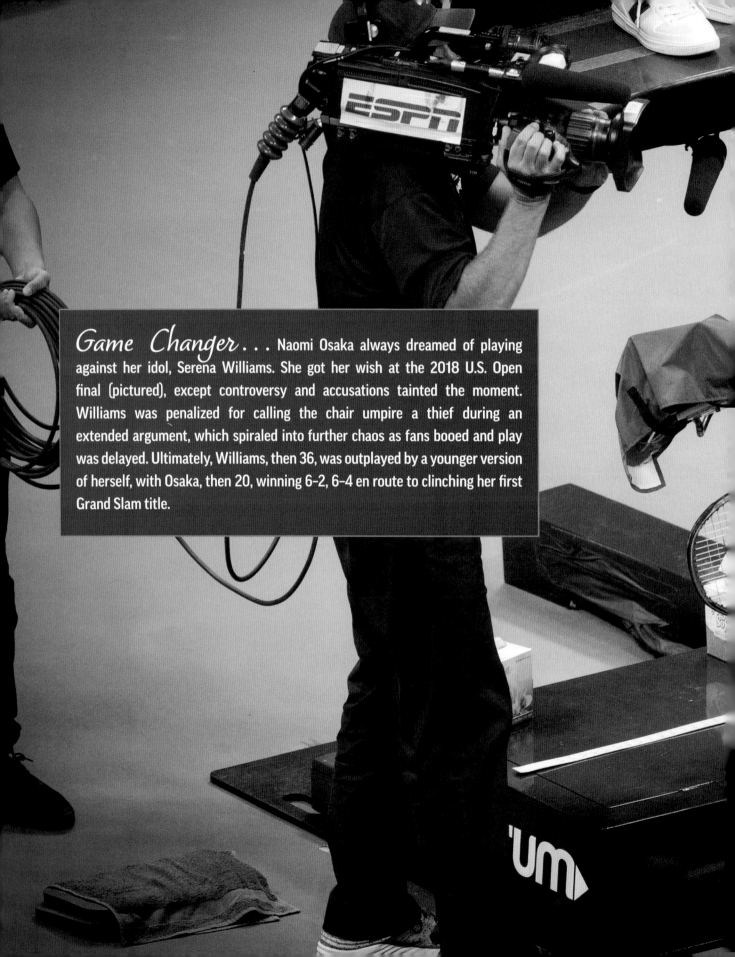

Game Changer... Naomi Osaka always dreamed of playing against her idol, Serena Williams. She got her wish at the 2018 U.S. Open final (pictured), except controversy and accusations tainted the moment. Williams was penalized for calling the chair umpire a thief during an extended argument, which spiraled into further chaos as fans booed and play was delayed. Ultimately, Williams, then 36, was outplayed by a younger version of herself, with Osaka, then 20, winning 6–2, 6–4 en route to clinching her first Grand Slam title.

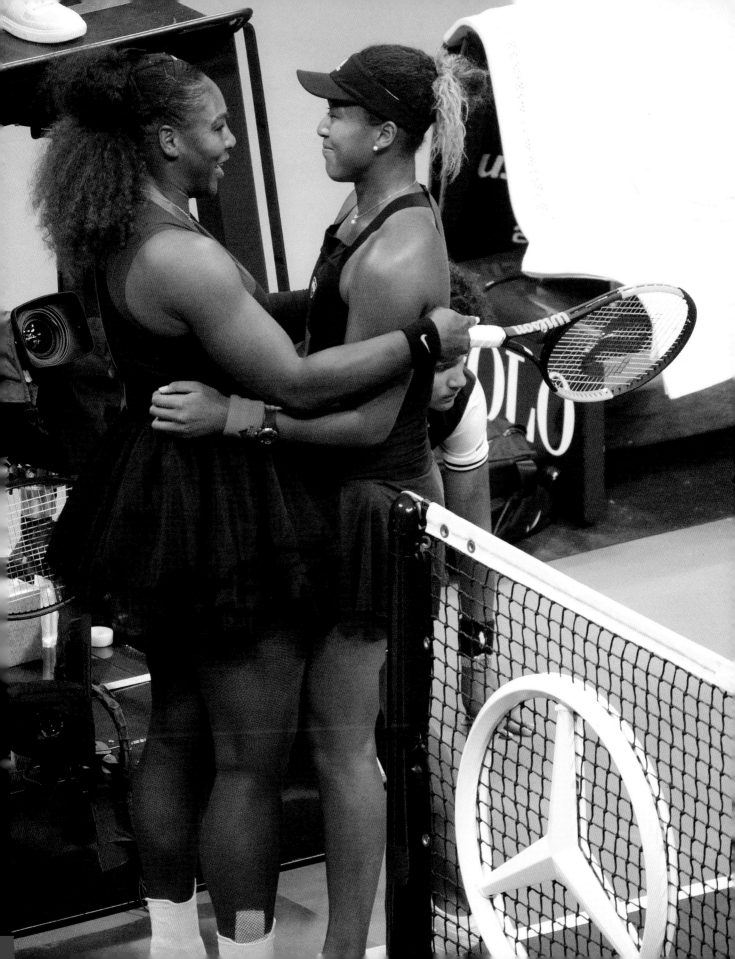

Cat OSTERMAN

softball

Plenty of athletes have come out of retirement to play or compete again. Michael Jordan is probably the most famous example, but Michael Phelps retired after the London Olympics and then came back to win five more gold medals in Rio de Janeiro four years later, and Rob Gronkowski won a Super Bowl the season he returned to the NFL.

That brings us to Cat Osterman. The three-time Olympian retired from softball in 2015. At that point, she'd checked off basically everything you could do in a career: She won a gold medal pitching for USA Softball at the 2004 Athens Olympics and a silver medal at the 2008 Beijing Olympics. She won two world championships. She was a Pro Fastpitch All-Star and a three-time USA Softball National Player of the Year at the University of Texas, where she led the Longhorns to three Women's College World Series appearances.

She was inducted into the Texas Sports Hall of Fame, and, in 2002, she became the first softball player to ever grace the cover of *Sports Illustrated* (she made a second cover in 2004 alongside her USA Softball teammates after the Olympics). After all of these accomplishments, retirement made complete sense.

But in 2018, the southpaw came out of retirement. And in 2021, she competed in her third Olympics in Tokyo, which was also the first time softball had been an Olympic sport since 2008. She was 38 years old when she took the mound for the United States and helped lead her team to a silver medal.

Osterman told the Associated Press that she's inspired by athletes like Tom Brady, Justin Verlander, and Aaron Rodgers because they've continued to be elite competitors despite being older than many of their peers.

"I can relate to the fact that you're passionate about what you do, and that you want to keep doing it as long as you're able to," Osterman said in 2021. "I read articles about them and I think, 'I know what this feels like.'"

Osterman was a youngster when she made her first U.S. national team in 2004. At 21, she was the youngest member on the team, taking a redshirt year at Texas in order to help Team USA win gold. She often made the best hitters look silly and posted a 59-4 record (with a 0.38 ERA) on the national team from 2001 to 2010.

Michael Silver wrote about Osterman for *Sports Illustrated* in 2005, when she returned to Texas for her junior year after spending 2004 with the national team (where she allowed no runs and struck out 23 in 14⅔ innings in Athens). "Osterman returned to Austin for her junior season, and the weak-hitting Longhorns immediately vaulted into the national-title hunt," Silver wrote. "Cat's stats (28-6 record, 0.32 ERA, 539 strikeouts in 243⅔ innings) suggest that she blows away hitters with pure power, but she actually confounds them with her uncanny late movement, particularly on a drop ball that her Olympic teammate Jennie Finch calls 'the dirtiest you'll ever see.'"

At Texas, where she is considered a legend on campus, Osterman holds records for victories (136), ERA (0.51), shutouts (85), and no-hitters (20). She finished college with a 136-25 overall record and was a four-time All-American. She's also still the NCAA record holder for perfect games (nine).

After graduation, Osterman spent more time with the national team and later played eight seasons in the National Pro Fastpitch league, where she won four league titles with the Rockford Thunder and USSSA Pride and is still the all-time ERA leader.

Some of Osterman's proudest moments of her career have been helping mold the next generation of softball players and growing the game. After she retired for the first time in 2015, Osterman was hired as a pitching coach at Texas State University, where she quickly transformed the Bobcats' pitching staff into one of the most dominant in the Sun Belt Conference.

In 2020, Osterman stepped down from the coaching staff to focus on winning another Olympic gold medal (Team USA was undefeated in the tournament until falling to Japan 2-0 in the final). While she may return to a dugout as a coach someday, we know for sure she won't be back on the mound, as she told reporters she was retiring for good after the Olympics. Instead, her plan is to return to Austin and work for a nonprofit.

LEFT: Cat Osterman in action during final, Summer Olympics, Beijing, China, 2008; **RIGHT:** Osterman in action during preliminaries, Summer Olympics, Athens, Greece, 2004

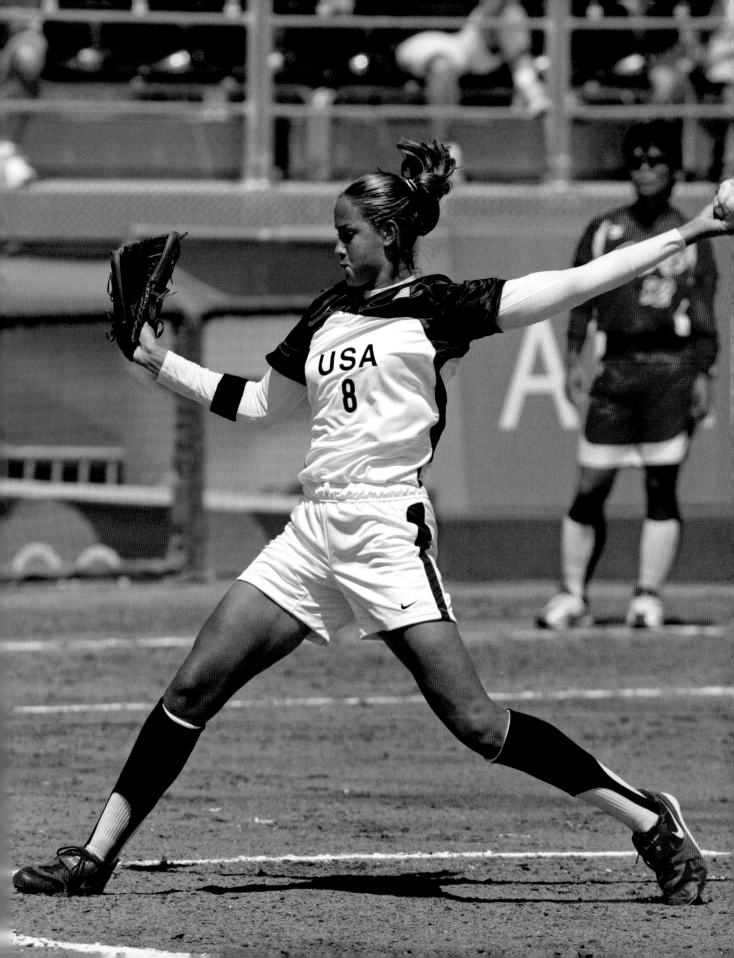

They called her the Tiger Woods of Asia for how she popularized women's golf in South Korea. Se Ri Pak was only 20 years old in 1998 when, in her rookie season, she delighted crowds by winning two majors: the McDonald's LPGA Championship and the U.S. Women's Open, giving women's golf its biggest boost since Nancy Lopez.

At the McDonald's LPGA event, Pak became the youngest woman to win a major since Sandra Post in 1968. Jaime Diaz described her game in *Sports Illustrated* at the time: "Pak bisected the narrow fairways and hit the small greens with a metronomic efficiency that produced an 11-under-par 273, on rounds of 65, 68, 72 and 68." Her performance was immediately compared to Woods winning the Masters in 1997 and how it energized the PGA Tour.

"At first glance, Pak's performance might seem like an accident," Diaz wrote. "An LPGA rookie who took up golf only six years ago, Pak still has a mediocre short game, and the win was her first top 10 finish, but the quality of her play was indisputable. Pak may be good enough to challenge the preeminence of such stars as Annika Sorenstam of Sweden and Australia's Karrie Webb. That's good news for the LPGA, whose depth and worldwide appeal have never been stronger."

Pak was a runner—a track and field sprinter, actually—before she set her sights on becoming the best golfer in the world. Her father introduced her to golf and she started playing at age 14. Pak immediately got the hang of it, and over the next four years she won more than 30 amateur events in Asia. She turned pro in 1996 and won six Korean LPGA tournaments. She later moved to the United States and signed a 10-year multimillion-dollar endorsement deal with Samsung.

Two months after her first major win, Pak won the U.S. Women's Open in one of the most memorable finishes of all time. She outdueled Jenny Chuasiriporn in a 20-hole playoff after tying in regulation. With the victory, Pak became the youngest woman to win two majors and the first rookie to win two majors since Juli Inkster in 1987. She finished her debut season in 1998 with a couple more tournament wins and was named LPGA rookie of the year.

Pak went on to become a global phenomenon. In South Korea, her face appeared on billboards, television, and the front pages of newspapers. TV cameras even followed Pak into her hospital room when she was admitted for exhaustion after returning to South Korea in the fall of 1998.

Diaz wrote that, according to Korean journalists, Pak was more popular than Los Angeles Dodgers pitcher Chan Ho Park. Korean reporters and fans alike flocked to the United States to watch her tournaments. Fans back home hosted watch parties when she was playing, and even former South Korean President Kim Dae-jung reached out to say congratulations after her first win.

"Since our country had its financial problems, Se Ri is even more important to Korea," Pak's manager Steven Sung Yong Kil told *Sports Illustrated* at the time. "They look at her for inspiration. Everyone expects her to be the No. 1 player, and they put a lot of pressure on her. When she goes back to Korea, or even when she eats at a Korean restaurant in America, everyone knows her."

Pak played from 1998 to 2016 and won 25 LPGA Tour titles, including five majors. She was the youngest player to be inducted into the World Golf Hall of Fame at age 30, won 14 times on the Korean LPGA Tour, and was the captain of South Korea's Olympic team at the 2016 Rio de Janeiro Games (where Inbee Park won the gold medal).

Despite all of her success, Pak was self-conscious about her English and fairly shy with reporters. But she was very clear about her position when asked about comparisons to Woods. As much as she appreciated what they had in common, she wanted to carve out her own identity.

"I don't want to copy him in everything because I do my best," Pak told *Sports Illustrated* in 1998. "Every time I hear Tiger Woods and me second. I want it me first, then later Tiger."

Pak's impact is still felt today and will be for many future generations of women's golf. In 2021, four of the top 10 players in the world and 18 of the top 50 were South Korean. "I think if we had no so-called Se Ri Kids, the Korean golf scene would be quite different today," Pak told the Associated Press when she retired in 2016.

RIGHT: Se Ri Pak in action during the Bell Micro LPGA Classic, Mobile, Alabama, USA, 2010

Candace PARKER

basketball

When Candace Parker was 15 years old, she dunked in a high school basketball game. She was the first girl in Illinois, and only the second in the nation, to throw down like that. TV cameras and news reporters huddled in her driveway the next morning.

That was only the beginning of Parkermania. She became the first girl to win the McDonald's All-American Game slam-dunk contest in 2004, beating out male opponents like future NBA stars Josh Smith and J. R. Smith. Her performance made the *NBC Nightly News* and she was interviewed on *The Today Show*. Parker was named Illinois Player of the Year three times and became the first person to win the Naismith National High School Player of the Year award twice.

Parker was also the center of an intense recruiting battle and became the first female player to announce her college decision on national TV. She chose Tennessee, coached by the legendary Pat Summitt, over DePaul, Duke, Maryland, and Texas.

At Tennessee, she won basically everything a basketball player could win as a two-time National Player of the Year and a two-time national champion. She was the No. 1 overall pick by the Los Angeles Sparks in the 2008 WNBA draft, and, as of 2021, has played 13 seasons in the league. At 36 years old, Parker is a WNBA champion and Finals MVP; a two-time league MVP, one of which she won her rookie year in 2008 while also earning rookie of the year; and a five-time All-Star. Parker is also a two-time Olympic gold medalist.

And that's just on the court. Off the court, Parker is a mom to daughter Lailaa and a sports broadcaster who dishes real talk to Shaquille O'Neal as the only female analyst on TNT's *Inside the NBA*.

Parker started playing basketball when she was six—learning the game was a family affair. Her father, Larry, who played for Iowa in the 1970s, coached her. Her mother, Sara, was an assistant coach on some of her AAU teams and helped her break down film. Her brothers, Anthony and Marcus, were high school stars, too, with Anthony eventually playing in the NBA and overseas.

And, being from Chicago, the family loved the Bulls. But Parker's favorite player wasn't Michael Jordan. It was Ron Harper, which delighted Summitt, according to a 2005 *Sports Illustrated* story written by Kelli Anderson. The six-foot-four Parker could not only post up, push the ball in transition, hit a three-pointer,

and dunk, but also play defense. As Anderson also wrote, Summitt was less thrilled with Parker's favorite WNBA player: Diana Taurasi. She torched the Vols too many times at UConn.

"Diana was so raw," Parker told *Sports Illustrated*. "She'd make moves you didn't think she could make. And I loved the air she had about her. Not cocky, but confident, in her game and in her team. Her team was like her personality. I'd like to have that effect someday."

And Parker has done just that, especially when she seamlessly juggled being a WNBA star and a full-time mom. Parker kept up her elite training regimen until two days before giving birth to her daughter in May 2009. She was back on the court by July, led the Sparks to the Western Conference Finals, and then flew off to Russia—with Lailaa—to play 25 games for UMMC Ekaterinburg.

After 13 years with the Sparks, Parker, who has averaged 16.9 points and 8.6 rebounds for her career, made a big change. In 2021, she signed with her hometown team, the Chicago Sky, as a free agent. (She also joined WNBA stars A'ja Wilson and Sue Bird on the cover of the June issue of *Sports Illustrated*.) Now she can play in front of her friends and family—especially her grandmother—for the first time in her legendary career.

LEFT: Candace Parker posing for a portrait, Newbury Park, California, USA, 2021; **ABOVE:** Parker in action during NCAA Basketball Tournament, Dayton, Ohio, USA, 2007

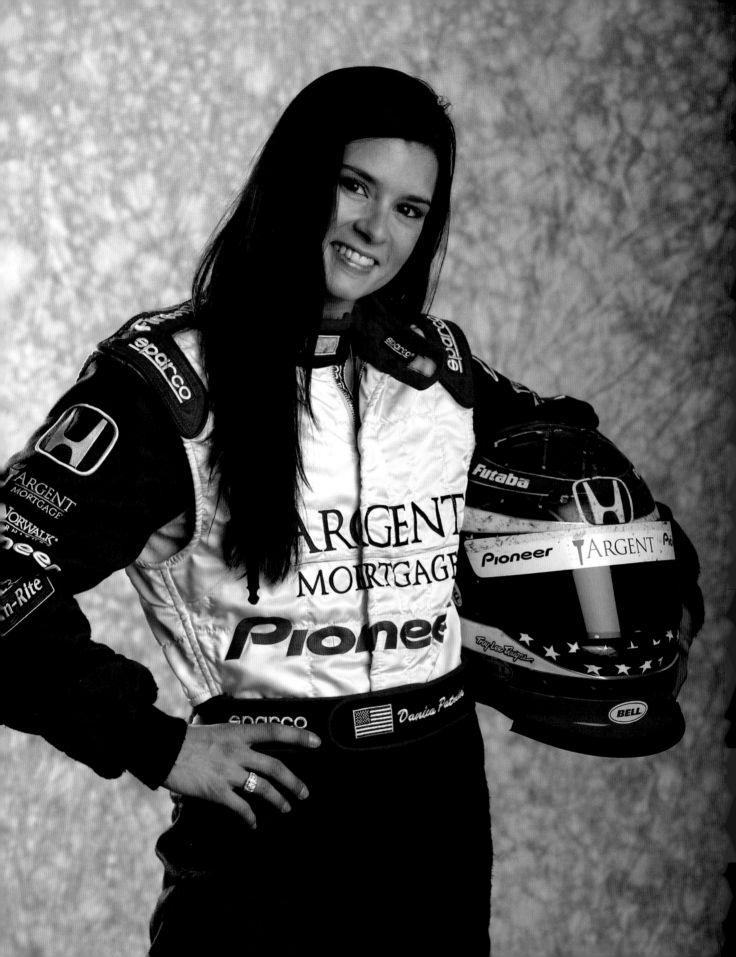

Danica PATRICK

race-car driving

anica Patrick's racing career began when she was 10. Her parents bought her and her sister go-karts, and she was immediately captivated—even after crashing head-on at 25 miles per hour into a concrete wall.

Patrick's father, T. J., thought he had killed his daughter with his gift. Her body had slammed hard into a column and she was slumped over in the car. But as it turned out, Patrick wasn't seriously hurt. "Instead, she was hooked," Lars Anderson wrote for *Sports Illustrated* in 2008.

Patrick won numerous regional and national go-kart titles, including at the track at Lowe's Motor Speedway in Charlotte when she was 13. She was in second place behind a young Sam Hornish Jr.—who would go on to win three IndyCar titles and the 2006 Indianapolis 500—as they headed into the final turn. Hornish lifted his foot off the gas, but Patrick didn't and they crashed. But she also sent a message to all her future opponents: she wasn't ever going to back down.

"I was totally going for the win," Patrick told *Sports Illustrated*. "I was going to get it or crash trying . . . I think I scared the boys, including Sam."

Eventually, Patrick dropped out of high school at age 16 and left her home in the Midwest to pursue a racing career in Europe. She was sponsored for a little while by John Mecom III, a Texas oilman, but he dropped his financial backing when he heard rumors that she was a party girl because she went out drinking with other racers. "I wasn't doing anything different than the guys were," Patrick told *Sports Illustrated*, "but because I was a girl, people started talking."

Frustrated but undeterred, Patrick's family supported her career until Bobby Rahal signed her to a three-year deal. After some impressive finishes, Rahal promoted her to his IndyCar team in 2005. That year Patrick stunned the world by leading 19 laps and finishing fourth in her first Indianapolis 500, becoming the first woman to lead laps and grab a top five finish. Three other women had qualified for the Indy 500—Janet Guthrie, Lyn St. James, and Sarah Fisher—but they weren't serious threats to win like Patrick. This was only Patrick's fifth race driving Indy cars and she'd never raced 500 miles before.

LEFT: Danica Patrick posing for a portrait during the Indianapolis 500, Indianapolis, Indiana, USA, 2005

"Moreover, the Indianapolis Motor Speedway is a notoriously difficult track for rookies," Anderson wrote. "It's narrow and the corners are only banked at nine degrees. Adding to the challenge, the event had the largest field of the year. Patrick was uncowed. 'I'm going to go out there and prove to you time and again that I belong here, that I will race up front, and that I'm a great driver and not just driving for a great team. There's a ton of stuff I need to learn, but if I catch a break here and there, don't make any mistakes, yes, I think a rookie can win.'"

Patrick could have won the historic race, but she followed instructions from her pit crew to back off to conserve fuel. Three cars passed her. "Not going for the victory in '05 is the single greatest regret of my life," Patrick told *Sports Illustrated*. "I promise you I won't ever do that again."

The media loved Patrick—she graced the cover of *Sports Illustrated* multiple times—and she was pure marketing gold for motor sports as an attractive and talented driver. Her celebrity skyrocketed despite not winning as many races as she would have liked. Little girls wanted to be her, grown men wanted to marry her, and sponsors wanted to support her. In 2008, at a race in Japan, she became the first female driver in IndyCar history to win a race.

And yet, no matter how popular she was, Patrick wasn't spared from sexist comments. "Rival drivers would tell you, while safely off the record, that she was all style and no substance," Anderson wrote, "and when she wrecked because of an aggressive move, you could often hear comments like, 'Well, it must be that time of the month.'"

In 2013, Patrick transitioned to the NASCAR Cup Series and broke more barriers with a record-setting performance in the Daytona 500. She became the first woman to win a NASCAR Cup Series pole when she set the fastest time in qualifying and then finished in eighth place, the best position ever for a female driver. In 2015, she broke the record for most top 10 finishes for a woman and currently holds the mark with seven.

Patrick retired in 2018 after racing the "Danica Double" by competing in two marquee events: the Daytona 500 and the Indy 500. She is now focused on the second act of her career as a businesswoman and entrepreneur. Patrick has launched a clothing line, written a book, hosts a podcast, is a motivational speaker, and owns a vineyard in Napa Valley.

aly RAISMAN

gymnastics

Her teammates called her "Grandma" at the 2016 Olympic Games because she was the oldest and most experienced member of the team. Aly Raisman was only 22 years old in Rio de Janeiro, but such is life in the world of gymnastics.

Raisman didn't really mind the nickname—she was a veteran, having won two gold medals and one bronze at the 2012 London Games. The Fierce Five, which included Raisman, Gabby Douglas, Kyla Ross, McKayla Maroney, and Jordyn Wieber, became the first American women's gymnastics team to win

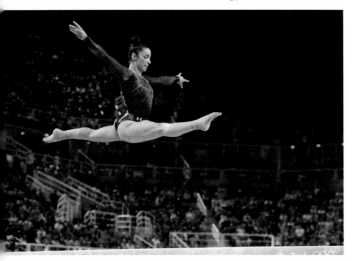

gold in the team event since the 1996 Olympics. Raisman also won a gold medal with her dazzling floor routine and a bronze on the balance beam.

Arguably more famous than Raisman at her debut Olympics were her hilarious parents, who quickly became perfect content for a *Saturday Night Live* sketch. NBC cameras caught Lynn and Rick Raisman squirming in their seats as they nervously watched their daughter perform. To NBC's delight, they were back to cheer her on in 2016. That's where Raisman captained the Final Five to another team gold medal. She also earned two silver medals, one in the all-around (behind teammate Simone Biles) and another on the floor.

Yes, Raisman won six medals, three of them gold, in two Olympics. She's also a two-time world champion. But her legacy will be defined by her leadership and activism to change the way society views women.

In January 2018, Raisman bravely and confidently read a statement confronting former USA Gymnastics team physician

Larry Nassar, who sexually abused her and hundreds of other young athletes for years while they were competing for the national team. Raisman was poised and deliberate in her words, which she read while looking directly at her abuser in the courtroom.

"Larry," Raisman said, "you do realize now that we, this group of women you so heartlessly abused over such a long period of time, are now a force—and *you* are nothing. The tables have turned, Larry. We have our voices, and we are not going anywhere."

The video of her speaking went viral. "Raisman was channeling an emotion that female celebrities are rarely allowed or encouraged to display: rage," Mina Kimes wrote for *ESPN* in 2018, after Nassar was sentenced to up to 175 years in prison. "Raw, unfiltered, incandescent rage, the sort of rage that's uncomfortable to look at, like pictures of a crime scene. Women were exhilarated. They shared the speech online and posted clips and painted quotes on signs, some of which Raisman saw afterward. When she realized how many women could relate to her story—how many women *understood* her story because it happened to them too—she was moved."

Despite her toughness, it was incredibly difficult and emotional for Raisman (and every other survivor) to use her voice to bring attention not only to what Nassar did for so many years, but also to the organizations that allowed it to happen. As Kimes wrote, Raisman started by delivering a message to Nassar, "but she finished it by pointing a blowtorch at every institution that enabled him, including USA Gymnastics and the U.S. Olympic Committee."

Raisman knows there's power in using her platform and isn't afraid to keep using it. She has traveled around the country giving interviews, speaking on college campuses, and sharing her story, which has in turn encouraged other survivors to speak out, sometimes for the first time. "There are so many people out there that are survivors, but there are few that have a voice," Raisman told *ESPN*. "I know that I'm one of the few that are being heard, so I just want to do right by people."

LEFT: Aly Raisman in action on balance beam, Summer Olympics, Rio de Janeiro, Brazil, 2016; **RIGHT:** Raisman in action during floor exercise, Summer Olympics, Rio de Janeiro, Brazil, 2016; **OVERLEAF:** Raisman and teammates posing with their Olympic medals, Summer Olympics, London, United Kingdom, 2012

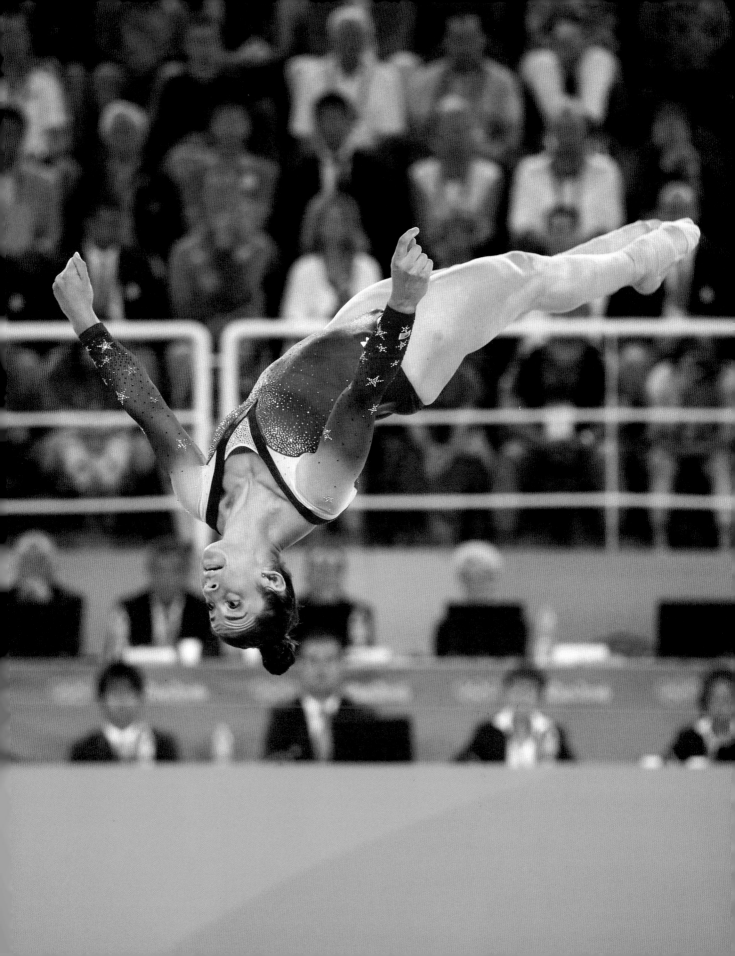

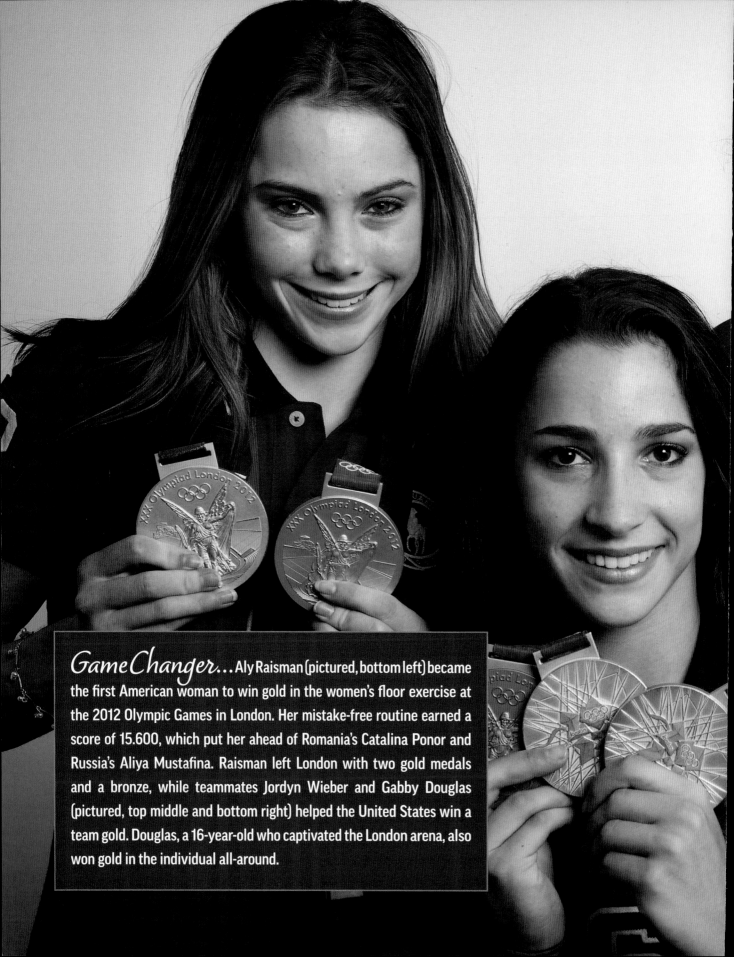

GameChanger… Aly Raisman (pictured, bottom left) became the first American woman to win gold in the women's floor exercise at the 2012 Olympic Games in London. Her mistake-free routine earned a score of 15.600, which put her ahead of Romania's Catalina Ponor and Russia's Aliya Mustafina. Raisman left London with two gold medals and a bronze, while teammates Jordyn Wieber and Gabby Douglas (pictured, top middle and bottom right) helped the United States win a team gold. Douglas, a 16-year-old who captivated the London arena, also won gold in the individual all-around.

Kikkan RANDALL

cross-country skiing

n her very last race of her very last Olympics, Kikkan Randall finally did what she'd been working her entire career toward—she won an Olympic medal. A gold medal, that is, in the team sprint free final with partner Jessie Diggins—the duo who won together at the 2013 world championships. They edged out Sweden by 0.19 seconds at the 2018 PyeongChang Games. It was the first time the United States had won a medal in cross-country skiing since Bill Koch's silver in the 30-kilometer event at the 1976 Innsbruck Games.

Randall, a five-time Olympic cross-country skier, had never finished better than sixth place in 18 tries. Better late than never, as it was at the ripe age of 35—and as the only mother on Team USA—that Randall fulfilled a lifelong dream.

It was hardly an accident that Randall got into cross-country skiing. Her father, Ronn, gave her ski boots while she was learning how to walk, and her aunt and uncle, Betsy and Chris Haines, were cross-country skiing Olympians. Randall's family lived in Anchorage, Alaska, and loved being outdoors.

Randall exuded a positive, playful, and sprightly personality and was also the ultimate competitor. She loved to dye her hair pink and paint her face for races, earning the nickname "Kikkanimal."

Randall was supposed to end America's cross-country medal drought four years prior at the 2014 Sochi Games. She came so close, lunging across the finish line in a quarterfinal sprint, only to find out she lost by a margin of 0.06 seconds.

Winning gold in PyeongChang was the perfect way to go out, and Randall retired shortly after. She gracefully ended her career after competing in five Olympics, nine world championships, and four International Ski Federation (FIS) World Cups. Randall was the first American woman to win a FIS cross-country World Cup title, crack the top three World Cup rankings, and win a World Cup title in individual and team sprint events.

Her retirement plan was to focus on her husband and then-two-year-old son. But three months later—on Mother's Day—Randall found a lump on her breast. And in July 2018 she announced on her blog that she had been diagnosed with breast cancer. "The color pink has taken on a new chapter in my life," Randall wrote with a nod to her signature hair color. She noted that her prognosis was good, but her life would change as she underwent treatment, which has included radiation and a lumpectomy.

Those close to Randall have always looked to her for strength, inspiration, and encouragement. Her mother, Deborah, told ESPN's Bonnie Ford in 2019 that the family joked that Randall "was an alien superhero . . . She doesn't let life take charge of her. She takes charge of life." For example, as Ford wrote, "no one else could have induced her brother Tanner to go running at dawn in 15-degree temperatures." As Tanner explained to ESPN, "She has a great way of inspiring—she pushes but not to the point of being obnoxious."

Throughout her cancer journey, Randall continued to inspire others by thinking positively and remembering that you can only control what you can control.

"Whenever I start to go down that road of fear of recurrence, being frustrated at what this has disrupted, at how this has altered me in ways that will never go back, I just kind of go, 'Well, we don't know,'" Randall told Ford. "I could live a long, healthy life and never have a problem with this again. Or it could crop up in a really nasty way, soon. I have to do all the things I can to give myself the best chance, but I can't control that. It's worth trying to appreciate the moments you have right in front of you, because that's what you have control of."

LEFT: Kikkan Randall posing for a portrait, Park City, Utah, USA, 2013; **ABOVE:** Randall in action during sprint free quarterfinals, Winter Olympics, Krasnodar, Russia, 2014; **OVERLEAF:** Randall in action during 4x5-kilometer relay, Winter Olympics, Krasnodar, Russia, 2014

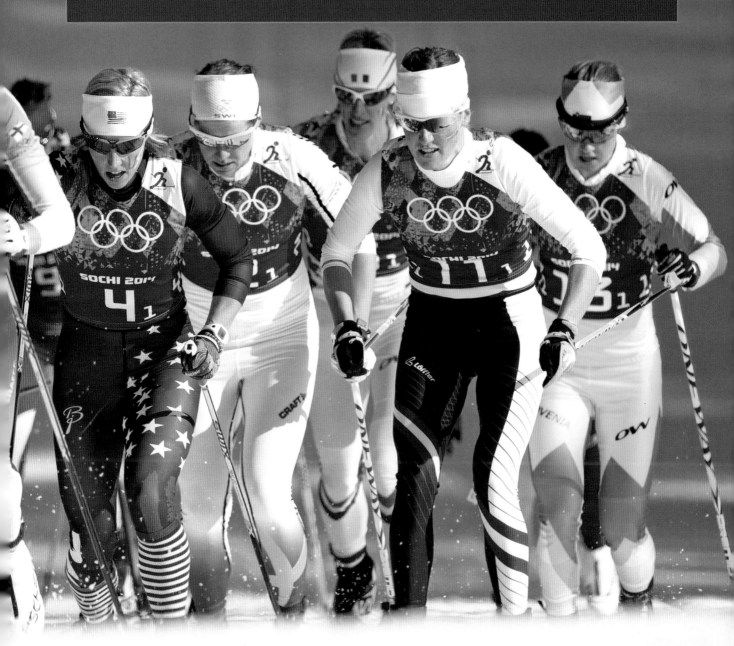

Game Changer... Kikkan Randall was poised to end America's cross-country medal drought at the 2014 Olympic Games in Sochi (pictured, wearing No. 4). She came very close, lunging across the finish line in a quarterfinal sprint only to later realize she lost by 0.06 seconds. Randall got sweet revenge four years later at the 2018 PyeongChang Games, when she and teammate Jessie Diggins won gold in the team sprint free final. It was the ideal way for Randall, who had spent her whole career training for that moment, to retire.

Megan RAPINOE

soccer

Perhaps the best way to sum up Megan Rapinoe is the way Grant Wahl did for *Sports Illustrated* after the 2019 World Cup win by the U.S. women's national soccer team (USWNT): "Rarely have we seen an athlete at the highest level talk the talk–and did [Rapinoe] ever, demanding equal pay for women players, increased investment in the women's game and greater respect for the LGBTQ and other minority communities–and then walk the walk, even with Donald Trump calling her out."

Rapinoe is a three-time Olympian (she won gold in 2012, bronze in 2021) and two-time World Cup champion, earning the Golden Boot (top scorer) and the Golden Ball (MVP) trophies after the USWNT won the 2019 final. She's a pink-haired activist who is unafraid to kneel in solidarity with Colin Kaepernick, regardless of the repercussions (and there were many). She's one of the team's clearest voices in demanding equal pay. Right before the 2019 World Cup, 28 members of the USWNT filed a gender-discrimination lawsuit against U.S. Soccer and Rapinoe was named as a plaintiff. She doesn't mind using her power to put pressure on FIFA to invest more in the women's game–she even called out its president, Gianni Infantino, on a FOX broadcast with millions watching and asked him about equal pay.

She's also the creator of "The Pose," her signature goal celebration, which caught on with NBA, NFL, and college football players. She's the first openly gay woman to pose for *Sports Illustrated*'s Swimsuit Issue, something she did to challenge hetero norms. And she had no problem standing up to Trump's criticisms on social media, responding with two goals in a 2019 World Cup semifinal win over France.

"Every team needs a Megan Rapinoe," global soccer star Alex Morgan told *Sports Illustrated* in 2019. "Both on and off the field."

Rapinoe is one of those once-in-a-lifetime athletes who is so much more than what she does on the soccer field. She's a superstar player, but she's also someone who could run for political office one day and have a legitimate chance of winning.

America was first introduced to Rapinoe at the 2011 World Cup when she scored a goal against Colombia, grabbed a corner flag, and sang Bruce Springsteen's "Born in the U.S.A." Then she had the beautiful 50-yard assist on Abby Wambach's game-winning goal in overtime that rallied the USWNT past Brazil in a tense quarterfinal. She followed that World Cup

performance by publicly coming out as gay before the 2012 Olympics. "That was the beginning of her activism," Wahl wrote.

Rapinoe, who is a fraternal twin, comes from a close-knit family who encouraged her to stand out. And she has had no problems doing just that. But when she decided to kneel during the national anthem before a NWSL game in 2016, she suffered some consequences. As Wahl wrote for *Sports Illustrated*, Rapinoe believed that she was "on the outs" with the national team in the months that followed. She wasn't called up for two friendlies and was missing on the roster for the 2017 SheBelieves Cup. U.S. Soccer issued a statement saying that it expected players and coaches to stand for the anthem. Rapinoe continued to kneel. After U.S. Soccer implemented a policy that all players were required to stand–or be suspended–she was called up for the next game and stood. It was an awkward and challenging time for Rapinoe, but she persevered while still standing up for what she believed in.

In the aftermath of George Floyd's death in 2020, some U.S. Soccer board members who originally voted to require players to stand "felt they had missed the point," according to the *Guardian*. The organization's president, Cindy Parlow, apologized to Rapinoe and U.S. Soccer later repealed the policy.

Back in 2019, after being asked too many times if the gender-discrimination lawsuit the USWNT had filed would affect the team's performance at the World Cup, Rapinoe answered by being the best player in the whole tournament. "I'm made for this," she told *Sports Illustrated* after the final. "I love it . . . To back up all those words with performances and back up all those performances with words, it's just incredible. I feel like this team is in the midst of changing the world around us as we live, and it's an incredible feeling."

Rapinoe proposed to her longtime girlfriend, WNBA superstar and five-time Olympic champion Sue Bird, in October 2020. The duo has emerged as a true power couple not only in sports, but also when it comes to fashion, media, and social issues.

The USWNT has a long legacy of brave pioneers whose goal is to leave the team better than they found it for the next generation. And Rapinoe is going above and beyond.

RIGHT: Megan Rapinoe posing for a portrait, San Jose, California, USA, 2019; **OVERLEAF:** Rapinoe posing with children at a youth soccer camp, Greenwich, Connecticut, USA, 2019

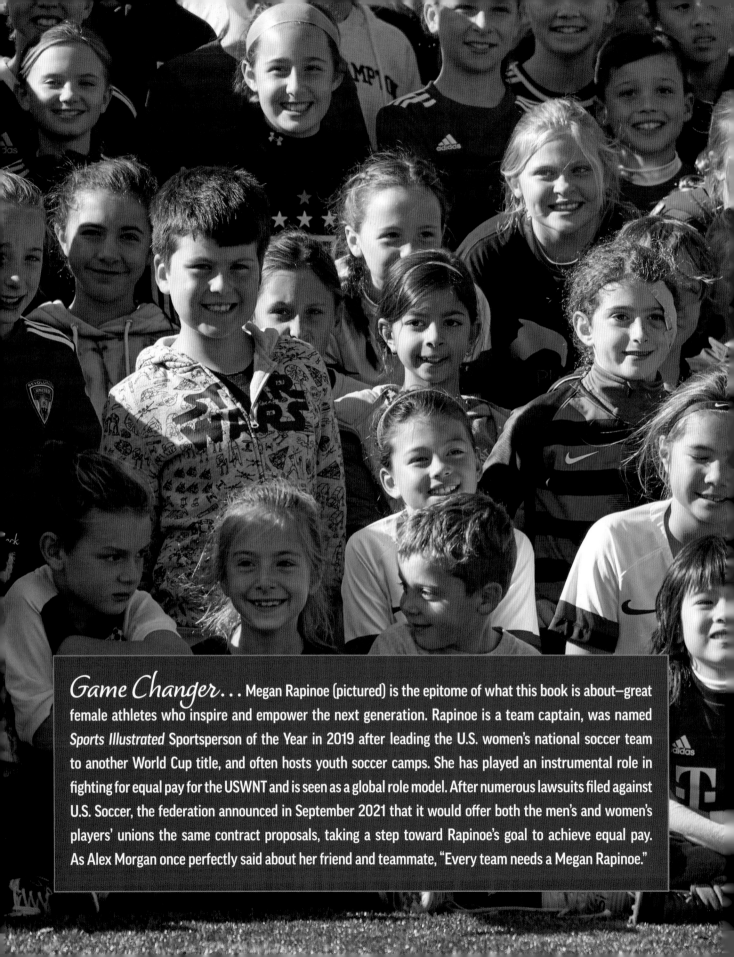

Game Changer... Megan Rapinoe (pictured) is the epitome of what this book is about—great female athletes who inspire and empower the next generation. Rapinoe is a team captain, was named *Sports Illustrated* Sportsperson of the Year in 2019 after leading the U.S. women's national soccer team to another World Cup title, and often hosts youth soccer camps. She has played an instrumental role in fighting for equal pay for the USWNT and is seen as a global role model. After numerous lawsuits filed against U.S. Soccer, the federation announced in September 2021 that it would offer both the men's and women's players' unions the same contract proposals, taking a step toward Rapinoe's goal to achieve equal pay. As Alex Morgan once perfectly said about her friend and teammate, "Every team needs a Megan Rapinoe."

Mary Lou RETTON

gymnastics

They called her "wonder girl" and "bubbly beyond belief." She was barely four-foot-nine and about 95 pounds, but overnight Mary Lou Retton became the most powerful and dominant gymnast in American history.

At the 1984 Los Angeles Games, 16-year-old Mary Lou became the first American woman to win a gold medal in gymnastics, scoring two perfect 10s along the way. In the final events of the women's all-around, Romania's Ecaterina Szabo

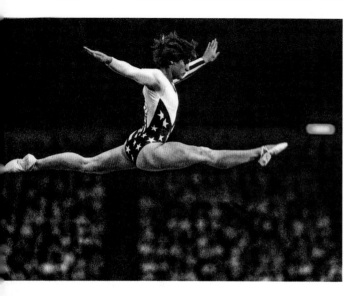

scored a 9.9 on the uneven bars, which meant that Retton would need a 10 on her vault to win gold. She had two attempts to do it and scored a perfect 10 on both.

Here's how it happened, according to *Sports Illustrated* writer Bob Ottum. Retton was the reigning American all-around champion and hadn't lost a meet in the past year and a half leading up to the Olympics. Szabo was a European junior champion, Romania's national champion, and had finished third behind two Soviet gymnasts in the 1983 world championships. With the Soviet Union boycotting these Olympic Games, the gold was Szabo's to win.

But, as Ottum wrote, Retton had prepared her own special version of the Tsukahara (a twisting layout back somersault) called the Sook, "a layout back somersault with a double twist." No other woman could do it and most men wouldn't try it.

"I knew I had it," Retton told *Sports Illustrated* then. "Listen: I knew by my run that I had it. I knew it when I was in the

air!" She landed perfectly and received a 10 from the judges. Then she got another 10 on her second run.

Retton was born in West Virginia in 1968 and was the youngest of five children, all of whom had sporty genes. For one, her father, Ron, played basketball for West Virginia University with Jerry West and then played shortstop in the New York Yankees farm system. Her siblings were successful athletes too.

Retton fell in love with gymnastics when she was eight years old and watched Nadia Comaneci at the 1976 Olympics in Montréal. "She recalls that she thought how 'lucky' Nadia was—not for winning, but for just being there," Ottum wrote. As it turned out, Comaneci's coach, Bela Karolyi, discovered Retton at a competition and started coaching her when she was 14.

Retton won five medals at the 1984 Los Angeles Games, which was the most won by an athlete during those Olympics. In her career, she was also the only woman to win three American Cups, and she won the all-around title at the 1984 national championships and at the Olympic Trials. She was also the first woman to appear on a Wheaties box.

After the Olympics, Retton was surprised by her fame and how many people recognized her. She may have made history and won Olympic medals, but she was still just a teenager.

"I mean, there were mobs of people," Retton told *Sports Illustrated*. "And the people knew me! They said things like, 'Mary Lou, you've been in our home. You've been in our living room. We feel like we know you, Mary Lou!'" She later added, "I still think it's kind of neat, too. I mean, I'd understand people recognizing me if I had purple hair or something, but I'm just a normal teenager. I'm still just Mary Lou."

Retton retired from competitive gymnastics in 1986, but remained involved with the sport and had a presence at future Olympics. She was an NBC commentator at the 1988 Olympics in Seoul and wrote a column for *USA Today* during the 1992 Barcelona Games and the 1996 Atlanta Games. She was inducted into the International Gymnastics Hall of Fame in 1997.

LEFT: Mary Lou Retton in action on balance beam, Summer Olympics, Los Angeles, California, USA, 1984; **RIGHT:** Retton in action during floor exercise, Summer Olympics, Los Angeles, California, USA, 1984

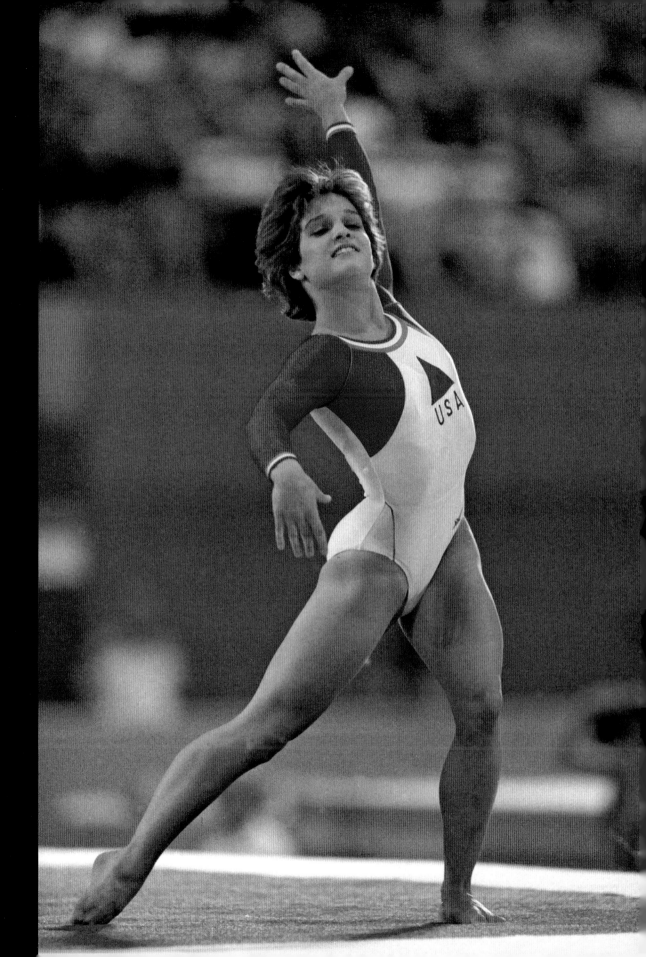

Kim RHODE
shooting

Kim Rhode has been a regular at the Olympics for decades. The American double trap and skeet shooter is a six-time Olympic medalist who became the first woman and second athlete ever to earn an individual medal in six consecutive Olympic Games (Italian luger Armin Zoeggeler is the other). Her six medals are the most all-time for a female shooter, and she is one of five athletes to earn a medal in six different Olympics.

To break it down, Rhode grabbed the world's attention as a 17-year-old winning gold in double trap at the 1996 Atlanta Games. She continued to rack up medals competing across the sport's different disciplines by winning bronze in Sydney (2000), gold in Athens (2004), silver in Beijing (2008), gold in London (2012), and bronze in Rio de Janeiro (2016).

"They all have a special meaning," Rhode told *Sports Illustrated* of her medals after the London Games, noting that the gold she won then was one of the most challenging because of all the adversity she had faced leading up to it. For example, ahead of the 2008 Beijing Games, her Perazzi MX12 shotgun was stolen from her truck, and, in 2011, she had a breast cancer scare (the tumor was benign). And she didn't know it at the time of the London Games, but she was pregnant when she won her second career gold medal.

Rhode's streak unfortunately ended. After finishing fourth in the women's trials, she did not qualify for the 2020 Tokyo Olympics (which were postponed to 2021 due to the COVID-19 pandemic). Only the top two make the team.

Rhode started shooting when she was 10, won her first national championship when she was 13, and qualified for her first Olympics by age 17. She was pretty much preordained to become the country's most accomplished shooter based on her heritage. At the 2017 World Cup, Rhode told *ESPN* about her great-great-grandfather George Ludwig Rhode, who fought in the American Indian Wars in the late 19th century.

"He was one of the 25 men handpicked by General Sibley to rescue General Custer at the Battle of Little Bighorn [in 1876]," she told *ESPN*. "The men ran into Chiefs Sitting Bull and Crazy Horse. Every time I heard the stories, the odds got bigger and bigger. But George Rhode only managed to escape after four days and eventually General Custer was killed."

Rhode grew up around guns and told *ESPN* that her father and grandfather encouraged her love for hunting and the outdoors. Despite her success—or rather directly because of it—Rhode has frequently been asked by reporters to comment on gun violence in America. Unlike many athletes who like to avoid confrontation and debate at all costs, Rhode is not afraid to talk about being a strong supporter of the Second Amendment. She's also an honorary lifetime member of the National Rifle Association.

"It's good to have conversation," Rhode told *ESPN*. "People are passionate on either side and that's a good thing."

Even though Rhode did not compete in her seventh straight Olympics in Tokyo in 2021, at age 40 she still has the desire to compete and is contemplating a return for the 2028 Los Angeles Games.

"The oldest medalist in the history of the Olympics was a shooter who was 72," she told *Sports Illustrated*, referencing Swedish shooter Oscar Swahn, who won a silver medal in 1920. "So I still have a few in me."

LEFT: Kim Rhode posing for a portrait, Los Angeles, California, USA, 2016; **ABOVE:** Rhode posing with her gold medal for skeet shooting, Summer Olympics, London, United Kingdom, 2012

Ronda ROUSEY

Ronda Rousey's fights pretty much always end the same way. As Jon Wertheim wrote about the legendary fighter for *Sports Illustrated* in 2015, Rousey likes to "take an opponent to the ground and apply an armbar, a relic from her days as a judo star. It is her go-to move . . . that entails using leverage to isolate an opponent's arm and then essentially manipulating the elbow. When an opponent/victim defiantly refuses to 'tap' (i.e., surrender), ligaments will begin popping like guitar strings. Rousey has her own imagery: 'It's like pulling a drumstick off a Thanksgiving turkey.'" With this move, Rousey transformed a sport. Dana White, president of the Ultimate Fighting Championship (UFC), always said there was no place for women in the Octagon unless they were wearing high heels and bikinis and holding up cards. But he eventually changed his mind thanks to Rousey and her skill and popularity.

Rousey made her UFC debut in 2013 and gave life to a sport that was in desperate need of a comeback. White has admitted in the past that there isn't another UFC fighter who is more valuable than her.

"The novelty of a fighting female was short-lived," Wertheim wrote. "It may have been jarring at first, watching Rousey beat the holy bejesus out of someone. But the conversation soon veered to whom she might fight next and how, in theory, she could be beaten. We got the predictable and primitive yeah-but-how-would-she-fare-against-a-dude? speculation that plods along (brontosaurus style!) when women do well in sports. But in this case, even that was a triumph in its way. In the testosterone-drenched world of cagefighting, whoever thought that the sport's alpha male wouldn't be male at all?"

Thanks to Rousey breaking barriers, the UFC added women's weight classes and more and more women got involved with the sport. "She's the reason [women] are in the UFC," former fighter Julie Kedzie told *Sports Illustrated*. "But if we're being honest, she's elevated the whole sport."

Rousey first started fighting as a kid. Her mom, AnnMaria, was the first American—male or female—to win a world judo championship in 1984. Her father, Ron, always told her she'd win the Olympics someday. But that was back when she was swimming competitively. After her father died, Rousey gave

up swimming and started practicing judo like her mom. When Rousey was 14 years old, she was invited to work out at the U.S. Olympic Training Center in Colorado Springs. That's where national team coaches learned that Rousey had no fear and would and could take on anyone.

Back home in Southern California, Rousey's mom helped her train. "I would armbar her every time she'd turn around," she told *Sports Illustrated*. Rousey hated it, but her mother was instilling invaluable skills in her daughter. "I'm doing this because I want nobody to be able to armbar you," she said. "I'm going to do this and do this until no one can catch you."

Rousey won the World Judo Championships in the under-20 division when she was 13 and became the youngest judoka at the 2004 Olympic Games in Athens, where she finished ninth. Four years later, at the Beijing Games, Rousey became the first American woman to win a judo medal when she earned bronze in the 63- to 70-kilogram division.

After the Olympics, Rousey fell on hard times and struggled to find purpose. She was done with judo and looking for something else. Eventually, a trainer told her to try out mixed martial arts (MMA). Intrigued, Rousey embarked on a new challenge. She won her MMA debut before signing a contract with Strikeforce, a UFC sister organization and the biggest circuit where women could compete. UFC would later absorb Strikeforce, and Rousey became the first woman to be crowned UFC Bantamweight Champion. She later set the record for most UFC titles and was the first female fighter to be inducted into the UFC Hall of Fame in 2018.

"She's the greatest athlete I've ever worked with. By far," White told *Sports Illustrated*. "She'll do the work of 20 male fighters. She'll bury anyone."

Later in 2018, Rousey became a professional wrestler and signed a contract with the WWE. Known as the "Baddest Woman on the Planet," Rousey won her first title at the Raw Women's Championship and has appeared in various events, such as WrestleMania 31, where she shared the ring with The Rock, Triple H, and Stephanie McMahon.

Rousey, the only woman to win a championship in both the UFC and WWE, stepped away from the ring in 2019, though it's possible she will return someday. She's married to former fighter Travis Browne and the two had their first child in 2021.

LEFT: Ronda Rousey posing for a portrait, Glendale, California, USA, 2012

Wilma RUDOLPH
track and field

Wilma Rudolph overcame polio and scarlet fever as a kid to become the "Fastest Woman in the World," winning three track and field gold medals at the 1960 Olympic Games in Rome. She was the first American woman to win three gold medals in one Olympics, which is how she earned her nickname.

Rudolph's upbringing was incredibly dramatic—so much so that NBC turned her autobiography *Wilma* into a television movie in the 1970s. Movie producer and Olympic historian Bud Greenspan said then that Rudolph "was the Jesse Owens of women's track and field, and like Jesse, she changed the sport for all time."

When Rudolph was four years old, she was diagnosed with double pneumonia and scarlet fever and nearly died. She later contracted polio, and her left leg was paralyzed. Resilient, Rudolph started hopping on her good leg when she was six and started to walk with metal braces when she was eight. By the time she was 11, Rudolph was out of her braces and started playing basketball with her brothers. Her newfound sports career was officially born.

Rudolph played high school basketball and became an all-state player—she once scored a Tennessee state record of 49 points in a game. She was a naturally gifted athlete, and her talent as a sprinter was discovered by Tennessee State University track coach Ed Temple, who encouraged her

to participate in his team's practices while she was still in high school. Rudolph was so good that in 1956, when she was 16 years old, she ran in the Melbourne Olympics, won a bronze medal in the 4x100-meter relay, and returned to high school afterward. She later received a scholarship from Temple to run at Tennessee State and made the 1960

Olympic team (Temple was the coach). In Rome, Rudolph won the 100- and 200-meter races while also anchoring the U.S. team in the 4x100-meter relay and breaking a world record.

This is how Barbara Heilman described Rudolph and her popularity for *Sports Illustrated* back then: "Her manners are of natural delicacy and sweetness as true as good weather. She tore up Rome, then Greece, England, Holland and Germany. In Cologne, it took mounted police to keep back her admirers; in Wuppertal, police dogs. In Berlin her public stole her shoes, surrounded her bus (she boarded it in her bare feet) and beat on it with their fists to make her wave. Autograph hunters jostled her wherever she went, and she was deluged with letters, gifts, telegrams and pleas that she stay where she was or come to a dozen cities where she wasn't."

Rudolph paved the way for all future Black athletes, like Florence Griffith Joyner, the next woman to win three gold medals in one Olympics in 1988, and Jackie Joyner-Kersee, who won six Olympic medals. But it wasn't just her historic Olympic medal haul that inspired future generations. Rudolph refused to attend a post-Olympics celebration back in Tennessee because the event would be segregated; the parade that was thrown for her in Clarksville was one of the first-ever integrated events in her hometown.

Rudolph, who died of brain cancer at age 54 in 1994, was voted into the National Track and Field Hall of Fame, the Women's Sports Foundation Hall of Fame, and the Black Athletes Hall of Fame, among other incredible honors. Her alma mater Tennessee State named an indoor track after her in 1988. But Rudolph, who goes down in history as one of the greatest athletes of all time, said she hoped her lasting legacy would be establishing the Wilma Rudolph Foundation, a nonprofit that promotes amateur athletics.

"The most important aspect is to be yourself and have confidence in yourself," Rudolph said. "The triumph can't be had without the struggle."

LEFT: Wilma Rudolph in action during 200-meter race, Summer Olympics, Rome, Italy, 1960; **RIGHT:** Rudolph with Galina Popova after USA-USSR Track and Field Dual Meet, Moscow, Russia, 1961

Mikaela SHIFFRIN

alpine skiing

I n a story told by *Sports Illustrated* writer Tim Layden, when Mikaela Shiffrin was six years old, her parents gave her a poster autographed by three-time U.S. Olympian Heidi Voelker. On the photo Voelker wrote, "A. B. F. T. T. B." which meant "Always Be Faster Than The Boys." This became a mantra for Shiffrin. She wrote the message on her skis, and later made it into a decal to put on her ski-racing helmet.

Fast-forward many years later and Shiffrin has lived this motto. She's a two-time Olympian and three-time medalist (two gold and one silver). At the 2014 Sochi Games, Shiffrin was 18 years old and became the youngest Alpine gold medalist in U.S. history and the youngest ever—male or female—to win in slalom. A day later, Shiffrin was already looking forward to the 2018 PyeongChang Games.

"Right now I'm dreaming of the next Olympics and winning five gold medals," Shiffrin told *Sports Illustrated*. Then she went a step further by saying, "When I'm done, I hope that I can look back and say that I changed the sport, that I pushed women's ski racing to be faster and more athletic."

In 2018, Shiffrin didn't win five gold medals, but she did earn one gold in the giant slalom and a silver in the Alpine combined. In addition to her Olympic medals, which she'll undoubtedly win more of in the years to come, she has won an American record six world championship titles, breaking records she once shared with Ted Ligety and Lindsey Vonn. She's only the second American woman (after Tamara McKinney in 1989) to win the super combined event at the World Alpine Skiing Championships. She had previously won four slalom gold medals and one Super-G, and those five titles had tied her with Ligety for the most world titles by an American. Shiffrin has won nine world championship medals in total.

This was all by the age of 25, by the way. And the most recent records came after facing adversity when her father unexpectedly died in an accident in 2020.

Shiffrin has always wanted to be the best skier in the world. She rose quickly to the top of her sport, thanks in part to training with her whole family. Her late father, Jeff, and mother, Eileen, grew up skiing. After they were married, they built their family and life around the sport. Their two children, daughter Mikaela and son Taylor, naturally developed a passion for racing with their parents as their teachers.

"It's a fundamental part of the Shiffrin origin story that her parents insist they emphasized development over race times, process over performance," Layden wrote in 2018. "Nevertheless, the results came. The kids learned skiing in the West and then both went to Burke (Vt.) Mountain Academy for high school. Taylor was good, Mikaela was a prodigy."

She made her debut on the World Cup circuit in 2011 as a 15-year-old, and then won the race two years later when she was 17. All these years later, Shiffrin is still predominantly coached by her mother.

"Mikaela lives, eats, sleeps and breathes ski racing," former coach Brandon Dyksterhouse told *Sports Illustrated*. "She wins a race, then she goes right to the gym. Mom is very driven and also very intense. You can have a coach-athlete relationship, but no one can push you like a parent."

One of the greatest stories that truly encapsulates Shiffrin and her skiing IQ happened when she was waiting her turn in a World Cup slalom race when she was 15. As Layden told it, Shiffrin was sitting next to Sarah Schleper, a four-time Olympian who was also racing that event. They were watching other racers come down the hill, which was something Schleper never liked to do because it made her nervous.

"Even at that point in my career, my confidence wasn't good enough to watch the other girls," Schleper told *Sports Illustrated* then. "But Mikaela watched them all, and she gave me this insane course report: 'Here is exactly what you have to do, right here, and here, and here.' And I went out and had one of my best races of the year. At the time, my son was four years old, and Mikaela was closer to his age than to mine. But I felt like she was a more mature athlete than I was."

When Shiffrin officially joined the U.S. ski team in the spring of 2012, she was already ranked No. 38 in the world in slalom. Rather than going to high school dances and football games, she opted to tour Europe in the World Cup with women much older than her. This life decision obviously served her well, as she is on her way to not only breaking more records and winning more medals and titles, but also doing what she always wanted to do: change the sport forever.

RIGHT: Mikaela Shiffrin in action during slalom race, Winter Olympics, Krasnodar, Russia, 2014

Annika SORENSTAM

golf

Annika Sorenstam will go down as one of the greatest—if not the greatest—female golfer of all time. In her 15-year Hall of Fame career, she broke records, won nearly every award possible, and, most importantly, left her mark on women's golf. Sorenstam, who grew up in Sweden, had a major impact on how golf is played, watched, and covered.

From 1993 to 2008, Sorenstam racked up 89 victories, including 72 LPGA wins, 10 of which were major championships. Of her many accolades, she holds the record for the number of Rolex Player of the Year awards (eight) and Vare Trophies for the lowest season scoring average (six). In 2001, she became the only woman to break 60 in an official event, for which she earned the nickname "Ms. 59." She was the first and only female to earn $20 million for LPGA career earnings, and her total of more than $22 million is nearly $6 million more than the next competitor.

In 2003, she was also the first woman since Babe Zaharias in 1945 to play in a PGA Tour event when she was invited to the Colonial in Fort Worth, Texas. Her barrier-breaking presence was met with global media attention and sexist comments.

"You'd struggle to find a dominating athlete who has done more and been less celebrated for it than Sorenstam, which has something to do with why she is playing the Colonial," Michael Bamberger wrote for *Sports Illustrated* ahead of the event in 2003. "She's not looking for attention; she's looking for a new challenge." While that may have been the case, being the only woman in a men's tournament put plenty of eyes on the women's game.

"There are plenty more people on the planet who know about Annika now than there were a month ago," her agent Mark Steinberg told *Sports Illustrated* then. "After Colonial there will be countless more. It's bittersweet that it took her accepting an invitation to play in a PGA Tour event for people to take notice of her. Her 42 LPGA victories [at that time] should have been more than enough."

Sadly, despite Sorenstam's massive success at this point in her career, Steinberg was right. As Bamberger wrote, "How many people know that in 2001 and '02 Sorenstam was the most dominant golfer in the world? The editors at *Golf for Women* magazine; the players on the insular LPGA Tour, including

Sorenstam's younger sister, Charlotta; Sorenstam's parents in Sweden, Gunilla and Tom. And that's pretty much it."

In those two years up to the Colonial, Sorenstam had played in 49 LPGA events and won 19 of them. Tiger Woods played in 38 PGA Tour events in the same period of time and won 10. She had spent years training to be the best in golf, with an intense workout regimen that included lifting weights, running, and "as many as 1,000 sit-ups a day." She changed her body and her game followed, allowing her to become bigger, stronger, and more aggressive.

While there was mostly support for Sorenstam, she endured comments from men who felt women had no business competing alongside them—much less on their pristine golf courses.

"It's an issue that she'll be taking a spot from somebody who's trying to earn a living," former golfer Frank Funk told *Sports Illustrated*, as if she wasn't also trying to earn the same kind of living.

Sorenstam persisted and continued on in her stellar career without ever giving in to those who thought she should be provocative or more charismatic or, in other words, not true to herself. "I like to let my clubs do the talking," she told *Sports Illustrated*.

Sorenstam started playing golf when she was 12 and played for the Swedish national team from 1987 to 1992. She left her home for the University of Arizona, where she was a two-time All-American and won an NCAA title in 1991. She was inducted into the Hall of Fame in 2003 and retired in 2008 to start a family, though she did serve as Team Europe's captain at the 2017 Solheim Cup.

These days Sorenstam has her hand in various business ventures. She's president and CEO of the ANNIKA brand, which combines her passions for golf, fitness, and charitable work. The company does everything from helping athletes with financial planning to designing golf courses to selling a women's golf clothing line and running a golf academy. She is also a regular analyst for NBC coverage of LPGA major championships and has her own wine label.

RIGHT: Annika Sorenstam in action during Kraft Nabisco Championship, Rancho Mirage, California, USA, 2003

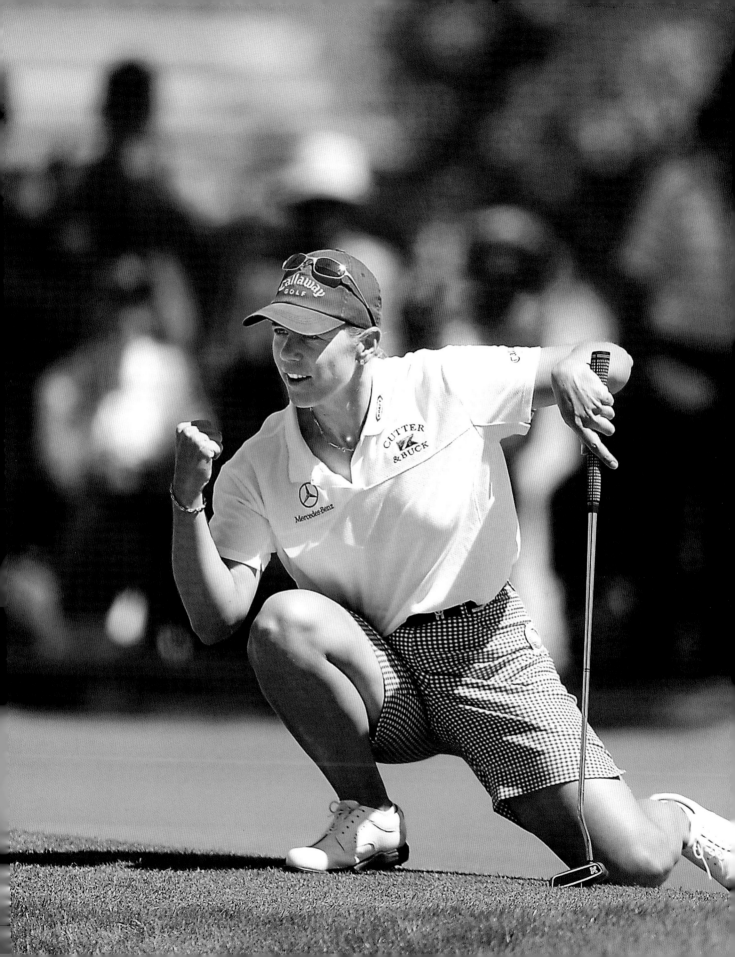

Dawn STALEY

basketball

This is how Dawn Staley described herself in a *Sports Illustrated* feature from 1990: "She's a loner. She would much rather be behind the scenes than in the scenes. And she always has a blank look on her face."

Staley, a junior at the time, was different than most college kids. She preferred staying at home to watch *Dirty Dancing* 50 times over going out and being social. But all of that changed on the basketball court.

"There Staley is transformed into a blazing allegro blur of excitement, a whirling dervish of a playmaker—very likely the best player on the best women's team in the country this year," the *Sports Illustrated* story continued. "Nobody plays with more verve and vigor—more devotion—than she does."

"The truth is," University of Virginia assistant coach Shawn Campbell told *Sports Illustrated*, "she's a different level. The things she can do, we can't coach."

That statement still holds true with everything Staley—who stood all of five-foot-five and couldn't even look most of her teammates in the eyes—has accomplished and will continue to accomplish in her Hall of Fame career. She was National Player of the Year in high school, where she won three city championships. During her four years at Virginia, Staley's teams put up a 110–21 record, went to three NCAA Final Fours, and played for a national championship. She was a two-time National Player of the Year, a two-time Atlantic Coast Conference Player of the Year, and was named Most Outstanding Player at the 1991 Final Four.

She also played point guard and took on a leadership role for USA Basketball from 1989 to 2004, where she had teammates like Lisa Leslie, Sheryl Swoopes, and Diana Taurasi. She was a two-time USA Basketball Female Athlete of the Year, a two-time International Basketball Federation (FIBA) World Championship gold medalist (1998 and 2002), and a three-time Olympic gold medalist. In fact, Staley was voted by all the U.S. team captains in 2004 to carry the American flag and lead the delegation into the Opening Ceremony of the Athens Olympics. She also played two years in the American Basketball League (ABL) and eight years in the WNBA; she was a five-time WNBA All-Star playing for the Charlotte Sting and later the Houston Comets.

She was so beloved and respected. As former teammate Jennifer Azzi put it to *Sports Illustrated* in 1996, "She was the kind of person that you would trust with your life."

Staley found her passion for basketball on the playground, competing with her three older brothers and a bunch of other boys. She learned to ignore dumb sexist comments like "You should be in the kitchen cooking" by outsmarting every guy on the court with her skill. Soon the boys figured out it would be in their best interest to have her on their team because her aptitude for the game helped them win.

"My advice to girls is to play against the guys," Staley told *Sports Illustrated* in 1990. "That gave me the heart to play against anybody. I'm glad they were rough. Guys seem to be born with basketball skills. Girls have to work to develop these skills. I don't know why. I do know basketball is my only fun. Nothing else ever interested me."

The stellar player turned into an even more stellar teacher by the time she was 30. A Philadelphia native—as well as a basketball icon by that point—Staley took the head coaching job at Temple in 2000 and turned the program around. She took the Owls—who hadn't posted a winning record since 1989-1990 and had never won the Atlantic 10 Conference—to winning four conference titles, six NCAA tournament appearances, and six 20-plus win seasons.

She left to become the head coach at South Carolina in 2008, and recently completed her 13th season with the Gamecocks. In that time she has led her team to six Southeastern Conference tournament championships, two Final Four runs, and the 2017 NCAA national title.

As her college coaching career caught fire, she simultaneously got involved with coaching the national team. Staley was an assistant coach from 2006 through the 2008 Olympics and then again for the 2016 Olympics. In March 2017, Staley was named head coach of the team she once played for.

Staley has won seven Olympic gold medals—three as a player (1996, 2000, and 2004), two as an assistant coach (2008 and 2016), and one as Team USA's head coach (2021). She is the first person to have earned both the USA Basketball National Coach of the Year and Athlete of the Year awards. In 2021, at the Tokyo Olympics, Staley also became the first person to win a gold medal as both a player and a head coach.

RIGHT: Dawn Staley posing for a portrait as Temple's coach, Philadelphia, Pennsylvania, USA, 2001

Breanna STEWART
basketball

What kind of person ruptures their Achilles tendon, undergoes surgery, goes through intense rehab, and doesn't play basketball for months only to return less than a year later and lead their team to a championship? And also be so good that they win Finals MVP? Kobe Bryant didn't even do that. But Breanna Stewart did.

Stewie, as she's called by her friends and teammates, ruptured her Achilles in 2019 while playing in the EuroLeague basketball championship game. It was the first serious injury of her superstar career, in which she was the No. 1 draft pick by the Seattle Storm in 2016 after winning four consecutive NCAA titles at UConn to go along with four straight Final Four Most Outstanding Player awards. No other player—male or female—has ever accomplished such an impossible feat. Stewart was named rookie of the year her first WNBA season and won a title in 2018, her third year in the league, after winning regular-season MVP. She was forced to miss the 2019 season and watched the WNBA Finals with her family, angry that she was injured and couldn't help her team defend its title.

And yet, one year later, amid a global pandemic, Stewart effortlessly led the Storm to the 2020 championship in the "wubble" (WNBA players and personnel were confined to playing and living in a "bubble" in Florida for the duration of the 2020 season in order to minimize the risk of spreading COVID-19). She was also a contender for regular-season MVP and the unanimous choice for Finals MVP. Only four other players in WNBA history have two Finals MVP awards: Cynthia Cooper, Lisa Leslie, Diana Taurasi, and Sylvia Fowles.

Stewart admitted after her injury that she wasn't sure if she was going to come back and play at the same level. She came back better, which is not surprising for a generational talent who was also the youngest member of the gold medal–winning team at the 2016 Rio de Janeiro Olympics. In 2021, she won a second straight gold with Team USA in Tokyo.

As she has morphed into a global superstar, Stewart has grown more comfortable using her platform to create awareness about issues that are important to her. In 2017, she joined the #MeToo movement by publishing a powerful essay in the *Players' Tribune* where she detailed years of sexual abuse when she was a child. She also decided to take part in the *ESPN* Body Issue to prove to others that they should be comfortable in their bodies. "It's hard to open up and tell your story, but it's worth it," Stewart told *ESPN* in 2018. "I've really embraced myself—being tall, understanding my body—and also the story that my body portrays."

Stewart has also been a leading voice when it comes to WNBA players advocating for social justice. During the 2020 season, she and her peers brought attention to violence against Black women and dedicated their WNBA season to Breonna Taylor. And it was Stewart who stepped up in front of everyone before the first game and asked for 26 seconds of silence to remember Taylor. Stewart participated in Black Lives Matter protests in Seattle and is unafraid to speak her mind about police brutality on social media, where she has nearly 100,000 followers on Twitter and more than 250,000 on Instagram.

Stewart has shown unwavering support for equality in all forms and called out the media for its lack of women's sports coverage when she won the 2016 ESPY Award for Best Female Athlete. And for that, she was one of five athletes chosen as *Sports Illustrated*'s 2020 Sportsperson of the Year. Her good friend Megan Rapinoe wrote about her for the magazine.

"Stewie is part of a new wave of sports activists, where it's just a given that as a white player she's going to stand up and talk about racism and equality and Black Lives Matter," Rapinoe wrote. "It's a given that she's going to say the hard things, that she is going to use her platform for good. And that gives me a lot of happiness and pride. Because the more we talk about these issues, the easier it is to talk about them. The bigger the conversation is, the less we have to talk about why it's important—and the more we can talk about the actual issues."

We always knew Stewart was going to be a great basketball player. Growing up in Syracuse, New York, she won two state championships, was National Gatorade Player of the Year, and was a McDonald's All-American. At UConn, her teams went 151–5 and won four NCAA titles. She remains the Huskies' second all-time leading scorer (2,676 points in four years) behind Maya Moore. She was a No. 1 draft pick, a two-time WNBA champion, a two-time All-Star, a two-time Olympic gold medalist . . . the list goes on, and undoubtedly will keep growing.

LEFT: Breanna Stewart posing for a portrait at UConn, Storrs, Connecticut, USA, 2016

Picabo STREET

alpine skiing

Picabo Street made quite a name for herself. As a three-time Olympian and two-time medalist, including one gold, she was the fastest, most dominant downhill skier of her era. She had nine World Cup downhill wins and was a three-time world champion. She was obsessed with speed and always moved fast, whether she was on the slopes or getting pulled over by a police officer.

Street was born to hippie parents named Stubby and Dee, who initially named her "Baby Girl." It was only three years later—when her family needed to travel internationally and passport officials didn't quite understand her name—that she was renamed Picabo, after a nearby town. (The name means "shining waters" in the language of the Native American tribe that once inhabited the region.) If that sounds like a strange story, well, her older brother was named "Baby Boy" before being renamed Baba Jomo. So he actually drew the short straw on memorable names.

Street grew up in a small Idaho town and wasn't allowed to watch television until she was 14. She was a tomboy and looked up to her brother. She liked to box and play football with the boys. "Kids would ask, 'Do you have a doll?'" Street told *Sports Illustrated*'s Michael Farber in 1995. "I'd say, 'No, I have a BB gun.'"

She started skiing when she was six. By age 10, Street was competing against and beating older skiers. She made the U.S. ski team when she was 17, but ran into trouble. Street didn't like to follow rules and had a bad attitude. She preferred partying over training. She was also a high school kid. U.S. ski coaches kicked her off the team because they felt she was lazy and out of shape, which ended up serving as a wake-up call. Street worked hard to return to the team six months later.

Street won her first race at the 1993 world championships, but didn't truly become an American sensation until she won a silver medal in the downhill at the 1994 Olympic Games in Lillehammer. Street followed that up by winning two World Cup titles in 1995 and 1996, plus a world championship in 1996. She was riding high at the top of her sport, getting endorsement deals and becoming an instant role model for the next generation.

"Street is a magnet for girls, who look at the strawberry-blonde braid, the freckles, the moon face, and see an older version of themselves," Farber wrote. "She gravitates to kids and kids to her. [Jay] Leno and [David] Letterman wanted her when Street returned from the Lillehammer Olympics with a silver medal. But instead of *The Tonight Show*, Picabo appeared on *American Gladiators* and *Sesame Street*."

And then she tore her ACL during a training run in Vail, Colorado, which required surgery. Usually it takes skiers two years to recover from an injury like that, but Street had her sights on competing in the 1998 Nagano Games. "When it comes to physical challenges," Street told *Sports Illustrated*, "I rarely doubt myself."

She rehabbed and came back one year later only to crash at the end of a pre-Olympic race. She suffered a concussion, but overcame that adversity too, and was able to go to Japan. While it turned out that Street wasn't fully recovered—she still had headaches—she won a gold medal in the Super-G in Nagano.

Street faced more tough times that season when she crashed into a fence going 70 miles per hour during a World Cup downhill race in Switzerland, breaking her left leg and tearing her right ACL. It took 45 minutes to get her down the mountain and longer for painkillers to kick in.

"I could've died up there," Street told *Sports Illustrated*. "I was losing blood. The pain was so intense. It was like somebody was inside my leg with a blowtorch. But I think I lay there all that time for a reason: I think I needed to be kicked in the teeth, woken up to how bad it can get."

And yet Street was back racing again in 2000. She wanted to go to the 2002 Olympics in Salt Lake City and hoped to become the first U.S. skier to win a medal in three consecutive Olympics. But she didn't come close, finishing 16th in the downhill. Street decided to retire from competitive skiing afterward.

Rick Reilly described her retirement at 30 years old like this: "If you know Picabo, your jaw just hit your cereal bowl. It'd be like a tiger walking up to you, stepping out of its skin and saying, 'That's it. I quit. I don't even like to hunt.'"

But, as Reilly concluded, calling it quits was actually the right example to set and the smartest thing she could do for her body.

RIGHT: Picabo Street celebrating after winning gold medal in Super-G race, Winter Olympics, Hakuba, Japan, 1998

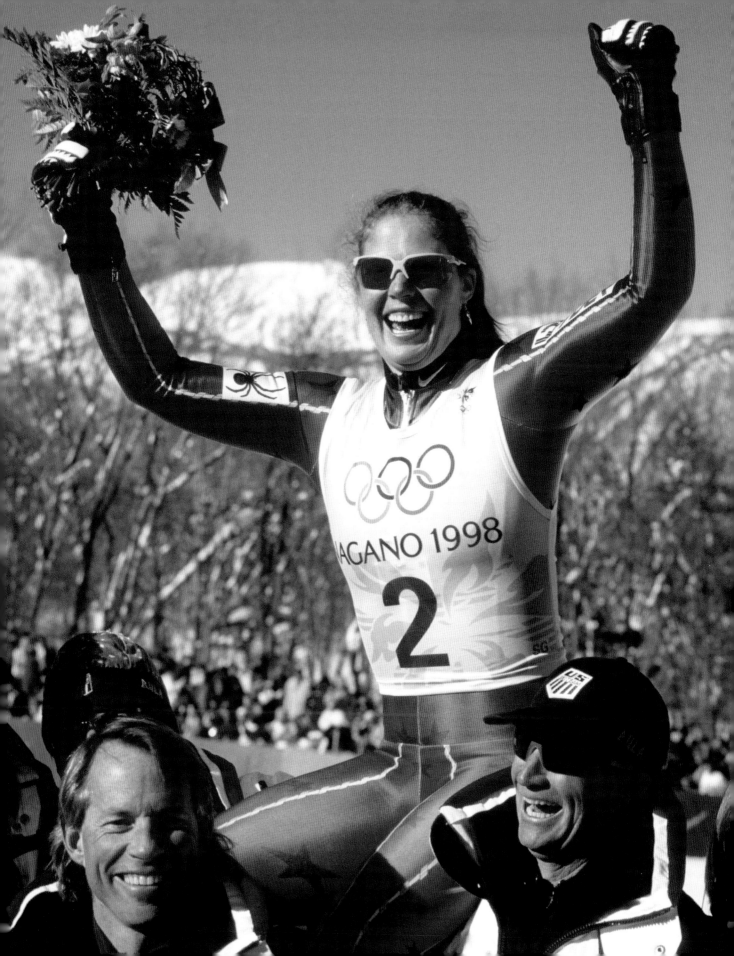

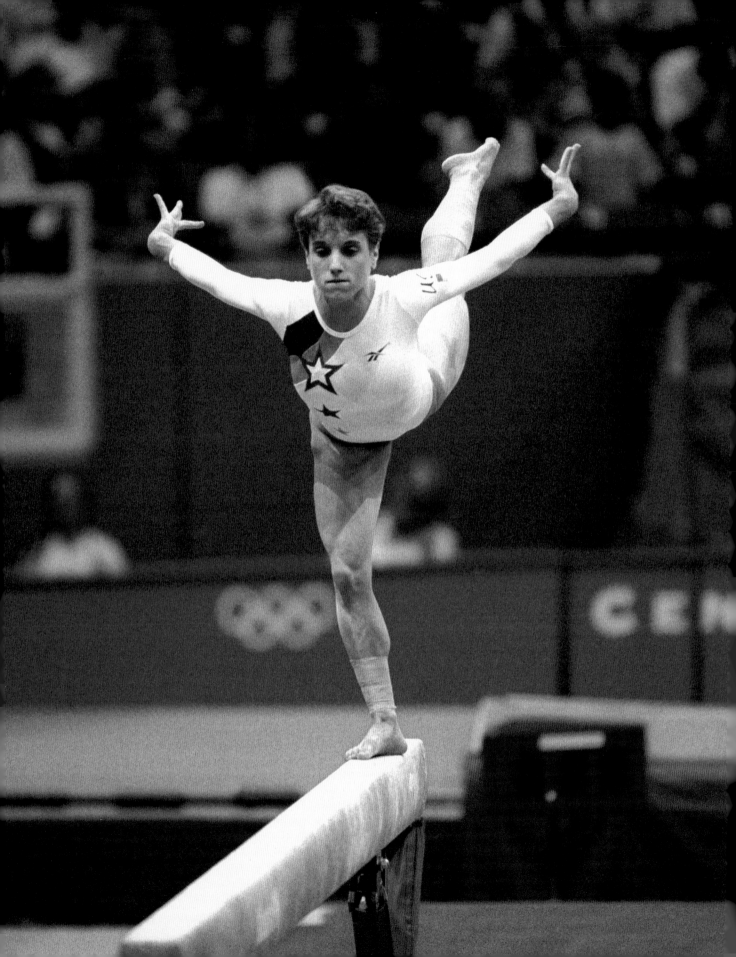

Kerri STRUG

gymnastics

A *Sports Illustrated* headline from 1996 said everything you needed to know about American gymnast Kerri Strug: "True Grit." Which is ironic, because this is how former USA Gymnastics coach Bela Karolyi described the four-foot-nine, 87-pound gymnast to the magazine back then: "She is just a little girl who was never the roughest, toughest girl, always a little shy, always standing behind someone else."

But Strug wasn't standing behind anybody when she became an overnight sensation and an American hero at the 1996 Olympic Games in Atlanta.

It was the final rotation of the gymnastics team event and only Strug was left to compete in the vault. Her Magnificent Seven teammates had faltered and it was up to her to land at least a 9.6, according to Karolyi's math, to hold off the Russians. Strug landed on her heels, staggered back, and crashed on her first vault. Her left ankle rolled, she heard something snap, and her leg went numb.

It took the judges about a minute to score her first vault and then, according to *Sports Illustrated* writer Jane Leavy, she had 30 seconds to decide what to do. Karolyi was yelling, "You can do it! Shake it out!" and thousands of fans were cheering for her inside the Georgia Dome. Strug was in massive amounts of pain, but thought about how she missed the all-around finals at the 1992 Barcelona Games. She was not going to live through that experience twice.

And so she went for it. It was a moment of ultimate sacrifice and athletic heroism, the epitome of what it means to take one for the team.

On her second vault, Strug sprinted down the runway, flew over the horse, and stuck her landing with an agonizing grimace on her face. She hopped on her good foot, found the strength to raise her arms to complete the vault, and then collapsed on the mat. The judges gave her a 9.712, which helped the United States win gold. She had done it—the pain was totally worth it. (It was later revealed that Karolyi's math had been wrong and the Americans didn't even need Strug to win. But nobody knew that at the time.)

LEFT: Kerri Strug in action on balance beam, Summer Olympics, Atlanta, Georgia, USA, 1996; RIGHT: Strug after landing on injured ankle during vault, Summer Olympics, Atlanta, Georgia, USA, 1996

Strug was in tears as she was helped off the floor. She was diagnosed with a third-degree ankle sprain. The plan was to go to the hospital, but Strug would not leave the Georgia Dome until she received her gold medal alongside her Magnificent Seven teammates.

That prompted one of the most famous Olympic scenes in history when Karolyi cradled the tiny gymnast in his arms as she waved to the crowd while fighting back tears. He carried her to the podium so she could stand with her team as gold medals were placed around their necks and the national anthem blared.

After the Olympics, Strug retired from gymnastics and enrolled at the University of California, Los Angeles, where she discovered a newfound love of running. She has run several marathons, including New York, Boston, and Chicago. Strug later transferred to Stanford and then moved to Washington, DC. She worked in the Treasury Department and then served as a program manager in the Office of Juvenile Justice and Delinquency Prevention, which is part of a team that awards federal grants to programs geared toward helping at-risk youth.

Strug also wrote a children's book called *Heart of Gold*, with some proceeds going toward the Special Olympics, as well as an autobiography called *Landing on My Feet*. She got endorsement deals, including one from ACE bandages, which were used to wrap her ankle after her vaulting injury. She went on tour with other Olympians, the Ice Capades, and *Walt Disney's World on Ice*, and appeared in cameos on various popular TV shows. She graced the cover of *Sports Illustrated* and a Wheaties cereal box, and was invited to President Bill Clinton's 50th birthday party.

While Strug now lives a much more normal and relaxed life, free of the regimented schedule of gymnastics, she remains an inspiration to young gymnasts everywhere dreaming of their Olympic moment.

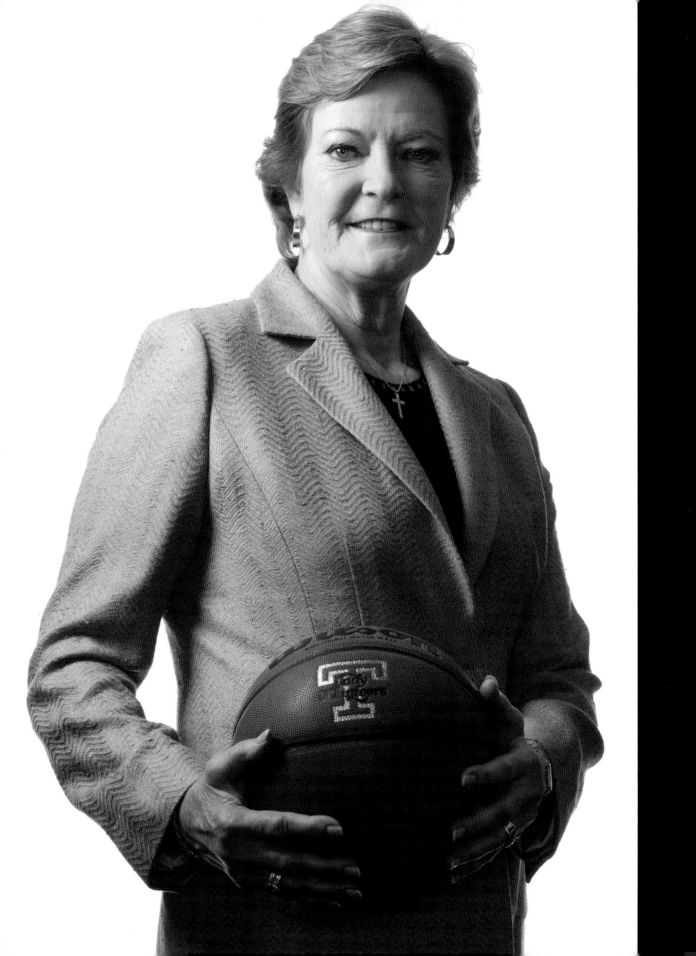

Pat SUMMITT

basketball

When we think of Pat Summitt, we immediately think of her legendary coaching career and the eight national championships Tennessee won. We think of how she empowered women and the relationships she had with her players. How she invested so much time and energy getting to know them and learning their values and hopes and dreams. With her piercing crystal-blue eyes, she could be intimidating, but also an incredible mother figure to her players.

"What I remember the most are the times when just she and I were in the office talking," Candace Parker wrote for *Sports Illustrated* in 2009 after Summitt became the first Division I basketball coach to win 1,000 games. "Her door was always open. Coach always remembers birthdays, cares about feelings and wants her athletes to succeed. I sometimes did not understand her logic, but now that I am out in the real world, I see that there was a method to her madness. Everything she did was to make me a better individual."

Summitt "grew up on a farm in Montgomery County, Tennessee, with three older brothers and no girl her age for miles around," Alexander Wolff wrote in his Sportswoman of the Year piece from 2011. The kids played two-on-two basketball in the hayloft after their chores—like milking cows and bailing hay—were done.

Summitt's whole life was about proving herself to her father, Richard, whose nickname was "Tall Man" (he was six-foot-five). He didn't know what to do with a daughter. "He raised me like a combination of a fourth son and an extra field hand. If I made a mistake, I got whipped. If I cried, I got whipped harder," Summitt told *Sports Illustrated*.

So she learned not to cry. She feared her father, but she also respected him. Her mother, on the other hand, was loving and nurturing. Summitt learned from both her parents and incorporated those qualities into her career.

Summitt's father understood how important basketball was to his daughter. For example, the high school in Clarksville dropped its girls' basketball program right before Summitt started attending, so the family moved to a new home in a new town just so she could play basketball. Summitt went on to play at the University of Tennessee at Martin (UT Martin), where she

starred from 1970 to 1974, and was a member of the program's most successful team, which went 22–3 in 1972–1973. She still holds a bunch of program records. Immediately after graduating, Summitt was named a graduate assistant coach at Tennessee. Soon after that, she was elevated to head coach when the previous one resigned. She coached her first game on December 7, 1974, six weeks before her 22nd birthday.

With zero coaching experience, Summitt taped ankles, washed uniforms, swept floors, and drove the team van, according to Wolff. She made players run suicide line drills. She also taught three physical education classes, worked to get her master's degree, and rehabbed an ACL she tore during her senior year at UT Martin. She stayed in basketball shape—running suicides herself and shooting hoops during the course of two-hour workouts at night—because she wanted to play in the 1976 Montréal Games, where women's basketball would make its Olympics debut. She made the team—at 24, she was the oldest player—and helped the United States win a silver medal.

Seven months later, she took the Lady Vols to the Final Four in her third year as coach. At Tennessee, Summitt "figured out how to frame criticism as a challenge, to bring out the competitor in each [player]," Wolff wrote. Eight years after that, as the national team coach, Summitt led the United States to a gold medal at the 1984 Los Angeles Games. She became the first person in USA Basketball history to win an Olympic medal as both an athlete and a coach.

Summitt announced in August 2011 that she was diagnosed with early onset Alzheimer's disease and stepped down as Tennessee's head coach. In 38 seasons, her teams won 1,098 games and eight national championships, and posted so many other impossibly crazy stats. "Since 1976 every Lady Vol to stay four years has reached at least one Final Four," Wolff wrote. "Nearly three of every four can claim some individual distinction, be it Olympian, All-America, All-SEC or All-Academic, while 74 players and staff have gone on to coach in their own right."

Her decision to go public with her Alzheimer's diagnosis was courageous. She added to her already one-of-a-kind legacy by bringing attention to the disease with the hope that it would create awareness and raise money for research. Summitt passed away in 2016.

LEFT: Pat Summitt posing for a portrait as Tennessee's head coach, Knoxville, Tennessee, USA, 2011

Sheryl SWOOPES
basketball

Her name doesn't just rhyme with hoops; it's synonymous with it. That was the theme of Kelli Anderson's *Sports Illustrated* story in 1993, when Sheryl Swoopes, then a senior at Texas Tech, scored 47 points in a thrilling 84–82 victory over Ohio State to win the national championship. Her points were the most ever scored in an NCAA national title game—women's or men's—and she still holds the record, topping Bill Walton's 44 points in 1973.

It was a big year for Swoopes, who scorched Texas with 53 points in the Southwest Conference tournament championship game a few weeks prior. She broke the Dallas Reunion Arena record of 50, which was shared by Larry Bird and Bernard King. She won basically every award in college, too, including being a two-time First Team All-American, Naismith College Player of the Year, and, unsurprisingly, earning NCAA Final Four Most Outstanding Player in 1993.

This was just a taste of what she would do as a pro playing for the Houston Comets. Swoopes, Cynthia Cooper, and Tina Thompson made up one of the most famous WNBA trios, creating a dynasty by winning four straight WNBA championships from 1997 to 2000. She was also a three-time MVP, six-time All-Star, and three-time Olympic gold medalist.

Unfortunately for Swoopes and her peers, though, the WNBA didn't exist when she graduated college. It was the first time Swoopes realized that being a female basketball player was different than being a male player. She'd been told that if she were a man, she probably would have been drafted in the lottery. Instead, she had to play in Europe and wait for the WNBA to launch in 1996. She became one of the first players to sign a contract.

Swoopes, who was inducted into the Basketball Hall of Fame in 2016, actually had to miss her first WNBA game because she was pregnant. She gave birth to her son four days later. But she was so determined to get on the court that she was back playing six weeks after he was born.

Swoopes developed a passion for basketball early on. She was a star player growing up in West Texas and had two older brothers who she always wanted to play with—even if they weren't as interested in playing with her. The boys at school weren't either. "In high school she would hang around the gym during the boys' pickup games, hoping they would come up one player short," Gerry Callahan described in a 1996 story for *Sports Illustrated*. "Who else can we get? The girl, someone would say. What about the girl? She would join the game, but the boys would play as if she weren't on the floor."

"The only time I got to shoot was if I got the rebound and dribbled the length of the court myself," Swoopes said. "It's always been that way. It didn't matter how good I was. It was always, 'You're a girl. You can't play with the guys.' It's always been motivation for me."

"Sometimes I just wanted her to come in and play with dolls. But right from the beginning she wanted to prove she could keep up with the boys," said Swoopes's mother, Louise.

Because of her talent and skill, Swoopes was often compared to Michael Jordan. In fact, Nancy Lieberman once called her "the female Jordan." Jordan himself was impressed with Swoopes and once invited her to work his basketball camp in Chicago. "That's the greatest compliment I've ever received because Michael has always been my idol," Swoopes told *Sports Illustrated*.

Swoopes—or "Her Airness," as she was also called—became the first person after Jordan to have a Nike shoe bearing her name. The Air Swoopes launched in 1996, following her performances in the NCAA national title game and the Olympic Games in Atlanta. "My Nike deal has done so much for women's basketball," Swoopes told *Sports Illustrated*. "Now every player on the national team has a shoe contract. Can you imagine that having happened five years ago? It wouldn't have."

While Swoopes broke down those barriers for women, there still haven't been many WNBA players with signature shoe deals, outside of Sabrina Ionescu's deal with Nike, Candace Parker's with Adidas, and Breanna Stewart's with Puma. But even those deals wouldn't have happened without Swoopes. She was the one who made it—and more—possible for women.

"She's where it all started," Rebecca Lobo told *Sports Illustrated*. "She's the first one to have a real recognizable name in women's basketball."

RIGHT: Sheryl Swoopes in action during semifinals, Summer Olympics, Athens, Greece, 2004

Junko Tabei always downplayed her achievements. For example, rather than tell people she was the first woman to climb Mount Everest, she would say, "I was the 36th person to climb Everest," according to a 1996 *Sports Illustrated* story.

That way of thinking was ingrained in Tabei's psyche growing up in Japan, where women were supposed to stay at home and raise children while men worked. Never one to play to those social norms, Tabei spent her life defying such expectations by climbing the tallest mountains all over the world.

Tabei climbed Everest in 1975 with a group of four women (and six Sherpas) who were part of a group she had founded a few years earlier. Tabei created the Ladies Climbing Club with the idea that women should lead their own expeditions. The group went on its first trip together in 1970 to Annapurna III. After that Tabei was focused on Everest, where there was a four-year waiting list. She and her group of climbers spent the years in between training and lining up sponsorships, which was difficult for women. "Most companies' reaction was that for women, it's impossible to climb Mount Everest," Tabei told *Sports Illustrated*. She did end up getting help from the Tokyo newspaper *Yomiuri Shimbun* and from Nihon Television.

Tabei left her three-year-old daughter at home with her husband and went to Nepal with her all-female climbing team in the spring of 1975. At 9,000 feet, they were hit by an avalanche and Tabei was buried and knocked unconscious. She had to be pulled out from under the snow and debris by the Sherpas. Miraculously, everyone in the group survived. Tabei was slightly injured and couldn't walk for the next two days, but she was determined to reach the summit.

Twelve days after the avalanche, "Tabei clambered on battered hands and knees to a spot she described as 'smaller than a tatami mat.' She turned her back on the stormy edge of Nepal and peered down at a tranquil valley in Tibet, China. Junko Tabei had become the first woman to reach the summit of Mount Everest," Robert Horn wrote for *Sports Illustrated* in 1996. Tabei felt no elation though. She was in too much pain. "All I felt was relief," she told the magazine.

LEFT: Junko Tabei posing for a portrait in the mountains, Kathmandu, Nepal, 2003

Tabei was born in the small Japanese town of Miharu, Fukushima, in 1939, the fifth daughter in a family of seven children. She fell in love with climbing when she was 10 after a teacher took her class to climb Mount Asahi and Mount Chausu.

Tabei's climbing aspirations were not considered appropriate for a young Japanese woman. After graduating college in 1962, she joined several clubs that were mostly for men—and sometimes they didn't want to climb with her. And yet, the four-foot-nine Tabei became a mountaineering giant anyway.

Naturally, publicity came with the territory after she climbed Everest. Horn wrote that the king of Nepal sent congratulations, her name appeared in newspapers and textbooks, and she was even honored by the Japanese government. She became the subject of a TV miniseries and toured around Japan making appearances.

Tabei fulfilled her dream of climbing the Seven Summits, becoming the first woman to do so. After Everest, she conquered Tanzania's Kilimanjaro in 1980, Argentina's Aconcagua in 1987, the United States' McKinley (now called Denali) in 1988, Russia's Elbrus in 1989, Antarctica's Vinson Massif in 1991, and Indonesia's Carstensz Pyramid in 1992. In all, she scaled 69 major mountains.

In 2002, Tabei went back to school to study ecology and dedicated herself to protecting and preserving the environment. She became an activist, focusing her research on the environmental degradation of Everest, which was due to heavy climbing traffic. She served as a director of the Himalayan Adventure Trust of Japan, a group that was instrumental in building an incinerator on the mountain for climbers' debris. Tabei also participated in regular "clean-up climbs" in Japan and the Himalayas and helped victims after the earthquake and tsunami that rocked Japan in 2011.

Tabei inspired generations of young girls and women. Since her remarkable quest, 635 women have reached the summit of Mount Everest. "There was never a question in my mind that I wanted to climb that mountain, no matter what other people said," Tabei told the *Japan Times* in 2012.

Tabei was diagnosed with cancer in 2012, but kept climbing until her body couldn't anymore. She passed away in 2016, at age 77. She will always be remembered as a pioneer who made the mountains an inclusive environment for women.

Diana TAURASI

basketball

Diana Taurasi is on the short list of the greatest women's basketball players of all time. She's a three-time WNBA champion and a former No. 1 overall pick by the Phoenix Mercury. She's a three-time NCAA national champion and was a two-time Naismith College Player of the Year at the University of Connecticut (UConn). She's a former rookie of the year, a nine-time WNBA All-Star, a six-time EuroLeague champion, and a two-time WNBA Finals MVP. She also won league MVP once, though it probably should have been more. She was the basis for the WNBA logo and is known as the "White Mamba," a nickname bestowed upon her by the "Black Mamba" himself, Kobe Bryant. And she's a five-time Olympic gold medalist. In fact, Taurasi and former college teammate Sue Bird are the first basketball players ever to win five Olympic gold medals, solidifying the duo, as their UConn coach Geno Auriemma told ESPN, as "the greatest teammates in the history of sports."

Her bio could go on for pages and pages of statistics and awards. Teammates have called her "ferocious." Auriemma has described her as "all the things you do not want to compete against. But she's also all the things you want in a teammate."

"The quality Taurasi shares most with, say, Michael Jordan is that she hates to lose," Michael Bamberger wrote for *Sports Illustrated* in 2003 after Taurasi led UConn to three straight NCAA titles. "For good or for bad she turns games into wars. You can't readily see it, because she masks her attitude with Magic Johnson's joie de basketball. Still, chances are good that you will lose to Diana Taurasi in H-O-R-S-E, or in arm wrestling, or in John Madden 2003 PlayStation football. Pretty much, you're not going to beat her at anything."

In 2003, UConn was 85–3 since Taurasi had arrived on campus in the fall of 2000. She finished her four years there with a 139–8 record, which included a 70-game winning streak.

After Taurasi led the Mercury to the 2009 WNBA title, scoring a game-high 26 points and making four of her last five three-point attempts, Jack McCallum wrote this about her for his *Sports Illustrated* Sportsperson of the Year nomination: "That's what she does. It's part of the cutthroat brio that defines her. She's the same way off the court, aggressive, open-minded, free with her opinions."

Taurasi's father, Mario, was born in Italy and raised in Argentina, and her mother, Liliana, was born and raised in Argentina. Their daughter was born in California, spoke Spanish, picked up basketball in the fourth grade, and became one of the most sought-after high school players in the history of the women's game. Despite her mother's initial wishes for her daughter to stay closer to home, Taurasi traveled 3,000 miles across the country to Connecticut for college because she knew she had to play for Auriemma. He would challenge her in ways she'd never experienced.

When she enrolled at UConn, Auriemma told her that she could be the best player ever, according to a story Frank Deford wrote for *Sports Illustrated* in 2003. Her sophomore season, UConn went 39–0 and she played alongside four other senior starters who would be taken in the top six of the WNBA draft, including No. 1 overall pick Bird. The next season, she was the lone returning starter on a team full of inexperienced players. She led them to a title anyway.

Taurasi has played her entire pro career for the Phoenix Mercury. She is the only player in WNBA history with at least 9,000 career points, 1,500 rebounds, 1,500 assists, 1,000 three-point field goals, and 300 blocks. Only 10 NBA guards can say the same for themselves, with James Harden as the only other active player.

Taurasi, who is married to former teammate Penny Taylor and has a son, headed into the 2021 season approaching age 40 with various injuries but no plans to retire. She told ESPN she'll know when it's time to call it quits: "I say this to a lot of my good friends: 'The minute you see that I suck, tell me and I'm out.' Instead of lying to me, someone let me know!"

Until then, she has no desire to stop playing the game she loves. "People ask me what I want to do after basketball," Taurasi told ESPN in a 2020 interview. "I'm doing basketball right now. I'm doing everything I can to be on the court. Not to be in the front office, not to coach. My sole objective is to be on the court and to be badass."

RIGHT: Diana Taurasi in action during preliminaries, Summer Olympics, Athens, Greece, 2004

Jenny THOMPSON

swimming

Jenny Thompson was once called the "grande dame of swimming." She won 31 world championships, 23 national titles, and 26 NCAA championships swimming for Stanford. She's a four-time Olympian and an eight-time gold medalist (her total Olympic medal count is 12). She set 15 world records, including one in the 1992 Barcelona Games in the 100-meter freestyle and another one seven years later at the 1999 world championships in the 100-meter butterfly. She nearly made it to the 1988 Olympic Games in Seoul when she was only 15.

But what Thompson is doing in her post-competitive swimming second act makes her even more impressive.

In 2001—after competing for the United States in three Olympic Games and graduating from Stanford with a BA in human biology—Thompson retired from swimming and went to medical school at Columbia University. She couldn't stay away from the pool for too long though. She jumped back in for her mental health. She needed a stress reliever from school and caring for her mother, who was battling cancer.

She took a year off from medical school and returned to Team USA, where she won five medals at the 2003 world championships in Barcelona and two more at the 2004 Olympics in Athens. Thompson earned her medical degree in 2006 and currently works as an anesthesiologist at the VA Medical Center in Charleston, South Carolina, where she worked on the front lines during the height of the COVID-19 pandemic.

In March 2020, Thompson was concerned that her hospital didn't have enough personal protective equipment—such as gloves, face shields, and masks—so her friends and former teammates Gabrielle Rose and Lea Maurer created a GoFundMe called "Go Jenny Go" to support getting more supplies. It took off with friends, family, and the international swimming community. According to the Team USA website, the GoFundMe raised nearly $11,000 for health-care workers at her hospital.

Thompson attributes being a dedicated, hard worker to her mother, Margrid, who passed away in 2004. Margrid Thompson raised four kids—Jenny was the youngest and had three older brothers—as a single mother. After getting divorced, Margrid found ways to keep her life in order. According to a 2000 *Sports Illustrated* story by Jack McCallum, "Margrid saw to it that they all played sports, made them take music lessons, pushed them, encouraged them, drove them here, there and everywhere, loved them without qualification. If Margrid had to go it alone, then she would be the best damn single parent any kid ever had."

All four kids turned out to be incredibly motivated and gifted. Jenny took flute and piano lessons, tap lessons, and played tennis. Swimming was her favorite, though, and she started climbing the regional rankings and qualified for the Junior Nationals by age 12. After that, Margrid moved the family from Massachusetts to New Hampshire so 13-year-old Thompson could train year-round with a team. McCallum wrote that the move made Margrid's work commute two hours long, but she was her daughter's biggest fan and greatest supporter, so it was worth it.

Thompson got a scholarship to swim at Stanford and led the Cardinals to NCAA team championships four consecutive years. In 1992, she became the first American woman in 61 years to set a world record in the 100-meter freestyle, swimming it in 54.48 seconds at the Olympic Trials. At the Barcelona Games, Thompson won two gold medals in the 4x100-meter freestyle and medley team relays, but a silver in the individual 100-meter free. She was angry because there were rumors that the Chinese team members were taking steroids, and she finished second behind Zhuang Yong.

At the Atlanta Games in 1996, Thompson was the U.S. captain and anchored her team to gold in both freestyle relays. She picked up another gold medal in the medley relay. In 2000, she earned three golds and a bronze in Sydney, and then two silver medals in Athens in 2004, making her the most decorated female swimmer in Olympic history.

Thompson—or rather Dr. Thompson—is married with two kids and lives on Daniel Island in Charleston, South Carolina.

LEFT: Jenny Thompson posing for a portrait, San Francisco, California, USA, 2000; **RIGHT:** Thompson in action during 4x100-meter medley relay final, Summer Olympics, Athens, Greece, 2004

Dara TORRES
swimming

Perhaps former U.S. swim coach Eddie Reese said it best when he tried describing what Dara Torres has accomplished. It was at the 2008 Olympic Games in Beijing. Torres, then a 41-year-old mother, had just come out of retirement for the third time to win three silver medals, adding to her collection and bringing her total number of Olympics to five. (This was the same Olympics where Torres's teammate, Michael Phelps, was being compared to the greatest Olympians of all time after winning eight gold medals in China.) So how would Reese describe what Torres had done? "I don't have a category for that," Reese told *Sports Illustrated*'s Kelli Anderson. "I think [only] Ripley's has a category for that."

Torres is known to have the longest successful career of any Olympic swimmer in history. She represented her country from ages 15 to 41 and earned 12 medals, four of them gold. She was the first American to swim in five Olympics, the oldest athlete to make a U.S. swimming team, and the oldest to win a gold medal.

As Anderson wrote for *Sports Illustrated* after the 2008 Olympics, "Torres's example will no doubt inspire others to reconsider retirement or plot out a longer arc for their careers. Kara Lynn Joyce, a 22-year-old who finished half a second behind Torres in the 50 free, didn't seem disappointed to lose to someone who is old enough to be her mother. 'It gives me hope for another 20 years,' she said."

After her fourth Olympics—the 2000 Sydney Games, where Torres won five medals—her coach told her, "It's a shame. You're not even at your peak yet." Torres was 33 years old at the time and was coming off a seven-year hiatus.

Torres first retired after winning gold in Barcelona in 1992. She got married, later divorced, appeared in infomercials, lived in New York City, worked as a model, and posed for the 1994 *Sports Illustrated* Swimsuit Issue. In 1999, she told the magazine that "someone egged me on," and she started training again. She put on 20 pounds of muscle and went on to win two gold and three bronze medals in Sydney.

Then she retired again, had a baby girl with David Hoffman in 2006, and then jumped back in the water after giving birth because her doctor told her she could swim to stay in shape. She swam for a U.S. Masters Team before her ultracompetitive mindset took over again. She started training, made the Olympic team for Beijing, and won three silver medals. She missed out on gold in the 50-meter freestyle by 0.01 seconds.

Dan Levin wrote about the origin of Torres's competitiveness for *Sports Illustrated* in 1984, when she was 17. Her drive to win was an inherent quality—and it helped that she had four athletic older brothers and a younger sister to challenge her. Her mother, Marylu, told the magazine that "she always wanted the edge on everyone. At the dinner table she had to have the biggest portion. In the car she always wanted to be in the front seat. She was competitive from the day she was born."

Torres started swimming when she was eight and set her first national age-group record—24.66 seconds in the 50 yards—when she was 12. One year later, when she was in seventh grade, she won a "most likely to break a record in the Guinness Book" award. When Torres was a junior in high school, she moved from Beverly Hills to Mission Viejo, California, specifically to train with Hall of Fame coach Mark Schubert. And in 1983, when she was 15, she broke the world record for the 50-meter freestyle. The next year she won her first Olympic medal as a member of the U.S. 4x100-meter freestyle relay team at the 1984 Olympic Games in Los Angeles.

In college at the University of Florida, Torres won 28 NCAA All-American swimming awards while also winning two silver medals at the 1988 Seoul Games.

In 2009, Torres won the ESPY Award for "Best Comeback" and was named one of the "Top Female Athletes of the Decade" by *Sports Illustrated*. She also wrote a memoir appropriately called *Age Is Just a Number: Achieve Your Dreams at Any Stage in Your Life*.

Torres continued swimming after the Beijing Games with her sights set on making a record sixth Olympic team in 2012, but she missed out on London by placing fourth in the 50-meter freestyle finals at the Olympic Trials. Only the top two finishers in each event qualified for the team. And so Torres retired for her fourth, and possibly final, time.

RIGHT: Dara Torres after 4x100-meter medley relay final, Summer Olympics, Beijing, China, 2008; **OVERLEAF:** Torres and teammates posing after winning silver medal for 4x100-meter medley relay, Summer Olympics, Beijing, China, 2008

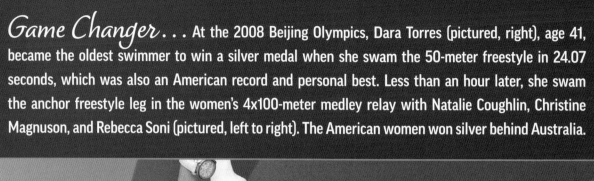

Game Changer . . . At the 2008 Beijing Olympics, Dara Torres (pictured, right), age 41, became the oldest swimmer to win a silver medal when she swam the 50-meter freestyle in 24.07 seconds, which was also an American record and personal best. Less than an hour later, she swam the anchor freestyle leg in the women's 4x100-meter medley relay with Natalie Coughlin, Christine Magnuson, and Rebecca Soni (pictured, left to right). The American women won silver behind Australia.

Lindsey Vonn is the epitome of the word fearless. She has a powerful body and knows how to use it to fly down mountains and shave off hundredths of a second that could separate first place from second, or a gold medal from no medal.

"I love pushing myself to the limit," Vonn told *Sports Illustrated*'s Tim Layden ahead of the 2018 Olympic Games in PyeongChang. "I love going fast."

The rush she gets from being a speed demon has come at a cost, however. While injuries are part of the deal when you're a ski racer, Vonn has endured more than most, suffering nine major injuries and undergoing five surgeries between 2006 and 2016.

This includes the 2006 pre-Olympics crash during a downhill training run where she nearly broke her back but somehow escaped from the hospital to compete in the Super-G (she finished seventh) and the downhill (eighth). In 2013, she blew out her right knee in a Super-G crash and then damaged the same knee while training for the Olympics. Always one to push the limits, Vonn continued to race after doctors told her the knee was stable and ultimately tore her ACL, which forced her to miss the 2014 Sochi Games.

In 2016, she fractured her right arm during training and, as Layden wrote, she was "evacuated from the hill in a truck, 90 minutes on unpaved roads." Vonn told *Sports Illustrated* it was "by far the most painful injury of my life. There was no med-pack on the hill, so no pain meds." She had no feeling in her hand for weeks and couldn't brush her teeth or hold a spoon. This prompted Vonn to make sure she always knew evacuation plans at every training location going forward.

And yet, even with all of those scary incidents, Vonn was always at the top of her sport. "She's still fearless," her coach Chris Knight told *Sports Illustrated* in 2018. "With everything she's come back from, it constantly amazes me that she has not backed off 1%."

Vonn started skiing when she was two years old. Her father, Alan Kildow, was a former ski racer so it was only natural that he'd introduce the sport to his daughter and help her career. When she was six, her dad brought her to train with his former coach, who said she skied "like a turtle," Vonn told *Sports Illustrated*. She quickly got better and faster, and when she was 13, the family moved from Minneapolis to Vail so she could keep training. At age 14, Vonn won the slalom at Italy's Trofeo Topolino and earned a spot on the U.S. development team. Over the next four years, she worked her way up to the U.S. women's A team. "You could see right away, with her talent, she was going to be one of the top racers," retired U.S. skier Kirsten Clark told *Sports Illustrated*.

Vonn skied in the 2002 Salt Lake City Games, finishing sixth in the combined and 32nd in slalom. In the summer of 2003, she amped up her training and worked with a professional trainer. She changed her body and "got rid of [her] baby fat," she told *Sports Illustrated*. Vonn got faster and earned her first World Cup podium finish in January 2004. In December of that year, she snagged her first World Cup win. Vonn was priming herself for an epic 2006 Olympics, but she crashed going 70 miles per hour two days before the Olympics, seriously injuring herself and her medal chances.

Vonn's gold medal downhill at the 2010 Olympic Games in Vancouver goes down as the most memorable run of her life. She received the Michael Phelps treatment ahead of the Vancouver Games, with NBC wanting maximum coverage of her events. She was stronger than she'd ever been after recovering from injuries sustained in the 2006 Turin Games and had the potential to win as many as four gold medals. She ended up winning one gold and one bronze.

Of course she wanted to defend her title in Sochi, and has said she "will forever be incredibly sad to have missed that." But no matter who comes along or which of her records are broken—cough, cough, Mikaela Shiffrin—Vonn's ski legacy is still strong. She competed in four Olympics, won three medals (including one gold), and won more than 80 World Cup races.

After winning a bronze medal in the downhill at the 2019 world championships, Vonn retired. While she was only 34 years old, her body needed a break after a career of broken bones and torn ligaments. Since leaving professional ski racing, Vonn has been involved in various projects, such as working with The Rock; making a documentary with her idol, Picabo Street; hosting a TV show on Amazon; and working as a commentator for NBC.

LEFT: Lindsey Vonn posing for a portrait with her medals, Winter Olympics, Vancouver, British Columbia, Canada, 2010; **OVERLEAF:** Vonn in action during downhill, Winter Olympics, Whistler, British Columbia, Canada, 2010

Game Changer... In typical Lindsey Vonn fashion, the aggressive and daring Alpine skier ignored pain, this time in her injured shin, and chased rival Julia Mancuso to become the first American woman to win an Olympic downhill gold medal (pictured). It was at the 2010 Olympic Games in Vancouver, and Vonn pushed herself and gained speed as she sped down the mountain, finishing in 1:44.19, just 0.56 seconds ahead of Mancuso. "It was a fight all the way down, but I told myself to keep pushing regardless of the consequences," Vonn said at the time. "I had to go for it every second."

Grete WAITZ
track and field

Grete Waitz had never even run a marathon when she set a world record at the 1978 New York City Marathon. Waitz, a Norwegian middle-distance runner who had already set two world records in the 3,000 meters, was invited to run as a "rabbit," which is someone who can set a fast pace for the top runners. Her husband, Jack, encouraged her to do it. She had hardly trained though—her longest run up until that point was 13 miles. Needless to say, she was suffering throughout the long 26.2 miles. When she won the race on pure raw stamina, Waitz threw her shoes at Jack and famously yelled, "I'll never do this stupid thing again."

But Waitz was hooked. She ran the next year, finishing nearly five minutes faster than in her first race and becoming the first woman to officially run a marathon in under two hours and 30 minutes. And then she kept on running, racing in a total of nine New York City Marathons and setting three world records. Her career would also include a world championship gold medal in 1983, an Olympic silver medal the next year, and legendary status as one of the greatest marathoners of all time.

Waitz always pushed herself to the limit and, in the process, broke barriers by proving that women could compete and belong in long-distance races at a time when the sport was starting to be recognized more seriously.

"She was the first lady of the marathon," Rob de Castella, a world champion marathon runner from Australia who trained with Waitz, told ESPN.

In addition to her love affair with the New York City Marathon, Waitz also won the London Marathon twice, the Stockholm Marathon once, and many other world races. She was always easily spotted on the course, with her graceful running style and blonde pigtails.

"She is our sport's towering legend," Mary Wittenberg, former New York Road Runners president, told the *New York Times*. "I believe not only in New York, but around the world, marathoning is what it is today because of Grete. She was the first big-time female track runner to step up to the marathon and change the whole sport."

Before she joined the marathon circuit, Waitz competed in the 1972 and 1976 Olympics in the 1,500 meters and set world records for the 3,000 meters in 1975 and 1976. She competed in the first-ever women's Olympic marathon at the 1984 Los Angeles Games, where she came in second behind American Joan Benoit Samuelson.

Waitz grew up in Oslo, Norway, with a father who was a pharmacist and a mother who worked in a grocery store. She became a geography teacher and was the oldest woman on the Norwegian national track team when she was invited to participate in the 1978 New York City Marathon. At that time, Waitz was contemplating retiring from running and focusing on teaching.

She became a kind of national hero in Norway. There's a statue of her outside Bislett Stadium in Oslo and she once appeared on a Norwegian postage stamp. In 2007, she established a foundation that sponsors runners in major races and supports cancer hospitals and patient centers. In 2008, she was honored by Norway's king with the Order of St. Olav for being a role model for female athletes. Waitz passed away in 2011 at age 57 after a battle with cancer, but in 2019, she posthumously received the International Olympic Committee's Women and Sport Award for Europe.

LEFT: Grete Waitz posing for a portrait, 1986; **RIGHT:** Waitz crossing finish line at New York City Marathon, New York, New York, USA, 1980

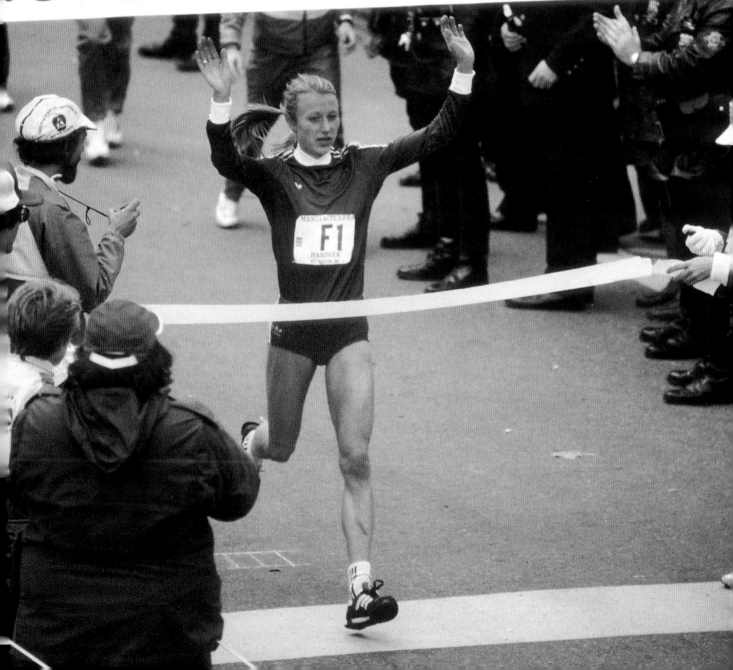

Kerri WALSH JENNINGS

volleyball

Kerri Walsh Jennings is unequivocally the greatest women's volleyball player of all time. Since her Olympic debut at the 2000 Sydney Games, she has won four medals, including three gold, and spent more than two decades dominating the sport. She had hoped to make a run at a sixth Olympics at the 2020 Tokyo Games (which were postponed to 2021 due to COVID-19). She even gathered her family to ask for their blessing to do the training she'd need to do to compete. She was still reeling from earning a bronze medal at the 2016 Rio de Janeiro Olympics and didn't want to retire until she won another gold.

Unfortunately for Walsh Jennings, she and her partner, Brooke Sweat, missed out on Tokyo after losing in the final qualifying match. It's unclear what she'll do next. At age 42, retirement might make sense, but she's not totally convinced yet.

"Every time I see an Olympic commercial, I kind of leave the room, which means I have some healing to do," Walsh Jennings told *USA Today*. "I love the Olympics. I love watching our country compete and I'm such a fan, but my heart hurts not being there. But I'm really excited for the inspiration of it all, because I think we all need that in our life right now."

While she may not be receiving the attention she would have if she had played in Tokyo, Walsh Jennings is an incredible example of a topic that isn't talked about enough: working moms. Walsh Jennings told ESPN that after she graduated from Stanford in 2001 and started her professional career, it was pretty much unheard of to accomplish the incredible things she has done while also being a mother.

"When I found out I was pregnant for the first time, the athlete in me was like, 'Oh my gosh, what did I just do?' Because I was literally advised, don't get pregnant. Wait until you're done," she said.

That would have required a lot of waiting for Walsh Jennings, who has been at the top of her sport for more than two decades. After graduating from Stanford, where she was a four-time first-team All-American indoor volleyball player and led the Cardinals to two NCAA championships, she joined the U.S. indoor national team for the 2000 Olympic Games in Sydney. The Americans finished in fourth place, and Walsh Jennings moved to the beach. That's where she partnered with Misty May-Treanor and won gold three times: 2004 in Athens, 2008 in Beijing, and 2012 in London.

It seemed like as soon as they joined forces on the beach in 2001, May-Treanor and Walsh Jennings became the most dominant duo in sports. Kelli Anderson broke it down for *Sports Illustrated* in 2009: "From August 26, 2007, to August 31, 2008, the pair won a record 112 straight matches and 19 straight titles in all competitions." The pair found a home in NBC's prime-time Olympic coverage when they defended their 2004 title. "As the network broadcast the matches live from Beijing into American homes for seven evenings during the Olympic fortnight, the team's enthusiasm, skill and gritty refusal to lose riveted millions. For all their dominance, May-Treanor and Walsh were easy to root for. Their chemistry was authentic, their joy in scoring big points infectious. As mentally exhausting as the pressure was in Beijing, the two welcomed it," wrote Anderson.

"We were proud to help the sport get that kind of exposure," said May-Treanor.

May-Treanor retired after the London Games, so Walsh Jennings partnered with April Ross in Rio de Janeiro. The pair earned a bronze medal, which served as fuel for Walsh Jennings in what she hoped would be her final Olympics.

While she didn't qualify for Tokyo, don't count her out of the Paris Olympics in 2024. "I'm on a mission of personal growth and to develop myself into the greatest human and athlete," Walsh Jennings told *USA Today*. "Whatever's firing me up, I want to develop that to be the best in me and volleyball is still the platform that allows me to keep expanding my potential. And I've fallen in love with that process."

Meanwhile, Walsh Jennings is doing her part to grow the game beyond people just watching it every four years at the Olympics. In 2017, she and her husband, former men's beach volleyball player Casey Jennings, created p1440, a digital platform exclusively built around the sport and culture of beach volleyball. The name p1440 was inspired by Walsh Jennings and her husband living 1,440 minutes of each day to the fullest. The platform offers opportunities for personal development and coaching, motivational talks from various experts, and the chance to play in volleyball tournaments around the country.

RIGHT: Kerri Walsh Jennings celebrating after semifinal match, Manhattan Beach Open, Manhattan Beach, California, USA, 2014; **OVERLEAF:** Walsh Jennings and Misty May-Treanor in action during gold-medal match, Summer Olympics, London, United Kingdom, 2012

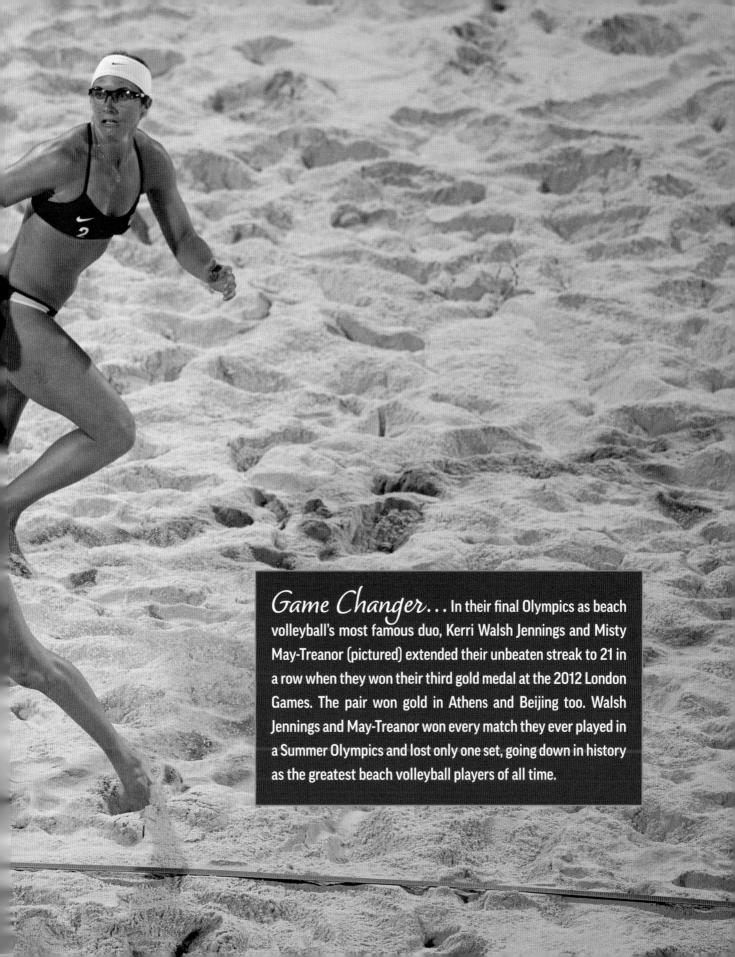

Game Changer... In their final Olympics as beach volleyball's most famous duo, Kerri Walsh Jennings and Misty May-Treanor (pictured) extended their unbeaten streak to 21 in a row when they won their third gold medal at the 2012 London Games. The pair won gold in Athens and Beijing too. Walsh Jennings and May-Treanor won every match they ever played in a Summer Olympics and lost only one set, going down in history as the greatest beach volleyball players of all time.

Abby WAMBACH

bby Wambach was the type of player who forced opponents to adapt. Given her size advantage (she towered over defenders at five-foot-eleven) and heading proficiency (her scoring preference), Wambach posed the worst type of matchup.

"Opponents have to play a different way when she's on the field," Alex Morgan told *Sports Illustrated*'s Grant Wahl in 2015 ahead of the World Cup. "To have to alter the way you play? That's crazy."

Even back in 2015, when Wambach, then 35 years old, was at the tail end of her career, she played an incredibly important role on the U.S. women's national soccer team (USWNT). If the Americans were going to win their third World Cup title, their first since 1999 and Wambach's first ever, she was going to have to do something she'd never done before—come off the bench rather than start, be a leader without being the star on the field. While this job was difficult for Wambach, as it would be for any superstar, she thrived, and the United States won the World Cup.

Wambach, who retired in 2015 shortly after winning that elusive World Cup, is a soccer legend. She's a two-time Olympic gold medalist, a World Cup champion, Ballon d'Or winner, and former USWNT captain. Up until 2020, she was the world's all-time scoring leader—male or female—finishing her career with 184 goals. (Canada's Christine Sinclair passed her with 185.) She's also a *New York Times* best-selling author and is married to Glennon Doyle, another *New York Times* best-selling author.

Wambach, the youngest of seven kids, played soccer at the University of Florida and then for the national team from 2001 to 2015. In her early days with the USWNT, she played with Mia Hamm, Julie Foudy, and Brandi Chastain. While most young players on a team of World Cup veterans might be shy and quiet, Wambach didn't have that problem. In fact, in 2003, as Mark Bechtel wrote for *Sports Illustrated*, Wambach's teammates gave her a shirt that said "Help, I'm Talking and I Can't Shut Up."

LEFT: Abby Wambach posing for a portrait ahead of FIFA World Cup, Jersey City, New Jersey, 2011; **OVERLEAF:** Wambach in action during gold-medal match, Summer Olympics, London, United Kingdom, 2012

"Whatever comes into my mind comes out of my mouth," Wambach told *Sports Illustrated*. "It's one of my least favorite traits and one of my most favorite traits."

Many times her chattiness and bluntness benefited her team, like when Wambach was unafraid to speak out against former FIFA president Sepp Blatter and the governing body's institutional sexism. She spoke out again when the greatest women's soccer players in the world were forced to play on turf at the 2015 World Cup even though the men's World Cup was always played on real grass.

Early on, Wambach relied on her size and scoring records. But when she got to the WUSA—the first U.S. women's professional soccer league—and was playing with Hamm, she realized she'd need to do more to reach her potential. Playing together on the Washington Freedom, Hamm took Wambach under her wing. The veteran called out the youngster for being unfit and taught her the importance of being in shape.

In 2013, Wambach broke Hamm's world-scoring record. But it was her goal in the 2011 World Cup quarterfinals against Brazil that truly made her a household name. In the 122nd minute of the must-win game, Megan Rapinoe sent a dagger of a cross with her left foot near the goal and Wambach leapt up and buried the ball into the back of the net with her head. The epic play will live forever in the USWNT history books. Wambach said she still has people come up to her thinking that the dramatic finish was for the World Cup title, but actually the United States lost to Japan after a shootout in the finals.

Wambach was inducted into the National Soccer Hall of Fame in 2019. Her second act postretirement has—arguably—been equally as interesting as her legendary soccer career. In 2017, she married Doyle, the activist author of *Untamed*, and they have three kids (from Doyle's previous marriage). In 2019, Wambach published her own memoir called *Wolfpack*, and before COVID-19 hit, she was traveling around the country promoting it. Among many other things, Wambach is an investor for the new NWSL team Angel City in Los Angeles, which was founded by women; an avid fighter for equal pay; and five years sober after publicly struggling with alcoholism. She will always be known as one of the greatest soccer players of all time.

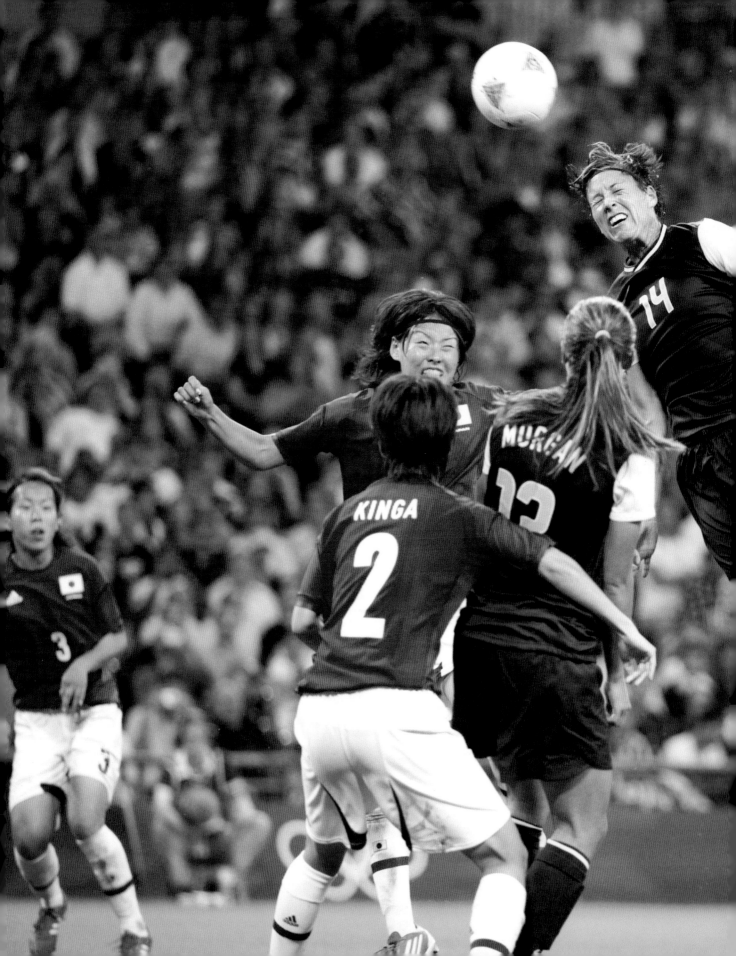

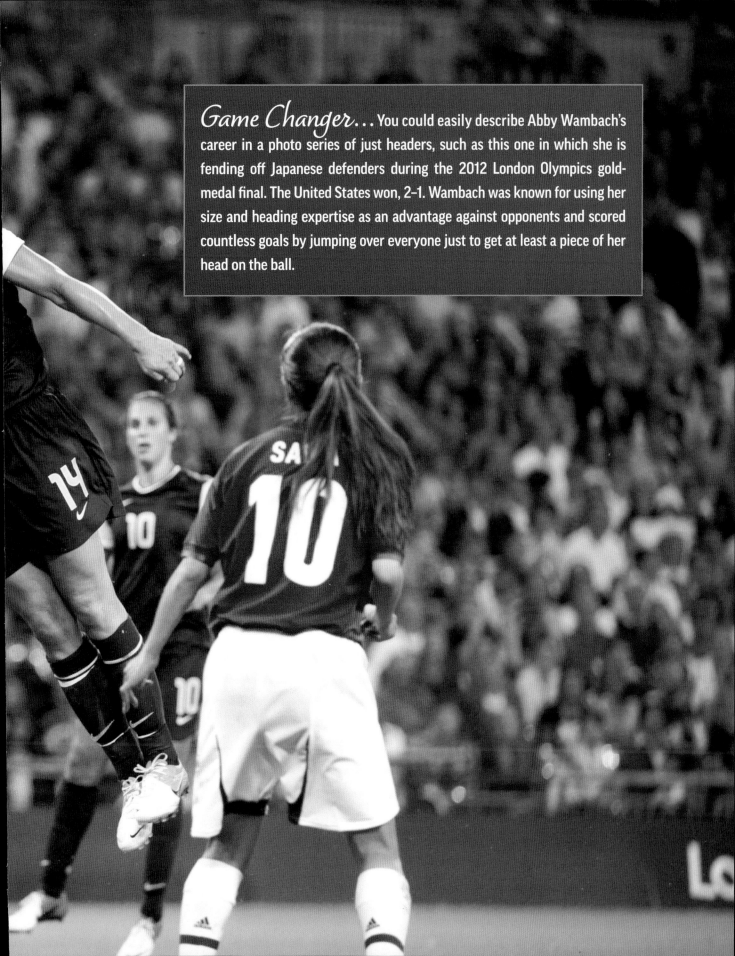

Game Changer… You could easily describe Abby Wambach's career in a photo series of just headers, such as this one in which she is fending off Japanese defenders during the 2012 London Olympics gold-medal final. The United States won, 2–1. Wambach was known for using her size and heading expertise as an advantage against opponents and scored countless goals by jumping over everyone just to get at least a piece of her head on the ball.

Kathy WHITWORTH

golf

Kathy Whitworth won a record 88 LPGA Tour tournaments—still more than anyone else, male or female—during her Hall of Fame career, which spanned from 1959 to 1991. For reference, the next closest golfer is Tiger Woods with 82. Whitworth also became the first woman to reach career earnings of $1 million on the LPGA Tour.

The first of her wins came in 1962 and the last in 1985. Somewhere in between, she gained the reputation for never three-putting and never making mistakes on the green. "When she has to have a putt, I mean absolutely has to have it for victory, she gets it every time," former LPGA golfer Sandra Haynie told *Sports Illustrated*. "[Sandra] Post and I tied at Port Charlotte this year, and Kathy needed a seven-footer to beat us. I put on my bracelets and was ready to go home before she hit the ball. There wasn't going to be a playoff."

Sometimes, people would ask Whitworth if she kept a lucky penny inside her putter (she didn't). Golfers, young and old, got nervous playing with her. They were intimidated by her many titles. "It's scary," Post told *Sports Illustrated* back then. "The only time I wasn't nervous was when I met her in the playoff for the LPGA. I knew I'd finish second, so I wasn't worried."

Whitworth was so good at winning, but somehow she never won the U.S. Women's Open Championship. Her theory, she told *Sports Illustrated*, was that she was always trying too hard to win so she didn't play well. But then again, Phil Mickelson, Sam Snead, and Nancy Lopez never won their national championships either.

"Turns out, you can have a rich and rewarding life without ever winning the U.S. Open," Michael Bamberger wrote for *Golf*. "Kathy's golf stories are seldom about how she won this event or that one. They're about how she and her contemporaries got on tour in the first place, and what they did there once they did."

Which brings us to the conversation about just how incredible Whitworth's career was. First of all, the obvious: she won 88 tournaments, including six major championships, but nobody really talks about it. If she were a man, this wouldn't be the case. Every time Tiger Woods played in a tournament

the conversation would center around how many more wins he needed to usurp the title. Many people do not even know who Whitworth is at all.

She played in an era in which women's golf was not yet televised, and an era where prize money was limited. In 32 years, she tallied $1.7 million in career earnings, pennies compared to what the top PGA Tour players make in a single tournament.

And yet she persisted, for a pure love of the game and to grow it for all of the women who came after her. In 1975, Whitworth became only the seventh woman to be elected into the LPGA Hall of Fame.

Whitworth hails from the small town of Jal, New Mexico, which is on the Texas border. "She was a small-town girl in a small-time sport," Barry McDermott wrote for *Sports Illustrated* in 1983. "Now she's a small-town lady in a big-time sport. Golf has changed, but Whitworth hasn't."

"Whitworth has always had the stats for stardom but has managed to avoid the role for a lot of reasons," McDermott wrote. "Because no one was watching back when she joined the LPGA, because she was shy, because she does what she does for motives dear only to her. She never has excited the public." As former LPGA golfer Judy Rankin described Whitworth to *Sports Illustrated*, "Some people are never meant for stardom, even if they are the star type."

Whitworth agreed. "It's not necessary for people to know you," she said. "The record itself speaks. That's all that really matters. Anyway, I don't know of any other thing I'd like to do or enjoy as much."

These days, Whitworth is still involved with the game she loves. She lives in Dallas, where she sometimes teaches lessons and hosts the annual Kathy Whitworth Invitational, a national junior tournament for girls. And if Woods—or anyone else—ever surpasses Whitworth to win 89 tournaments one day, it will be the perfect time to highlight her remarkable career.

LEFT: Kathy Whitworth in action during LPGA event, Tallahassee, Florida, 1991; **RIGHT:** Whitworth posing for a portrait, Roanoke, Texas, USA, 2009

Hayley WICKENHEISER

hockey

Hayley Wickenheiser's dad, Tom, once told this great story about his daughter. "There was a time, I forget exactly how old Hayley was, when I sat her down," he told *Sports Illustrated*'s Leigh Montville in 1998. "I tried to explain life. She was a good athlete in all sports—softball, volleyball, basketball. I told her these were sports with an upside. She probably should concentrate on them. Hockey, I said, really didn't have a future. She said she didn't care. She wanted to play hockey."

That is basically all you need to know about Wickenheiser, who became the greatest women's hockey player in the world. Just ask Wayne Gretzky, who once called her the "female Gordie Howe." Wickenheiser played in six Olympics for Canada and won four gold medals during her barrier-breaking career while becoming the national team's all-time leading scorer with 168 goals. She was the first woman to play full-time professional hockey in a men's league at a position other than goalie.

As Montville described in his story, Wickenheiser was "strong and skilled, lethal with a slap shot . . . when she began playing, a female hockey player was an aberration, a curiosity, even in a country teeming with hockey players. For Hayley to dream about a future in that sport seemed as unrealistic as to dream about riding a giraffe on the moon."

Wickenheiser didn't have female role models, so she looked up to Canadian superstars like Gretzky, Howe, and Mario Lemieux. She played on boys' teams until she was 12 years old. She was the best player on the ice and even won MVP of the gold-medal game at the 18-and-under Canada Winter Games in 1991. "But she was always a marked player," Montville wrote. "Opposing coaches would ask their players, 'Do you want to get beaten by a girl?'"

In 1990, the first International Ice Hockey Federation Women's World Championship was held in Ottawa and the final was broadcast on television. Canada beat the United States 5–2, and that got Wickenheiser thinking that maybe she had a legitimate future in the sport after all if she could eventually play on the national team. Around this same time, Wickenheiser's family moved from Saskatchewan to Calgary, where there was a girls' hockey team for her to play on. This created an actual path for her to make the national team.

Wickenheiser made her world championship debut when she was 15 years old, becoming the youngest player to ever represent Canada. She later became the star of the Canadian national team, getting paid to play professional hockey. By the end of her career, she had played in 12 world championships and won seven gold medals.

At the 1998 Nagano Olympics, Wickenheiser was already considered the best player in the world. At Salt Lake City in 2002, she was the Olympics' leading scorer in hockey, with seven goals and three assists, and she was named MVP after helping Canada win its first Olympic gold medal. She earned MVP again four years later at the Turin Games, with five goals and 12 assists during another gold-medal run. At the 2014 Olympic Games in Sochi, she was Canada's flag bearer at the Opening Ceremony.

Wickenheiser played in Canadian women's professional hockey leagues for various teams, including the Edmonton Chimos and Calgary Oval X-Treme. In January 2003, she played for HC Salamat in the second division of the Finnish Elite League, the top professional hockey league in Finland. Three weeks into her rookie season, she became the first woman to score a goal in a men's professional league.

In 2010, she enrolled at the University of Calgary and played hockey for the Dinos' women's team. In her first year, she won the Brodrick Trophy, and in the 2011–2012 season, she led her team to its first-ever national title.

Wickenheiser retired from playing hockey in 2017 to pursue another dream—going to medical school. And in 2018, she was hired by the Toronto Maple Leafs, where she holds the highest hockey operations role ever for a woman in the NHL as the senior director of player development.

Wickenheiser was inducted into the Hall of Fame in 2019 and graduated medical school in 2021 (at age 42) after serving on the front lines during the COVID-19 pandemic. She plans to begin her residency at a Toronto hospital while simultaneously working for the Maple Leafs.

Before winning gold at the 2010 Vancouver Games, Wickenheiser told *Sports Illustrated*, "I feel a responsibility to raise the level of the [women's] game every time I play." She's certainly done that and so much more for all women by setting an example of what it means to follow your dreams.

RIGHT: Hayley Wickenheiser in action during semifinals, Winter Olympics, Turin, Italy, 2006

She was in a Beyoncé video and won the Australian Open while pregnant. She's a fashion designer and has sat next to *Vogue*'s editor in chief, Anna Wintour, during New York Fashion Week. She's friends with Sheryl Sandberg, and married Reddit cofounder Alexis Ohanian. And whenever she ultimately wins that elusive 24th Grand Slam singles title—which will tie her with Margaret Court for the most ever—Serena Williams will have done it after giving birth to her daughter, Olympia.

"I do want to be known as the greatest ever," Williams told *Sports Illustrated*'s S. L. Price back in 2015, when she was named the magazine's Sportsperson of the Year.

As far as her tennis career goes, she's the overwhelming GOAT. Everyone else is playing for second. As of spring 2021, Williams has 73 career singles titles, which include 23 Grand Slams. She needs to win one more to tie Court's 24 and then another to take sole possession of the most Grand Slam singles titles of all time, male or female.

Whenever she does accomplish this feat—and there's every reason to believe that she will—Williams will join a short list of Grand Slam singles title-winning mothers alongside Court, Evonne Goolagong, and Kim Clijsters. Unlike her peers, who all gave birth in their 20s and came back, Williams had Olympia at age 35 and then resumed her career. It's important for Williams to have her daughter in the stands, watching her and seeing firsthand how big she can dream.

Williams grew up in Compton, California, the youngest of five girls. She started playing tennis at age three after her parents, Richard Williams and Oracene Price, taught themselves how to play. Eventually Richard left his job to coach both Serena and her older sister Venus full time. By 1991, when the girls were ages nine and ten, respectively, they faced each other in a junior tournament final. A few months later, the family moved to Haines City, Florida, so Venus and Serena could attend Rick Macci's tennis academy and train at a higher level.

Serena Williams made her pro debut when she was 13 at the 1995 Bell Challenge in Québec. She lost and didn't play in a tournament again until the 1997 Ameritech Cup where, as the 304th-ranked player in the world, she made it to the semifinal by upsetting No. 7 Mary Pierce and No. 4 Monica Seles. A couple of years later, when she was 17, Williams won her first Grand Slam title at the 1999 U.S. Open, becoming the first Black woman to win a major in the Open Era.

All of a sudden, Williams was on the cover of *Sports Illustrated* and she and Venus were asked to be in an episode of *The Simpsons*. It was the beginning of Williams's life in "celebrity hyperspace," as Price called it.

More than two decades later, her list of accomplishments is astounding. She has earned more than $94 million in prize money and been ranked No. 1 in the world. Her 23 Grand Slam titles are made up of seven Wimbledons, seven Australian Opens, six U.S. Opens, and three French Opens. In 2013, she won 11 singles titles. In 2015, she won five titles, including the French Open when she was nursing injuries and battling the flu.

Her career also includes facing her sister 30 times, the first being at the 1998 Australian Open. Serena holds an 18–12 advantage, and together they've won 14 Grand Slam doubles titles and three Olympic gold medals.

When she was younger, Williams was asked what she likes most about tennis. She didn't hesitate to answer. "Winning," she told *Sports Illustrated*. "I like going out and beating up on people. I get joy out of that. I really do."

Williams has dealt with adversity too, like when she experienced racism at Indian Wells in 2001. She didn't return to the venue until 14 years later, which was a significant and brave moment in her career. "I had been a teenager at Indian Wells, and that was hard for me to go through—especially when I was thinking, It's 2001, I [shouldn't] have to deal with that stuff as much anymore," Williams told *Sports Illustrated*. "Now, fastforward to 2015, and we still have young Black men being killed. Someone needed to do something . . . I needed to go back there and speak out against racism."

And so she did. It's obvious that Williams is fearless and unafraid to use her platform to raise awareness for issues that are important to her, like racism, gender equality, and body image. She's bold, confident, and courageous. What it all boils down to is that Williams is a global tennis superstar, but she transcends her sport. She's an entrepreneur, a fashion designer, and a mother. And it's impressive how good she has been at so many things for so long.

LEFT: Serena Williams in action during French Open, Paris, France, 2008; **OVERLEAF:** Williams in action during U.S. Open, Flushing, New York, USA, 2019

Game Changer… Serena Williams (pictured) has proven to us all that she is, in fact, human. Williams, who is still angling for that elusive 24th Grand Slam title that would tie her with Margaret Court for the most of all time, has not won a major tournament since giving birth to her daughter, Olympia, in 2017. Williams has struggled to regain form and has endured various injuries, like when she tearfully retired due to back spasms in the 2019 Rogers Cup final after falling behind to then-19-year-old Bianca Andreescu. But, as the greatest of all time, there's no reason to believe she won't hoist a Grand Slam title trophy once again.

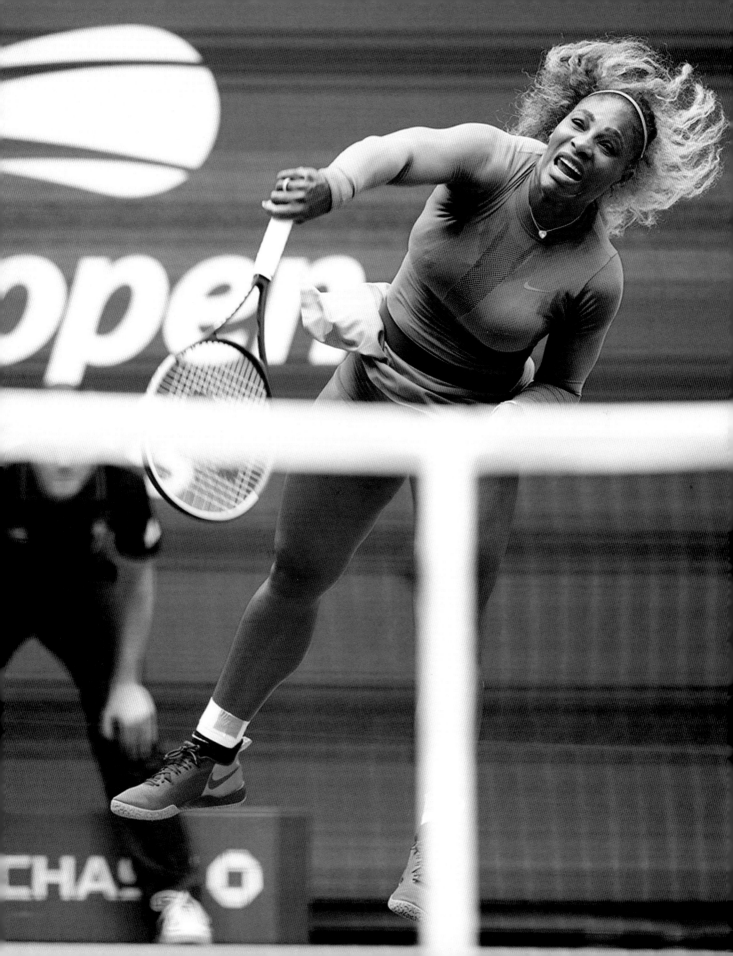

Venus WILLIAMS

What would it be like if Venus Williams existed in a world where her younger sister Serena Williams wasn't the greatest women's tennis player of all time? Serena has won 23 Grand Slam singles titles, and if (when) she wins two more, she will hold the all-time world record for both men and women. Venus has won seven Grand Slam singles titles, which is nothing to sneeze at, but she doesn't get the recognition she deserves because of Serena's overshadowing success.

When the sisters were little and just starting to be groomed for tennis greatness, however, Venus was the more talented phenom who everyone thought would be No. 1. And it's not that she's not one of the best tennis players of all time—she is—it's just that her sister is Serena.

As the story goes, parents Richard Williams and Oracene Price moved their family from Southern California to Florida when Venus and Serena were kids so they could train at Rick Macci's tennis academy. Richard, who taught himself how to play tennis in part by watching instructional videos and was the girls' coach, was very particular about his daughters' development. He didn't allow them to play in many junior tournaments when they were younger and was strict when it came to their education. "He and Oracene demanded that the girls expend as much energy on education as they did on practice," S. L. Price wrote for *Sports Illustrated* in 1999.

"Richard and I had ups and downs over a lot of things," Macci told *Sports Illustrated*. "But he's always been an incredible father to those two girls. I can remember 50 times when he called off practice because Venus's grades were down. They'd be in my office studying French, and I'd be saying, 'Hey, we've got to work.'"

With help from Macci, Venus turned pro at age 14. She won her first Grand Slam singles title at Wimbledon in 2000, defeating defending champion Lindsay Davenport 6-3, 7-6. Venus, who was 20 years old at the time, took out No. 1 Martina Hingis, her sister Serena, and Davenport on her way to the title.

When she beat Serena in the semifinal, Price wrote, "she had never been sadder in winning." Both sisters wanted to win and believed they would win. The moment was historic, though, because with that victory Venus became the first Black athlete to win the tournament since Arthur Ashe in 1975 and the first Black woman since Althea Gibson in 1958.

While Serena's career later took off and rocketed into another universe, she initially struggled to beat her sister. "Venus is the only opponent she hasn't solved," Price wrote. "Serena is still intimidated by the family pecking order. She also says that whenever she envisions winning a Grand Slam title, the only opponent she can conjure up is Venus."

The 1997 U.S. Open was the Venus Williams show, though. In her debut, the budding 17-year-old icon with beads in her hair "grabbed the women's field by the throat" and became the tournament's first unseeded women's finalist in the Open Era.

"Suddenly," Price wrote, "tennis had a brilliant new talent—witty, intelligent and charismatic—streetwise child of gang-plagued Compton, California, who could well be sports' next Tiger Woods."

But as she marched toward a finals showdown with Hingis, the world's No. 1 player, there was public resentment toward Williams and her family. According to Price, players complained about her arrogance, saying she was unfriendly and talked trash. Eventually things came to a boiling point, and her first U.S. Open was marked by conversations and questions about race in women's tennis. But Williams, only 17, handled it with the level of maturity you'd expect from an older player.

"It's like, Squish them down, they can't have that confidence," Oracene Williams told *Sports Illustrated* when discussing how people resent her daughters' cockiness. "I teach my kids to live in reality: You're Black, you always have to work harder—but you don't have to prove yourself to anybody. I don't expect you to, and I don't expect you to apologize. Ever."

Williams's early career was heavy on winning singles titles—she won most of her Grand Slams from 2000 to 2008 and didn't win another until the 2017 Australian Open. She hasn't claimed another one since. While she hasn't retired from tennis yet—she has spent nearly 30 years on the WTA tour and has won more than $42 million in prize money—Williams has other entrepreneurial endeavors she's passionate about, like her two fashion and design brands, EleVen and V Starr.

In 1994, 14-year-old Venus said, "I think I can change the game." Even though her career will always be tied to her sister's, she has certainly achieved what she set out to do.

RIGHT: Venus Williams in action during Wimbledon, London, United Kingdom, 2000

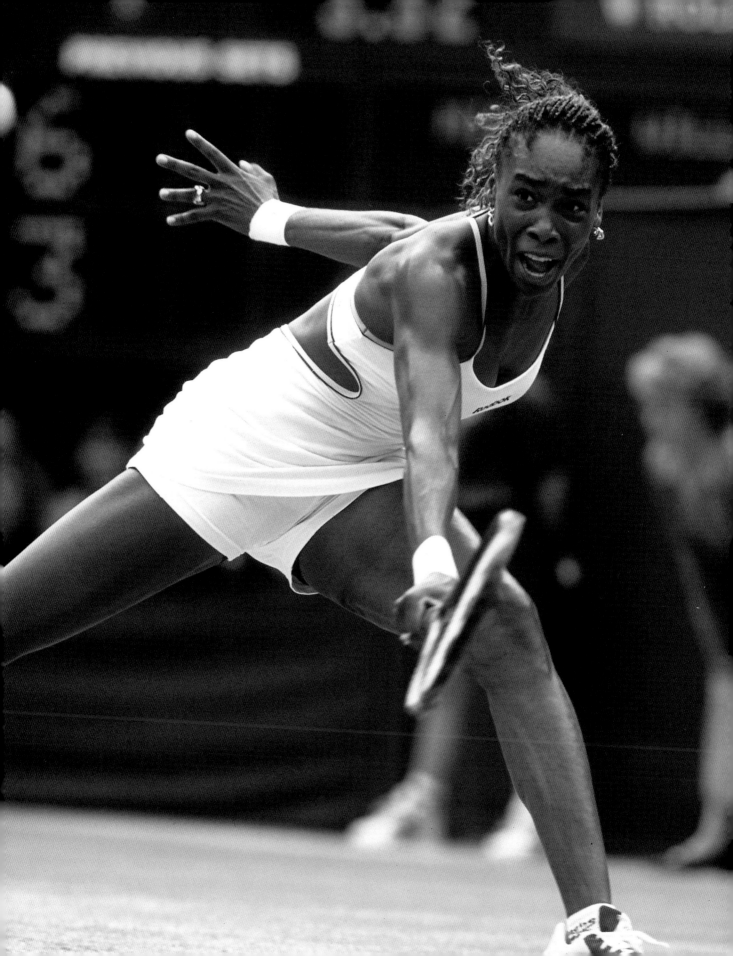

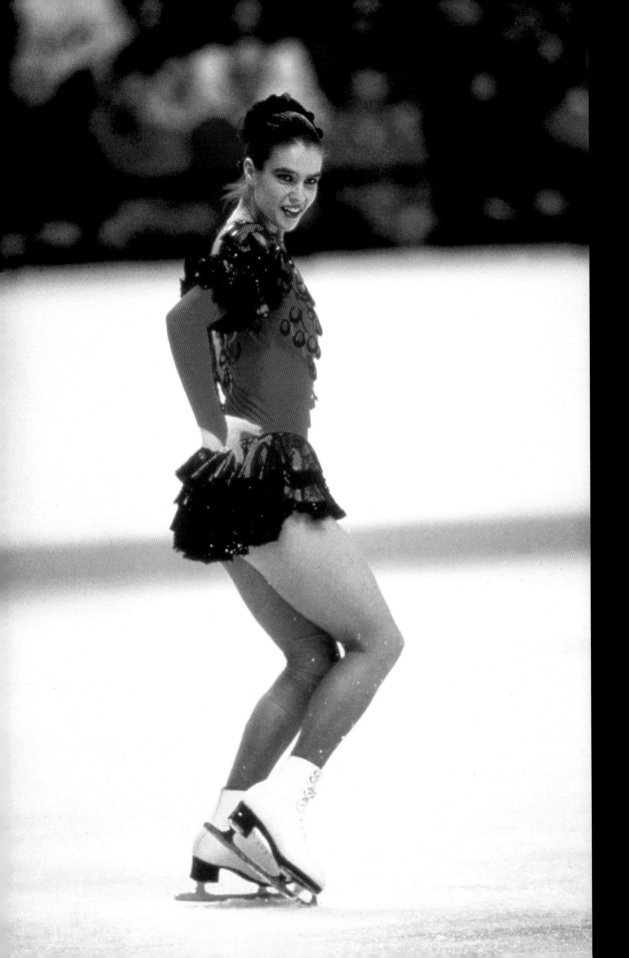

Katarina WITT
figure skating

At one point, Katarina Witt had to fill her bathtub with love letters because she received so many. This was some time after the 1984 Olympic Games in Sarajevo, where her routine, as well as her beautiful blue eyes, melted hearts all over the world, earning her a gold medal.

Her performance was "the perfect blend of art and athleticism, pirouettes and panache," Rick Reilly wrote for *Sports Illustrated*. "As skaters go, Witt is Michael Jordan playing in a YMCA league."

Witt is one of the greatest figure skaters in the world. She is a three-time Olympian, two-time gold medalist, four-time world champion, six-time European champion, and an eight-time national champion. When she won gold at the 1988 Calgary Games, she became the first women's singles skater since Sonja Henie in 1936 to win consecutive gold medals in the Olympics.

"If she were an American her face would be everywhere," Olympic gold medalist Peggy Fleming told *Sports Illustrated*. "I mean, look at her."

Witt grew up in Karl-Marx-Stadt in what was then the German Democratic Republic. Her father was a director in a co-op that produced plants and seeds while her mother worked as a physical therapist. When their daughter was five years old, she fell in love with ice skating. "She would stray off during walks with her kindergarten class and peer into an ice arena," Anita Verschoth wrote for *Sports Illustrated*. After a bit of begging, Witt convinced her mother to let her take skating lessons. By the time she was 10, Witt was recruited by the famous coach Jutta Muller, who trained some of the world's greatest figure skaters. It was considered an honor. When she was 11, Witt landed her first triple salchow.

Muller trained her skaters to have both style and skill. As Reilly described it, "Half of Muller's secret is that if you skate for her, you do it looking as if you have just stepped out of a stretch limo . . . She spends hundreds of hours teaching smiles, contact, glitz and sass. Besides schooling Witt in the intricacies of splits, spins and toe loops, Muller coifs Katarina's hair,

applies her makeup and fusses about her costumes. More than for any master of the sport, for her the look must be just so."

Muller's method was intense and required an inordinate amount of discipline from her athletes, but it worked. Many of her skaters won Olympic medals and European championships. Her skaters learned to flirt with the audience. "A skater does not skate just for herself," Muller said. "She should please the crowd." And Witt knew how to be showy and engaging, and also elegant and graceful. "Nobody in skating does it better than Witt and Muller, an intoxicating team," Reilly wrote.

Between the 1988 and 1994 Olympics, Witt went on tour in the United States and Canada with American figure skater and Olympic and world champion Brian Boitano. Their show was so successful that it sold out Madison Square Garden. After the tour, Witt trained for the Lillehammer Games, where she finished seventh in the singles short program. For the next decade, she went back on tour in North America with *Stars on Ice* and *Champions on Ice*. She took full advantage of her celebrity status, appeared in various television shows and movies, and wrote a book called *Only with Passion*. Witt was inducted into the World Figure Skating Hall of Fame in 1995.

While she will be remembered for her enchanting gold-medal performances and captivating good looks, Witt hopes people think of her as a good skater, "one who launched an era in which practitioners of her sport tell a story on ice."

Just watch her program from the 1988 Olympic Games, where she skated to music from the opera *Carmen*, and you'll know she accomplished just that.

LEFT: Katarina Witt in action during singles finals, Winter Olympics, Calgary, Alberta, Canada, 1988; **RIGHT:** Witt posing with gold medal, Winter Olympics, Calgary, Alberta, Canada, 1988

Mickey WRIGHT

I n 1964, when Mickey Wright was 29 years old, she set a record for the lowest 18-hole score with the first 62 in LPGA history. By this point in her career, Wright was already considered the best female golfer of all time. She was still young, but she was already thinking about retirement. According to *Sports Illustrated*, Leonard Wirtz–who was the director of the LPGA Tour and her confidant at the time–convinced Wright she couldn't retire yet because there was still so much she hadn't accomplished. So Wright went out and shot a nine-under-par 62 that broke the old LPGA record of 64 held by Patty Berg and Ruth Jessen. This was at the Tall City Open in Midland, Texas, on a challenging course where the men's record at the time was 66.

Wright, still known as one of the greatest female golfers ever, won 82 LPGA tournaments, 13 of them majors, from 1955 to 1980. She was known for her swing, which was simple and compact. As legendary golfer Ben Hogan described it, "she had the finest golf swing I ever saw." Wright was passed in career victories only by Kathy Whitworth's 88 and in majors only by Berg's 15–records that still hold today.

At the time, there was no one more important and impactful to women's golf than Wright. She was a great ambassador and drew comparisons to Babe Zaharias. She had a specific style, always wearing "crisp, neat blouses, crisp, neat shorts and crisp, neat eyeglasses" on the golf course.

Wright grew up as a tomboy in San Diego and, according to *Sports Illustrated*, "preferred football and baseball with the boys to dolls with the girls." She was introduced to golf when her father gave her a toy set of clubs when she was 10 years old. "The first time she went out to play with them she swung so hard at the ball she broke every club. So she started off with a forceful interest in the game."

Wright was tall–five-foot-eight by age 11–so she had a powerful swing and could hit the ball far. By 14, she started developing her swing more. Per *Sports Illustrated*, "While her classmates were at the movies, Mickey was on the golf course. She played every day, carrying her own clubs in a white canvas bag. She would hit as many as 300 balls in one practice

session, scooping them up later with a tin can nailed to the end of a board."

Wright won the U.S. Girls' Junior Championship at age 17 and turned pro at 19. In 1963, when she was 28, Wright won 13 LPGA tournaments, which is still a record for a single season. The next year she won 11. Wright won both the U.S. Women's Open and the LPGA four times. From 1960 to 1964, she earned five consecutive Vare Trophies for the lowest scoring average on the LPGA Tour, and she twice shot rounds of 62. Annika Sorenstam holds the lowest record now, shooting a 59 in 2001.

When Wright briefly contemplated retirement in 1965 and Wirtz talked her out of it, women's golf dodged a bullet. No golfer did more to contribute to the growth of the LPGA than her. "We were struggling to find 30 girls to play the tour because we weren't paying money to the lower spots," Wirtz told *Sports Illustrated*. "I said to Mickey, 'I want to reduce the winner's percentage of the purse from 20 to 15 so we can pay more to the others.' The only player it was going to affect was Mickey, because she was winning everything. She said, 'If it's going to help the tour, I'm for it.' Nobody knows this stuff. She made sacrifices, put up with all sorts of crap: sponsors who threatened to cancel their tournaments if Mickey didn't play, writers who treated it like an insult if she didn't win their hometown event. She felt so much pressure to play, so much pressure to win."

Wright was inducted into the LPGA Hall of Fame in 1964 and the World Golf Hall of Fame in 1976. What made her more likable–or less likable, depending who you ask–was that even though she had superstar stats, she didn't want the superstar limelight. She was often described as a recluse and didn't like big parties or dinners, unless they were her own. She preferred a simple life without public appearances.

Wright retired and moved to Port St. Lucie, Florida. Until she passed away from a heart attack in 2020 at the age of 85, she still played the game she loved often, hitting balls off a mat on her back patio.

"She sort of revolutionized golf for us because she was so good and her swing was so perfect," former golfer Betsy Rawls told the Associated Press in 2006. "Even though we were competitors, she was a joy to watch."

LEFT: Mickey Wright in action during U.S. Women's Open, Myrtle Beach, South Carolina, USA, 1962

Minxia WU
diving

There's a famous story about Minxia Wu from the 2012 London Olympics. It's not about what she accomplished there, which was winning two gold medals in the synchronized and individual three-meter springboard diving events. After she earned those medals, a story published by *Time* revealed that a Chinese "micro-blogging website" ratted out Wu's parents for keeping her mother's battle with cancer and the deaths of her grandparents from her so she wouldn't lose focus while training for the Olympics.

Wu made history in London as the first diver to ever take home the top prize in three consecutive Olympics. After her events were over, according to *Time*, Wu's father told the *Shanghai Morning Post* about the family secrets they had kept from Wu. "We never tell her what's happening at home," he said. "When grandma died, [Wu] seemed almost like she had a premonition, and she called us asking if she was okay. We had

to lie; we told her, 'everything's okay.'" Wu's father went on to say that the family has kept secrets like this from their daughter "for so many years."

Despite such unusual parenting, Wu had one of the greatest diving careers of all time. She won seven medals, including five gold, over the course of four Olympics. She was the first woman to collect four consecutive gold medals in the Olympic three-meter synchronized springboard, and did so with three different partners, from the Athens Games in 2004 through the Rio de Janeiro Games in 2016. Wu also earned one silver medal in Athens and one bronze medal in Beijing in the individual springboard, and won 14 world championships, including eight gold medals.

"When I first got into diving, I thought it was a very exciting sport," Wu told the Associated Press at the Rio de Janeiro Games. "My personality, I always want to win."

Wu was 30 years old in 2016, making her the oldest female diver to win gold at the Olympics. The record was previously held by American Micki King, who won gold in the three-meter springboard when she was 28 at the 1972 Munich Games.

China's men and women have long dominated the international diving scene, from platform to springboard and every event in between. After Wu and her partner Tingmao Shi won gold in the synchronized event in Rio de Janeiro, Italy's Tania Cagnotto summed up what it's like to compete against their team. "We are used to diving against the Chinese," Cagnotto told the Associated Press. "We don't even think about the gold. Gold is for China."

Wu retired from her sport after the Rio de Janeiro Games—she was only 31 years old, but her body told her it was time to stop. "Reluctantly, it's time to call it a day," Wu said on live Chinese TV. "The story of Chinese diving didn't start with me and it won't end with me. I am really sorry, but my physical condition does not allow me to continue training. I've always feared this day coming."

While her dominant career is over, she will always be one of the most decorated and successful Chinese divers of all time.

LEFT: Minxia Wu and Jingjing Guo in action during three-meter springboard, Summer Olympics, Beijing, China, 2008; **RIGHT:** Wu and Zi He posing with gold medals after winning three-meter springboard, Summer Olympics, London, United Kingdom, 2012; **OVERLEAF:** Wu and Guo in action during three-meter springboard, Summer Olympics, Beijing, China, 2008

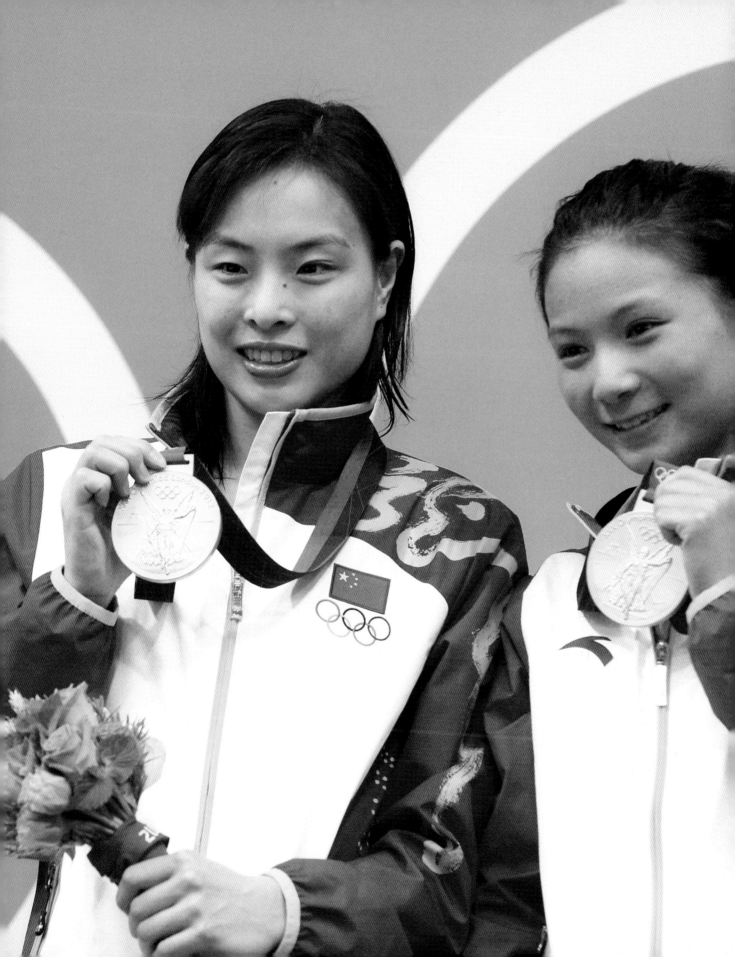

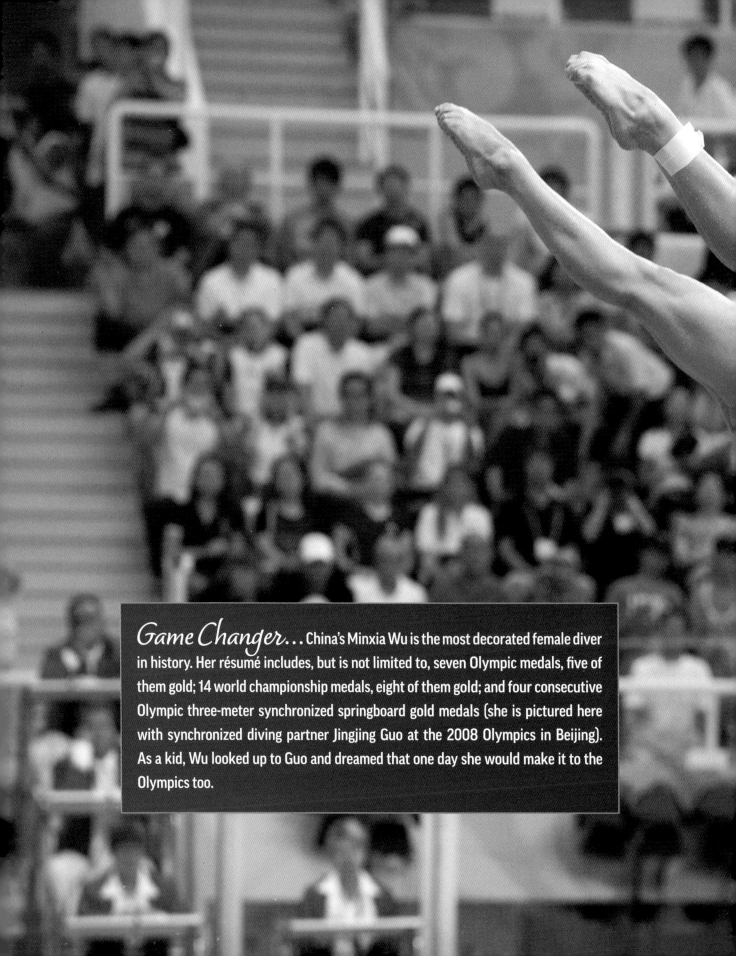

Game Changer... China's Minxia Wu is the most decorated female diver in history. Her résumé includes, but is not limited to, seven Olympic medals, five of them gold; 14 world championship medals, eight of them gold; and four consecutive Olympic three-meter synchronized springboard gold medals (she is pictured here with synchronized diving partner Jingjing Guo at the 2008 Olympics in Beijing). As a kid, Wu looked up to Guo and dreamed that one day she would make it to the Olympics too.

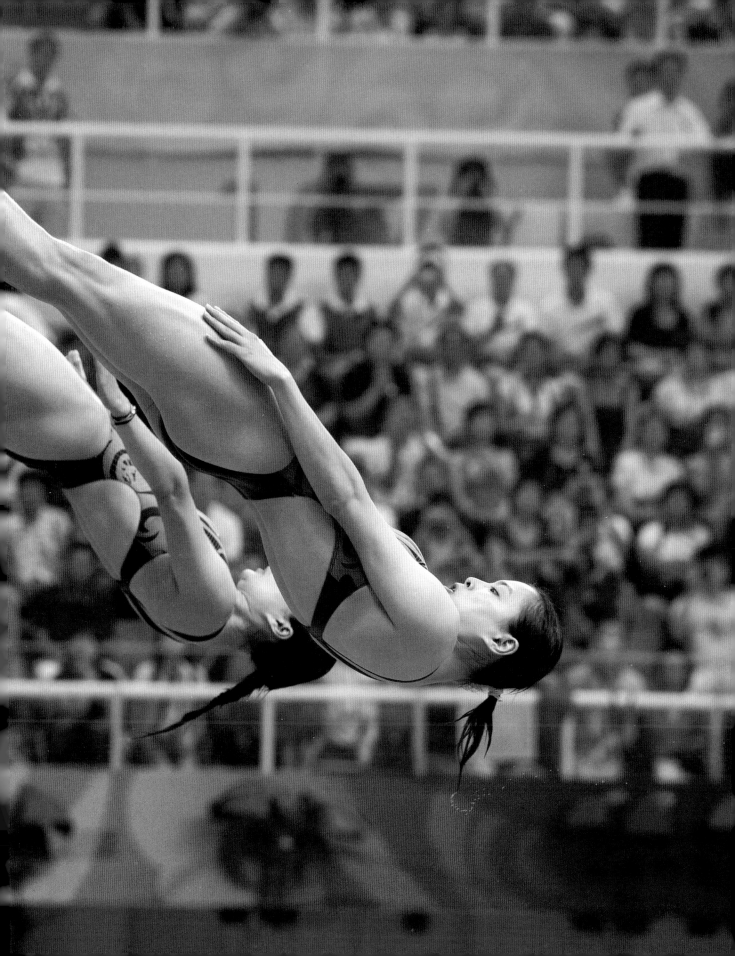

Trischa ZORN

swimming

f anyone ever breaks Trischa Zorn's record for medals, that means they will have won 56 of them. Not even Michael Phelps can touch this one.

Zorn is the most decorated Paralympian in history, winning 55 medals, including 41 gold, over the course of seven different Paralympic Games. She has won every event, from backstroke to breaststroke, freestyle to butterfly, and individual medley relays—and all in multiple distances. It's not silly to think that perhaps no one will ever come close to touching her place in history.

Zorn was born with a birth defect called aniridia, which left her legally blind in both eyes. But she defied any and all odds stacked against her and became a competitive swimmer by counting strokes to each turn. Her biggest Paralympic medal haul came at the 1988 Seoul Games when Zorn, then 24 years old, won 12 gold medals.

"Everyone asked if it got boring going to the awards stand," she told *Sports Illustrated*. "But it never got old for me."

Zorn first started swimming when she was 10 years old for her local swim team in Mission Viejo, California. She later became a four-time All-American backstroker at the University of Nebraska, where she was the first visually impaired athlete to earn an NCAA Division I scholarship. She competed in her first Paralympic Games at Arnhem in 1980. She was 16 years old and won seven gold medals. She kept winning and winning and winning, and even once competed in the Olympic Trials.

While she has worked remarkably hard to achieve such improbable feats, Zorn has sometimes felt doubted by those who do not immediately see her disability. According to Yahoo, Zorn often opted to swim without a "bonker," which is a pole used to warn visually impaired swimmers that they are approaching the end of the pool. Zorn experienced a lot of critics and skeptics early in her career, so much so that her classification as a blind swimmer was questioned at the 2000 Sydney Games. By this time she had already earned 49 medals, which included her 41 golds.

Zorn didn't win gold in Australia, but she did earn four silver medals and a bronze. She competed in her final Paralympics four years later in Athens at age 40 and carried the American flag at the Closing Ceremony. She competed in two events and won a bronze medal in the 100-meter backstroke to close out her legendary career.

Out of all the medals she'd won, Zorn told the U.S. Olympic and Paralympic Museum that her last medal was her most memorable because it happened right after her mom passed away from breast cancer. "She had always attended all my competitions and it was hard to know she was not going to be there," she said.

Zorn retired after the Athens Games and pursued a career as a lawyer—she was in law school leading up to the Sydney Games, but took time off to compete. She went back to school and graduated in 2007. She now works as an attorney with the U.S. Department of Veterans Affairs. She was inducted into the Paralympic Hall of Fame in 2012, and USA Swimming created the Trischa L. Zorn Award to honor an outstanding performance by a swimmer or relay team with disabilities.

While she doesn't swim as much anymore, she hopes she has set an example and paved the way for future swimmers and athletes with disabilities to have the same kinds of opportunities. "I want to believe that I made a positive impact on the sport and on the Paralympic Games," she told TeamUSA.org.

RIGHT: Trischa Zorn in action during 100-meter final, Paralympic Games, Sydney, Australia, 2000

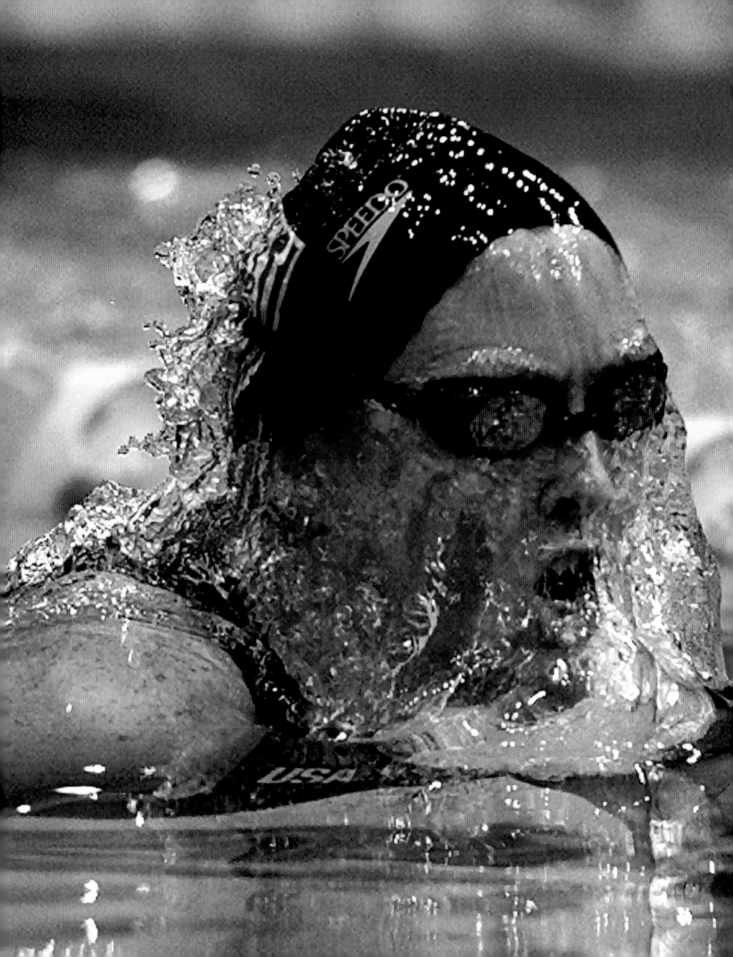

Sources

Michelle Akers
Michael Bamberger, "Dream Come True," *Sports Illustrated*, December 20, 1999, https://vault.si.com/vault/1999/12/20/dream-come-true-michelle-akers-and-the-19-other-members-of-the-world-cup-winning-us-soccer-team-gave-america-a-summer-to-savor-forever.

Grant Wahl, "Green Acres," *Sports Illustrated*, July 4, 2011, https://vault.si.com/vault/2011/07/04/green-acres.

Kelly Whiteside, "World Beater," *Sports Illustrated*, June 5, 1995, https://vault.si.com/vault/1995/06/05/world-beater-michelle-akers-soccers-top-female-is-ready-to-lead-the-us-to-another-title.

Lisa Andersen
Godwin Kelly, "Four-Time World Surfing Champ Lisa Anderson Honored by Daytona Beach," *Daytona Beach News-Journal*, August 2, 2019, https://www.news-journalonline.com/sports/20190802/four-time-world-surfing-champ-lisa-andersen-honored-by-daytona-beach.

Franz Lidz, "Mother on Board," *Sports Illustrated*, November 13, 1995, https://vault.si.com/vault/1995/11/13/mother-on-board-exrunaway-lisa-andersen-is-the-top-performer-and-only-mom-on-the-pro-circuit.

Kristin Armstrong
Kristin Armstrong, http://www.kristinarmstrongusa.com/.

Associated Press, "Retired Kristin Armstrong Ponders Future On and Off the Bike," *USA Today*, October 30, 2009, https://usatoday30.usatoday.com/sports/cycling/2009-10-30-kristin-armstrong_N.htm.

Derek Bouchard-Hall (@DBouchardHall), "Kristin Armstrong is . . ." Twitter, August 10, 2016, https://twitter.com/DBouchardHall/status/763360965920301060.

Daniel McMahon, "Out of Retirement and Into Gold, 42-Year-Old American Kristin Armstrong Just Made Olympic History," *Business Insider*, August 10, 2016, https://www.businessinsider.com/kristin-armstrong-wins-third-straight-olympic-gold-medal-2016-8.

Peggy Shinn, "At 42, Cyclist Kristin Armstrong Wins Third Straight Olympic Gold in Time Trial," TeamUSA, August 10, 2016, https://www.teamusa.org/news/2016/august/10/at-42-cyclist-kristin-armstrong-wins-third-straight-olympic-gold-in-time-trial.

Joan Benoit Samuelson
Brian Dalek, "Joan Benoit Samuelson Crushes Goal With 3:04 Boston Marathon Time," *Runner's World*, April 15, 2019, https://www.runnersworld.com/news/a27153381/joan-benoit-samuelson-boston-marathon-40th-anniversary/.

Jaime Lowe, "Joan Benoit Samuelson," *Sports Illustrated*, July 12, 2004, https://vault.si.com/vault/2004/07/12/joan-benoit-samuelson.

Kenny Moore, "Her Life Is in Apple Pie Order," *Sports Illustrated*, March 4, 1985, https://vault.si.com/vault/1985/03/04/her-life-is-in-apple-pie-order.

Simone Biles
"Biography," Simone Biles, https://www.simonebiles.com/bio.

Simone Biles (@simonebiles), "Most of you know me . . ." Instagram, January 15, 2018, https://www.instagram.com/p/Bd_C55cHWUQ/?hl=en.

"Simone Biles Legacy Scholarship Fund," University of the People, https://www.uopeople.edu/tuition-free/our-scholarships/simone-biles-legacy-scholarship-fund/.

SI Staff, "The Best, Bar None," *Sports Illustrated*, December 17, 2018, https://vault.si.com/vault/2018/12/17/best-bar-none.

SI Staff, "Flipping Awesome," *Sports Illustrated*, August 22, 2016, https://vault.si.com/vault/2016/08/22/flipping-awesome.

Sue Bird
Kelli Anderson, "The Sky's the Limit," *Sports Illustrated*, July 1, 2002, https://vault.si.com/vault/2002/07/01/the-skys-the-limit-wnba-rookie-sue-bird-has-the-game-and-the-charm-to-become-the-most-popular-female-team-sport-athlete-ever.

Mechelle Voepel, "Ready to Let You In," *ESPN*, July 20, 2017, http://www.espn.com/espnw/feature/20088416/wnba-all-star-sue-bird-ready-let-in.

Marit Bjoergen
"Marit Bjoergen," Olympics, https://olympics.com/en/athletes/marit-bjoergen.

Bonnie Blair
Associated Press, "New Blair on Big Oval," *USA Today*, January 4, 2018, https://www.usatoday.com/story/sports/olympics/2018/01/04/new-blair-on-big-oval-bonnies-daughter-is-a-speedskater/1091611982/.

Sally Jenkins, "A Bonnie Blare," *Sports Illustrated*, February 17, 1992, https://vault.si.com/vault/1992/02/17/speed-skating-a-bonnie-blare-a-throng-of-relatives-cheered-bonnie-blair-to-another-gold-in-the-500.

Steve Rushin, "The Last Lap," *Sports Illustrated*, February 27, 1995, https://vault.si.com/vault/1995/02/27/the-last-lap-after-racing-to-another-world-title-bonnie-blair-leaves-the-us-facing-a-big-chill-in-her-sport.

Alexander Wolff, "Bonnie's Bounty," *Sports Illustrated*, March 7, 1994, https://vault.si.com/vault/1994/03/07/bonnies-bounty-unassuming-bonnie-blair-sped-to-victory-in-the-1000-meters-to-become-the-uss-most-gilded-woman-olympian-ever.

Alexander Wolff, "Whooosh!" *Sports Illustrated*, February 28, 1994, https://vault.si.com/vault/1994/02/28/whooosh-to-the-delight-of-their-fans-dan-jansen-won-at-last-and-bonnie-blair-won-again.

Susan Butcher
Mark Bechtel, "Four-Time Iditarod Champion Susan Butcher, 1955–2006," *Sports Illustrated*, August 14, 2006, https://vault.si.com/vault/2006/08/14/fourtime-iditarod-champion-susan-butcher-19552006.

Sonja Steptoe, "The Dogged Pursuit of Excellence," *Sports Illustrated*, February 11, 1991, https://vault.si.com/vault/1991/02/11/the-dogged-pursuit-of-excellence-susan-butcher-is-mushing-toward-a-record-fifth-win-in-the-iditarod-race.

Brandi Chastain
Kelli Anderson, "Brandi Chastain," *Sports Illustrated*, July 13, 2009, https://vault.si.com/vault/2009/07/13/brandi-chastain.

Tim Crothers, "Spectacular Takeoff," *Sports Illustrated*, July 3, 2000, https://vault.si.com/vault/2000/07/03/spectacular-takeoff-in-the-year-since-her-world-cup-clinching-penalty-kick-went-in-and-her-jersey-came-off-brandi-chastain-has-been-riding-high-enjoying-every-minute-of-her-celebrity.

Roy Rivenburg, "His Best Shots," *UCI News*, January 2, 2019, https://news.uci.edu/2019/01/02/his-best-shots/.

Grant Wahl, "Out of This World," *Sports Illustrated*, July 19, 1999, https://vault.si.com/vault/1999/07/19/out-of-this-world-with-the-cup-on-the-line-a-last-second-hunch-and-a-clutch-left-foot-lifted-the-us-to-a-breathtaking-victory-over-china.

Kelly Clark
Associated Press, "Kelly Clark, Olympic Gold Medalist and Pioneer, Retiring from Snowboarding," ESPN, January 25, 2019, https://www.espn.com/olympics/snowboarding/story/_/id/25847274/kelly-clark-olympic-gold-medalist-pioneer-retiring-snowboarding.

"Kelly Clark," Team USA, https://www.teamusa.org/us-ski-and-snowboard/athletes/kelly-clark.

Kelly Clark Foundation, https://kcfoundation.squarespace.com/photography.

Alyssa Roenigk, "Newly Retired Snowboarder Kelly Clark Is Learning to Be Comfortable Being Uncomfortable," ESPN, March 7, 2019, https://www.espn.com/olympics/story/_/id/26143460/newly-retired-snowboarder-kelly-clark-learning-comfortable-being-uncomfortable.

Nadia Comaneci
Frank Deford, "Nadia Awed Ya," *Sports Illustrated*, August 2, 1976, https://vault.si.com/vault/1976/08/02/nadia-comaneci-1976-olympics-perfect-scores.

Bob Ottum, "The Search for Nadia," *Sports Illustrated*, November 19, 1979, https://vault.si.com/vault/1979/11/19/the-search-for-nadia-the-author-plunges-into-the-mists-of-transylvania-in-quest-of-the-worlds-favorite-gymnast-nadia-comaneci-she-had-been-perfect-then-she-had-faded-from-view-now-it-develops-there-is-a-new-nadia.

Anita Verschoth, "A Great Leap Backward," *Sports Illustrated*, April 12, 1976, https://vault.si.com/vault/1976/04/12/a-great-leap-backward.

Cynthia Cooper
Kelli Anderson, "Coop De Grace," *Sports Illustrated*, September 13, 1999, https://vault.si.com/vault/1999/09/13/coop-de-grace-overcoming-a-season-filled-with-adversity-not-to-mention-a-stunning-buzzer-beater-cynthia-cooper-powered-the-houston-comets-to-a-third-straight-wnba-title.

Johnette Howard, "Comet's Tale," *Sports Illustrated*, August 25, 1997, https://vault.si.com/vault/1997/08/25/comets-tale-on-and-off-the-court-houstons-cynthia-cooper-is-indeed-most-valuable.

Misty Copeland
Misty Copeland, mistycopeland.com.

Ruth La Ferla, "The Rise and Rise of Misty Copeland," *New York Times*, December 18, 2015, https://www.nytimes.com/2015/12/20/fashion/the-rise-and-rise-of-misty-copeland.html.

Roslyn Sulcas, "A Singular Ballerina's Multiple Paths," *New York Times*, February 21, 2014, https://www.nytimes.com/2014/02/23/arts/dance/misty-copeland-prepares-for-release-of-her-memoir.html?_r=0.

Natalie Coughlin
Kelli Anderson, "The Next Golden Girl," *Sports Illustrated*, July 28, 2003, https://vault.si.com/vault/2003/07/28/the-next-golden-girl-versatile-natalie-coughlin-who-qualified-for-seven-events-at-this-weeks-world-championships-is-on-course-to-be-a-star-at-the-olympics.

Chris Ballard, "The Future Is Wow!" *Sports Illustrated*, April 1, 2002, https://vault.si.com/vault/2002/04/01/the-future-is-wow-cal-sophomore-natalie-coughlin-is-making-waves-that-could-carry-her-to-athens.

Jeff Faraudo, "Cal Swimming," *Sports Illustrated*, February 13, 2020, https://www.si.com/college/cal/other-sports/natalie-coughlin-entering-bay-area-sports-hall-of-fame.

Mo'ne Davis
Scooby Axson, "Mo'ne Davis on This Week's National *Sports Illustrated* Cover," *Sports Illustrated*, August 19, 2014, https://www.si.com/more-sports/2014/08/19/mone-davis-little-league-world-series-sports-illustrated-cover.

Albert Chen, "The Ace of the Place," *Sports Illustrated*, August 25, 2014, https://vault.si.com/vault/2014/08/25/the-ace-of-the-place.

Albert Chen, "The Mo'ne Effect," *Sports Illustrated*, December 15, 2014, https://vault.si.com/vault/2014/12/15/the-mone-effect.

Alexandra Fenwick, "Pro Forma?" *Sports Illustrated*, September 1, 2014, https://vault.si.com/vault/2014/09/01/pro-forma.

SI Staff, "Table of Contents," *Sports Illustrated*, August 25, 2014, https://vault.si.com/vault/2014/08/25/1012625-toc.

Shemar Woods, "Mo'ne Davis Is Ready for Her Next Journey," *Sports Illustrated*, July 2, 2019, https://www.si.com/softball/2019/07/02/mone-davis-little-league-world-series-hampton-university.

Mary Decker Slaney
David Burnett, "The Real Story Behind This Iconic Olympics Photo," *Runner's World*, July 24, 2020, https://www.runnersworld.com/runners-stories/a33367218/mary-decker-zola-budd-1984-olympics/.

Kenny Moore, "She Runs and We Are Lifted," *Sports Illustrated*, December 26, 1983, https://vault.si.com/vault/1983/12/26/she-runs-and-we-are-lifted.

Kenny Moore, "Sweet, Sweet Revenge," *Sports Illustrated*, July 29, 1985, https://vault.si.com/vault/1985/07/29/sweet-sweet-revenge.

Craig Neff, "Mary, Mary, Still Contrary," *Sports Illustrated*, January 28, 1985, https://vault.si.com/vault/1985/01/28/mary-mary-still-contrary.

Merrell Noden, "Runner Mary Decker Slaney, February 18, 1980," *Sports Illustrated*, February 17, 1997, https://vault.si.com/vault/1997/02/17/runner-mary-decker-slaney-february-18-1980.

Elena Delle Donne
Elena Delle Donne, "An Open Letter about My Health," *Players' Tribune*, July 15, 2020, https://www.theplayerstribune.com/articles/elena-delle-donne-wnba-season-lyme-disease.

Selena Roberts, "Burning to Play Again," *Sports Illustrated*, November 16, 2009, https://vault.si.com/vault/2009/11/16/burning-to-play-again.

L. Jon Wertheim, "Driving for Home," *Sports Illustrated*, January 23, 2012, https://vault.si.com/vault/2012/01/23/driving-for-home.

Gail Devers
"Gail Devers," USATF, http://legacy.usatf.org/athletes/bios/TrackAndFieldArchive/2007/Devers_Gail.asp#:~:text=The%2040%2Dyear%2Dold%20Devers,%2D40%20athletes%20(8.71).

Tim Layden, "Over Life's Hurdles," *Sports Illustrated*, February 12, 2007, https://vault.si.com/vault/2007/02/12/over-lifes-hurdles.

Kenny Moore, "Dash to Glory," *Sports Illustrated*, August 10, 1992, https://vault.si.com/vault/1992/08/10/track-and-field-dash-to-glory-gail-deverss-victory-in-the-100-highlighted-a-heavenly-week-of-olympic-competition.

Kenny Moore, "Gail Force," *Sports Illustrated*, May 10, 1993, https://vault.si.com/vault/1993/05/10/gail-force-driven-by-a-vision-gail-devers-made-an-amazing-comeback-from-a-crippling-illness-to-win-olympic-gold.

Kirstie Ennis
Macaela MacKenzie, "Kirstie Ennis Is Climbing the Highest Mountains in the World—While Wearing a Prosthetic Leg," *Glamour*, July 16, 2019, https://www.glamour.com/story/kirstie-ennis-is-climbing-the-highest-mountains-in-the-world-while-wearing-a-prosthetic-leg.

Alyssa Roenigk, "Veteran and Hopeful Paralympian Ennis on the Power of Sports," ESPN, June 30, 2017, https://www.espn.com/olympics/story/_/page/espnwbodyennis/mountaineer-wounded-warrior-kirstie-ennis-long-road-recovery-body-2017.

"Who Is Kirstie Ennis?" Kirstie Ennis Foundation, https://kirstieennisfoundation.com/about-kirstie/.

Janet Evans
Bruce Anderson, "America's New Golden Girl," *Sports Illustrated*, August 10, 1987, https://vault.si.com/vault/1987/08/10/americas-new-golden-girl-janet-evans-15-stole-the-show-at-the-us-championships-setting-two-world-records-and-winning-four-events.
Bruce Anderson, "Of God and Glee," *Sports Illustrated*, October 3, 1988, https://vault.si.com/vault/1988/10/03/of-god-and-glee.
"Janet Evans," Olympics, https://olympics.com/en/athletes/janet-evans.
Jill Lieber, "Meet a Small Wonder in the Distance Freestyle Events," *Sports Illustrated*, September 14, 1988, https://vault.si.com/vault/1988/09/14/meet-a-small-wonder-in-the-distance-freestyle-events-the-diminutive-janet-evans-stands-head-and-shoulders-above-the-crowd.
J. E. Vader, "The Golden Girl Makes a Splash," *Sports Illustrated*, April 3, 1989, https://vault.si.com/vault/1989/04/03/the-golden-girl-makes-a-splash.

Chris Evert
"Chris Evert," International Tennis Hall of Fame, https://www.tennisfame.com/hall-of-famers/inductees/chris-evert.
Chris Evert, http://chrisevert.net/.
Curry Kirkpatrick, "Say Hello to the Girl Next Door," *Sports Illustrated*, August 30, 1976, https://vault.si.com/vault/1976/08/30/say-hello-to-the-girl-next-door.
Sarah Pileggi, "The Court Belongs to Chris," *Sports Illustrated*, December 20, 1976, https://vault.si.com/vault/1976/12/20/the-court-belongs-to-chris.

Allyson Felix
Greg Bishop, "Allyson Felix's Dignified Finish Sets Up a Promising Future for U.S. Women's Track," *Sports Illustrated*, August 7, 2021, https://www.si.com/olympics/2021/08/07/allyson-felix-makes-history-11th-medal-future.
Greg Bishop, "With History on the Line, Allyson Felix Did What No One Expected from Her," *Sports Illustrated*, August 6, 2021, https://www.si.com/olympics/2021/08/06/allyson-felix-unexpected-bronze-medal-400-meter-final.
Allyson Felix, "My Own Nike Pregnancy Story," *New York Times*, May 22, 2019, https://www.nytimes.com/2019/05/22/opinion/allyson-felix-pregnancy-nike.html.
Tim Layden, "Catch Her If You Can," *Sports Illustrated*, June 9, 2003, https://vault.si.com/vault/2003/06/09/catch-her-if-you-can-california-sprinter-allyson-felix-will-soon-be-giving-marion-jones-a-run-for-her-money.

Lisa Fernandez
Kelley King, "Question 9," *Sports Illustrated*, September 11, 2000, https://vault.si.com/vault/2000/09/11/question-9-will-anyone-get-a-hit-off-us-softball-ace-lisa-fernandez.
SI Staff, "Lisa Fernandez Update," *Sports Illustrated*, April 7, 2008, https://vault.si.com/vault/2008/04/07/lisa-fernandez-update.
Shelley Smith, "Lisa Fernandez," *Sports Illustrated*, May 24, 1993, https://vault.si.com/vault/1993/05/24/lisa-fernandez.

Jennie Finch
Mark Beech, "Star-Powered," *Sports Illustrated*, June 20, 2005, https://vault.si.com/vault/2005/06/20/starpowered.
"Biography," Jennie Finch, https://www.jenniefinch.com/biography.
David Epstein, "The Boss of Toss," *Sports Illustrated*, August 2, 2010, https://vault.si.com/vault/2010/08/02/the-boss-of-toss.
Michael Farber, "On Top of the World," *Sports Illustrated*, August 30, 2004, https://vault.si.com/vault/2004/08/30/on-top-of-the-world.

Birgit Fischer
"Birgit Fischer," Olympics, https://olympics.com/en/athletes/birgit-fischer.
"Birgit Fischer," Olympics, March 14, 2021, https://olympics.com/tokyo-2020/en/news/birgit-fischer-the-youngest-and-the-oldest-kayaking-champion.

Peggy Fleming
Bob Ottum, "Crystal and Steel on the Ice," *Sports Illustrated*, March 13, 1967, https://vault.si.com/vault/1967/03/13/crystal-and-steel-on-the-ice.
Bob Ottum, "The Perils of Peggy and a Great Silver Raid," *Sports Illustrated*, February 19, 1968, https://vault.si.com/vault/1968/02/19/the-perils-of-peggy-and-a-great-silver-raid.
E. M. Swift, "35. Peggy Fleming," *Sports Illustrated*, September 19, 1994, https://vault.si.com/vault/1994/09/19/35-peggy-fleming.

Missy Franklin
"About Missy," Missy Franklin, https://www.missyfranklin.com/about.
Kelli Anderson, "London Calling," *Sports Illustrated*, August 8, 2011, https://vault.si.com/vault/2011/08/08/london-calling.
Kelli Anderson, "Miss Sunshine," *Sports Illustrated*, August 13, 2012, https://vault.si.com/vault/2012/08/13/miss-sunshine.
Kelli Anderson, "Show Stopper," *Sports Illustrated*, July 23, 2012, https://vault.si.com/vault/2012/07/23/show-stopper.
Kelli Anderson, "Sweet 16," *Sports Illustrated*, May 23, 2011, https://vault.si.com/vault/2011/05/23/sweet-16.
Alexandra Fenwick, "Faces in the Crowd," *Sports Illustrated*, April 11, 2011, https://vault.si.com/vault/2011/04/11/faces-in-the-crowd.
Eric Todisco, "Retired Olympian Missy Franklin Says She Can Barely Swim Today," *People*, October 21, 2020, https://people.com/sports/missy-franklin-barely-swim-today-shoulder-injuries/.

Althea Gibson
Michael Bamberger, "Inside the White Lines," *Sports Illustrated*, November 29, 1999, https://vault.si.com/vault/1999/11/29/inside-the-white-lines-july-6-1957-althea-gibson-wins-wimbledon.
Mark Bechtel, "Trailblazer Althea Gibson, 1927–2003," *Sports Illustrated*, October 6, 2003, https://vault.si.com/vault/2003/10/06/trailblazer-althea-gibson-19272003.
Joan Bruce, "Althea the First," *Sports Illustrated*, July 15, 1957, https://vault.si.com/vault/1957/07/15/althea-the-first.
Sally H. Jacobs, "Althea Gibson, Tennis Star Ahead of Her Time, Gets Her Due at Last," *New York Times*, August 26, 2019, https://www.nytimes.com/2019/08/26/sports/althea-gibson-statue-us-open.html.
Sarah Palfrey, "Althea Gibson, A Shy and Awkward Girl . . . " *Sports Illustrated*, September 2, 1957, https://vault.si.com/vault/1957/09/02/althea-gibson-a-shy-and-awkward-girl-who-had-to-fight-herself-as-often-as-a-hostile-world-this-week-will-try-for-her-first-national-singles-title-at-forest-hills-here-is-a-warm-glimpse-of-her-by-an-old-friend.
SI Staff, "Cover Description," *Sports Illustrated*, September 2, 1957, https://vault.si.com/vault/1957/09/02/cover-description.
SI Staff, "The New Gibson Girl," *Sports Illustrated*, July 2, 1956, https://vault.si.com/vault/1956/07/02/the-new-gibson-girl.

Evonne Goolagong
Walter Bingham, "A Waltz at Wimbledon," *Sports Illustrated*, July 12, 1971, https://vault.si.com/vault/1971/07/12/a-waltz-at-wimbledon.
Jeff Pearlman, "Evonne Goolagong, Tennis Champion, April 26, 1976," *Sports Illustrated*, May 25, 1998, https://vault.si.com/vault/1998/05/25/evonne-goolagong-tennis-champion-april-26-1976.
L. Jon Wertheim, "People's Champion," *Sports Illustrated*, July 11, 2005, https://vault.si.com/vault/2005/07/11/peoples-champion.

Steffi Graf
Sally Jenkins, "Do Not Disturb," *Sports Illustrated*, May 23, 1994, https://vault.si.com/vault/1994/05/23/do-not-disturb-if-steffi-graf-could-shut-out-the-world-the-way-she-shuts-down-opponents-on-the-court-then-for-her-life-would-be-perfect.
Curry Kirkpatrick, "Serving Her Country," *Sports Illustrated*, June 26, 1989, https://vault.si.com/vault/1989/06/26/serving-her-country-a-grand-slam-may-have-brought-west-germanys-steffi-graf-fame-and-fortune-but-to-the-delight-of-her-countrymen-whove-watched-her-climb-to-the-top-she-remains-one-of-them.
William Nack, "The Trials of Steffi Graf," *Sports Illustrated*, November 18, 1996, https://vault.si.com/vault/1996/11/18/the-trials-of-steffi-graf-with-her-father-in-jail-and-her-own-innocence-being-questioned-the-worlds-best-woman-tennis-player-has-finally-been-forced-to-take-control-of-her-life.
Bruce Newman, "Unstoppable Steffi," *Sports Illustrated*, March 27, 1989, https://vault.si.com/vault/1989/03/27/unstoppable-steffi-awesome-in-88-steffi-graf-is-even-better-now-as-she-pursues-a-second-straight-slam.

Cammi Granato
Kelli Anderson, "Lady with a Big Stick," *Sports Illustrated*, February 8, 1993, https://vault.si.com/vault/1993/02/08/lady-with-a-big-stick-cammi-granato-product-of-a-hockey-mad-family-is-the-top-player-on-the-best-team-in-the-nation.

Florence Griffith Joyner
Christine Brennan, "Year of the Sprinter," *Washington Post*, September 16, 1988, https://www.washingtonpost.com/archive/sports/1988/09/16/year-of-the-sprinter-100-meters-to-glory/0eb241ac-1ebd-4536-8b76-67088214a479/.

Tim Layden, "Florence Griffith Joyner (1959–98)," *Sports Illustrated*, September 28, 1998, https://vault.si.com/vault/1998/09/28/florence-griffith-joyner-1959-98.
Kenny Moore, "Go, Flo, Go," *Sports Illustrated*, October 3, 1988, https://vault.si.com/vault/1988/10/03/track-and-field-go-flo-go-florence-griffith-joyner-did-just-that-in-blazing-to-victory-in-the-100-meters.
Kenny Moore, "Very Fancy, Very Fast," *Sports Illustrated*, September 14, 1988, https://vault.si.com/vault/1988/09/14/very-fancy-very-fast-us-sprinter-florence-griffith-joyner-is-certainly-eyecatching-if-that-is-you-can-catch-her.
Lindsay Parks Pieper, "Star-Spangled Fingernails," *Sport in American History* (blog), April 20, 2015, https://ussporthistory.com/2015/04/20/star-spangled-fingernails-florence-griffith-joyner-and-the-mediation-of-black-femininity/.

Gabriele Grunewald
Brave Like Gabe, https://www.bravelikegabe.org/.
Tim Layden, "Brave Like Gabe," *Sports Illustrated*, June 11, 2019, https://www.si.com/olympics/2019/06/12/gabe-grunewald-runner-cancer-battle-inspiration.
SI Staff, "Athlete Gets Cancer. Athlete Fights Cancer. Repeat, Again & Again," *Sports Illustrated*, July 17, 2017, https://vault.si.com/vault/2017/07/17/athlete-gets-cancer-athlete-fights-cancer-repeat-again-again.

Janet Guthrie
Charles Hirshberg, "Born to Drive," *Sports Illustrated*, June 6, 2005, https://vault.si.com/vault/2005/06/06/born-to-drive.
Charles Hirshberg, "Under the Hood," *Sports Illustrated*, December 19, 2005, https://vault.si.com/vault/2005/12/19/under-the-hood.
Laken Litman, "From Sleeping in Her Car to the Indy 500," *Indianapolis Star*, May 26, 2017, https://www.indystar.com/story/sports/motor/indy-500/2017/05/26/sleeping-her-car-indy-500-how-janet-guthrie-changed-racing-women/347958001/.
Sam Moses, "Gentleman John Stands Pat," *Sports Illustrated*, May 24, 1976, https://vault.si.com/vault/1976/05/24/gentleman-john-stands-pat.

Dorothy Hamill
Steve Wulf, "Cinderella Story," *Sports Illustrated*, March 7, 1994, https://vault.si.com/vault/1994/03/07/cinderella-story-former-olympic-champion-dorothy-hamill-has-found-a-perfect-fit-as-owner-and-star-of-the-ice-capades.

Mia Hamm
Gary Smith, "The Secret Life of Mia Hamm," *Sports Illustrated*, September 22, 2003, https://vault.si.com/vault/2003/09/22/mia-hamm-us-womens-national-team-greatest.
Grant Wahl, "A Woman in Full," *Sports Illustrated*, December 20, 2004, https://vault.si.com/vault/2004/12/20/a-woman-in-full.

Becky Hammon
Andrew Lawrence, "Changing of the Guard," *Sports Illustrated*, August 4, 2008, https://vault.si.com/vault/2008/08/04/changing-of-the-guard.
Dave McMenamin, "Spurs' Becky Hammon: Being First Woman to Serve as NBA Head Coach 'A Substantial Moment,'" ESPN, December 30, 2020, https://www.espn.com/nba/story/_/id/30627408/spurs-becky-hammon-becomes-first-woman-nba-regular-season-history-act-head-coach.
Joan Niesen, "Becky Hammon," *Sports Illustrated*, August 25, 2014, https://vault.si.com/vault/2014/08/25/becky-hammon.
SI Staff, "Ponytail Express," *Sports Illustrated*, December 14, 2015, https://vault.si.com/vault/2015/12/14/ponytail-express.

Lynn Hill
Lynn Hill Climbing, https://lynnhillclimbing.com/.
"Lynn Hill Freed El Cap in a Day in 1994," *Gripped: The Climbing Magazine*, November 8, 2020, https://gripped.com/uncategorized/lynn-hill-freed-el-cap-in-a-day-in-1994/.

Sabrina Ionescu
Emily Carson, "Sabrina Ionescu and Kobe Bryant," *Sporting News*, April 17, 2020, https://www.sportingnews.com/us/nba/news/sabrina-ionescu-kobe-bryant-friendship-timeline/1drj26q6mgrku1jh9emw75gwri.
Sabrina Ionescu, "Kobe Bryant Memorial," *Los Angeles Times*, February 24, 2020, https://www.latimes.com/sports/story/2020-02-24/kobe-bryant-memorial-sabrina-ionescu-talks-about-what-kobe-bryant-meant-to-her.
Joan Niesen, "The Making of Sabrina Ionescu, Oregon's Lean, Mean, Triple-Double Machine," *Sports Illustrated*, March 5, 2019, https://www.si.com/college/2019/03/05/sabrina-ionescu-oregon-women-ncaa-triple-doubles.

SI Staff, "Three for All," *Sports Illustrated*, March 11, 2019, https://vault.si.com/vault/2019/03/11/three-all.

Jackie Joyner-Kersee
Tim Layden, "Leap for Glory," *Sports Illustrated*, August 3, 1996, https://vault.si.com/vault/1996/08/03/leap-for-glory-in-her-last-hurrah-jackie-joyner-kersee-won-a-bronze-in-the-long-jump-her-sixth-olympic-medal.
Kenny Moore, "Proving Her Point," *Sports Illustrated*, October 3, 1988, https://vault.si.com/vault/1988/10/03/track-and-field-proving-her-point-jackie-joyner-kersee-fulfilled-expectations-in-winning-the-heptathlon.
Kenny Moore, "Ties That Bind," *Sports Illustrated*, April 27, 1987, https://vault.si.com/vault/1987/04/27/ties-that-bind-jackie-joyner-has-a-world-record-and-her-older-brother-al-has-an-olympic-gold-medal-best-of-all-the-two-of-them-have-each-other.

Chloe Kim
Michael Rosenberg, "Chloe Kim Is an Unforgettable Star after Gold Medal Performance at the 2018 Olympics," *Sports Illustrated*, November 28, 2018, https://www.si.com/olympics/2018/11/28/chloe-kim-winter-olympics-2018-sportsperson-top-moments.
Michael Rosenberg, "With an Endearing Personality and Unmatched Talent, Chloe Kim Emerges as the Star of the Winter Olympics," *Sports Illustrated*, February 13, 2018, https://www.si.com/olympics/2018/02/13/chloe-kim-winter-olympics-pyeongchang-2018.
SI Staff, "Chloe Kim, Super Chill," *Sports Illustrated*, January 29, 2018, https://vault.si.com/vault/2018/01/29/chloe-kim-super-chill.

Billie Jean King
Frank Deford, "Mrs. Billie Jean King!" *Sports Illustrated*, May 19, 1975, https://vault.si.com/vault/1975/05/19/mrs-billie-jean-king.
Sally Jenkins, "5. Billie Jean King," *Sports Illustrated*, September 19, 1994, https://vault.si.com/vault/1994/09/19/5-billie-jean-king.
Billie Jean King, https://www.billiejeanking.com/.
Curry Kirkpatrick, "There She Is, Ms. America," *Sports Illustrated*, October 1, 1973, https://vault.si.com/vault/1973/10/01/there-she-is-ms-america.
Ilana Kloss, "My Inspiration," WTA Tour, June 15, 2020, https://www.wtatennis.com/news/1679472/my-inspiration-billie-jean-king-by-ilana-kloss.

Julie Krone
Michael Diegnan, "Where Are They Now?" ABC Sports Online, April 19, 2001, http://www.espn.com/abcsports/s/2001/0417/1174371.html.
Gina Maranto, "A Woman of Substance," *Sports Illustrated*, August 24, 1987, https://vault.si.com/vault/1987/08/24/a-woman-of-substance-jockey-julie-krone-4-ft-10-12-in-looms-large-at-monmouth.
William Nack, "The Ride of Her Life," *Sports Illustrated*, June 13, 1994, https://vault.si.com/vault/1994/06/13/the-ride-of-her-life-after-a-spill-last-summer-that-almost-killed-her-julie-krone-has-returned-to-the-winners-circle.

Michelle Kwan
Andrew Lawrence, "Michelle Kwan," *Sports Illustrated*, August 2, 2010, https://vault.si.com/vault/2010/08/02/michelle-kwan.
"Michelle Kwan," Olympics, https://olympics.com/en/athletes/michelle-kwan.
E. M. Swift, "Into the Light," *Sports Illustrated*, February 9, 1998, https://vault.si.com/vault/1998/02/09/into-the-light-a-lifetime-of-dedication-gave-michelle-kwan-of-the-us-the-strength-to-step-out-of-the-shadows-of-doubt-and-move-to-the-edge-of-perfection.
E. M. Swift, "A Star Is Reborn," *Sports Illustrated*, January 19, 1998, https://vault.si.com/vault/1998/01/19/a-star-is-reborn-in-a-pas-de-deux-with-perfection-michelle-kwan-regained-the-us-title-and-became-the-leading-lady-on-a-potent-national-team.

Larisa Latynina
"Larisa Latynina," Olympics, https://olympics.com/en/athletes/larisa-latynina.
"Record-Breaking Gymnast Latynina Certain She Was 'Born a Winner,'" Olympics, September 4, 2019, https://olympics.com/ioc/news/record-breaking-gymnast-latynina-certain-she-was-born-a-winner.

Katie Ledecky
SI Staff, "Iron Butterfly," *Sports Illustrated*, August 22, 2016, https://vault.si.com/vault/2016/08/22/iron-butterfly.
SI Staff, "Out of Ordinary," *Sports Illustrated*, May 30, 2016, https://vault.si.com/vault/2016/05/30/out-ordinary.

Lisa Leslie
Kelli Anderson, "Smooth Move," *Sports Illustrated*, September 21, 2009, https://vault.si.com/vault/2009/09/21/smooth-move.
Shelley Smith, "She Was Truckin'," *Sports Illustrated*, February 19, 1990, https://vault.si.com/vault/1990/02/19/she-was-truckin-schoolgirl-lisa-leslie-scored-101-points-in-the-first-half-and-then-the-opposition-went-home.
Phil Taylor, "A Model Role Model," *Sports Illustrated*, November 25, 1991, https://vault.si.com/vault/1991/11/25/a-model-role-model-southern-californias-lisa-leslie-is-the-kind-of-player-who-can-elevate-the-womens-game-to-greater-heights.
Phil Taylor, "Spirits of '72," *Sports Illustrated*, May 7, 2012, https://vault.si.com/vault/2012/05/07/spirits-of-72.

Nancy Lieberman
Curry Kirkpatrick, "The Game Is Her Dominion," *Sports Illustrated*, December 3, 1979, https://vault.si.com/vault/1979/12/03/the-game-is-her-dominion-nancy-lieberman-of-old-dominion-rules-the-world-of-womens-basketball-to-which-her-rough-and-tumble-style-of-play-has-given-a-spectacular-new-dimension.
Franz Lidz, "Mixing It Up with the Guys," *Sports Illustrated*, June 23, 1986, https://vault.si.com/vault/1986/06/23/mixing-it-up-with-the-guys.
Steve Wulf, "A Girl Who's Just One of the Guys," *Sports Illustrated*, July 21, 1980, https://vault.si.com/vault/1980/07/21/a-girl-whos-just-one-of-the-guys-nancy-lieberman-is-holding-her-own-in-a-tough-summer-league-that-includes-some-nba-players.

Carli Lloyd
Charlotte Carroll, "Trainer: USWNT's Carli Lloyd Received Offer to Kick in NFL Preseason Game," *Sports Illustrated*, August 26, 2019, https://www.si.com/soccer/2019/08/27/carli-lloyd-nfl-kicker-preseason-offer-field-goal.
Julie Foudy, "Episode 17: Carli Lloyd," October 15, 2019, in *Laughter Permitted with Julie Foudy*, ESPNW, podcast, https://www.espn.com/radio/play/_/id/27847644.
SI Staff, "Aye, Carli," *Sports Illustrated*, July 20, 2015, https://vault.si.com/vault/2015/07/20/aye-carli.
SI Staff, "The Case for . . . Carli Lloyd," *Sports Illustrated*, November 9, 2015, https://vault.si.com/vault/2015/11/09/case-carli-lloyd.

Rebecca Lobo
SI Staff, "At Home in the Hall," *Sports Illustrated*, September 18, 2017, https://vault.si.com/vault/2017/09/18/home-hall.
Rick Telander, "The Post with the Most," *Sports Illustrated*, March 20, 1995, https://vault.si.com/vault/1995/03/20/the-post-with-the-most-writers-cramp-may-be-all-that-can-stop-rebecca-lobo-no-1-uconns-fan-favorite.

Jessica Long
"2021 Toyota Big Game Commercial: Jessica Long's Story," YouTube, February 3, 2021, https://www.youtube.com/watch?v=fqWG5_7nwyk.
Amp Media, "London 2019: Jessica Long's Mixed Memories," World Para Swimming, August 13, 2019, https://www.paralympic.org/feature/london-2019-jessica-long-s-mixed-memories.
Andrew Binner, "From Siberia to Swimming Stardom," Olympics, March 30, 2021, https://olympics.com/en/featured-news/siberia-to-swimming-stardom-paralympic-jessica-long-amazing-story.
Coleman Hodges, "Jessica Long Explains Surreal Experience of Being Featured in Super Bowl Ad," March 14, 2021, in *SwimSwam*, podcast, https://swimswam.com/jessica-long-explains-surreal-experience-of-being-featured-in-super-bowl-ad/.

Nancy Lopez
Frank Deford, "Nancy with the Laughing Face," *Sports Illustrated*, July 10, 1978, https://vault.si.com/vault/1978/07/10/nancy-with-the-laughing-face-shes-no-longer-a-golfer-shes-an-event-but-the-dazzling-lopez-has-kept-her-cool-thanks-in-part-to-a-very-savvy-caddie-named-roscoe.
Frank Lipsey, "Nancy Lopez," *Sports Illustrated*, July 14, 2008, https://vault.si.com/vault/2008/07/14/nancy-lopez.
Barry McDermott, "All Smiles While She Tears Up the Tour," *Sports Illustrated*, June 19, 1978, https://vault.si.com/vault/1978/06/19/all-smiles-while-she-tears-up-the-tour-nancy-lopez-the-amazing-21-year-old-rookie-won-her-fourth-straight-tournament-by-routing-the-field-in-the-lpga-championship.
Beth Ann Nichols, "Nancy Lopez Took LPGA by Storm, but Will We See Another Like Her," *Golfweek*, March 31, 2019, https://golfweek.usatoday.com/2019/03/31/golf-nancy-lopez-lpga-profile-history/.

Tegla Loroupe
Merrell Noden, "She's In It for the Long Run," *Sports Illustrated*, November 2, 1998, https://vault.si.com/vault/1998/11/02/shes-in-it-for-the-long-run-tegla-loroupe-aims-to-lower-her-marathon-best-and-elevate-kenyan-women.
SI Staff, "The Longest Run," *Sports Illustrated*, July 25, 2016, https://vault.si.com/vault/2016/07/25/longest-run.

Ellen MacArthur
"Ellen MacArthur Cancer Trust," RYA, https://www.rya.org.uk/about-us/charities-foundations/ellen-macarthur-cancer-trust.
Ellen MacArthur Foundation, https://www.ellenmacarthurfoundation.org/.
Franz Lidz, "Going It Alone," *Sports Illustrated*, September 12, 2005, https://vault.si.com/vault/2005/09/12/going-it-alone.

Marta
Charlotte Carroll, "Brazil's Marta Gives Inspiring Speech to Next Generation Following France Loss," *Sports Illustrated*, June 23, 2019, https://www.si.com/soccer/2019/06/23/marta-brazil-inspiring-speech-video.
Deborah Espinosa, "In Brazil, Female Warriors Fight for a Level Playing Field," World Justice Project, 2015, https://worldjusticeproject.org/photo-essays/brazil-female-warriors-fight-level-playing-field.
Alana Glass, "Brazil Announces Equal Pay for Women's and Men's National Teams," Forbes, September 2, 2020, https://www.forbes.com/sites/alanaglass/2020/09/02/brazil-announces-equal-pay-for-womens-and-mens-national-teams/?sh=3c79a39084d5.
Joey Gulino, "Changed the Game," Yahoo Sports, March 31, 2021, https://sports.yahoo.com/changed-the-game-marta-crawled-so-womens-soccer-in-brazil-could-run-120045570.html.

Tatyana McFadden
Cindy Kuzma, "There's No Hill Tatyana McFadden Can't Climb," *Women's Running*, January 17, 2021, https://www.womensrunning.com/culture/people/tatyana-mcfadden-lessons-in-resilience/.
Tatyana McFadden, https://www.tatyanamcfadden.com/.

Ann Meyers Drysdale
Dana Hunsinger Benbow, "Ann Meyers Took Her Best Shot at Making the Pacers," *Indianapolis Star*, June 2, 2015, https://www.indystar.com/story/sports/nba/pacers/2015/06/02/ann-meyers-took-best-shot-making-pacers/28345597/.
Cody Cunningham, "Ann Meyers Drysdale Led the Way for Women in Sports," NBA, March 8, 2020, https://www.nba.com/suns/features/historic-journey-hall-famer-ann-meyers-drysdale#.

Cheryl Miller
Roger Jackson, "She May Well Be the Best Ever," *Sports Illustrated*, November 29, 1982, https://vault.si.com/vault/1982/11/29/she-may-well-be-the-best-ever.
Curry Kirkpatrick, "Lights! Camera! Cheryl!" *Sports Illustrated*, November 20, 1985, https://vault.si.com/vault/1985/11/20/lights-camera-cheryl.
Phil Taylor, "A Model Role Model," *Sports Illustrated*, November 25, 1991, https://vault.si.com/vault/1991/11/25/a-model-role-model-southern-californias-lisa-leslie-is-the-kind-of-player-who-can-elevate-the-womens-game-to-greater-heights.

Shannon Miller
Greg Bishop, "The Magnificent Seven," *Sports Illustrated*, July 7, 2016, https://www.si.com/olympics/2016/07/07/gymnastics-magnificent-seven-1996-olympics-atlanta.
Brian Cazeneuve, "Sooner Surprise," *Sports Illustrated*, December 29, 2003, https://vault.si.com/vault/2003/12/29/sooner-surprise-who-would-have-guessed-that-football-mad-oklahoma-is-also-a-gymnastics-hotbed.
Lauren Green, "Lessons from the Olympics Helped Shannon Miller Fight Ovarian Cancer," *Sports Illustrated*, October 1, 2020, https://www.si.com/olympics/2020/10/01/shannon-miller-ovarian-cancer-battle-tokyo-olympics.
Shannon Miller, https://www.shannonmiller.com/.

Maya Moore
Kelli Anderson, "Ready for Moore?" *Sports Illustrated*, November 17, 2008, https://vault.si.com/vault/2008/11/17/ready-for-moore.
Richard Deitsch, "The Case for . . . Maya Moore," *Sports Illustrated*, October 21, 2013, https://vault.si.com/vault/2013/10/21/the-case-for-maya-moore.
Jack McCallum, "The Nutmeg Dynasty," *Sports Illustrated*, December 13, 2010, https://vault.si.com/vault/2010/12/13/the-nutmeg-dynasty.

Maya Moore, "The Shift," *Players' Tribune*, February 6, 2019, https://www.theplayerstribune.com/articles/maya-moore-wnba-announcement.

Kurt Streeter, "Jonathan Irons, Helped by WNBA Star Maya Moore, Freed From Prison," *New York Times*, July 1, 2020, https://www.nytimes.com/2020/07/01/sports/basketball/maya-moore-jonathan-irons-freed.html.

Kurt Streeter, "Maya Moore Left Basketball. A Prisoner Needed Her Help," *New York Times*, June 30, 2019, https://www.nytimes.com/2019/06/30/sports/maya-moore-wnba-quit.html.

Alex Morgan

Grant Wahl, "Alex in Wonderland," *Sports Illustrated*, June 24, 2013, https://vault.si.com/vault/2013/06/24/alex-in-wonderland.

Grant Wahl, "The Power to Rule," *Sports Illustrated*, June 27, 2011, https://vault.si.com/vault/2011/06/27/the-power-to-rule.

Martina Navratilova

Frank Deford, "Yes, You Can Go Home Again," *Sports Illustrated*, August 4, 1986, https://vault.si.com/vault/1986/08/04/yes-you-can-go-home-again-martina-navratilova-went-home-to-czechoslovakia-and-found-fans-plentiful-at-the-federation-cup.

Martina Navratilova, "An Open Letter from Martina Navratilova to Margaret Court Arena," *Sydney Morning Herald*, June 1, 2017, https://www.smh.com.au/sport/tennis/an-open-letter-from-martina-navratilova-to-margaret-court-arena-20170601-gwhuyx.html.

Jeremiah Tax, "Martina Navratilova's Account of Her Life Is Fascinating, If Flawed," *Sports Illustrated*, June 10, 1985, https://vault.si.com/vault/1985/06/10/martina-navratilovas-account-of-her-life-is-fascinating-if-flawed.

Alexander Wolff, "14. Martina Navratilova," *Sports Illustrated*, September 19, 1994, https://vault.si.com/vault/1994/09/19/14-martina-navratilova.

Diana Nyad

Kelli Anderson, "Timed Traveler," *Sports Illustrated*, October 14, 2013, https://vault.si.com/vault/2013/10/14/timed-traveler.

Dan Levin, "An Ill Wind That Blew No Good," *Sports Illustrated*, August 28, 1978, https://vault.si.com/vault/1978/08/28/an-ill-wind-that-blew-no-good-diana-nyad-failed-to-swim-from-cuba-to-key-west-when-adverse-winds-whipping-up-huge-swells-forced-her-out-of-the-water.

Diana Nyad, "Diana Nyad: My Life After Sexual Assault," *New York Times*, November 9, 2017, https://www.nytimes.com/2017/11/09/opinion/diana-nyad-sexual-assault.html.

Naomi Osaka

Martina Navratilova, "Meet Your 2020 Sportsperson of the Year Winners: Naomi Osaka," *Sports Illustrated*, December 7, 2020, https://www.si.com/sportsperson/2020/12/07/naomi-osaka-sportsperson-award.

Naomi Osaka (@naomiosaka), "Undoubtedly the greatest . . ." Twitter, July 23, 2021, https://twitter.com/naomiosaka/status/1418602684580438019.

George Ramsay, "These Were the Black Victims Naomi Osaka Honored on Face Masks at the US Open," CNN.com, September 14, 2020, https://www.cnn.com/2020/09/11/tennis/naomi-osaka-us-open-face-mask-spt-intl/index.html.

Joshua Robinson, "Naomi Osaka Wins the Australian Open, Her Fourth Grand Slam Title," *Wall Street Journal*, February 20, 2021, https://www.wsj.com/articles/naomi-osaka-wins-the-australian-open-her-fourth-grand-slam-title-11613815609.

SI Staff, "Bitter and Sweet," *Sports Illustrated*, December 17, 2018, https://vault.si.com/vault/2018/12/17/bitter-and-sweet.

SI Staff, "Here Comes the Champ," *Sports Illustrated*, February 11, 2019, https://vault.si.com/vault/2019/02/11/here-comes-champ.

Cat Osterman

Cliff Brunt, "Former Texas Star Cat Osterman Looks to End Decorated Softball Career on Top," Hook'Em.com, February 8, 2021, https://www.hookem.com/story/sports/softball/2021/02/08/texas-softball-former-star-cat-osterman-end-softball-career/4434468001/.

Michael Farber, "On Top of the World," *Sports Illustrated*, August 30, 2004, https://vault.si.com/vault/2004/08/30/on-top-of-the-world.

Graham Hays, "Cat Osterman, Prepping for Olympics, Steps Down as Texas State Assistant," ESPN, May 12, 2021, https://www.espn.com/olympics/story/_/id/29166860/cat-osterman-prepping-olympics-steps-texas-state-assistant.

Cat Osterman, https://www.catosterman.com/.

Michael Silver, "Hitting the Big Time," *Sports Illustrated*, June 6, 2005, https://vault.si.com/vault/2005/06/06/-hitting-the-big-time.

Se Ri Pak

Michael Bamberger, "Yes Se Ri," *Sports Illustrated*, August 3, 1998, https://vault.si.com/vault/1998/08/03/yes-se-ri-her-three-victories-in-a-month-left-no-doubt-that-lpga-rookie-se-ri-pak-is-the-genuine-article-this-week-she-can-make-history.

Jaime Diaz, "The Whole Pak-Age," *Sports Illustrated*, May 25, 1998, https://vault.si.com/vault/1998/05/25/the-whole-pak-age-twenty-year-old-se-ri-pak-of-south-korea-staked-a-claim-on-the-future-with-a-victory-at-the-lpga-championship.

"Se Ri Pak Ends Hall of Fame Career with Emotional Send-Off," *Golf*, October 13, 2016, https://golf.com/news/se-ri-pak-ends-hall-of-fame-career-with-emotional-send-off/.

Candace Parker

Kelli Anderson, "Candace, Take Two," *Sports Illustrated*, November 21, 2005, https://vault.si.com/vault/2005/11/21/candace-take-two.

Kelli Anderson, "A Hit Sequel," *Sports Illustrated*, March 10, 2008, https://vault.si.com/vault/2008/03/10/a-hit-sequel.

Andrew Lawrence, "Sparks Are Gonna Fly," *Sports Illustrated*, June 6, 2011, https://vault.si.com/vault/2011/06/06/sparks-are-gonna-fly.

Danica Patrick

Kelli Anderson, "Lone Star," *Sports Illustrated*, June 20, 2005, https://vault.si.com/vault/2005/06/20/lone-star.

Lars Anderson, "Forget the Hype," *Sports Illustrated*, May 19, 2008, https://vault.si.com/vault/2008/05/19/forget-the-hype.

Lars Anderson, "No Spin," *Sports Illustrated*, February 15, 2010, https://vault.si.com/vault/2010/02/15/no-spin-danica-brings-the-dazzle.

SI Staff, "Here She Comes," *Sports Illustrated*, June 6, 2005, https://vault.si.com/vault/2005/06/06/here-she-comes.

Aly Raisman

Mina Kimes, "Aly Raisman Takes the Floor," *ESPN*, July 18, 2018, http://www.espn.com/espnw/feature/24078028/olympian-aly-raisman-change-way-our-society-views-women.

Kikkan Randall

Bonnie D. Ford, "The Rough Terrain," *ESPN*, February 21, 2019, http://www.espn.com/espnw/feature/26032552/kikkan-randall-shares-journey-rough-terrain.

Kikkan Randall, https://www.kikkan.com/.

Alexander Wolff, "Kikkan Randall Making the Best of a Frustrating Winter Olympics," *Sports Illustrated*, February 18, 2014, https://www.si.com/olympics/2014/02/18/sochi-olympics-kikkan-randall-cross-country-skiing.

Megan Rapinoe

Caitlin Murray, "Stand or Kneel?" *Guardian*, February 26, 2021, https://www.theguardian.com/football/2021/feb/26/megan-rapinoe-national-anthem-vote-general-meeting.

SI Staff, "Unflappable. Unapologetic. Unequaled," *Sports Illustrated*, July 15, 2019, https://vault.si.com/vault/2019/07/15/unflappable-unapologetic-unequaled.

SI Staff, "USA in Pinoe Veritas," *Sports Illustrated*, June 3, 2019, https://vault.si.com/vault/2019/06/03/usa-pinoe-veritas.

Jenny Vrentas, "2019 Sportsperson of the Year: Megan Rapinoe," *Sports Illustrated*, December 9, 2019, https://www.si.com/sportsperson/2019/12/09/megan-rapinoe-2019-sportsperson-of-the-year.

Grant Wahl, "Unquiet American," *Sports Illustrated*, August 6, 2012, https://vault.si.com/vault/2012/08/06/unquiet-american.

Mary Lou Retton

Frank Deford, "Rising to Great Heights," *Sports Illustrated*, December 24, 1984, https://vault.si.com/vault/1984/12/24/rising-to-great-heights.

Bob Ottum, "It's Up to You, Mary Lou," *Sports Illustrated*, July 18, 1984, https://vault.si.com/vault/1984/07/18/its-up-to-you-mary-lou.

Bob Ottum, "A Vault without Fault," *Sports Illustrated*, August 13, 1984, https://vault.si.com/vault/1984/08/13/a-vault-without-fault.

Kim Rhode

Brian Cazeneuve, "The Year of the Women," *Sports Illustrated*, December 17, 2012, https://vault.si.com/vault/2012/12/17/the-year-of-the-women.

S. L. Price, "She's the Greatest," *Sports Illustrated*, August 6, 2012, https://vault.si.com/vault/2012/08/06/shes-the-greatest.

Jonathan Selvaraj, "US Shooter Kim Rhode Talks Guns, Trump and Little Bighorn," ESPN, March 3, 2017, https://www.espn.com/shooting/story/_/id/18814114/us-shooter-kim-rhode-talks-guns-trump-little-bighorn.

Ronda Rousey

Melissa Segura, "Ronda Rousey Lays the Smack Down," *Sports Illustrated*, November 5, 2012, https://vault.si.com/vault/2012/11/05/ronda-rousey-lays-the-smack-down.

L. Jon Wertheim, "The Unbreakable Ronda Rousey," *Sports Illustrated*, May 18, 2015, https://vault.si.com/vault/2015/05/18/the-unbreakable-ronda-rousey.

Wilma Rudolph

Barbara Heilman, "Like Nothing Else in Tennessee," *Sports Illustrated*, November 14, 1960, https://vault.si.com/vault/1960/11/14/like-nothing-else-in-tennessee.

Frank Litsky, "Wilma Rudolph, Star of the 1960 Olympics, Dies at 54," *New York Times*, November 13, 1994, https://www.nytimes.com/1994/11/13/obituaries/wilma-rudolph-star-of-the-1960-olympics-dies-at-54.html.

M. B. Roberts, "Rudolph Ran and World Went Wild," ESPN, https://www.espn.com/sportscentury/features/00016444.html.

Wilma Rudolph, https://wilmarudolph.com/.

Mikaela Shiffrin

Greg Bishop, "Mikaela Shiffrin's View from the Top," *Sports Illustrated*, February 18, 2020, https://www.si.com/olympics/2020/02/18/mikaela-shiffrins-view-from-the-top.

Tim Layden, "Near Future," *Sports Illustrated*, March 3, 2014, https://vault.si.com/vault/2014/03/03/near-future.

Tim Layden, "So Good, So Young," *Sports Illustrated*, February 3, 2014, https://vault.si.com/vault/2014/02/03/so-good-so-young.

SI Staff, "Mikaela Shiffrin Pump Up the Volume," *Sports Illustrated*, January 29, 2018, https://vault.si.com/vault/2018/01/29/mikaela-shiffrin-pump-volume.

Annika Sorenstam

Michael Bamberger, "Time Tested," *Sports Illustrated*, August 11, 2003, https://vault.si.com/vault/2003/08/11/time-tested-the-clock-is-ticking-on-annika-sorenstams-hall-of-fame-career-and-thats-what-made-completing-her-grand-slam-at-royal-lytham-special.

Michael Bamberger, "A Woman among Men," *Sports Illustrated*, February 24, 2003, https://vault.si.com/vault/2003/02/24/a-woman-among-men-annika-sorenstam-the-worlds-best-female-golfer-has-labored-in-the-obscurity-of-the-lpga-but-thats-all-changed-now-that-shes-preparing-to-tee-it-up-with-the-big-boys.

Dawn Staley

SI Staff, "A Blazing Dawn," *Sports Illustrated*, November 19, 1990, https://vault.si.com/vault/1990/11/19/scouting-reports-a-blazing-dawn-dawn-staley-all-5-ft-5-in-of-her-lifts-virginia-to-bold-new-heights.

SI Staff, "New Vibrations," *Sports Illustrated*, April 10, 2017, https://vault.si.com/vault/2017/04/10/new-vibrations.

Dawn Staley (@dawnstaley), "Yooooo I'm so with this . . ." Twitter, May 17, 2021, https://twitter.com/dawnstaley/status/1394320050123952131.

Alexander Wolff, "Steward of the Game," *Sports Illustrated*, July 24, 1996, https://vault.si.com/vault/1996/07/24/steward-of-the-game-us-guard-dawn-staley-plays-with-savvy-and-compassion.

Breanna Stewart

Emma Carmichael, "The Swing Shift," *Sports Illustrated*, March 24, 2014, https://vault.si.com/vault/2014/03/24/the-swing-shift.

Julie Foudy, "Breanna Stewart Opens Up about Her Story of Sexual Abuse," ESPN, June 25, 2018, https://www.espn.com/wnba/story/_/id/23853238/wnba-breanna-stewart-talks-julie-foudy-surviving-sexual-abuse-body-issue-2018.

Megan Rapinoe, "Meet Your 2020 Sportsperson of the Year Winners: Breanna Stewart," *Sports Illustrated*, December 7, 2020, https://www.si.com/sportsperson/2020/12/07/breanna-stewart-seattle-storm-sportsperson-award.

SI Staff, "Winners Gonna Win," *Sports Illustrated*, December 17, 2018, https://vault.si.com/vault/2018/12/17/winners-gonna-win.

Picabo Street

Michael Farber, "Playing Picabo," *Sports Illustrated*, December 18, 1995, https://vault.si.com/vault/1995/12/18/playing-picabo-life-is-a-game-for-the-uss-picabo-street-the-top-woman-downhiller-and-shes-winning.

Rick Reilly, "Uphill Battle for a Downhill Skier," *Sports Illustrated*, November 23, 1998, https://vault.si.com/vault/1998/11/23/the-life-of-reilly-uphill-battle-for-a-downhill-skier.

Kerri Strug

Richard Hoffer, "Day 5, a Most Unlikely Hero," *Sports Illustrated*, August 5, 1996, https://vault.si.com/vault/1996/08/05/day-5-a-most-unlikely-hero.

Johnette Howard, "True Grit," *Sports Illustrated*, July 24, 1996, https://vault.si.com/vault/1996/07/24/us-women-gymnastics-gold-1996-olympics-atlanta-kerri-strug.

Jane Leavy, "Happy Landing," *Sports Illustrated*, August 11, 1997, https://vault.si.com/vault/1997/08/11/happy-landing-a-year-after-her-olympic-vault-to-fame-kerri-strug-is-in-college-learning-to-live-like-an-ordinary-kid.

SI Staff, "Catching Up with Kerri Strug," *Sports Illustrated*, July 25, 2008, https://www.si.com/olympics/2008/07/26/strug-cuw.

SI Staff, "Profile in Courage," *Sports Illustrated*, August 5, 1996, https://vault.si.com/vault/1996/08/05/profile-courage-competition-marked-drama-emotion-and-finally-heroism-american-women-won-their-first.

Pat Summitt

Kelli Anderson, "A Coach in the Game," *Sports Illustrated*, September 5, 2011, https://vault.si.com/vault/2011/09/05/a-coach-in-the-game.

Candace Parker, "Ain't She Grand?" *Sports Illustrated*, February 16, 2009, https://vault.si.com/vault/2009/02/16/aint-she-grand.

Gary Smith, "Eyes of the Storm," *Sports Illustrated*, March 2, 1998, https://vault.si.com/vault/1998/03/02/eyes-of-the-storm-when-tennessees-whirlwind-of-a-coach-pat-summitt-hits-you-with-her-steely-gaze-you-get-a-dose-of-the-intensity-that-has-carried-the-lady-vols-to-five-ncaa-titles.

Alexander Wolff, "Sportswoman of the Year: Pat Summitt," *Sports Illustrated*, December 12, 2011, https://vault.si.com/vault/2011/12/12/sportsman-of-the-year-mike-krzyzewski-sportswoman-of-the-year-pat-summitt.

Sheryl Swoopes

Kelli Anderson, "Rhymes with Hoops," *Sports Illustrated*, April 12, 1993, https://vault.si.com/vault/1993/04/12/rhymes-with-hoops-sheryl-swoopes-was-the-name-of-the-game-as-she-led-texas-tech-to-the-womens-ncaa-title.

Christine Brennan, "Gender Gap Sends Futures on Different Paths," *Washington Post*, June 15, 1993, https://www.washingtonpost.com/archive/sports/1993/06/15/gender-gap-sends-futures-on-different-paths/e8a0a3fe-9767-40f6-be84-b1163785a47b/.

Gerry Callahan, "Little Sister Driven to Prove Herself against Her Older Brothers and Other Boys, Sheryl Swoopes Became Queen of the Court," *Sports Illustrated*, July 19, 1996, https://vault.si.com/vault/1996/07/19/little-sister-driven-to-prove-herself-against-her-older-brothers-and-other-boys-sheryl-swoopes-became-queen-of-the-court.

Sheryl Swoopes, "The Legend of Michael Jordan," *Players' Tribune*, https://projects.theplayerstribune.com/legend-of-michael-jordan/p/1.

Junko Tabei

Abbie Barronian, "Junko Tabei, the First Woman to Climb Everest and the Seven Summits," *Adventure Journal*, December 31, 2020, https://www.adventure-journal.com/2020/12/junko-taibei-first-woman-climb-everest-seven-summits/.

Bill Chappell, "Japanese Climber Junko Tabei, First Woman to Conquer Mount Everest, Dies at 77," NPR, October 22, 2016, https://www.npr.org/sections/thetwo-way/2016/10/22/498971169/japanese-climber-junko-tabei-first-woman-to-conquer-mount-everest-dies-at-77.

Robert Horn, "No Mountain Too High for Her," *Sports Illustrated*, April 29, 1996, https://vault.si.com/vault/1996/04/29/no-mountain-too-high-for-her-junko-tabei-defied-japanese-views-of-women-to-become-an-expert-climber.

Diana Taurasi

Michael Bamberger, "Driving Force," *Sports Illustrated*, January 20, 2003, https://vault.si.com/vault/2003/01/20/driving-force-guard-diana-taurasi-gear-bending-game-and-relentless-style-had-uconn-streaking-toward-a-record.

Katie Barnes, "WNBA's Diana Taurasi: 'My Sole Objective Is to Be on the Court and to Be Badass," ESPN, December 17, 2020, https://www.espn.com/wnba/story/_/id/30534084/wnba-diana-taurasi-my-sole-objective-on-court-badass.

Frank Deford, "Geno Auriemma + Diana Taurasi = Love, Italian Style," *Sports Illustrated*, November 24, 2003, https://vault.si.com/vault/2003/11/24/geno-auriemma-diana-taurasi-love-italian-style-a-pair-of-paisans-at-uconn-share-a-passion-for-hoops-that-makes-a-perfect-match-of-cocky-coach-and-fearless-player.

Frank Deford, "UConn's Flashy Finish," *Sports Illustrated*, April 19, 2004, https://vault.si.com/vault/2004/04/19/uconns-flashy-finish-connecticuts-diana-taurasi-capped-her-matchless-career-and-her-teams-strange-yearwith-a-threepeat-so-whats-next.

SI Staff, "My Sportsman: Diana Taurasi," *Sports Illustrated*, November 2, 2009, https://www.si.com/sportsperson/2009/11/02/mccallum-taurasi.

Mechelle Voepel, "Olympics 2021," ESPN, August 8, 2021, https://www.espn.com/olympics/story/_/id/31983426/olympics-2021-five-olympic-gold-medalists-sue-bird-diana-taurasi-greatest-teammates-history-sports.

Jenny Thompson

Joanne C. Gerstner, "Trading the Pool for a Hospital, Jenny Thompson Is Ready to Fight COVID-19 on the Front Lines," Team USA, May 5, 2020, https://www.teamusa.org/News/2020/May/05/Trading-The-Pool-For-A-Hospital-Jenny-Thompson-Is-Ready-To-Fight-COVID19-On-The-Front-Lines.

Jack McCallum, "Unflagging," *Sports Illustrated*, August 14, 2000, https://vault.si.com/vault/2000/08/14/unflagging-five-time-gold-medalist-jenny-thompson-27-plans-to-undress-her-younger-rivals-in-sydney-and-become-the-most-decorated-us-woman-olympian-ever.

Dara Torres

Kelli Anderson, "One for the Aged," *Sports Illustrated*, August 25, 2008, https://vault.si.com/vault/2008/08/25/one-for-the-aged.

Dan Levin, "She's Set Her Sights on L.A.," *Sports Illustrated*, June 18, 1984, https://vault.si.com/vault/1984/06/18/shes-set-her-sights-on-la.

SI Staff, "Adult Swim," *Sports Illustrated*, August 13, 2007, https://vault.si.com/vault/2007/08/13/adult-swim.

Lindsey Vonn

Tim Layden, "Ready to Rock," *Sports Illustrated*, February 8, 2010, https://vault.si.com/vault/2010/02/08/ready-to-rock.

Austin Murphy, "Smashing Success," *Sports Illustrated*, March 10, 2008, https://vault.si.com/vault/2008/03/10/smashing-success.

SI Staff, "Scarred, Yes But Never Scared," *Sports Illustrated*, January 15, 2018, https://vault.si.com/vault/2018/01/15/scarred-yes-never-scared.

Grete Waitz

Associated Press, "Marathon Great Grete Waitz Dies at 57," ESPN, April 19, 2011, https://www.espn.com/olympics/trackandfield/news/story?id=6387774.

Kenny Moore, "Getting a L'egg Up in New York," *Sports Illustrated*, June 10, 1985, https://vault.si.com/vault/1985/06/10/getting-a-legg-up-in-new-york.

Kenny Moore, "There Are Only 26 Miles to Go," *Sports Illustrated*, November 3, 1980, https://vault.si.com/vault/1980/11/03/there-are-only-26-miles-to-go-and-at-the-new-york-marathons-end-there-was-a-predictable-winner-in-grete-waitz-a-surprise-in-alberto-salazar.

Liz Robbins and Bruce Weber, "Grete Waitz, Marathon Champion, Dies at 57," *New York Times*, April 19, 2011, https://www.nytimes.com/2011/04/20/sports/othersports/20waitz.html.

Kerri Walsh Jennings

Kelli Anderson, "A Sand Slam," *Sports Illustrated*, December 29, 2008, https://vault.si.com/vault/2008/12/29/a-sand-slam.

Alyssa Hertel, "Kerri Walsh Jennings Still Falling in Love with Beach Volleyball after Missing First Olympics in 20 Years," *USA Today*, July 26, 2021, https://www.usatoday.com/story/sports/olympics/2021/07/26/kerri-walsh-jennings-misses-tokyo-olympics-future-beach-volleyball/8084052002/.

Tory Z. Roy, "Adia Barnes, Candace Parker, Kerri Walsh Jennings: To Be a Working Mom in Sports," ESPN, May 9, 2021, https://www.espn.com/wnba/story/_/id/31411623/adia-barnes-candace-parker-kerri-walsh-jennings-working-mom-sports.

Kerri Walsh Jennings, p1440.com.

Abby Wambach

Mark Bechtel, "The Mouth That Scored," *Sports Illustrated*, October 1, 2007, https://vault.si.com/vault/2007/10/01/the-mouth-that-scored.

Jessica Bennett, "Are You a Glennon or an Abby?" *New York Times*, May 11, 2021, https://www.nytimes.com/2021/05/11/style/glennon-doyle-abby-wambach-instagram-podcast.html.

Grant Wahl, "Abby's Road," *Sports Illustrated*, June 8, 2015, https://vault.si.com/vault/2015/06/08/abbys-road-to-world-cup-glory-at-last-to-peace-of-mind.

Kathy Whitworth

Michael Bamberger, "Kathy Whitworth, Golf's Winningest Player, Has Covered Significant Ground in Helping Grow the Game She Loves," *Golf*, March 8, 2021, https://golf.com/news/features/kathy-whitworth-helping-grow-golf/.

Curry Kirkpatrick, "Put on Your Bracelets, Kathy Is Here," *Sports Illustrated*, May 12, 1969, https://vault.si.com/vault/1969/05/12/put-on-your-bracelets-kathy-is-here.

Barry McDermott, "Wrong Image but the Right Touch," *Sports Illustrated*, July 25, 1983, https://vault.si.com/vault/1983/07/25/wrong-image-but-the-right-touch.

Hayley Wickenheiser

Leigh Montville, "Hayley Wickenheiser," *Sports Illustrated*, February 9, 1998, https://vault.si.com/vault/1998/02/09/hayley-wickenheiser.

SI Staff, "Woman Athletes of the Year," *Sports Illustrated*, December 31, 2007, https://vault.si.com/vault/2007/12/31/woman-athletes-of-the-year.

Nick Zaccardi, "Wayne Gretzky Compares Hayley Wickenheiser to NHL Legend," NBC Sports, January 16, 2017, https://olympics.nbcsports.com/2017/01/16/wayne-gretzky-hayley-wickenheiser-gordie-howe/.

Serena Williams

SI Staff, "A Different Kind of Competitor," *Sports Illustrated*, September 24, 2018, https://vault.si.com/vault/2018/09/24/different-kind-competitor.

SI Staff, "Serena Williams," *Sports Illustrated*, December 21, 2015, https://vault.si.com/vault/2015/12/21/serena-williams.

Venus Williams

Sally Jenkins, "Venus Rising," *Sports Illustrated*, November 14, 1994, https://vault.si.com/vault/1994/11/14/venus-rising-at-14-fledgling-pro-venus-williams-has-it-all-talent-charisma-and-a-tennis-dad.

S. L. Price, "Who's Your Daddy?" *Sports Illustrated*, May 31, 1999, https://vault.si.com/vault/1999/05/31/whos-your-daddy-call-richard-williams-what-you-wantbizarre-deceitful-or-perhaps-madbut-be-sure-of-one-thing-he-has-brilliantly-guided-the-careers-and-lives-of-his-daughters-venus-and-serena-the-hottest-players-in-tennis.

SI Staff, "Venus Venerated," *Sports Illustrated*, September 4, 2017, https://vault.si.com/vault/2017/09/04/venus-venerated.

Katarina Witt

Rick Reilly, "Behold the Shining Star of the G.D.R.," *Sports Illustrated*, January 20, 1986, https://vault.si.com/vault/1986/01/20/behold-the-shining-star-of-the-gdr.

E. M. Swift, "To Witt, the Victory," *Sports Illustrated*, March 7, 1988, https://vault.si.com/vault/1988/03/07/to-witt-the-victory-katarina-witts-carmen-turned-out-to-be-good-as-gold-after-debi-thomass-came-to-a-bad-end-in-calgary.

Anita Verschoth, "A Dazzling Display of Witt," *Sports Illustrated*, March 18, 1985, https://vault.si.com/vault/1985/03/18/a-dazzling-display-of-witt.

Mickey Wright

Michael Bamberger, "The Queen of Swing," *Sports Illustrated*, July 31, 2000, https://vault.si.com/vault/2000/07/31/the-queen-of-swing-after-dominating-golf-like-no-one-else-mickey-wright-took-her-leave-though-she-wont-let-you-visit-shes-happy-to-tell-you-why.

Richard Goldstein, "Mickey Wright, One of the Greatest Players in Women's Golf, Dies at 85," *New York Times*, February 17, 2020, https://www.nytimes.com/2020/02/17/obituaries/mickey-wright-dies.html.

SI Staff, "Mickey Wright," *Sports Illustrated*, July 12, 1965, https://vault.si.com/vault/1965/07/12/mickey-wright-a-retreat-from-a-flawless-image.

SI Staff, "When Mickey Wright Did Nothing Wrong," *Sports Illustrated*, November 23, 1964, https://vault.si.com/vault/1964/11/23/when-mickey-wright-did-nothing-wrong.

Minxia Wu

"Minxia Wu," Olympics, https://olympics.com/en/athletes/minxia-wu.

Everett Rosenfeld, "Wu Minxia: Chinese Diver's Parents Hid Family Illness, Deaths from Her," *Time*, August 3, 2012, https://olympics.time.com/2012/08/03/wu-minxia-chinese-divers-parents-hid-family-illness-deaths-from-her/.

SI Staff, "China's Wu Wins Record 5th Olympic Diving Gold Medal," *Sports Illustrated*, August 7, 2016, https://www.si.com/olympics/2016/08/07/ap-oly-div-diving.

Trischa Zorn

Karen Price, "Swimmer Trischa Zorn's Paralympic Legacy Goes Beyond Her Staggering 55-Medal Haul," TeamUSA, October 26, 2020, https://www.teamusa.org/News/2020/October/26/Swimmer-Trischa-Zorns-Paralympic-Legacy-Goes-Beyond-Her-Staggering-Medal-Haul.

Liz Roscher, "Changed the Game: Trischa Zorn's 55 Medals Set the Standard for Paralympic Swimmers," Yahoo Sports, March 17, 2021, https://www.yahoo.com/entertainment/changed-the-game-trischa-zorns-55-medals-set-the-standard-for-paralympic-swimmers-130016459.html.

SI Staff, "Champions All," *Sports Illustrated*, December 19, 1988, https://vault.si.com/vault/1988/12/19/champions-all.

"Swimmer Trischa Zorn Won an Amazing 55 Paralympic Medals," United States Olympic and Paralympic Museum, https://usopm.org/swimmer-trischa-zorn-won-an-amazing-55-paralympic-medals/.